London Statues

Arthur Byron

London Statues

A guide to London's
outdoor statues
and sculpture

Constable London

First published in Great Britain 1981
by Constable & Company Ltd
10 Orange Street London WC2H 7EG
Copyright © 1981 by Arthur Byron
ISBN 0 09 463430 0
Set in Monophoto Times New Roman
Printed in Great Britain by
BAS Printers Ltd, Over Wallop,
Hampshire

To Evelyn

Contents

Illustrations

The photographs are by Peter Pearson-Lunde. Additional photographs by Richard Byron and Arthur Byron

The maps were drawn by Patrick Leeson

Preface

London is one of the largest cities in the world and it seems
extraordinary that no comprehensive book about its statues has
appeared for fifty years, and perhaps even more extraordinary that
there is no book at all about its sculpture. This inexplicable gap in
the literature of London's monuments seemed to me a very good
reason for writing a guide to the six hundred odd statues, pieces of
sculpture, monuments and obelisks to be found outdoors in
London. It also seemed a good idea to have a book small enough to
be carried about easily and consulted on the appropriate site. The
Constable guide book format fills these requirements perfectly. It is
of interest that new pieces of sculpture far outnumber new statues
erected in London since the war; there has also been a great increase
in public awareness of three dimensional art.

This book lists outdoor statues, pieces of sculpture, memorials
and obelisks which, for better or worse, all help to make London
look distinctive. A chapter is devoted to each group, and each
chapter is arranged so that a short introduction precedes the list (in
alphabetical order) and description of each item. There is a final
chapter on the sculptors themselves.

The area covered is that of Greater London. Relatively little is to
be found south of the river, and what sculpture there is lies mostly
around the South Bank Gardens, though there are significant
examples in Battersea and Dulwich, as well as Greenwich.

The immense variety of subject and style, and the exciting range
of materials used, ensures endless enjoyment and instruction—both
historical and aesthetic—for those who wish to see and know more
about London's statues.

I am indebted to many people for help in writing this book; in
particular Mr R. Ashman, Mr Wilfrid Blunt, Professor Alan
Bowness, Mr Richard Brown, Mr Phillip Carpmael, Mr Richard
Calvocoressi, Mrs Cazalet-Keir, Mr Robert Cecil, Mr Curle, Mr
Peter Curnow, Miss Diana Detterding, Mr Draude, Mr Peter Elliot,
Sir Seymour Egerton, Mr Percy Flaxman, Mr Richard Gabrielozy,
Mr Arthur Grimwade, Mr Alec Harrison, Miss Mollie Hattam, Mr
Herman, Mr Felix Hope-Nicholson, Mr D. M. F. Jones, Mr E. M.

Kelly, Mr Tom Long, Miss Hester Mallin, Miss Maxey, Mr David
Mitchinson, Miss Patricia Mowbray, Sir Reginald Murley, Mr
Howard Nixon, Mr Bernard Nurse, Miss Maureen O'Connor, Mr
P. E. Pritchard, Mr John Profumo, Mr Paul Ridgeway, Mr Bruce
Robinson, Mr Birger Schaathun, Mr Brian Smith, Canon Charles
Smith, Sir John Summerson, Mr Syadkowski, Mr Targett, Mrs
Margaret Toynbee, Mr Roger Walters, The Duke of Wellington and
Mr A. Brett Young.

The Library Staff of Chelsea, Kensington, Westminster Reference,
Hammersmith, Swiss Cottage, Ministry of Defence, City of London,
Holborn, Camden, Royal Academy, R.I.B.A. and the Victoria and
Albert Museum and various members of the City of London
Architects and Planning Department have also aided me greatly.

I am most grateful to Mr Henry Moore and the Barbara
Hepworth Museum for providing photographs.

Above all, my thanks go to my son Richard, whose help and
extensive knowledge of London has been invaluable.

1 Statues

Statues have always been a mark of civilization. The ancient Egyptians made endless statues of their Pharaohs, sometimes twenty times life size, though they had more reason to do so as their Pharaohs often became gods. The Greeks decorated their temples and *agoras* with statues of gods and famous men and the Romans did so on an even bigger scale. The idea of commemorating great events or important people is natural, so it is not surprising that London is rich in such things, especially in Victorian statues when the British Empire was at its apogee.

Every ruler since Elizabeth, except Edward VIII, is on view, some standing, some on horseback and George I at the top of a steeple. Politicians are rather fond of giving each other statues but there are also plenty of soldiers, though only five Admirals and two Air Marshals. Only three members of the stage are honoured. Henry Irving and Sarah Siddons have statues while David Garrick has a medallion. There are numerous social workers, writers and explorers besides nine women and five Americans, four of whom were Presidents.

It is surprising to find as many as a dozen statues, ten of which are kings, being clothed in Roman dress. There are four riders without stirrups, but for the two kings in Roman dress this is correct, as stirrups did not really come in until the fifth century A.D. when Rome was on the decline.

Quite a lot of books are carried, whether it be the Bible as in the case of Robert Raikes, the founder of Sunday Schools, or the catalogue of the Great Exhibition which Prince Albert has in his right hand. Charles James Fox clasps a copy of the Magna Carta. Emmeline Pankhurst holds a lorgnette but Besant wears his spectacles. Both Wellington and Captain Cook grasp telescopes while Lord Napier and General Gordon have a pair of binoculars. Isambard Brunel holds a pair of compasses. Byron and J. R. Green have large dogs beside them. Reynolds and Millais each hold a palette and a brush, Churchill and a few others have walking sticks and Sir Sidney Waterlow sensibly has an umbrella. A boy in the Quintin Hogg group is carrying a football. Some statues like

Achilles, which incidentally is a misnomer, are cast out of enemy cannon and at the back of the Guards' Crimean Memorial in Waterloo Place there are real mortars actually used at the Battle of Sebastopol. Only Sir Thomas More has his signature on his plinth. Captain Scott was sculpted by his wife and near the Round Pond there is a large seated statue of Queen Victoria by her talented daughter Princess Louise.

One of the problems has been to decide whether any statues now indoors should be included. In principle they are not, but there seems to be good reason to mention William III in the Bank of England as two other statues of him are already listed as well as the others out of doors at the Bank. There is a very fine bust of James I just inside the entrance to the Banqueting House and it is within a few yards of Charles I over the entrance door outside. Then again John Milton used to be outdoors in the churchyard of St. Giles, Cripplegate, but has now been moved into the church. Another example is the Royal Exchange which had no roof over the courtyard when it was rebuilt in 1844 and the statue of Queen Victoria had to be replaced in 1895 owing to its deterioration from the weather. All the courtyard ones are included. There are a few further instances but they would seem to be justified for cogent reasons.

When it comes to statues on the face of buildings they too are in general not included but again there are a few exceptions. Having decided to include the statues inside the Royal Exchange, it seems difficult to exclude the two on its outside, especially as one is Dick Whittington. The Royal Geographical have the only statues of Livingstone and Shackleton in niches on their building especially designed to take statues, while in the archway of the Prudential there is a bust of Dickens who also has an important relief on the wall of a house in Marylebone Road surrounded by bas-reliefs of Dombey and other characters from books he wrote when living there.

There are over 370 statues on the outside of the Houses of Parliament alone and many government buildings such as the Foreign Office, the Victoria and Albert Museum and the Record Office are covered with statues. The Museum of Mankind in Burlington Gardens has twenty-two statues including Cicero and

Galen, Archimedes and Plato. None of these buildings, on which there are one hundred additional statues, are included, but details of most of them can be found in that excellent book by Lord Edward Gleichen, *London's Open Air Statuary*, Longmans 1928. It is out of print but some libraries have it.

A list of statues follows after which there is a description of each person and statue. In the last column of the lists of statues the word 'erected' indicates the date the statue was erected on the site mentioned.

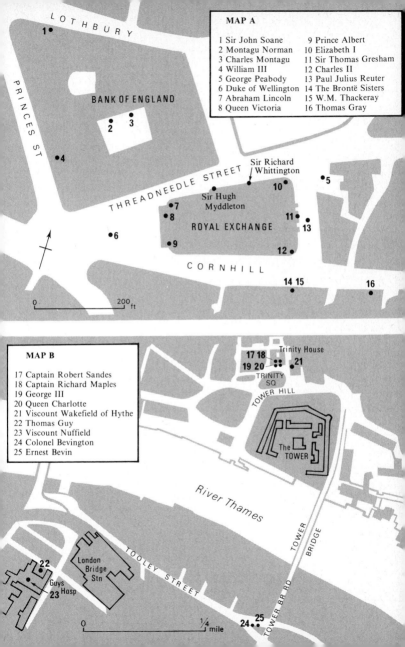

MAP A

1 Sir John Soane
2 Montagu Norman
3 Charles Montagu
4 William III
5 George Peabody
6 Duke of Wellington
7 Abraham Lincoln
8 Queen Victoria
9 Prince Albert
10 Elizabeth I
11 Sir Thomas Gresham
12 Charles II
13 Paul Julius Reuter
14 The Brontë Sisters
15 W.M. Thackeray
16 Thomas Gray

LOTHBURY

PRINCES ST

BANK OF ENGLAND

THREADNEEDLE STREET

Sir Richard Whittington

Sir Hugh Myddleton

ROYAL EXCHANGE

CORNHILL

0 200 ft

MAP B

17 Captain Robert Sandes
18 Captain Richard Maples
19 George III
20 Queen Charlotte
21 Viscount Wakefield of Hythe
22 Thomas Guy
23 Viscount Nuffield
24 Colonel Bevington
25 Ernest Bevin

Trinity House

TRINITY SQ

TOWER HILL

The TOWER

River Thames

TOWER BR RD

TOWER BRIDGE

London Bridge Stn

TOOLEY STREET

Guys Hosp

0 ¼ mile

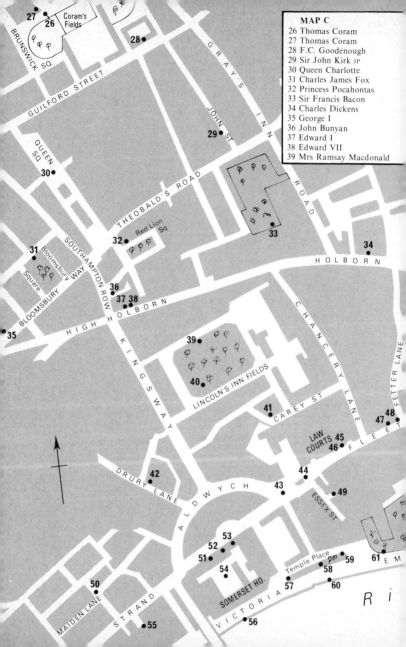

Map of the City of London area showing numbered locations, including Smithfield Market, Holborn Viaduct, St Bartholomew's Hospital, Little Britain, London Wall, Aldermanbury, Giltspur St, Gresham St, Farringdon St, Shoe Lane, Newgate Street, St Martin's le Grand, Cheapside, Warwick La, Ludgate Hill, St Paul's, St Paul's Churchy'd, Cannon St, Winston Churchill, New Bridge St, Tudor St, Blackfriars Stn, Blackfriars Bridge, and the River Thames.

MAP D

85 Sir Joshua Reynolds PRA
86 John Hunter
87 William Shakespeare
88 Sir Isaac Newton FRS
89 William Hogarth
90 Nurse Cavell
91 George Washington
92 George IV
93 Bartolomeu Diaz
94 General Sir Charles James Napier
95 Admiral Lord Nelson
96 Sir Henry Havelock
97 Charles I
98 W. S. Gilbert
99 Robert Burns
100 Lord Cheylesmore
101 Sir Wilfrid Lawson
102 Henry Fawcett
103 Robert Raikes
104 Sir Arthur Sullivan
105 Sir Joseph Bazalgette
106 General Sir James Outram Bt
107 Sir Henry Bartle Frere
108 2nd Duke of Cambridge
109 Field-Marshal Viscount Wolseley
110 Samuel Plimsoll
111 William Tyndale
112 Field-Marshal Lord Roberts of Kandahar VC
113 Duke of Devonshire
114 Charles I
115 James I
116 General Gordon
117 Viscount Portal of Hungerford
118 Lord Kitchener of Khartoum
119 Field-Marshal Earl Haig
120 Sir Walter Raleigh
121 Air Chief Marshal Viscount Trenchard
122 Lord Grey of Falloden
123 Field-Marshal Viscount Montgomery
124 Norman Shaw
125 Sir Robert Clive
126 Charles Dickens
127 Queen Boadicea
128 George Canning
129 Abraham Lincoln
130 Charles I
131 Oliver Cromwell
132 Richard I
133 Sir Robert Peel
134 Earl of Beaconsfield
135 Earl of Derby
136 Viscount Palmerston
137 Field-Marshal Jan Smuts OM
138 Sir Winston Churchill
139 Admiral Earl Beatty
140 Admiral Lord Cunningham
141 Admiral Lord Jellicoe
142 Henry III
143 Queen Victoria
144 Edward the Confessor
145 Elizabeth I

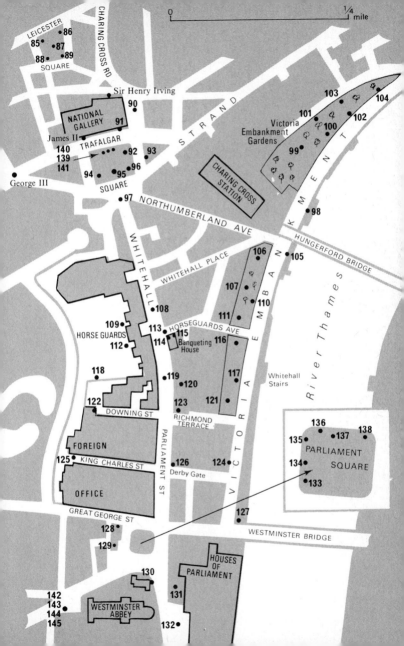

0 _____ 1/4 mile

LEICESTER
SQUARE
•85 •86
•87
•88 •89

CHARING CROSS RD

Sir Henry Irving
•90

NATIONAL
GALLERY
•91

James II
140 TRAFALGAR
139
141 •92 •93
•94 •95 •96
SQUARE

George III •

STRAND

Victoria
Embankment
Gardens
•99 •100 •101 •102 •103 •104

EMBANKMENT

CHARING CROSS
STATION

•97 NORTHUMBERLAND AVE

•98

HUNGERFORD BRIDGE

WHITEHALL PLACE

•106 •105

•107
•108
•110
•111

WHITEHALL

•109 HORSE GUARDS
•112

•113 HORSEGUARDS AVE
•114 •115
Banqueting
House

•116

•117

Whitehall
Stairs

River Thames

•118

•119
•120

•123
RICHMOND
TERRACE

•121

•122 DOWNING ST

FOREIGN

•125 KING CHARLES ST

OFFICE

PARLIAMENT ST

•126
Derby Gate

•124

VICTORIA EMBANKMENT

PARLIAMENT
SQUARE
•135 •136 •137 •138
•134
•133

GREAT GEORGE ST

•127

WESTMINSTER BRIDGE

•128
•129

HOUSES
OF
PARLIAMENT

•130

•131

142
143
144 •
145

WESTMINSTER
ABBEY

•132

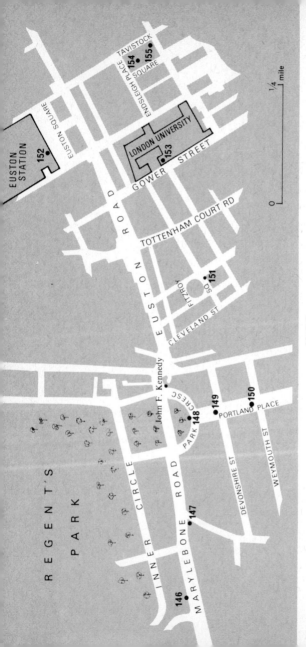

MAP E

146 Madame Tussaud
147 Charles Dickens
148 Duke of Kent
149 Lord Lister OM
150 Field-Marshal Sir George White VC OM
151 Krishna Menon
152 Robert Stephenson
153 Richard Trevithick
154 Mahatma Gandhi
155 Dame Aldrich-Blake

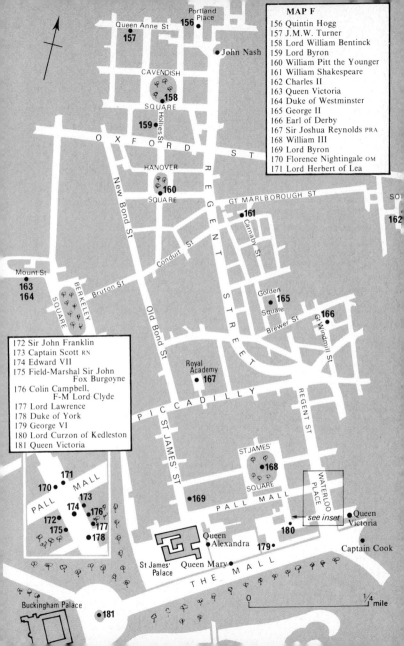

MAP F

156 Quintin Hogg
157 J.M.W. Turner
158 Lord William Bentinck
159 Lord Byron
160 William Pitt the Younger
161 William Shakespeare
162 Charles II
163 Queen Victoria
164 Duke of Westminster
165 George II
166 Earl of Derby
167 Sir Joshua Reynolds PRA
168 William III
169 Lord Byron
170 Florence Nightingale OM
171 Lord Herbert of Lea

172 Sir John Franklin
173 Captain Scott RN
174 Edward VII
175 Field-Marshal Sir John
 Fox Burgoyne
176 Colin Campbell,
 F-M Lord Clyde
177 Lord Lawrence
178 Duke of York
179 George VI
180 Lord Curzon of Kedleston
181 Queen Victoria

Portland Place
Queen Anne St 156
157
John Nash
CAVENDISH
158
SQUARE
Holles St
159
O X F O R D S T
New Bond St
HANOVER
160
SQUARE
GT MARLBOROUGH ST
SO
162
161
Carnaby St
Conduit St
Mount St
163
164
BERKELEY
SQUARE
Bruton St
Golden
165
Square
166
Brewer St
Gt Windmill St
Old Bond St
R E G E N T S T R E E T
Royal
Academy
167
REGENT ST
P I C C A D I L L Y
ST JAMES'
168
SQUARE
171
MALL
170
173
PALL
174 176
172
177
175 178
169
PALL MALL
180
WATERLOO
PLACE
see inset
Queen
Victoria
Captain Cook
Queen
Alexandra
179
ST JAMES'
ST JAMES'
PALACE
Queen Mary
T H E M A L L
Buckingham Palace
181
0 ¼ mile

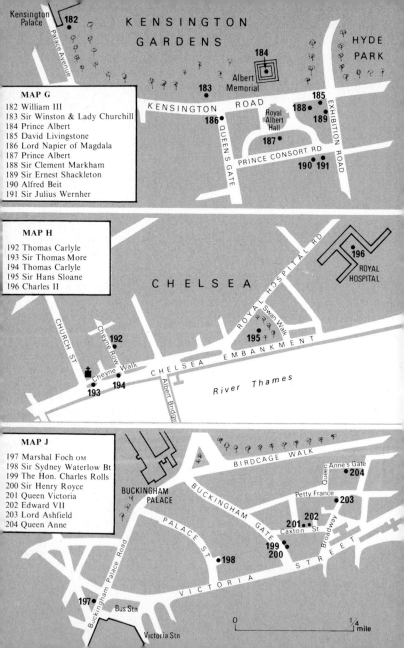

KENSINGTON GARDENS

Kensington Palace

182

HYDE PARK

184
Albert Memorial

183

KENSINGTON ROAD

QUEEN'S GATE

Royal Albert Hall

186

185
188
189

EXHIBITION ROAD

187

PRINCE CONSORT RD

190 191

MAP G
182 William III
183 Sir Winston & Lady Churchill
184 Prince Albert
185 David Livingstone
186 Lord Napier of Magdala
187 Prince Albert
188 Sir Clement Markham
189 Sir Ernest Shackleton
190 Alfred Beit
191 Sir Julius Wernher

MAP H
192 Thomas Carlyle
193 Sir Thomas More
194 Thomas Carlyle
195 Sir Hans Sloane
196 Charles II

CHELSEA

CHURCH ST

Cheyne Row

192

ROYAL HOSPITAL RD

Swan Walk

196
ROYAL HOSPITAL

195

194

193

CHEYNE WALK

CHELSEA EMBANKMENT

Albert Bridge

River Thames

MAP J
197 Marshal Foch OM
198 Sir Sydney Waterlow Bt
199 The Hon. Charles Rolls
200 Sir Henry Royce
201 Queen Victoria
202 Edward VII
203 Lord Ashfield
204 Queen Anne

BIRDCAGE WALK

Queen Anne's Gate

204

BUCKINGHAM PALACE

BUCKINGHAM GATE

Petty France

203

PALACE ST

201 202

Caxton St

BROADWAY

199
200

198

BUCKINGHAM PALACE ROAD

VICTORIA STREET

197

Bus Stn

Victoria Stn

0 1/4 mile

Statues

NAME	MAP	SITE	STATUE BUST EQUESTRIAN MEDALLION	MATERIAL	SCULPTOR	ERECTED
Prince Albert 1819–61	G	Behind the Albert Hall, S.W.7	S	Bronze	Joseph Durham	1899
	G	Albert Memorial, Kensington Gardens	S	Bronze	John Foley, R.A.	1875
	C	Holborn Circus, E.C.1	E	Bronze	Charles Bacon	1874
	A	Inside Royal Exchange, E.C.2	S	White Marble	John G. Lough	1847
Sir John Alcock 1892–1919		Heathrow Airport between terminals 2 and 3	S	Stone	William Macmillan, R.A.	1966
Dame Louisa Aldrich-Blake 1863–1925	E	Tavistock Square, W.C.1	B	Bronze	A. G. Walker	1927
Queen Alexandra 1844–1925		West Wall of Marlborough House, S.W.1	S	Bronze	Sir Alfred Gilbert, R.A.	1932

	Location		Material	Sculptor	Date
	In pediment of first floor window of 59 Knightsbridge, S.W.1	B	Stone	Unknown	1902
	London Hospital, Mile End Road, E.1	S	Bronze	George Edward Wade	1908
King Alfred 849–99	Trinity Church Square, Southwark, S.E.1	S	Stone	Unknown	1824
	Buxton Memorial Victoria Tower Gardens	S	Fibreglass	Department of Environment	1980
Queen Anne 1665–1714	C In front of St. Paul's, E.C.4	S	Sicilian Marble	R. Belt, copy of Francis Bird	1886
	J Outside 15 Queen Anne's Gate, S.W.1	S	Stone	Unknown	c. 1708
Lord Ashfield 1874–1948	J St. James's Park Underground Station, Broadway, S.W.1	M	Bronze	A. Pallitser	1959
Sir Francis Bacon 1561–1626	C Gray's Inn, South Square, W.C.1	S	Bronze	F. W. Pomeroy, R.A.	1912

NAME	MAP	SITE	STATUE BUST EQUESTRIAN MEDALLION	MATERIAL	SCULPTOR	ERECTED
Sir Francis Bacon (*continued*)	C	City of London School, Victoria Embankment, E.C.4	S	Stone	J. Daymond & Son	1882
General Lord Baden-Powell 1857–1941		Queen's Gate, S.W.7	S	Granite	Donald Potter	1961
Sir Joseph Bazalgette 1819–91	D	Embankment Wall opposite Northumberland Avenue, W.C.2	B	Bronze	George Simmonds	1899
Earl of Beaconsfield 1804–81	D	Parliament Square, S.W.1	S	Bronze	Mario Razzi	1883
Admiral Earl Beatty 1871–1936	D	Trafalgar Square, S.W.1	B	Bronze	William Macmillan, R.A.	1948
St. Thomas à Becket 1118–70	C	St. Paul's Churchyard, south side	S	Bronze	E. Bainbridge Copnall	1973

Name	Location		Material	Sculptor	Date
Duke of Bedford 1765–1805	Russell Square, W.C.2	s	Bronze	Sir Richard Westmacott, R.A.	1809
Alfred Beit 1853–1906	Imperial College of Science, Prince Albert Road, S.W.7	G, B	Stone	Paul Montford	1910
Lord William Bentinck 1802–48	Cavendish Square, W.1	F, s	Bronze	Thomas Campbell	1851
Sir Walter Besant 1836–1901	Victoria Embankment, W.C.2, River Wall	C, B	Bronze	Sir George Frampton, R.A.	1904
Ernest Bevin, P.C. 1881–1951	Tooley Street, S.E.1 Tower Bridge Road	B	Bronze	E. Whitney-Smith	1955
Colonel Bevington 1832–1917	Tooley Street, S.E.1 Tower Bridge Road	B, s	Bronze	Sydney Marsh	1910
Queen Boadicea 1st century A.D.	Victoria Embankment, S.W.1 by Westminster Bridge	D, s	Bronze	Thomas Thornycroft	1902
Simon Bolivar 1783–1830	Belgrave Square, S.W.1	s	Bronze	Hugo Daini	1974

NAME	MAP	SITE	STATUE BUST EQUESTRIAN MEDALLION	MATERIAL	SCULPTOR	ERECTED
William Booth 1829–1912		Wm. Booth Training College, Champion Park, S.E.5	S	Bronze	George Edward Wade	1929
		Mile End Road, E.1 North side	B	Bronze	George Edward Wade	1927
		ditto	S	Fibreglass	George Edward Wade	1979
Catherine Booth 1829–90		Wm. Booth Training College, Champion Park, S.E.5	S	Bronze	George Edward Wade	1929
James Boswell 1740–95		Plaque on Dr. Johnson q.v.	M	Bronze		
Brontë sisters	A	32 Cornhill, E.C.3	Relief	Wood	Walter Gilbert	1939
Sir Arthur Brown 1886–1948		Heathrow Airport between terminals 2 and 3	S	Stone	William Macmillan, R.A.	1966

Subject		Location		Material	Sculptor	Year
Isambard Kingdom Brunel 1806–59	C	Victoria Embankment and Temple Place, W.C.2	s	Bronze	Baron Carlo Marochetti, R.A.	1877
John Bunyan 1628–88	C	Baptist Church House, Southampton Row and Catton Street, W.C.1	s	Stone	Richard Garbe	1901
Field-Marshal Sir John Fox Burgoyne 1782–1871	F	Waterloo Place, S.W.1	s	Bronze	Sir Joseph Edgar Boehm, R.A.	1877
Robert Burns 1759–96	D	Victoria Embankment Gardens, W.C.2	s	Bronze	Sir John Steell	1844
Lord Byron 1788–1824		Hyde Park, Hamilton Gardens, W.1	s	Bronze	Richard C. Belt	1880
	F	7/10 St. James's Street, S.W.1 entrance	M	Marble	Unknown	1926
	F	John Lewis, Holles Street, W.1	M	Bronze	Tom Painter	1960
2nd Duke of Cambridge 1819–1904	D	Whitehall, London, S.W.1	E	Bronze	Adrian Jones	1907

NAME	MAP	SITE	STATUE BUST EQUESTRIAN MEDALLION	MATERIAL	SCULPTOR	ERECTED
Sir Colin Campbell, 1st Lord Clyde 1792–1863	F	Waterloo Place, London, S.W.1	S	Bronze	Baron Carlo Marochetti, R.A.	1867
George Canning 1770–1827	D	Parliament Square, S.W.1	S	Bronze	Sir Richard Westmacott, R.A.	1867
Thomas Carlyle 1795–1881	H	Cheyne Walk, S.W.3	S	Bronze	Sir Joseph Boehm, R.A.	1882
	H	24 Cheyne Row, S.W.3	M	Portland Stone	C. F. A. Voysey and B. Creswick	1900
Major John Cartwright 1740–1824		Cartwright Gardens, Euston Road, W.C.1	S	Bronze	George Clarke	1831
Sir John Cass 1661–1718		In City of London Polytechnic, E.C.3	S	Lead	F. L. Roubillac	1934

Name		Location		Material	Sculptor	Year
Nurse Cavell 1865–1915	D	St. Martin's Place, W.C.2	S	Marble and granite	Sir George Frampton, R.A.	1920
Sir Charles Chaplin 1889–1977		Leicester Square	S	Bronze	John Doubleday	1981
Charles I 1600–49	D	Trafalgar Square, S.W.1	E	Bronze	Hubert Le Sueur	1675
	D	Over entrance Banqueting Hall, Whitehall, S.W.1	B	Lead	Unknown	1950
	D	East Door, St. Margaret's, Westminster	B	Lead	Unknown	1949
Charles II 1630–85	H	Royal Hospital, Chelsea, S.W.3	S	Bronze	Grinling Gibbons	1692
	A	Inside Royal Exchange, E.C.2	S	Marble	John Spiller	1844
	F	Soho Square, W.1.	S	Stone	Caius Gabriel Cibber	1938

NAME	MAP	SITE	STATUE BUST EQUESTRIAN MEDALLION	MATERIAL	SCULPTOR	ERECTED
Queen Charlotte 1744–1818	B	Trinity House façade, Trinity Square, E.C.3	M	Coade stone	M. J. Baker	1776
probably	C	Queen Square, W.C.1	s	Lead	Unknown	c. 1775
	C	Somerset House façade, W.C.2	M	Stone	Joseph Wilton	1780
Lord Cheylesmore 1848–1925	D	Victoria Embankment Gardens, W.C.2.	s	Stone	Sir Edwin Lutyens, P.R.A.	1930
Frederick Chopin 1810–49		Beside Festival Hall, S.E.1	s	Bronze	B. Kubica	1975
Sir Winston Churchill 1874–1965	D	Parliament Square, S.W.1	s	Bronze	Ivor Roberts-Jones	1973
	C	Financial Times Cannon Street, E.C.4.	Mask	Bronze	Frank Dobson	1959

Subject		Location		Material	Sculptor	Date
Sir Winston and Lady Churchill	G	Kensington Gardens, S.W.7	s	Bronze	Oscar Nemon	1981
Sir Robert Clayton 1629–1707		North Wing Terrace of St. Thomas' Hospital, S.E.1	s	Stone	Grinling Gibbons	1976
Lord Clive 1725–74	D	King Charles Street, S.W.1	s	Bronze	John Tweed	1917
Lord Clyde, *see* Sir Colin Campbell						
Richard Cobden 1804–65		Hampstead Road, N.W.1	s	Marble	W. and T. Wills	1868
Dean John Colet 1467–1519		St. Paul's School, Barnes, S.W.13	s	Bronze	Sir Wm. Hamo Thornycroft, R.A.	1968
Captain Cook 1728–79	F	East end of The Mall, S.W.1	s	Bronze	Sir Thomas Brock, R.A.	1914
Thomas Coram c. 1668–1751	C	Brunswick Square, W.C.1	s	Bronze	William Macmillan, R.A.	1963
	C	Over door of 40 Brunswick Square	B	Stone	D. Evans	1937

NAME	MAP	SITE	STATUE BUST EQUESTRIAN MEDALLION	MATERIAL	SCULPTOR	ERECTED
Oliver Cromwell 1599–1658	D	By Westminster Hall, S.W.1	S	Bronze	Sir Wm. Hamo Thornycroft, R.A.	1899
Admiral Lord Cunningham 1883–1963	D	Trafalgar Square, S.W.1	B	Bronze	Franta Belsky	1967
Lord Curzon of Kedleston 1859–1925	F	Carlton House Terrace, S.W.1	S	Bronze	Sir Bertram Mackennal, R.A.	1931
Earl of Derby 1799–1869	D	Parliament Square, S.W.1	S	Bronze	Matthew Noble	1874
	F	22 Great Windmill Street, W.1	B	Stone	Unknown	1871
Robert Devereux 1591–1646	C	20 Devereux Court, Fleet Street, E.C.4	B	Stone painted	Unknown	1676
Duke of Devonshire 1833–1908	D	Whitehall and Horse Guards Avenue, S.W.1	S	Bronze	Herbert Hampton	1910

Subject		Location		Material	Sculptor	Date
Bartolomeu Diaz c. 1450–1500	D	S. Africa House, Trafalgar Square, S.W.1	s	Stone	Coert Steynberg	1934
Charles Dickens 1812–70	C	Prudential Building in archway, Holborn, E.C.1	B	Cupronized plaster	Percy Fitzgerald	1907
	E	Corner of Marylebone Road and Marylebone High Street, N.W.1	M	Stone	Eastcourt J. Clack	1960
	D	Red Lion Inn, Parliament Street, S.W.1	Head	Stone	Unknown	1900
Sir Alexander Dickson 1777–1840		Royal Artillery Mess, Woolwich	M	Bronze	Sir Francis Chantrey, R.A.	1912
Disraeli, *see* Earl of Beaconsfield						
Edward the Confessor 1004–66	D	On column in front of Westminster Abbey	s	Stone	J. R. Clayton	1861
Edward I 1239–1307	C	Top floor 114 High Holborn, W.C.1	s	Stone	Richard Garbe	1902

NAME	MAP	SITE	STATUE BUST EQUESTRIAN MEDALLION	MATERIAL	SCULPTOR	ERECTED
Edward VI 1537–53		North Wing Terrace of St. Thomas' Hospital, S.E.1	S	Bronze	Peter Scheemakers	1976
		North Wing Terrace of St. Thomas' Hospital, S.E.1	S	Stone	Thomas Cartwright	1976
Edward VII 1841–1910	F	Waterloo Place, S.W.1	E	Bronze	Sir Bertram Mackennal, R.A.	1921
		Edward VII Memorial Park, Shadwell, E.1	M	Bronze	Sir Bertram Mackennal, R.A.	1922
		Tooting Broadway, S.W.17	S	Bronze	L. F. Roselieb	1911
	C	Temple Bar, Strand, W.C.2	S	Marble	Sir Joseph Boehm, R.A.	1918

	Location		Material	Sculptor	Year
C	Top Floor, 114 High Holborn, W.C.1	S	Stone	Richard Garbe	1902
J	Caxton Hall, S.W.1	S	Terracotta	Unknown	1902
	University College School, Frognal, N.W.3	S	Stone	Unknown	1907
	Mile End Road, E.1 opposite London Hospital	M	Bronze	W. S. Frith	1911
	Mile End Road, E.1, further east	B	Bronze	Unknown	1911
	In pediment of first floor window of 55 Knightsbridge, S.W.1	B	Stone	Unknown	1902
Elizabeth I 1533–1603					
C	St. Dunstan-in-the-West, Strand, W.C.2	S	Stone	William Kerwin	1833
A	Inside the Royal Exchange, E.C.2	S	Marble	M. L. Watson	1847
D	Column in front of Westminster Abbey	S	Stone	J. R. Clayton	1861

NAME	MAP	SITE	STATUE BUST EQUESTRIAN MEDALLION	MATERIAL	SCULPTOR	ERECTED
Elizabeth I (*continued*)		Speech Room, Harrow School	S	Stone	Unknown	1925
Earl of Essex *see* Robert Devereux						
Stephen Fairbairn 1862–1938		The Mile Post on the Surrey bank, Putney to Mortlake footpath, S.W.15	M	Bronze	G. C. Drinkwater	1963
Henry Fawcett 1833–84	D	Victoria Embankment Gardens, W.C.2	M	Bronze	Mary Grant and Basil Champneys	1886
Henry FitzAilwin ?–1212	C	25 Holborn Viaduct, E.C.1	S	Stone	H. Bursill	1868
Marshal Foch, O.M. 1851–1929	J	Grosvenor Gardens, S.W.1	E	Bronze	G. Malissard	1930

Subject		Location		Material	Sculptor	Year
Onslow Ford, R.A. 1852–1901		Corner of Abbey Road and Grove End Road, N.W.8	B	Bronze	A. C. Lacchesi	1903
W. E. Forster 1819–86	C	Victoria Embankment Gardens, W.C.2	s	Bronze	H. R. Pinker	1890
Charles James Fox 1749–1806	C	Bloomsbury Square, W.C.1	s	Bronze	Sir Richard Westmacott, R.A.	1816
Sir John Franklin 1786–1847	F	Waterloo Place, S.W.1	s	Bronze	Matthew Noble	1866
Sir Henry Bartle Frere 1815–84	D	Victoria Embankment Gardens, S.W.1	s	Bronze	Sir Thomas Brock, R.A.	1888
Sigmund Freud 1856–1939		Adelaide Road, Swiss Cottage, N.W.3	s	Bronze	Oscar Nemon	1970
Elizabeth Fry 1780–1845		Wormwood Scrubs Prison, W.12	M	Stone	Unknown	1874
Mahatma Gandhi 1869–1948	E	Tavistock Square, W.C.1	s	Bronze	Fredda Brilliant	1956
David Garrick 1717–79	C	27 Southampton Street, W.C.2	M	Bronze	H. C. Fehr	1901

NAME	MAP	SITE	STATUE BUST EQUESTRIAN MEDALLION	MATERIAL	SCULPTOR	ERECTED
Sir Robert Geffrye 1613–1704		Over door of Geffrye Museum, Kingsland Road, E.2	S	Lead	Replica of John Van Nost's	1913
George I 1660–1727	C	St. George's Church, Bloomsbury Way, W.C.1	S	Stone	Nicholas Hawksmoor	1730
George II 1683–1760	F	Golden Square, W.1	S	Lead painted white	John Van Nost the elder	1753
		Greenwich Hospital	S	Marble	John Michael Rysbrack	1735
George III 1738–1820	D	Pall Mall East, Cockspur Street, S.W.1	E	Bronze	Matthew Cotes Wyatt	1836
	C	Somerset House quadrangle, W.C.2	S	Bronze	John Bacon senior	1788

		Location		Material	Sculptor	Date
	B	Façade of Trinity House, E.C.3	M	Coade stone	M. J. Baker	1796
	C	Façade of Somerset House, W.C.2	M	Stone	Joseph Wilton	1780
George IV 1762–1830	D	Trafalgar Square, S.W.1	E	Bronze	Sir Francis Legatt Chantrey, R.A.	1843
when Prince of Wales	C	Façade of Somerset House, W.C.2	M	Stone	Joseph Wilton	1780
George V 1865–1936		Old Palace Yard, S.W.1	S	Stone	Sir William Reid Dick, R.A.	1947
George VI 1895–1952	F	Carlton House Terrace, S.W.1	S	Stone	William Macmillan, R.A.	1955
William Schwenck Gilbert 1836–1911	D	Victoria Embankment, W.C.2	M	Bronze	Sir George Frampton, R.A.	1913
William Ewart Gladstone 1809–98	C	Strand and Aldwych, W.C.2	S	Bronze	Sir Wm. Hamo Thornycroft, R.A.	1905
		Bow Churchyard, E.3	S	Bronze	Albert Bruce-Joy	1882

NAME	MAP	SITE	STATUE BUST EQUESTRIAN MEDALLION	MATERIAL	SCULPTOR	ERECTED
F. C. Goodenough 1866–1934	C	London House, Mecklenburgh Square, W.C.1	M	Bronze	William Macmillan, R.A.	1936
General Gordon 1833–85	D	Victoria Embankment Gardens, S.W.1, behind Whitehall	S	Bronze	Sir Wm. Hamo Thornycroft, R.A.	1953
Thomas Gray 1716–71	A	39 Cornhill, E.C.3	M	Bronze	F. W. Pomeroy, R.A.	1917
John Richard Green 1837–83		Poplar Public Baths, East India Dock Road, E.14	S	Bronze	E. W. Wyon	1866
Sir Thomas Gresham 1519–79	A	Royal Exchange, E.C.2, in niche in front of clock tower	S	Stone	William Behnes	1845
	C	Gresham House, 24 Holborn Viaduct, E.C.1	S	Stone	H. Bursill	1868

Lord Grey of Fallodon 1862–1933	D	Foreign Office wall, at bottom of Downing Street steps, S.W.1	M	Stone	Sir Wm. Reid Dick, R.A.	1937
Thomas Guy 1644–1724	B	Guy's Hospital, S.E.1	s	Brass	Peter Scheemakers	c. 1733
Guy of Warwick 15th century	C	Newgate Street and Warwick Lane, E.C.1	s	Stone	Unknown	1967
Field-Marshal Earl Haig 1861–1926	D	Whitehall, S.W.1	E	Bronze	A. F. Hardiman, R.A.	1937
Alfred Harmsworth, *see* Northcliffe						
Sir Augustus Harris 1852–96	C	Façade of Drury Lane Theatre, W.C.2	B	Bronze	Sir Thomas Brock, R.A.	c. 1900
Sir Henry Havelock 1795–1857	D	Trafalgar Square, S.W.1	s	Bronze	William Behnes	1861
Henry III 1207–72	D	Column in front of Westminster Abbey, S.W.1	s	Stone	J. R. Clayton	1861

NAME	MAP	SITE	STATUE BUST EQUESTRIAN MEDALLION	MATERIAL	SCULPTOR	ERECTED
Henry VIII 1491–1547	C	Over gateway to St. Bartholomew's Hospital, E.C.1	S	Stone	Francis Bird	1702
Lord Herbert of Lea 1810–61	F	Waterloo Place, S.W.1	S	Bronze	John H. Foley, R.A.	1915
Sir Rowland Hill 1795–1879	C	King Edward Street, E.C.1	S	Granite	E. Onslow Ford, R.A.	1923
William Hogarth 1697–1764	D	Leicester Square, W.C.2	B	Stone	Joseph Durham	1875
Quintin Hogg 1845–1903	F	Langham Place, W.1	S	Bronze	Sir George Frampton, R.A.	1906
3rd Lord Holland 1773–1840		Holland Park, W.1	S	Bronze	G. F. Watts, R.A. and Edgar Boehm, R.A.	1872
John Howard 1726–90		Wormwood Scrubs Prison, W.12	M	Stone	Unknown	1874

Subject		Location		Material	Sculptor	Year
John Hunter 1728–93	D	Leicester Square, W.C.2	B	Stone	Thomas Woolner, R.A.	1874
	D	Lincolns Inn Fields, W.C.2	B	Bronze	Nigel Boonham	1979
William Huskisson 1770–1830	D	Pimlico Gardens, S.W.1, opposite Dolphin Square	s	Marble	John Gibson, R.A.	1915
Sir Henry Irving 1838–1905	D	Behind the National Portrait Gallery, Charing Cross Road, W.C.2	s	Bronze	Sir Thomas Brock, R.A.	1910
James I 1566–1625	D	Inside Banqueting House, entrance, Whitehall, S.W.1	B	Bronze	Hubert Le Sueur	c. 1815
James II 1633–1701	D	In front of National Gallery, S.W.1	s	Bronze	Grinling Gibbons	1948
Admiral Lord Jellicoe 1859–1935	D	Trafalgar Square, S.W.1	B	Bronze	Sir Charles Wheeler, R.A.	1948

NAME	MAP	SITE	STATUE BUST EQUESTRIAN MEDALLION	MATERIAL	SCULPTOR	ERECTED
Dr. Edward Jenner 1749–1823		Kensington Gardens at end of Long Water	S	Bronze	W. Calder Marshall, R.A.	1862
Dr. Samuel Johnson 1709–84	C	Behind St. Clement Danes, Strand, W.C.2	S	Bronze	Percy Fitzgerald	1910
Inigo Jones 1573–1652		Chiswick House, Chiswick, W.4	S	Stone	J. M. Rysback	1729
President John Kennedy 1917–63	E	Marylebone Road, N.W.1	B	Bronze	Jacques Lipchitz	1965
Duke of Kent 1767–1820	E	Park Crescent, W.1	S	Bronze	Sebastian Gahagan	1827
Sir John Kirk, J.P. 1847–1922	C	31 John Street, W.C.1	M	Bronze	Unknown	c. 1925
Lord Kitchener of Khartoum 1850–1916	D	Horse Guards Parade, S.W.1	S	Bronze	John Tweed	1926

		In pediment of first floor window, 73 Knightsbridge, S.W.1	B	Stone	Unknown	1902
Charles Lamb 1775–1834	C	Giltspur Street, E.C.1	B	Bronze	Sir William Reynolds-Stephens	1962
George Lansbury, P.C. 1859–1940		Hyde Park, Serpentine	M	Bronze	H. Wilson Parker	1953
Lord Lawrence 1811–79	F	Waterloo Place, S.W.1	S	Bronze	Sir Joseph Edgar Boehm, R.A.	1882
Sir Wilfrid Lawson 1829–1906	D	Victoria Embankment Gardens, W.C.2	S	Bronze	David McGill	1909
President Abraham Lincoln 1809–65	D	Parliament Square, S.W.1	S	Bronze	Copy of Augustus Saint-Gaudens	1920
	A	Royal Exchange interior, E.C.2	B	Indiana Limestone	Andrew O'Connor	1930
Lord Lister, O.M. 1827–1912	E	Portland Place, W.1	B	Bronze	Sir Thomas Brock, R.A.	1924

NAME	MAP	SITE	STATUE BUST EQUESTRIAN MEDALLION	MATERIAL	SCULPTOR	ERECTED
David Livingstone 1813–73	G	Royal Geographic Society, Kensington Gore, S.W.7	s	Bronze	J. B. Huxley-Jones	1953
Mrs. Ramsay MacDonald 1870–1911	C	North side of Lincolns Inn Fields, W.C.2	s	Bronze and Stone	Richard R. Goulden	1914
Sir James McGrigor, Bt. 1771–1858		Atterbury Street, Millbank, S.W.1	s	Bronze	Matthew Noble	1909
Captain Richard Maples c. 1630–80	B	Inside Trinity House, Trinity Square, E.C.3	s	Lead painted	Jasper Latham	1681
Sir Clement Markham 1830–1916	G	Forecourt of Royal Geographical Society, Kensington Gore, S.W.7	B	Bronze	F. W. Pomeroy, R.A.	1921
Karl Marx 1818–83		Highgate Cemetery	B	Bronze	Laurence Bradshaw	1956

Queen Mary 1867–1953	F	Garden Wall of Marlborough House, S.W.1	M	Bronze	Sir William Reid Dick, R.A.	1967
Mary Queen of Scots 1542–87	C	143 Fleet Street, E.C.4	S	Stone	Unknown	c. 1880
Earl of Meath 1841–1929		Lancaster Gate, W.2	M	Stone	Herman Cawthra	1934
Krishna Menon 1896–1974	E	Fitzroy Square, W.1	B	Bronze	Fredda Brilliant	1929
Lord Melchett 1868–1930		Imperial Chemical Industries, Millbank. S.W.1	Head	Stone	W. B. Sagan	1977
John Stuart Mill 1806–73	C	Victoria Embankment Gardens, W.C.2	S	Bronze	Thomas Woolner, R.A.	1878
Sir John Millais, P.R.A. 1829–96		Garden of Tate Gallery, S.W.1	S	Bronze	Sir Thomas Brock, R.A.	1904
Viscount Milner 1854–1925		Toynbee Hall, Commercial Street, E.1	M	Bronze	Gilbert Ledward, R.A.	1931
John Milton 1608–74	C	St. Giles's Church, Cripplegate, London Wall, E.C.2	S	Bronze	Horace Montford	1904

NAME	MAP	SITE	STATUE	BUST	EQUESTRIAN	MEDALLION	MATERIAL	SCULPTOR	ERECTED
John Milton (*continued*)	C	City of London School, Victoria Embankment, E.C.4	s				Stone	J. Daymond & Son	1882
Charles Montagu 1661–1715	A	Central Court of Bank of England, E.C.2	s				Stone	Sir Charles Wheeler, P.R.A.	1932
Field-Marshal Viscount Montgomery 1887–1976	D	Whitehall, S.W.1 (S.W. corner of Ministry of Defence)	s				Bronze	Oscar Nemon	1980
Sir Thomas More 1478–1535	C	City of London School, Victoria Embankment, E.C.4	s				Stone	J. Daymond & Son	1882
	H	Chelsea Embankment, S.W.3, opposite Chelsea Old Church	s				Bronze	L. Cubitt Bevis	1969
	C	Corner Carey and Serle Street, W.C.2	s				Stone	Robert Smith	1886

Subject		Location		Material	Sculptor	Date
Sir Hugh Myddleton 1560–1631		Islington Green, N.1	s	Sicilian Marble	John Thomas	1862
	A	North side of Royal Exchange, E.C.2	s	Stone	Samuel Joseph	1845
General Sir Charles James Napier 1782–1853	D	Trafalgar Square, S.W.1	s	Bronze	George Canon Adams	1855
Lord Napier of Magdala 1810–90	G	Queen's Gate, S.W.7	E	Bronze	Sir Joseph Edgar Boehm, R.A.	1920
John Nash 1752–1835		3 Chester Terrace	B	Plaster	Unknown	1930
		All Souls, Langham Place, W.1	B	Bronze	Cecil Thomas both taken from William Behnes	1956
Admiral Lord Nelson 1758–1805	D	Trafalgar Square, S.W.1	s	Stone	Edward Baily, R.A.	1843
Cardinal Newman 1801–90		Brompton Oratory, S.W.3	s	Marble	Léon-Joseph Chavalliaud	1896

NAME	MAP	SITE	STATUE BUST EQUESTRIAN MEDALLION	MATERIAL	SCULPTOR	ERECTED
Sir Isaac Newton, F.R.S. 1642–1727	D	Leicester Square, W.C.2	B	Stone	W. Calder Marshall, R.A.	1874
	C	City of London School, Victoria Embankment, E.C.4	s	Stone	J. Daymond & Son	1882
Florence Nightingale, O.M. 1820–1910	F	Waterloo Place, S.W.1	S	Bronze	Arthur George Walker, R.A.	1915
		North Wing Terrace of St. Thomas' Hospital, S.E.1	s	Composite material	Frederick Mancini	1975
Montagu Norman 1871–1950	A	Central Court of Bank of England, E.C.2	s	Stone	Sir Charles Wheeler, P.R.A	1946
Viscount Northcliffe 1865–1922	C	St. Dunstan-in-the-West, Strand, W.C.2	B	Bronze	Lady Scott	1930

Subject		Location		Material	Sculptor	Date
Viscount Nuffield 1877–1963	B	Guy's Hospital, S.E.1	s	Bronze	Maurice Lambert	1949
T. P. O'Connor 1848–1929	C	Fleet Street, E.C.4, opposite *Daily Telegraph* building	B	Bronze	F. Doyle-Jones	1934
General Sir James Outram, Bt. 1803–63	D	Victoria Embankment Gardens, S.W.1	s	Bronze	Matthew Noble	1871
Viscount Palmerston 1784–1865	D	Parliament Square, S.W.1	s	Bronze	Thomas Woolner, R.A.	1876
Dame Christabel Pankhurst 1881–1958		Victoria Tower Gardens, S.W.1	M	Bronze	Unknown	1959
Emmeline Pankhurst 1858–1928		Victoria Tower Gardens, S.W.1	s	Bronze	Arthur George Walker, R.A.	1930
Sir Joseph Paxton 1801–65		Crystal Palace, S.E.19	B	Marble	W. F. Woodington, A.R.A.	1869
George Peabody 1795–1869	A	Behind the Royal Exchange, E.C.2	s	Bronze	W. W. Story	1869

NAME	MAP	SITE	STATUE BUST EQUESTRIAN MEDALLION	MATERIAL	SCULPTOR	ERECTED
Sir Robert Peel 1788–1850	D	Parliament Square, S.W.1	S	Bronze	Matthew Noble	1877
		Police College, Hendon Way, N.W.2	S	Bronze	William Behnes	1971
Count Peter of Savoy 1203–68	C	Over Strand entrance to Savoy Hotel, W.C.2	S	Gilt Bronze	F. Lynn Jenkins	1904
Admiral Arthur Phillip 1738–1814	C	25 Cannon Street, E.C.4	B	Bronze	Charles Hartwell	1968
William Pitt the Younger 1759–1806	F	Hanover Square, W.1	S	Bronze	Sir Francis Legatt Chantrey, R.A.	1831
Samuel Plimsoll 1824–98	D	Victoria Embankment Gardens, S.W.1	B	Bronze	F. V. Blundstone	1929

Subject		Location		Material	Sculptor	Year
Princess Pocahontas c. 1595–1617	C	Red Lion Square, W.C.1	s	Bronze	David McFall, R.A.	1956
Viscount Portal of Hungerford 1893–1971	D	Victoria Embankment Gardens, S.W.1	s	Bronze	Oscar Nemon	1975
Joseph Priestley 1733–1804	D	30 Russell Square, W.C.1	s	Stone	Gilbert Bayes	1914
Robert Raikes 1735–1811	D	Victoria Embankment Gardens, W.C.2	s	Bronze	Sir Thomas Brock, R.A.	1880
Sir Walter Raleigh 1552–1618	D	Whitehall, S.W.1	s	Bronze	William Macmillan, R.A.	1959
Paul Julius Reuter 1816–99	A	Behind the Royal Exchange, E.C.2	B	Granite	M. Black	1976
Sir Joshua Reynolds, P.R.A. 1723–92	F	Courtyard of Royal Academy, W.1	s	Bronze	Alfred Drury, R.A.	1931
	D	Leicester Square, W.C.2	B	Stone	Henry Weekes, R.A.	1874

NAME	MAP	SITE	STATUE BUST EQUESTRIAN MEDALLION	MATERIAL	SCULPTOR	ERECTED
Richard I 1157–99	D	In front of House of Lords, S.W.1	E	Bronze	Baron Carlo Marochetti, R.A.	1860
Field-Marshal Lord Roberts of Kandahar, V.C. 1832–1914	D	Horse Guards Parade, S.W.1	E	Bronze	Harry Bates, A.R.A.	1924
		In pediment of first floor window of 69 Knightsbridge, S.W.1	B	Stone	Unknown	1902
The Hon. Charles Rolls 1877–1910	J	Entrance of Rolls-Royce Building, 65 Buckingham Gate, S.W.1	B	Bronze	William Macmillan, R.A.	1978
President Franklin Roosevelt 1882–1945		Grosvenor Square, W.1	S	Bronze	Sir William Reid Dick, R.A.	1948

Name / Dates		Location		Material	Sculptor	Year
Dante Gabriel Rossetti 1828–82		Cheyne Walk, S.W.3	M	Bronze	Ford Maddox Brown	1887
Sir Henry Royce 1863–1933	J	Entrance of Rolls-Royce Building, 65 Buckingham Gate S.W.1	B	Bronze	William Macmillan, R.A.	1978
Marquis of Salisbury 1830–1903		In pediment of first floor window of 87 Knightsbridge, S.W.1	B	Stone	Unknown	1902
Captain Robert Sandes c. 1660–1721	B	Inside Trinity House, Trinity Square, E.C.3	S	Lead painted	Peter Scheemakers	1953
Captain Scott, R.N. 1868–1912	F	Waterloo Place, S.W.1	S	Bronze	Lady Scott	1915
Sir Ernest Shackleton 1874–1922	G	Royal Geographical Society, Exhibition Road, S.W.7	S	Bronze	C. Sargeant Jagger	1932
William Shakespeare 1564–1616	D	Leicester Square, W.C.2	S	Marble	Giovanni Fontana, copy of Scheemakers'	1874

NAME	MAP	SITE	STATUE BUST EQUESTRIAN MEDALLION	MATERIAL	SCULPTOR	ERECTED
William Shakespeare (*continued*)	C	Garden in Aldermanbury, E.C.2	B	Bronze	Charles J. Allen	1895
	F	Corner of Gt. Marlborough Street and Foubert's Place, W.1	B	Stone	Unknown	*c.* 1912
	C	City of London School, Victoria Embankment, E.C.4	S	Stone	J. Daymond & Son	1882
Norman Shaw 1831–1912	D	2nd storey, Norman Shaw House, Victoria Embankment, S.W.1	M	Stone	Sir William Hamo Thornycroft, R.A.	1914
Sarah Siddons 1755–1831		Paddington Green, W.2	S	White Marble	Léon-Joseph Chavalliaud	1897
Sir Hans Sloane 1660–1753	H	Chelsea Physic Garden, Royal Hospital Road, S.W.3	S	White Marble	John Michael Rysbrack	1748

Subject		Location		Material	Sculptor	Year
Captain John Smith 1580–1631	C	Cheapside, E.C.2, beside St. Mary-le-Bow	s	Bronze	Charles Renick copied from William Couper	1960
Field-Marshal Jan Smuts, O.M. 1870–1950	D	Parliament Square, S.W.1	s	Bronze	Sir Jacob Epstein	1956
Sir John Soane 1753–1837	A	Bank of England, Lothbury, E.C.2	s	Stone	Sir William Reid Dick, R.A.	1937
W. T. Stead 1849–1912	C	Victoria Embankment Wall, E.C.2	M	Bronze	Sir George Frampton, R.A.	1920
Robert Stephenson 1803–59	E	Inside Euston Station, N.W.1	s	Bronze	Baron Carlo Marochetti, R.A.	1968
Major-General Sir Herbert Stewart 1843–85		Hans Place, S.W.1	M	Bronze	Sir Joseph Boehm, R.A.	1886
Sir Arthur Sullivan 1842–1900	D	Victoria Embankment Gardens	B	Bronze	Sir William Goscombe John, R.A.	1903
Sir Henry Tate 1819–99		Opposite Lambeth Town Hall, Effra Road, S.W.2	B	Bronze	Sir Thomas Brock, R.A.	1905

NAME	MAP	SITE	STATUE BUST EQUESTRIAN MEDALLION	MATERIAL	SCULPTOR	ERECTED
Archbishop Temple 1821–1902		In pediment over first floor window of 87 Knightsbridge, S.W.1	B	Stone	Unknown	1902
W. M. Thackeray 1811–63	A	32 Cornhill, E.C.3	Relief	Wood	Walter Gilbert	1939
Mrs. Thrale 1741–1821		Plaque on Dr. Johnson q.v.	M	Bronze		
Dr. Bentley Todd 1809–60		Courtyard of King's College Hospital, Denmark Hill, S.E.5	S	Marble	Matthew Noble	1913
Air Chief Marshal Viscount Trenchard 1873–1956	D	Victoria Embankment Gardens, S.W.1	S	Bronze	William Macmillan, R.A.	1961
Richard Trevithick 1771–1833	E	Gower Street, W.C.1, opposite University Street	M	Bronze	L. S. Merrifield	1933

J. M. W. Turner 1775–1851	F	22/23 Queen Anne Street, W.1	M	Stone	W. C. H. King	1937
Madame Tussaud 1760–1850	E	Madam Tussaud's façade, Marylebone Road, N.W.1	M	Fibreglass	Arthur Pollen	1969
William Tyndale c. 1490–1536	D	Victoria Embankment Gardens, S.W.1	S	Bronze	Sir Joseph Boehm, R.A.	1884
Queen Victoria 1819–1901		Kensington Gardens	S	White Marble	Princess Louise	1893
	A	Royal Exchange interior, E.C.2	S	Marble	Sir Hamo Thornycroft, R.A.	1895
	C	Temple Bar Memorial, W.C.2	S	Marble	Sir Joseph Boehm, R.A.	1880
	C	Victoria Embankment, Blackfriars Bridge, E.C.4	S	Bronze	C. B. Birch, R.A.	1896
	F	In front of Buckingham Palace, S.W.1	S	Marble	Sir Thomas Brock, R.A.	1921

NAME	MAP	SITE	STATUE BUST EQUESTRIAN MEDALLION	MATERIAL	SCULPTOR	ERECTED
Queen Victoria (*continued*)	J	Niche over Caxton Hall entrance, S.W.1	S	Terracotta	Unknown	1902
	F	15 Carlton House Terrace, S.W.1	S	Marble	Sir Thomas Brock, R.A.	1973
	C	Railings of The Temple, Victoria Embankment, E.C.4	M	Marble	C. H. Mabey	1902
	D	Column in front of Westminster Abbey	S	Stone	J. R. Clayton	1861
		Buxton Memorial Victoria Tower Gardens	S	Fibreglass	Department of Environment	1980
		Warwick Gardens, W.14	M	Bronze	F. L. Florence	1934
	F	121 Mount Street, W.1	B	Marble	Unknown	1887
		Parsee fountain, Broad Walk, Regent's Park	B	Stone	Unknown	1869

Subject	Ref	Location	Type	Material	Sculptor	Date
Viscount Wakefield of Hythe 1859–1941	B	41 Coopers Row, E.C.3	M	Bronze	Cecil Thomas, O.B.E.	1937
Edgar Wallace 1875–1932	C	Ludgate Circus, E.C.4, north-west side	M	Bronze	F. Doyle-Jones	1934
George Washington 1732–99	D	In front of National Gallery, S.W.1	s	Bronze	Copy of Jean-Antoine Houdon in Richmond, Va.	1921
Sir Sydney Waterlow, Bt. 1822–1906		Waterlow Park, Highgate Hill, N.19	s	Bronze	Frank Taubman	1900
	J	Westminster City School, Palace St., S.W.1	s	Bronze	Frank Taubman (replica)	1901
George Frederick Watts, O.M. 1817–1904	C	Postman's Park, Aldersgate St., E.C.1	s	Wood	T. H. Wren	1905
Field-Marshal the Duke of Wellington 1769–1852		Hyde Park Corner, W.1	E	Bronze	Sir Joseph Boehm, R.A.	1888

NAME	MAP	SITE	STATUE BUST EQUESTRIAN MEDALLION	MATERIAL	SCULPTOR	ERECTED
Field-Marshal the Duke of Wellington (*continued*)	A	Royal Exchange, E.C.2	E	Bronze	Sir Francis Chantrey, R.A. and Henry Weekes, R.A.	1844
Sir Julius Wernher 1850–1912	G	Imperial College of Science, Prince Consort Road, S.W.7	B	Stone	Paul Montford	1910
Rev. John Wesley 1703–91	F	Wesley's Chapel, 47 City Road, E.C.1	S	Bronze	J. Adams Acton	1891
Duke of Westminster 1825–99	F	121 Mount Street, W.1, round corner in Carpenter Street	B	Marble	Unknown	1887
Field-Marshal Sir George White, V.C., O.M. 1835–1912	E	Portland Place, W.1	E	Bronze	John Tweed	1922

Subject	Location		Material	Sculptor	Date
Sir Richard Whittington, M.P. 1358–1423	Whittington College, Highgate	s	Stone	Unknown	c. 1827
	A N. Side of Royal Exchange, E.C.2	s	Stone	J. E. Carew	1845
	At foot of Highgate Hill, N.9		Stone memorial with cat on top		1921 cat 1964
William III 1650–1702	A Bank of England, Princes St. entrance, E.C.2	s	Stone	Sir Henry Cheere	1735
	F St. James's Square, S.W.1	E	Bronze	John Bacon Junior, but designed by his father, John Bacon, R.A.	1808
	G Garden of Kensington Palace, W.8	s	Bronze	H. Baucke	1907
William IV 1765–1837	Beside William Walk, Greenwich, S.E.10	s	Foggin Tor Granite	Samuel Nixon	1938

NAME	MAP	SITE	STATUE BUST EQUESTRIAN MEDALLION	MATERIAL	SCULPTOR	ERECTED
General James Wolfe 1727–59		Greenwich Park	S	Bronze	Dr. Tait Mackenzie	1930
Field-Marshal Viscount Wolseley 1833–1913	D	Horse Guards Parade, S.W.1	E	Bronze	Sir William Goscombe John, R.A.	1920
Duke of York 1763–1827	F	At top of Duke of York's column, Waterloo Place, S.W.1	S	Bronze	Benjamin Wyatt the column, Sir Richard Westmacott, R.A. the statue	1834

ADDENDUM

NAME	MAP	SITE	STATUE BUST EQUESTRIAN MEDALLION	MATERIAL	SCULPTOR	ERECTED
Bertrand Russell 1872–1970		Red Lion Square, W.C.1		Bronze	Marcelle Quinton	1980

Prince Albert (1819–61)

Albert the Good, the Prince Consort, the husband of Queen
Victoria has a number of statues in London, the best known being
that in the Albert Memorial in Kensington Gardens, though it is the
Memorial rather than the statue that is remembered and that is
described in the chapter on Memorials.

Prince Albert was born near Coburg in Germany in 1819 and
married Queen Victoria in 1840. Considering the times and his
background he was a man of above average taste who composed
music and did much to encourage the arts and industry. Probably
his greatest achievement was his support in promoting the Great
Exhibition of 1851 in Hyde Park, which was a resounding success
and which was visited by the Queen over forty times. It is
commemorated by a square-shaped column, with appropriate
inscriptions, at the rear of the Albert Hall, which is surmounted by
Joseph Durham's bronze statue cast in 1858, three years before
Albert died. The Robin Hood boots and spurs are very surprising
beneath the Garter robes. It was at first in the gardens of the Royal
Horticultural Society before being moved to its present place in
1899. It cost £800.

After his death from typhoid at Windsor, the public soon began
to realize what they had lost, and a meeting convened by the Lord
Mayor exactly one month after his death organized committees
throughout the kingdom to raise money for a memorial. Everyone
knows the outcome. The memorial was the design of Sir Gilbert
Scott, R.A. but the fifteen-foot-high, ten ton bronze statue of
Albert was by John H. Foley, R.A. Prince Albert is seated wearing
the robes and insignia of the Order of the Garter and his head and
shoulders are leaning forward. The seated position was chosen to
give contrast to the numerous standing figures that form part of the
edifice surrounding him. His left foot rests on a footstool and his
right hand holds a catalogue of the Great Exhibition. Altogether it
is a very relaxed piece of work and it was sad that Foley died before
it was erected in 1875.

The fine equestrian statue of Richard I in front of the House of
Lords was by Baron Carlo Marochetti, R.A. and a plaster copy of
it had been shown in the Great Exhibition, as a result of which
Marochetti was commissioned to do the sculpture of Albert for the

Memorial. He produced a full-sized model which was not accepted. Before he could complete another version he died and the commission was given to Foley. Marochetti completed recumbent figures of Queen Victoria and Prince Albert for the Royal Mausoleum at Frogmore, and Albert's was placed in position in 1868 but the Queen's had to await her death in 1901.

The most delightful statue of Prince Albert stands in Holborn Circus, where he is mounted on a charger in the uniform of a Field-Marshal, doffing his plumed hat in a most unmilitary manner but making him the politest statue in London. There are bronze figures of Commerce and Peace at either end of the oblong plinth, and the bronze plaques on either side represent Prince Albert laying the foundation stone of the Royal Exchange on one side and Britannia distributing 1851 Great Exhibition awards on the other. The statue by Charles Bacon cost £2000 and was erected in 1874.

As he laid the foundation stone of the Royal Exchange, it is not surprising to find a statue of the Prince in it. Just inside the door on the right there is a large marble statue of him in Garter robes by J. G. Lough, dating from 1847.

Sir John Alcock, D.F.C. (1892–1919)
Almost every American and a great many Englishmen think that Lindbergh, the American, was the first person to fly the Atlantic, but that is quite untrue. Eight years before Lindbergh, John Alcock and Arthur Brown (q.v.) flew from St. John's, Newfoundland and landed on the west coast of Ireland at Clifden in Galway on 15 June 1919, having taken 16 hours 27 minutes. They averaged almost 120 m.p.h. The plane was a converted Vickers Vimy, with two Rolls-Royce Eagle engines, each of 360 hp, an aeroplane that had been designed to bomb Berlin during the First World War but which never did so, as the Armistice came before the raid could be planned. The flight covered 1,890 miles. Both men received a knighthood.

Alcock had flown before the War when he joined the Royal Naval Air Service and became a famous pilot. On one occasion after bombing Istanbul he was forced to land on the sea and swim ashore

Prince Albert, by Charles Bacon

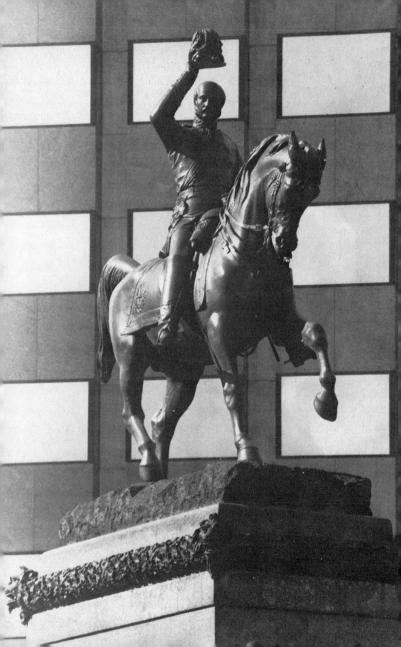

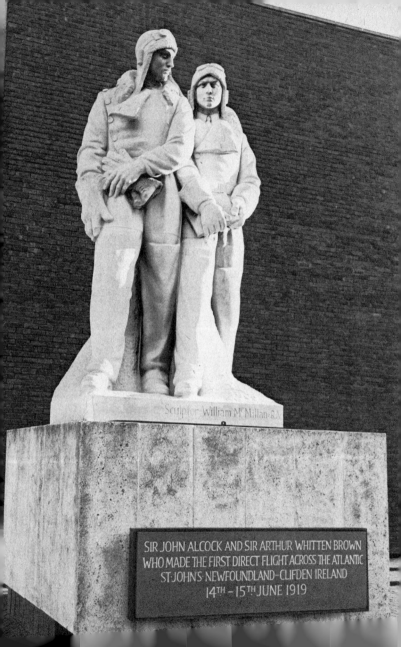

Sculptor William McMillan A.

SIR JOHN ALCOCK AND SIR ARTHUR WHITTEN BROWN
WHO MADE THE FIRST DIRECT FLIGHT ACROSS THE ATLANTIC
ST·JOHN'S NEWFOUNDLAND–CLIFDEN IRELAND
14TH –15TH JUNE 1919

in Gallipoli, where he was captured by the Turks and imprisoned. Alcock was experimenting on 19 December 1919 with his amphibian aeroplane when it crashed in Normandy and he died of the injuries.

Their granite statue by William Macmillan, R.A. has them both on a plinth in flying kit with shoulders touching. Below, it states simply that they 'made the first direct flight across the Atlantic St. John's Newfoundland Clifden Ireland 14–15 June 1919'. Initially in 1954 it was put on the north side of the airport where nobody saw it and in 1966 it was moved to the south wing of Terminal 3. Eight years later it has a place of honour between Terminals 2 and 3, near the Central Tower. Projecting from the rear of the sculpture, and not easily seen, there is a symbolic study of a hand holding a trident over the fierce waves and a dove flying peacefully above.

Dame Louisa Aldrich-Blake

The only person to have twin busts on the one plinth (they are back to back) is a remarkable lady surgeon, Dame Louisa Brandreth Aldrich-Blake, D.B.E., (1863–1925). She was Dean of the London (Royal Free Hospital) School of Medicine for Women from 1914–25, Consulting Surgeon and Surgeon to the Elizabeth Garrett Anderson Hospital from 1893 to 1925. What was also remarkable about her was 'her skill in boxing and cricket'—to quote the *Dictionary of National Biography*.

In the south-east corner of Tavistock Square there is a circular stone seat with a pillar rising from the centre. On each side of the pillar there is a bronze bust by A. G. Walker. It was designed by Sir Edwin Lutyens in 1927. The inscription on the garden side ends with 'The path of the just is as a shining light', and on the other 'glorious is the fruit of good labour'.

Queen Alexandra

Queen Alexandra (1844–1925) was the Danish wife of King Edward VII. Until Edward succeeded to the throne they lived in Marlborough House, so it is not surprising to find a Memorial to her set in the wall of Marlborough House garden opposite St. James's Palace.

Sir John Alcock and Sir Arthur Brown, the first men to fly the Atlantic 1919, by William Macmillan, R.A.

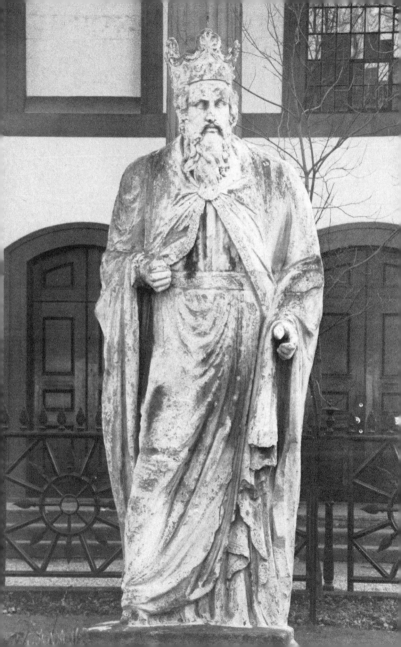

There are a number of bronze allegorical figures and the effect is almost Art Nouveau and not like anything else done by Sir Alfred Gilbert, R.A., who is better known for his Eros. Below the two main figures there is a fountain and behind it all a bronze screen with a lamp in both top corners. The plinth is of red Aberdeen granite. It is nineteen feet high and nearly eighteen feet wide and the whole work weighs nine tons. It was unveiled by King George V in 1932.

Her statue in the main court of London Hospital by George Edward Wade shows her in full coronation robes, wearing a crown and holding a sceptre in her hand. The inscription says that in 1900 she 'introduced to England the Finsen Light cure for Lupus and presented the first lamp to this hospital'. A bronze plaque shows her in a ward. It was erected in 1908.

There is a small stone bust of Alexandra just below the second floor window of 59, Knightsbridge, a companion piece to Edward VII at 55. The building went up in 1902.

King Alfred

Alfred, rightly called the Great, was king of the West Saxons. After nine battles he finally defeated the Danes and held England south of the Thames and parts of Mercia (the Midlands). Alfred traditionally created the British Navy and with his fleet attacked the Danes in East Anglia, after which Northumbria submitted and he became overlord of all England. He then devoted himself to legislation, government administration and the encouragement of learning, besides translating a number of books. Born in 849 at Wantage he died aged 50.

Appropriately, his statue is the oldest to be seen. He is in medieval garb and it dates from the end of the fourteenth century. It was removed in 1822 from the side of Westminster Hall when two inns known as Heaven and Hell were demolished. This oversize statue wears a crown and is thought to be King Alfred but there is no real evidence. It was placed in Trinity Square, now called Trinity Church Square, when this was laid out in 1824. The sculptor is unknown.

King Alfred

Alfred is also among the eight fibreglass figures on the Buxton
Memorial in Victoria Tower Gardens, replaced in 1980.

Queen Anne

St. Paul's Cathedral was completed in 1710 during Queen Anne's
reign. Her statue by Francis Bird was erected in front of it two years
later, but it deteriorated so badly that it was replaced in 1886 by a
very poor copy, the work of Richard Belt. At the foot are four
women representing England, France (probably), Ireland and North
America. Bird also sculpted the representation of the conversion of
St. Paul in the pediment of the west front. As Queen Anne had her
back to the cathedral and faced a spirit shop at the top of Ludgate
Hill there were some ribald rhymes about it such as:

Brandy Nan, Brandy Nan, you're left in the lurch
With your face to the gin shop, your back to the church.

The original Bird statue was removed to St. Leonards by Augustus
Hare, the delightful writer on guides to London and Rome, and is
still there in what is now a convent school. She is crowned and
carries an orb and sceptre, all three being gilded.

Queen Anne's Gate in Westminster has the finest examples of
houses built during that Queen's reign. They were erected in 1704 or
1705 for William Paterson, a founder of the Bank of England and,
soon after, the street was divided in two by a wall which extended
from the projecting part of No. 15, where the stone statue of Queen
Anne now stands. The east or Abbey end was called Park Street and
the west side Queen Square. The statue can be seen in Hatton's New
View of London of 1708 in Queen Square against the wall.

The property passed to Sir Theodore Janssen, who sold it by
public auction on 27 March 1723 to try and recoup some of the
£200,000 he lost in the South Sea Bubble. The statue, which was
mentioned in the sale, became the joint interest of the owners of the
houses. It has changed hands a number of times, and after the last
war it was presented to the Gardeners' Company by a former

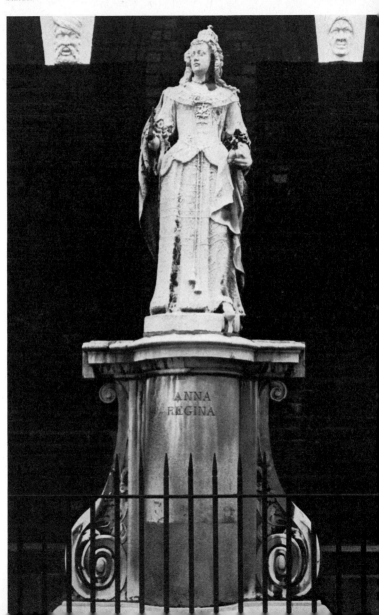

ANNA
REGINA

Master of the Company and by them to the nation in 1974.

The Queen is wearing the full costume of the Order of the Garter and a crown, but the back of her robe is still roughcast and unfinished. She holds an orb and sceptre. The sculptor is unknown and there is no evidence that it was Francis Bird.

Lord Ashfield

Albert Stanley (1874–1948) was created Baron Ashfield in 1920. He had been an M.P. and a P.C. but was known for his work on the London Underground. A bronze plaque is to be found on the corner wall of St. James's Park Underground station on which he is referred to as 'the Creator of Modern Transport.' Erected in 1959, it is by A. Pallitser.

Francis Bacon

Francis Bacon (1561–1626) was a man of great intellect who kept his head—in every sense—in spite of being a favourite of Queen Elizabeth. He might be regarded as the father of the inductive method of scientific inquiry, as his writing greatly influenced contemporary and later thinking. His essays proved to be his most popular work.

The great Lord Burghley, whose nephew Bacon was, would not take him under his wing, but he managed to get himself attached to Queen Elizabeth's favourite, the Earl of Essex, who gave him land and made him his protégé. Being by nature a devious fair-weather friend, Bacon had no qualms in voluntarily prosecuting Essex for treason when the time came, just as later on he prosecuted his great friend Somerset for murder. He ingratiated himself into King James I's favour, and by his obsequiousness he became in turn Attorney-General and Lord Chancellor, when he took the title of Lord Verulam. Later he was created Viscount St. Albans. Nemesis finally caught up with him and he was arraigned before his fellow peers for taking bribes as a judge. He was convicted, fined and imprisoned in the Tower. Though he was soon released, he was banished from court and parliament. He died in debt.

Bacon studied law in Gray's Inn, and his bronze statue by F. W. Pomeroy, R. A. standing in the South Square was put up in 1912 to mark his tercentenary as Treasurer of the Inn. He is wearing the

robes of a Lord Chancellor.

On the second floor of the City of London School, built in 1882, almost opposite Blackfriars Bridge, there are stone statues of Bacon, Shakespeare, Milton and Newton between the windows. Sir Thomas More is round the corner. They were executed by J. Daymond & Son in 1882.

General Lord Baden-Powell, O.M.
Robert Stephenson Smyth Baden-Powell (1857–1941) is best known as founder of the Boy Scouts in 1908, a movement that has become world-wide. Two years later he and his wife started the Girl Guides, but before all that he had first leapt to fame as the defender of Mafeking during 1899 and 1900, an event which caused enormous excitement in England. Previously he had served in India, Afghanistan, Ashanti and Matabeleland. He became a general, was raised to the peerage in 1929 and received the O.M. in 1937.

His statue by Donald Potter stands outside the Scout Headquarters at the corner of Queen's Gate and Cromwell Road. It is in granite and he is depicted as a bald, bent old man who is anything but an inspiration to youth. It was erected in 1961.

Sir Joseph Bazalgette
Joseph Bazalgette (1819–91) was a remarkable engineer and London owes him a great debt. He was responsible for building the Victoria Embankment which stretches from Westminster to Blackfriars Bridge between 1862 and 1874, in which year he was knighted. The enormity of the task may be realized when one finds that the Thames was pushed back nearly 130 yards from the York Water Gate near Charing Cross to its present position. Reducing the width of the Thames increased its rate of flow and that is why it can never get frozen over again. The scheme cost £1,553,000.

Bazalgette was also responsible for the great drop in London's death rate, which happened within five years of his drainage systems' being completed. He built eighty-three miles of large intercepting sewers draining a hundred square miles of buildings. This system was opened in 1865 and cost four million pounds. He also built Battersea, Putney and Hammersmith bridges.

On the river wall, on the Westminster side of Hungerford

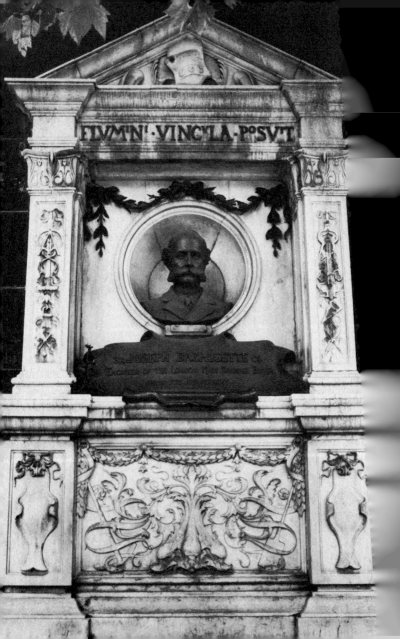

Bridge, there is a bust of him by George Simonds set in an elaborate surround which has various symbols of the builder. It was put up in 1899.

Lord Beaconsfield
Lord Beaconsfield (1804–81) is better known as Benjamin Disraeli. Besides being a brilliant politician he was a famous novelist. He twice became Prime Minister but he is probably best known for his astuteness in acquiring half the Suez Canal shares for Britain. He was also, and unlike Gladstone, a favourite of Queen Victoria. In the statue of him he his wearing peer's robes with the Garter regalia, the garter itself made conspicuous by a pulled back robe. He died on 19 April 1881 and the statue by Mario Razzi was unveiled two years later. That day is still commemorated as Primrose Day, the primrose being his favourite flower.

Admiral Lord Beatty, O.M.
In Trafalgar Square there is a bronze bust by William Macmillan, R.A. of Earl Beatty (1871–1936), the famous Admiral of the First World War who succeeded Jellicoe as Commander-in-Chief of the Grand Fleet in 1916. Previous to that he had made a name for himself in the China War of 1900 and in the First World War, prior to the battle of Jutland, he had sunk the German battle cruiser *Blucher* off the Dogger Bank. 1948.

St Thomas à Becket
Everybody knows the story of Thomas à Becket (1118–70) the English saint and martyr. He rose to become Chancellor and later Archbishop of Canterbury. He was murdered in his cathedral by four knights who were reputed to have heard Henry II say 'who will rid me of this turbulent priest?' A plaque in the north-west transept of Canterbury cathedral records the murder of Becket. He was canonized in 1172 and his tomb became the scene of pilgrimages until Henry VIII forbade all reference to him.

E. Bainbridge Copnall has created a recumbent bronze figure in the agony of death which is almost the only statue to be treated as a

Sir Joseph Bazalgette, by George Simonds

modern sculpture. It is on the south side of St Paul's churchyard. 1973.

5th Duke of Bedford

A large area between the Strand and the Marylebone Road belongs to the Bedford family, so it is not surprising to find a statue of Francis Russell, the 5th Duke of Bedford (1765–1805) in Russell Square, which he laid out, it being a part of their Bloomsbury property. The statue by Westmacott shows Russell as the agriculturist he was, with a sheep beside him and his hand on a plough. He was a member of the first Board of Agriculture. The statue dates from 1809.

Alfred Beit

Two brothers who made a vast fortune out of gold and diamonds in South Africa were Alfred (1853–1906) and Otto Beit. Born in Hamburg they moved to London and became British. Their firm was Wernher, Beit & Co. and on his return from South Africa, where he was associated with Cecil Rhodes at one time, Alfred, with his partner Julius Wernher, built the College of Mines in Prince Consort Road, which is now part of the Imperial College of Science. Albert is reputed to have given away £2 million but, unlike his younger brother Otto, he was not made a K.C.M.G. or a Knight.

The stone busts of Beit and Wernher (q.v.) on either side of the entrance to the College are the work of Paul Montford, erected in 1910.

Lord William Bentinck

Another Square with a statue is Cavendish Square where Thomas Campbell's bronze of Lord William Bentinck (1802–48) was erected in 1851. Bentinck, a son of the 4th Duke of Portland, was a politician who was taken up by his uncle George Canning (q.v.). He also took a great interest in the Turf and did much to raise the tone of racing.

Sir Walter Besant

Sir Walter Besant (1836–1901) was a man of letters and a great social reformer. He was Utopian in character and largely through

him the People's Palace was established in the East End. He was the
first chairman of the incorporated Society of Authors. His sister-in-
law was Annie Besant, the great theosophist. There is a bronze bust
of him and a panel by Sir George Framton, R.A. on the river wall
of Victoria Embankment, which was erected in 1904. There is also a
replica in St. Paul's Cathedral. His statue is the only outdoor one in
London that has spectacles.

Ernest Bevin P.C., M.P.
Ernie Bevin (1881–1951) was a big man in every sense of the word.
He was self-taught but was a very successful negotiator and was
known as 'the Dockers' K.C.'. He created the gigantic Transport
and General Workers' Union and later became Chairman of the
T.U.C. In the Second War he was a very important Minister of
Labour and later in Attlee's government he was Foreign Secretary.
 His bronze bust by E. Whitney-Smith stands on a stone column at
the Tower Bridge end of Tooley Street in Bermondsey. It was
erected in 1955.

Colonel Bevington, V.D., J.P.
A very few yards from Ernest Bevin in Tooley Street is a statue of
the bearded Colonel Samuel Bourne Bevington, V.D., J.P.
(1832–1917) in mayoral robes. From 1900 to 1902 he was the
first Mayor of Bermondsey. The statue was erected by his fellow
citizens in 1910. The sculptor was Sydney Marsh.

Queen Boadicea
Boadicea, also spelt Boudicca, was a red-headed Queen and one of
the great heroines of English history largely because she defeated the
Romans. She captured Colchester from them and took London and
St. Albans and, according to Tacitus, she put to death as many as
70,000 Romans; but finally she was defeated in A.D. 62 and took
poison rather than be captured. She was Queen of the Iceni, one of
the many tribes of Britain. In spite of all the glory she had to wait
1,840 years before getting a statue, but many would say that
Thomas Thornycroft made up for it with his spirited two-horse
chariot with scythed wheels and a proud Boadicea standing up in it
with her two daughters, though she has no reins to drive it. It stands

on the north side of Westminster Bridge facing the Houses of
Parliament. 1902.

Simon Bolivar

Simon Bolivar (1783–1830) was born in Venezuela and as a
statesman and a general he devoted his life to liberating the north of
South America from the Spanish yoke. He succeeded in driving the
Spaniards out of Venezuela, Colombia, Peru and Ecuador, and out
of the northern part of Peru he created in 1825 a new State called
Bolivia after him.

Bolivar's bronze statue by Hugo Daini stands on the east corner
of Belgrave Square. His uniform is a masterpiece of tailoring and he
holds a scroll in one hand. It was erected in 1974 on behalf of the
Council of Latin America. On the base are coats of arms of the
countries above and Panama.

General and Mrs William Booth

The Salvation Army is one of the great international organizations.
It started with open air revivalist services in the East End but its
name did not become official until 1878. William Booth (1829–1912)
was appointed its first general and in 1927 his fine bust by G. E.
Wade was added to the commemorative stone at the west end of the
Mile End Road by Cambridge Heath Road, which had marked the
site of the early meetings. He was greatly helped by his wife
Catherine (1829–90). There is now a William Booth Training College
in Champion Park, Denmark Hill, in front of which are bronze
statues, also by G. E. Wade, of both of them. The statues marked
the centenary of their birth.

A replica of Wade's statue of William Booth at Denmark Hill has
been erected in the Mile End Road at the other end of the plot of
ground that has his delightful bust. It is in fibreglass and painted
grey to defeat the vandals, but in no time they tore the book out of
his hand. His fingers have been repaired but the book was not
replaced. The bottom half has been filled with concrete as a
deterrent. He looks impressive in his frogged frock coat and his
outstretched hand. On Booth's tunic is the Salvation Army motif

Queen Boadicea, by Thomas Thornycroft

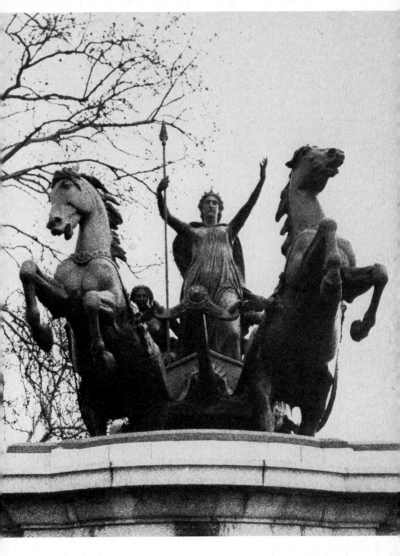

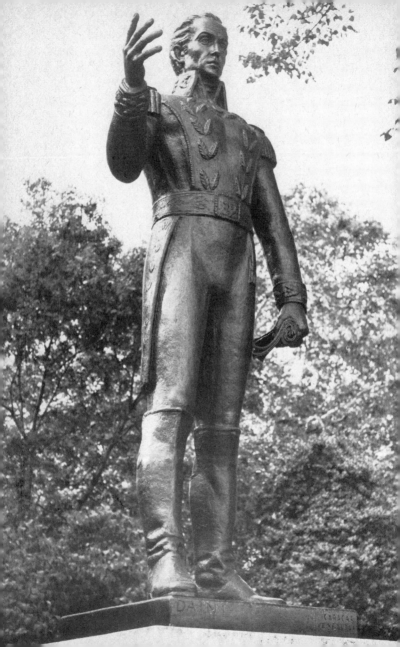

and motto 'Blood and Fire'. The statue was put up in 1979 to mark
the 150th anniversary of General Booth's birth.

James Boswell

James Boswell (1740–95) would no doubt be happy to know not
only that he is commemorated but also that he still remains at Dr.
Samuel Johnson's feet so to speak. He has become famous largely
through his *Life of Samuel Johnson* but his outspoken diaries are
important works. He was a Scot and he went with Johnson on a
tour of the Hebrides in 1773, each writing a version of the journey.

In front of the pedestal on which stands Percy Fitzgerald's statue
of Johnson (q.v.) in the Strand there is a plaque of Boswell.

The Brontë Sisters: William Makepeace Thackeray

Charlotte (1816–55), Emily (1818–48) and Anne (1820–49) were three
remarkable daughters of a Yorkshire clergyman, Patrick Brontë.
Each became a governess, each had a pseudonym that included Bell,
each wrote poetry and novels and each died young. It was Charlotte
who wrote the, then, very advanced novel *Jane Eyre* which
anticipated equality for women, while in the same year, 1847, Emily
produced *Wuthering Heights*, full of thwarted love and heroic
themes. Both are classics in their utterly different ways.

Charlotte married her father's curate and died the next year
during her pregnancy. Their brother Branwell (1817–48) ran up
debts and squandered whatever talent he had.

The very ornate pair of mahogany doors at 32 Cornhill is divided
into eight panels, each deeply carved and each depicting scenes from
the long history of Cornhill. At the bottom right, two Brontë sisters,
one carrying an umbrella, are shown in the publishing house of
Smith Elder and Company talking to William Makepeace
Thackeray (1811–63) who is holding his top hat and in the other
hand a book. Thackeray became a journalist, a popular writer in
Punch and finally a great novelist with such successes as *Vanity Fair*,
Pendennis and *The Newcomes*. He also undertook popular lecture
tours in America.

The doors were designed by B. P. Arnold and carved by Walter

Simon Bolivar, founder of Bolivia, by Hugo Daini

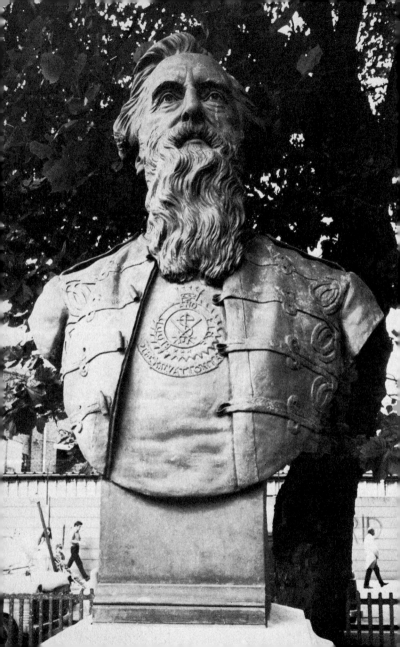

Gilbert, who is best known for his great gates at Buckingham
Palace. They were put up in 1939.

Sir Arthur Brown (1861–1948)

Arthur Whitten Brown became world famous when he landed in
Ireland after he and John Alcock, (q.v.) became the first people ever
to fly the Atlantic non-stop. They had taken off at St. John's,
Newfoundland, on 14 June 1919 and took 16 hours 27 minutes.
Brown acted as navigator. During the war he transferred from the
Army to the Royal Flying Corps, was shot down behind the
German lines and was a prisoner for eighteen months. He was
knighted and later joined an engineering firm.

See under Alcock for details of the flight and the statue.

Isambard Kingdom Brunel

Isambard Kingdom Brunel (1806–59) was the brilliant son of a
brilliant father, Sir Marc Isambard Brunel (1769–1849), whose chief
claim to fame was the construction of the Thames Tunnel between
1825 and 1843, the first of its kind. The son, who assisted his father
in this venture, became engineer for the Great Western Railway and
later turned his mind to shipbuilding as well as to bridges and
docks. He built the *Great Western*, which was the first transatlantic
steamship and the *Great Eastern* (1845), the first ocean steamer
driven by screw. At that time she was the largest ship ever built and
cost £732,000, but she was not a success and ended her days cable-
laying.

Brunel's bronze statue by Baron Carlo Marochetti, R.A. stands
in front of a stone screen at the corner of Victoria Embankment and
Temple Place. His left hand holds a pair of dividers and a quill pen.
The pedestal and surround is by Norman Shaw, 1877. Followers of
men's dress may notice that Brunel's trousers, though not tight,
have five buttons on the outside of each leg. This was a fashion that
began about 1849 and only lasted ten years.

John Bunyan

John Bunyan (1628–88) is best known for his *Pilgrim's Progress*,

General William Booth, by G. E. Wade

first published in 1678, which he mostly thought out during his twelve-and-a-half years in Bedford gaol for unlawful preaching. He was the son of a tinker and while working with his father he married a poor girl who had two books: *The Plain Man's Pathway to Heaven* and *The Practice of Piety*. These greatly influenced his life and thinking. He later became a dedicated but narrow-minded pastor and a prolific writer. He was buried in Bunhill Fields, the cemetery for Dissenters where Defoe and William Blake were later buried. His stone eight-foot statue by Richard Garbe is in a niche on the first floor of the Baptist Church House at the corner of Southampton Row and Catton Street. He holds a book in his hand and below are the opening lines of *Pilgrim's Progress*, 'As I walked through the wilderness of this world I lightened on a certain place'. 1901.

Sir John Fox Burgoyne

Field-Marshal Sir John Fox Burgoyne (1782–1871) was even more versatile a man than his natural father General John Burgoyne, who at the age of seventeen eloped with the Earl of Derby's daughter and later had an affair with an opera singer, their son being the future Field-Marshal. Both were soldiers with chequered careers. The father became a general and had to surrender to General Gates at Saratoga. The son was with Moore on the retreat to Corunna and later fought with Wellington in the Peninsular War. He became chief of the engineering section in the Crimea but was recalled, perhaps unjustly, as he was created a Baronet in 1856, made Constable of the Tower 1865 and a Field-Marshal in 1868. His statue in bronze by Sir Joseph Boehm, R.A. was erected in Waterloo Place in 1877.

Robert Burns

There is a bronze statue of Robert Burns (1759–96) in Victoria Embankment Gardens showing him composing, with a pile of books beside the tree stump he is sitting on. The statue was a gift of John Gordon Crawford, a fellow Scot, as was the sculptor Sir John Steell. Robbie Burns is one of Scotland's greatest poets. He contemplated going to Jamaica and to raise the money he started writing poetry.

Robert Burns, by Sir John Steell

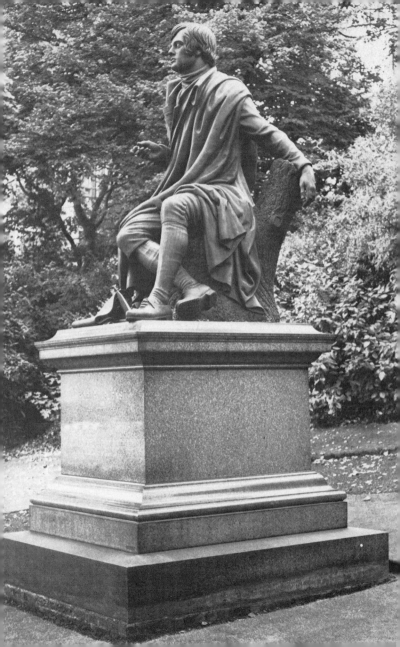

When he found the poems sold, he was encouraged to stay and write
more and he became a popular poet of folk traditions which have
become a cult anywhere in the world where Scots are to be found.
He was very much a man of the people, a great Radical and a great
lover. An illness caused his early death at the age of thirty-seven.
1844.

Lord Byron

Lord Byron (1788–1824) did not get recognition in Poet's Corner in
Westminster Abbey until 1969, having been banned by various
Deans. But other authorities were more lenient and since 1880 he
has had a statue just inside Hyde Park near Hyde Park Corner. The
Greek government gave a fifty-seven-ton slab of *rosso antico*
marble which forms the base but Richard Belt has made a poor job
of the statue. Byron is seated on a rock leaning over in an awkward
manner while his huge Newfoundland dog Bo'sun looks up
affectionately, but Byron looks the other way. According to his
friend Trelawney 'it does not in the remotest degree resemble Byron
either in face or figure'. Surprisingly it won the competition for this
statue and the £3,500 prize money. *See* Belt *under* Sculptors.

 Byron was born in a house in Holles Street now occupied by John
Lewis's who in 1900 put a bust of Lord Byron in their shop window.
It was bombed in the last war and was replaced by a medallion in
1960, the work of Tom Painter. When *Childe Harold* was published
Lord Byron was living at 8 St. James's Street which is now Byron
House, 7/10 St. James's Street and it was while there that he is
quoted as saying, 'I awoke one morning and found myself famous'.
Inside the entrance hall there is a larger-than-life marble medallion
of Byron presented by Sir John Sinclair. Underneath is engraved
Shelley's quotation from *Adonais*, 'The pilgrim of eternity'. It was
first placed on the façade of the former house in 1906 and moved
inside when the present building was completed in 1926.

 Few Englishmen have been labelled romantic in the way that
Byron has been and few have had a greater literary success in early
life. His fall from grace was equally great and sudden, but if
England could not accept him he became and still is a hero to the
Greeks. It was while helping them gain their liberty from the Turks
that he died at Missolonghi.

Lord Byron, by Richard Belt

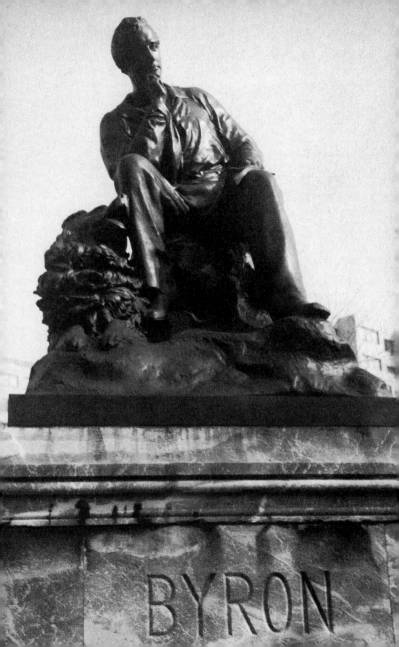

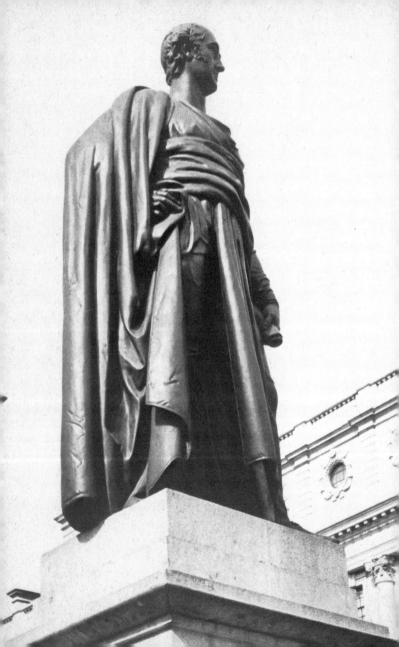

The Duke of Cambridge
Another Royal Field-Marshal is the 2nd Duke of Cambridge
(1819–1904), a grandson of George III, who fought in the Crimean
War at Alma and Inkerman where he had a horse shot under him.
His equestrian statue, which stands in the middle of Whitehall, is by
Adrian Jones, who was a Captain in the 3rd Hussars and also a
Veterinary Surgeon. The Duke is holding a Field-Marshal's baton in
his left hand, having been made a Field-Marshal in 1862. He
married an actress. Miss Farebrother, and their children bear the
name of Fitzgeorge. 1907.

Sir Colin Campbell, Lord Clyde
Sir Colin Campbell (1792–1863) disproves the theory that in the
nineteenth century one could not attain high rank unless well-born
or rich. His father was a Glasgow carpenter and Campbell rose from
being an Ensign in 1808 to Field-Marshal in 1859, a remarkable
achievement. He was seldom out of the wars, beginning with the
Walcheren expedition in 1809, the Peninsular War, with service in
America, China, the Sikh War of 1848–9, Crimea and India where
he led the relief of Lucknow. He was created Lord Clyde in 1858
and was buried in Westminster Abbey. His bronze statue in
Waterloo Place by Baron Carlo Marochetti, R.A. was erected in
1867. He is in uniform holding his helmet. On the base Britannia sits
upright on a lion while holding out an olive branch.

George Canning
George Canning (1770–1827) was a distinguished statesman and
orator. From the bar he entered parliament as a protégé of Pitt. He
was our Ambassador in Portugal, was twice Foreign Secretary and
finally Prime Minister just before his death. He was a civilized,
brilliant and witty man and his doggerel on the Dutch traders is well
known.

In matters of commerce the fault of the Dutch
Is offering too little and asking too much.

George Canning, by Sir Richard Westmacott, R.A.

His best-known remark comes from a speech in 1826: 'I called the New World into existence, to redress the balance of the Old'.

His statue by Sir Richard Westmacott, R.A. shows him in a classical pose and carrying a scroll in his left hand. It was first placed in Palace Yard in 1832 but it was re-sited in Parliament Square in 1867.

Thomas Carlyle

Thomas Carlyle, known as the Sage of Chelsea, was born in 1795 in Scotland but moved to London in 1835 and remained there till he died at his home in 24 Cheyne Row in 1881. His house is only a hundred yards from his statue by Sir Joseph Edgar Boehm, R.A. which stands in the gardens at the bottom of the street. 1883. He is seated in a chair with a pile of books beside it. It is said to be a great likeness. He was a prolific writer and his *French Revolution* is perhaps his best-known work. His house is open as a museum, and on its outside there is a medallion of Carlyle designed by C. F. A. Voysey and sculptured by B. Creswick, in Portland stone. 1900.

Major John Cartwright

John Cartwright (1740–1824) was the brother of William, the inventor of the power loom. John was a sailor under Howe, then a soldier and a political writer, being a great advocate of manhood suffrage, anti-slavery and reform. He was nearly sent to prison for sedition when aged eighty-one but was let off with a big fine. There is a seated bronze statue of him by George Clarke in Cartwright Gardens (named after him), off the Euston Road, 1831.

Sir John Cass

One of the finest statues in London is in the City of London Polytechnic, though when it is repaired it will be moved elsewhere. He lived from 1661 to 1718 and, besides being an Alderman and Sheriff, he was a Member of Parliament for the City of London.

His lead statue was executed in 1751 by F. L. Roubillac, the greatest sculptor of his generation, and shows him with superbly

Thomas Carlyle, by Sir Edgar Boehm, R.A.

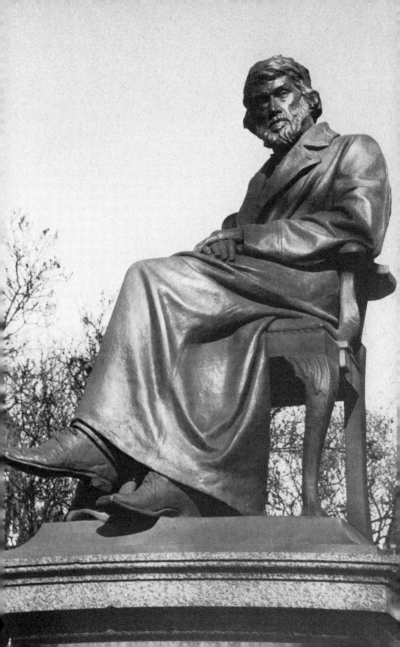

modelled sable edges to his sheriff's gown and to his sleeves, with his buckle shoes and his fine periwig and lace jabot. It is a masterpiece and it is a great pity that it is so little seen. It started off in his former school site by St. Botolph's Church and then moved to Jewry Street in 1910 where it was erected over the entrance, in the niche on the second floor, but was moved inside in 1934. After being repaired in 1980 it will probably go inside the Sir John Cass Primary school opposite St Botoloph's church in Aldgate.

Nurse Cavell

Edith Cavell (1865–1915) was made matron of a Brussels hospital in 1906 and when the war came she remained on. The Germans convicted her for helping British soldiers to escape and shot her in Brussels at dawn on 12 October 1915. This probably did their cause more harm than good as she became a martyr and the effect on public opinion was devastating. A large austere memorial twenty-five feet high by Sir George Frampton, R.A. has a statue of her on the front of it, dressed as a nurse. It was erected in St. Martin's Place opposite the National Portrait Gallery in 1920 and her last words 'Patriotism is not enough' were added to it four years later. The memorial was considered too modern when it was put up and bitterly criticized.

Sir Charles Chaplin

Nearly everyone who went to see films between the wars would rate Charlie Chaplin (1889–1977) as the greatest comedian the cinema had ever produced and most of them would still be of the same opinion. Chaplin, who was London born, came up the hard way. He went to Hollywood with Fred Karno in 1914 and soon had his own company, when he produced *The Gold Rush* and other masterpieces. He was extremely versatile, as he not only acted in his inimitable way but he composed the music and dances for *Limelight* and other films besides directing. He was knighted in 1975.

John Doubleday has sculpted a bronze figure of Chaplin a little over life-size showing him with his cane, his bowler hat and his baggy trousers. It was put up in 1981 in Leicester Square.

Sir Charles Chaplin, by John Doubleday

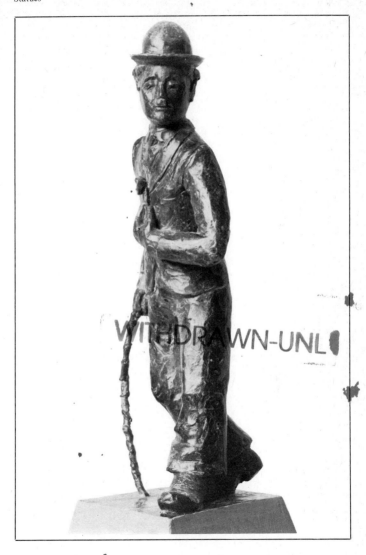

King Charles I

The splendid contemporary equestrian statue of Charles I (1600–49) on his Flemish stallion is by Hubert le Sueur, a Huguenot, whose name and the date of casting, 1633, is on the horse's left forefoot. It cost £600. Few statues have had such a chequered life. It was first placed in the churchyard of St. Paul's, Covent Garden, and on the outbreak of Civil War in 1642 it was hidden in the crypt. Thirteen years later it was seized by Cromwell's men and sold 'for the rate of old brass, by the pound rate' to John Rivett, a brazier, who pretended to have melted it down and sold countless mementoes to Royalists, supposedly from the statue's bronze. Puritans, too, gloried in its destruction and bought pieces to celebrate the King's downfall.

After the Restoration the statue reappeared and there were ownership disputes, but in 1675 the statue became the property of Charles II and was erected that year on the site of an old Eleanor Cross, on a stone pedestal carved by the King's mason, Joshua Marshall, after a design of Christopher Wren. The pedestal was cleaned for the first time in January 1977. It faces down Whitehall, so that Charles I is the only monarch whose statue looks down upon the scene of his death.

Le Sueur had worked in Paris before coming to London and to a certain extent the statue is based on the one of Henri IV on the Port Neuf, which le Sueur knew well.

Charles's sword has also been a source of trouble, as it and the 'George' decoration were stolen in 1844 when Queen Victoria drove by to open the new Royal Exchange. The sword was replaced, but that in turn was broken by a newspaper reporter in 1867 and stolen by a passer-by. It was finally replaced in 1947, when the statue was returned from its wartime evacuation at Mentmore. Charles's execution on 30 January 1649 is commemorated every year with a small ceremony, when wreaths are placed round the statue.

Examples of serendipity are all too few, but a case in point is that of Mr. Hedly Hope-Nicholson, for very many years the Secretary of the Society of King Charles the Martyr, finding three lead busts of Charles I in a builder's yard in Fulham just after the last war. He

Charles I

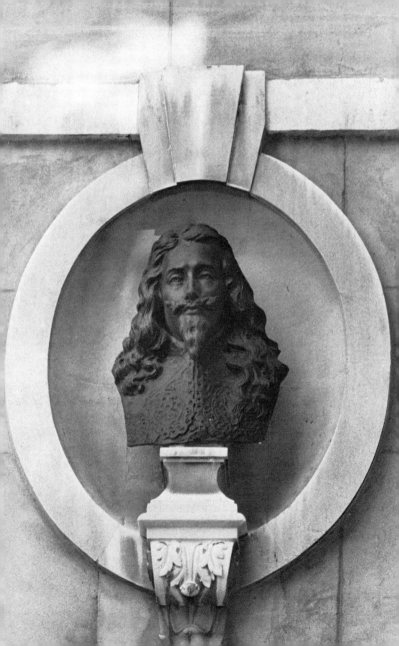

presented the best copy to the Banqueting House, where in 1950 it was placed in a circular niche over the present entrance which was built to James Wyatt's designs in 1809–10.

A very similar bust was offered to Westminster Abbey but Dean Don refused it. Luckily Canon Charles Smyth, Rector of St. Margaret's, Westminster, was able to buy it, and give it to his church. This was most appropriate, as Charles had been tried and executed in his parish. Canon Smyth clearly had a sense of history as well as a sense of humour and so he put it on a niche on the outside of the building above the door which is between the East window and Parliament Square. The irony of this site is that Charles looks straight across the road to Cromwell who, not surprisingly, has downcast eyes, although Hamo Thornycroft, his sculptor, could hardly have anticipated this event.

The third copy, which differs from the other two, is in the possession of Mr Felix Hope-Nicholson, the son of the finder, but not on view.

The sculptor is unknown but the three busts bear little relation to the Bernini bust in Windsor Castle which was taken from Van Dyck's triple head of Charles I, also in Windsor.

Charles I is also among the figures on the Buxton Memorial in Victoria Tower Gardens.

Charles II

Besides being known as Old Rowley, Charles II (1630–85) was referred to as the Merry Monarch, perhaps partly because of his propensity for mistresses and their royal bastards. He was a generous and astute man having 'a world of wit and not a grain of ill-nature in him' according to Defoe. Charles landed at Dover in 1660 and the Restoration began. Two years later he married the Portuguese Princess Catherine of Braganza, but it was a childless marriage. He accepted money from Louis XIV, but would not be bought. Charles avenged the Dutch raid on Medway shipping by building the most powerful navy of the day. The Habeas Corpus Act was passed and the people rarely had been so prosperous, but Charles had to put up with troubled times on the Continent.

Charles II, by Grinling Gibbons

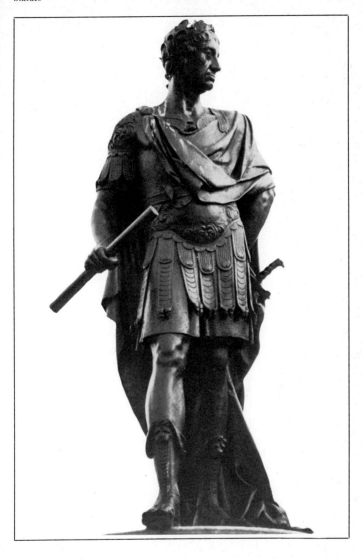

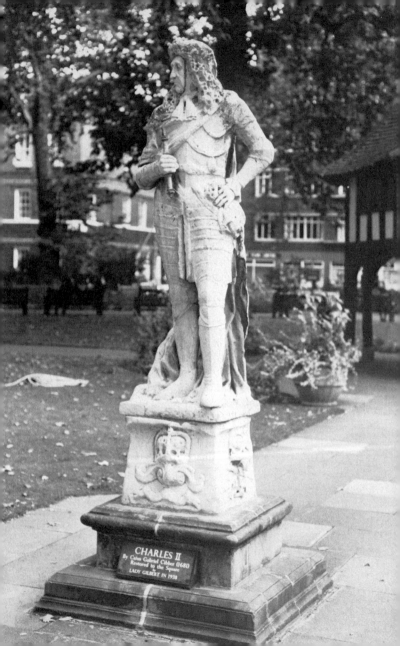

CHARLES II
By Caius Gabriel Cibber 1680
Restored to the Square
LADY GILBERT IN 1938

Greenwich observatory was founded and London was rebuilt following the Great Fire of 1666.

Charles was lucky to have Sir Christopher Wren to rebuild its churches and St. Paul's. Sir Peter Lely was court painter, Henry Purcell was 'Composer for the King's violins' and William Wycherley's *The Country Wife* was played to packed houses. Isaac Newton's apple dropped in either 1665 or 1666.

The stone statue of Charles II by Caius Gabriel Cibber stands in Soho Square, which was laid out in 1681 during his reign. In 1876 the statue was given to F. A. Goodall, R.A., who took it to Grimsdyke, Harrow Weald and on his death W. S. Gilbert had it. Lady Gilbert gave it back and it was re-erected in Soho Square in 1938 in a slightly battered condition. Charles is in armour and holding a sceptre.

Another contemporary statue is the superb bronze by Grinling Gibbons, a companion piece to James II outside the National Gallery. Both were the gift of Tobias Rustat when Keeper of Hampton Court. It cost £300 and was presented to Charles in 1676, but not erected in the centre of the main or Figure Court of Chelsea Hospital which Charles founded, until 1692. Charles is wearing Roman costume and on 29 May, Oak Apple day, he is decorated with oak leaves to commemorate his escape from the Roundheads, when he hid in an oak tree at Boscobel after his defeat at the Battle of Worcester, 1651. The Chelsea Pensioners all parade and enjoy double rations that day.

In the far right-hand corner of the Royal Exchange there is also a statue of Charles II by John Spiller the younger, dating from the late eighteenth century, but not put there until 1844.

Queen Charlotte

High up on the façade of Trinity House in the City there are medallions by M. J. Baker of George III and his wife Charlotte, Princess of Mecklenburg-Strelitz (1744–1818). They married in 1761 and she had fifteen children.

Queen Charlotte also has a medallion on the façade of Somerset House next to the king, by Joseph Wilton. 1780.

Charles II, by Caius Gabriel Cibber

There is a leaden statue of a woman wearing a crown and with a
sceptre in her right hand in Queen Square, behind Southampton
Row, but no one knows the name of the sculptor nor which Queen
it is, though Charlotte is the chief contender, with Mary and Anne
close runners-up. The dress could apply to any of them but the
statue's face is pretty, which should eliminate them all, especially
Charlotte. c. 1775.

Lord Cheylesmore
The fourth Baron Cheylesmore, G.B.E, K.C.M.G, K.C.V.O.
(1848–1925) was in the Grenadier Guards and became a Major-
General. He was Chairman of the National Rifle Association and
Chairman of the London County Council in 1912–13.

His statue in Portland stone by Sir Edwin Lutyens, P.R.A. is in
the part of Victoria Embankment Gardens near Temple station. It
has two bays with seats. In Vauxhall Park there is a goldfish basin
by Basil Champneys in memory of him. 1930.

Frederick Chopin
Frederick Chopin (1810–49), born in Poland, was the son of a
French father. He became a great pianist and a much greater
composer, his music being almost entirely composed for the piano.
He achieved fame in Vienna and then in Paris but he visited
England in 1837 and again in 1848. Liszt introduced him to George
Sand (Madame Dudevant) and he lived with her on and off from
1836–47, mostly at Nohent in central France. He became the idol of
the salons in Paris where he introduced mazurkas, of which he
composed fifty. His exuberantly romantic work is full of subtle
fancy and beauty and even his funeral march is resonant with
haunting majesty. He died of consumption in Paris aged thirty-eight.

Beside the Festival Hall a somewhat ethereal bronze figure rises
up with the head of Chopin emerging from folds of material. Its
black marble base is set upon a raised garden and on the plinth is
his Polish name Fryderyk Chopin and 'given by the people of
Poland', but it was erected through the initiative of Stefania
Nierkrasz and was subscribed for mostly by Poles in this country
and Poland. The sculptor was B. Kubica, a Pole. 1975.

Sir Winston Churchill

Winston Leonard Spencer Churchill (1874–1965) needs no
introduction. It is fitting that his bronze statue is oversize and that it
is in Parliament Square on its own, half-facing the House of
Commons, the scene of so many triumphs. Ivor Roberts-Jones has
produced a dominant, though somewhat aged, but still an expressive
figure, leaning forward, with his right hand on his stick. On the
front of the granite plinth is carved in big letters the one word
Churchill. 1973.

Over the main entrance of Bracken House, the *Financial Times*
building in Cannon Street, there is an ornate astronomical clock
with all the signs of the Zodiac, in the centre of which is a bronze
mask of Winston Churchill. Brendan Bracken, who was a great
personal friend of Churchill, was Chairman of the *Financial Times*.
The sculptor was Frank Dobson and it was erected in 1959.

The outer ring of the clock gives the minutes, the next ring the
hours and the inner ring the months. There are two panels; one
gives the day and the other the phases of the moon.

Sir Winston and Lady Churchill

For many years Winston Churchill and his wife Clemmie lived in a
house in Hyde Park Gate and now both are dead a bronze statue of
the two of them is being put up in Kensington Gardens near their
house. The sculptor is Oscar Nemon who has done a number of
statues of Churchill from life including the ones at Woodford, which
was Churchill's constituency, and the Guildhall. It is based on the
Blenheim maquette of them both, for which Lady Churchill posed.
The work is much larger than lifesize as they are both seated and it
was important that they were not dwarfed by the trees, 1981.

Sir Robert Clayton

The only outdoor stone statue by Grinling Gibbons is that of Sir
Robert Clayton (1629–1707) who was Lord Mayor of London in
1679, President of the Governors and a generous benefactor of St.
Thomas' Hospital. The work was commissioned during his lifetime
and shows him in contemporary dress with a long wig. In his right
hand he holds a scroll. One hand is a nineteenth-century
replacement. After his death the pedestal was embellished with
cherubim and festoons. The statue originally stood in Clayton

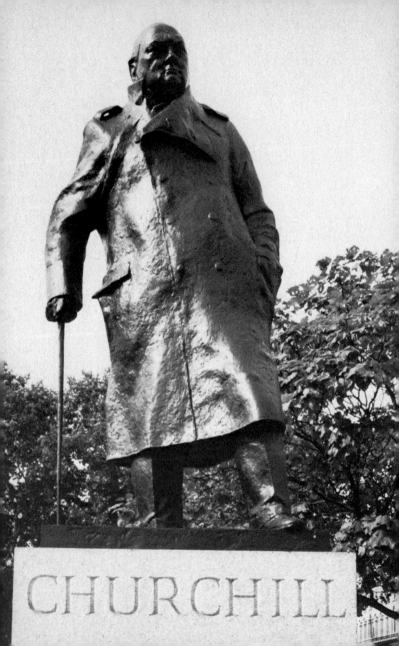

CHURCHILL

Court, Southwark where the hospital started. It was then moved to the Victorian blocks opened in 1871 and is now on the north wing terrace of the new hospital beside Edward VI. 1976.

Robert Clive, 1st Lord Clive

It was thanks to such people as Robert Clive (1725–74) that the British Empire was founded. The son of a Shropshire lawyer, he found himself penniless in Madras in 1744 and attempted suicide twice. Each time the pistol failed to fire, so he threw it away with a prophetic remark, 'It appears that I am destined for something. I will live.' His first turning-point was the capture of Arcot in 1751 and then withstanding the eleven week siege that followed. His greatest success was his victory at Plessey in 1757. He had previously occupied Calcutta and destroyed French power in Bengal. On his return to England he soon became an M.P. and was raised to the Irish peerage as Baron Clive of Plessey. He later went back to Bengal to put some order into the Civil Service and the Army before returning finally to England, where he got no thanks but abuse for the work he had done. This affected him to the extent of committing suicide by shooting—this time successfully—at his house in 45 Berkeley Square, one of the few Georgian houses remaining in the square.

 His statue in bronze by John Tweed was just off Whitehall in 1912 but it was moved in 1917 to the end of King Charles Street, where he stands on his plinth looking over St. James's Park. The plaques round the base show him at Arcot, Plessey and as Ruler of Bengal.

Richard Cobden

Richard Cobden (1804–65) was called the Apostle of Free Trade. In 1841 he became an M.P. and the Corn Laws were abolished five years later, partly due to his great speeches. He travelled a great deal; to America twice, the Levant and Europe. He refused honours. He was the father-in-law of the painter W. R. Sickert. His marble statue by W. and T. Wills, standing at the north end of Hampstead Road in Camden Town, cost £320 and was erected three years after his death. It is strange to think that Napoleon III was the biggest contributor to the fund.

Winston Churchill, by Ivor Roberts-Jones

Dean Colet

John Colet (1467–1519), the son of a Lord Mayor, met
Savonarola on a journey to Italy and later Erasmus at Oxford. Colet
was an advanced theologian, but that did not stop him becoming
Dean of St. Paul's though he is best known for his part in founding
St. Paul's School in Hammersmith. It was moved across the river to
Barnes in 1968, as was his statue, with two kneeling scholars beside
him, by Sir William Hamo Thornycroft, R.A.

Henry Condell *see* **Shakespeare**

Captain Cook

James Cook (1728–79) started off as a merchant seaman but joined
the Navy in 1759. After eight years surveying the St. Lawrence he
was given the command of the *Endeavour* on a voyage to the Pacific
to observe the transit of Venus. He then completed his voyage round
the world, discovering the east coast of Australia on the way. He
sailed on two further voyages of discovery, the second one proving
fatal, as he was killed in the Hawaiian Islands. His statue at the
Admiralty Arch end of the Mall by Sir Thomas Brock, R.A. shows
him standing in front of a capstan with one foot rather
uncomfortably on a coil of rope. He holds a telescope in his hand.
Erected 1914.

Thomas Coram

Not many philanthropists end their last years badly in need of
charity from others, but such was the case of Thomas Coram
(*c.* 1668–1751). He spent more money than he should have in starting
up the Foundling Hospital for children, who were first admitted in
1745. William Hogarth, one of his warmest supporters, painted his
portrait and he induced famous artists like Gainsborough to present
paintings to the Hospital. The Hospital, which supports about five
hundred children, was moved in 1926 from Guildford Street to
Redhill. He was known as Captain Coram from his early days at sea
which included being shipwrecked at Cuxhaven. He was a Younger
Brother of Trinity House and a Trustee of the Colony of Georgia.

His bronze statue by William Macmillan, R.A. was erected in

Brunswick Square in 1963 adjoining the site of his Foundling
Hospital. He is seated in a chair holding the Charter of the Hospital
in one hand and a gauntlet in the other. It was taken from
Hogarth's portrait. Above the entrance to 40 Brunswick Square
there is a stone bust of Coram by D. Evans dating from 1937.

Oliver Cromwell

Oliver Cromwell (1599–1658) was not royal but he was a ruler of
England, though he did not get a statue till 1899 and then it was
thanks to Lord Roseberry. As Cromwell had virtually abolished
Parliament it would have been ironical had Members voted him a
statue, though the liberals tried to do so in 1895 but were
persuaded against it by the Irish Members who can never forget or
forgive. Hamo Thornycroft's fine statue in front of Westminster
Hall shows a bareheaded Cromwell with a sword in his right hand
and a Bible in his left. His dignity is slightly impaired by his having
his spurs on the wrong way up. 1899.

Cromwell became Lord Protector and during the last four years
of his life he virtually ruled without a Parliament. He was a great
soldier and administrator but his Puritans have a lot to account for
and the hatred of them was shown when, after his body was buried
in Westminster Abbey, it was dug up soon after the Restoration and
taken to Tyburn and gibbeted.

The statue which has 'warts and all' is badly sited, as passers-by
seldom see the bronze lion lower down the plinth. His eyes are
downcast, as well they might be, for immediately opposite him a
bust of Charles I stares at him from above a door at the east end of
St. Margaret's church (q.v.). It is significant that Cromwell has
turned his back on Parliament.

Admiral Lord Cunningham, O.M.

The only Second War Admiral to get a statue was Andrew
Cunningham (1883–1963), and most deservedly so. His rout of the
Italian Navy at the battle of Matapan near the end of 1940 virtually
put it out of action for the rest of the war. His bravery and resource
during the evacuation of Crete largely saved complete disaster.
Before all that he had won a D.S.O. and two bars in the First War.
In 1946 the O.M. and a peerage were conferred on him. His younger

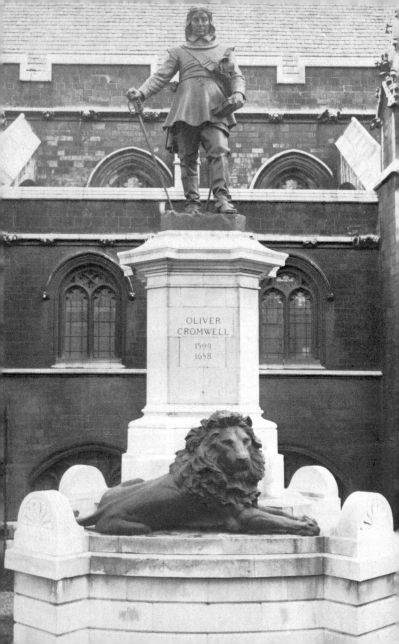

OLIVER
CROMWELL

1599
1658

brother Alan drove the Italians out of Abyssinia in 1941 and was knighted.

A bronze bust of him by Franta Belsky was placed on the north wall of Trafalgar Square in 1967, putting him in the company of Jellicoe and Beatty.

Lord Curzon of Kedleston

The best example of an autocrat failing to achieve his ambition, probably because he lived in the wrong century, namely the twentieth, is afforded by George Nathaniel Curzon (1859–1925). A brilliant brain who, in spite of not getting a first at Oxford, subsequently was made a Fellow of All Souls. He became an M.P. before he was thirty and Viceroy of India before he was forty. There he created the North-West Frontier Province, partitioned Bengal and trod on a lot of toes, including Kitchener's, until he finally had to resign. He accepted an Irish barony so as not to be excluded from the House of Commons, received the Garter and in 1919 became Foreign Secretary, but he failed in his great ambition of being Prime Minister when Bonar Law resigned in 1923. He was defeated by Baldwin. It was a lasting disappointment not even made up for by his being created a Marquess.

There was however an unexpected side to this fastidious man, who all his life had suffered pain from curvature of the spine. Soon after the publication in 1907 of Eleanor Glyn's notorious novel *Three Weeks* the following jingle went the rounds.

> Would you rather sin
> With Eleanor Glyn
> On a tiger skin
> Or would you prefer
> To err with her
> On a different fur?

It was Curzon who was her lover and who may possibly have preferred, but who definitely provided, the tiger skin.

His unapproachable and pompous manner in or out of

Oliver Cromwell, by Sir William Hamo Thornycroft, R.A.

Parliament likened him to that of 'a divinity addressing blackbeetles'
but one is sure that, were he alive, he would be delighted to know
his bronze statue by Sir Bertram Mackennal, R.A. shows him in full
garter robes and has been in aristocratic Carlton House Terrace
since 1931, almost opposite his old home at No. 1.

Earl of Derby
One of the very few people to become Prime Minister three times
was Edward Stanley the 14th Lord Derby (1799–1869). He was a
great supporter of the Reform Bill and the emancipation of slaves.
He was a famous speaker and was known as 'the Rupert of Debate'.
His bronze statue by Matthew Noble is at the back of Parliament
Square in line with Disraeli, who unveiled it, and Peel, two other
Prime Ministers. The most interesting thing about it is one of the
plaques on the base which shows the inside of the House of
Commons before it was burnt down in 1834 and replaced by the
present one. It was referred to as St. Stephen's Chapel. It had been
remodelled by Sir Christopher Wren. 1874.
 After this dignified setting it is odd to find a stone bust of him in a
niche on a first floor in Great Windmill Street, next to the St. James
and St. Peter school, where he is surrounded by topless bars and
strip clubs. 1871.

Robert Devereux, Earl of Essex
Robert Devereux (1591–1646) was the grandson of the Earl of
Essex, the great favourite of Queen Elizabeth, beheaded for treason
in 1601. The earldom was restored by James I in 1604 and Robert
became the third and last Earl of Essex. During Charles I reign he
sided with the Roundheads and became a brave but bad
Parliamentarian general. He led a disastrous march into Cornwall,
whence he fled by sea and soon afterwards died.
 The Essex family acquired a house running down to the Thames
from Fleet Street on the site of the present Essex Street, off which
there is a passage called Devereux Court which doubles back into
Fleet Street. Round the corner on the second floor on the front of
the Devereux Inn is a painted stone bust of the 3rd Earl of Essex
wearing a wig, dating from 1676. The two coats of arms are of the
two earls who lived on the site. There had been an inn on this site

since Edward III's time but its great days were after it became a
coffee house in 1665 when it was known as The Grecian as it was run
by a Greek. Steele refers to it in the first number of *The Tatler* and
Addison in *The Spectator* (No. 49). Dr. Johnson wrote about it and
frequented it, as did Isaac Newton and other members of the Royal
Society. It was near Essex Stairs on the Thames and nowadays there
is a gate into Inner Temple opposite it.

Duke of Devonshire
In the middle of Horse Guards Avenue where it meets Whitehall
there is a bronze statue of the 8th Duke of Devonshire (1833–1908)
by Hebert Hampton. The War Office is on the corner, which
accounts for the Duke being so sited as he was twice Secretary of
State for War. It was erected in 1910. He is wearing Court dress and
knee-breeches.

Bartolomeu Diaz
One of the foremost Portuguese navigators was Bartolomeu Diaz,
who was sent in 1486 with two ships to discover the unknown
southern parts of the west coasts of Africa. A violent storm drove
him round the Cape of Good Hope and he reached Algoa Bay
without realizing he had rounded the Cape, which he named Cape
of Storms. He thus became the first navigator to round the Cape. He
later sailed with Vasco da Gama and in 1500 when he was probably
aged fifty, he was lost in a storm when on an expedition with Pedro
Cabral, who discovered Brazil.
 Facing Nelson's monument there is a large stone statue of the
explorer on the first-floor level of South Africa House. On his right
is a column with the name DIAS and 1488 on the base. On his left
there is a globe and the stern of a ship. It is the work of Coert
Steynberg and was sculped when the building was completed in 1934.

Charles Dickens
On the ground floor of Ferguson House where 51 Marylebone Road
and Marylebone High Street meet, a corner section has been opened
up and on a wall there is a relief of Charles Dickens and various
characters from the books he wrote when living in a house on that

site. In the middle are Mr. Dombey and his son Paul. David
Copperfield and Mr. Micawber are bottom right, while at the top
right there are Little Nell and her grandfather and Scrooge. There
are also Mrs. Gamp, Barnaby Rudge and the raven. All the figures
were done in 1960 by Eastcourt J. Clack.

Dickens also lived in Furnival's Inn in 1836 when he wrote the
Pickwick Papers. The huge Prudential Offices in Holborn now
occupy that site, and going through their main entrance there is a
cupronized plaster bust of Dickens by Percy Fitzgerald placed there
in 1907.

On the second floor of the Red Lion at the corner of Parliament
Street and Derby Gate there is a teracotta full face head of Dickens
dating from 1900. Tradition has it that when he went in there as a
young man the landlady gave him a kiss.

Major-General Sir Alexander Dickson, G.C.B., K.C.H.:
General Sir Collingwood Dickson, V.C., G.C.B.
An unusual memorial is the twenty-five-foot high quadrilateral of
grey granite that was moved in 1912 to a position opposite the
Royal Artillery Officers' Mess at Woolwich. Previously it had been
erected in 1844 near the Rotunda, having been put up to the
memory of Major-General Sir Alexander Dickson (1777–1840) who
had served as Wellington's Commander of the Royal Artillery
during the Peninsular War. He was made G.C.B. in 1838 and later
became K.C.H., an unusual honour, it being Knight Commander of
the Royal Hanoverian Guelphic Order. William IV, monarch of
Hanover, was the last British sovereign to confer this Order. His
bronze medallion by Sir Francis Chantrey is on one of the faces of
the monument. In 1920 a further inscription was added to the
memory of his third son, General Sir Collingwood Dickson, V.C.,
G.C.B. (1817–1904) who received his V.C. at Sebastopol, having
also distinguished himself at Inkerman. He became General in 1877
and was made Inspector-General of Artillery, an obsolete post, as
well as Master Gunner of St. James's Park, a delightful title that
goes back to 1678 and which is still extant, it being an honour
that goes to the most distinguished Gunner.

Benjamin Disraeli, *see* **Lord Beaconsfield**

Edward the Confessor

The last real Anglo-Saxon king was Edward the Confessor
(1004–66). He was the son of Ethelred the Unready and married
Edith, daughter of the great Earl Godwin. He became king in 1042,
but he was a weak monarch with strong ascetic and religious feelings
for which he was canonized in 1161. His appeal to the Duke of
Normandy precipitated the Norman invasion. King Harold II who
succeeded him as king for a few months and who was killed at
Hastings, was his brother-in-law. Edward is depicted in the Bayeux
tapestry.

On the pillar erected in 1861 in front of Westminster Abbey, which
was begun by Edward the Confessor, there is a stone statue of him
by J. R. Clayton. Beside him are Henry II, Elizabeth and Victoria.
See also under Regimental War Memorials.

Edward I

Edward (1239–1307) was on the last Crusade when his father Henry
III died in 1272. He was not crowned until two years later. He was a
great lawgiver and generally stabilized the country. He subdued
Wales and after the death of the Scottish Queen, the Maid of
Norway, he partly subdued Scotland, defeating, then executing
William Wallace (q.v. in Memorials) in 1305. In 1254 he married
Eleanor of Castille and their son Edward became the first Prince of
Wales in 1301. Edward banished the 16,000 Jews in England. He
took the Coronation Stone from Scone and put it in Westminster
Abbey.

There is a stone statue of him by Richard Garbe high up on the
outside of the National Westminster Bank, 114 High Holborn,
opposite Holborn tube station. *See also* Eleanor Cross *under*
Memorials. 1902.

Edward VI

The only son of Henry VIII was by Jane Seymour, who died soon
after giving birth. Edward VI was only nine when he succeeded his
father in 1547 and only lived till 1553, but his short reign was
notable for the first Authorized Version of the Book of Common
Prayer. The Reformation continued only to be reversed by his half-
sister Mary when she succeeded him.

Edward re-founded St. Thomas' Hospital after it had been closed

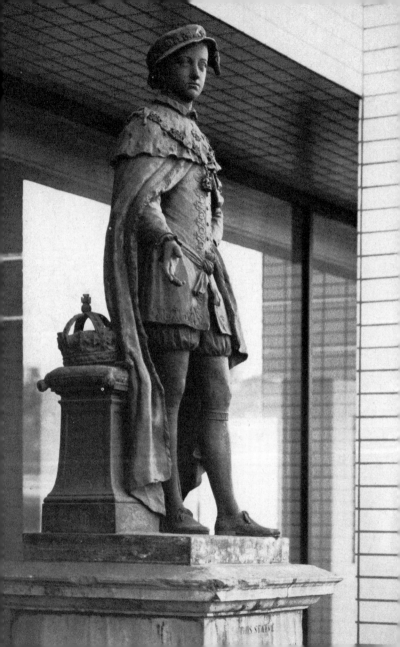

by Henry VIII and on the terrace of the north wing of the hospital there is a stone sculpture of Edward VI wearing a crown, holding a sceptre in his right hand and a scroll in his left, which is a replacement. It was sculpted by Thomas Cartwright in 1681 and originally stood at the gateway of the old hospital surrounded by four stone cripples, who now stand against pillars in the entrance hall of the Ward Block very near Edward VI. There are two male and two female cripples each about four feet high. They were all moved to the new building in 1976. Next to Edward VI there is a statue of Sir Robert Clayton (q.v.) by Grinling Gibbons.

A few yards further on towards the river there is a statue of Florence Nightingale by Frederick Mancini and beside it another statue, in bronze, of Edward VI by Peter Scheemakers, the famous Flemish sculptor who lived in London from 1735–69. This work dates from 1737. The king is robed and with a Garter collar. His crown is on a small stand beside him. He is wearing a cap and his right hand is extended. On the marble plinth there is an inscription in English on one side and in Latin on the opposite, part of which reads, 'This statue of Edward VI a most excellent prince of exemplary piety, wisdom and above his years. The glory and ornament of his reign and most magnificent founder of this hospital.'

Edward VII
In the Mile End Road there are two memorials to Edward VII. One opposite the London Hospital has a medallion of him on a column surmounted by a winged angel, eighteen feet high in all. On either side are sculptures and fountains. One is called Justice and has a boy with a book: the other Liberty, with a boy holding a charming stone motor car of 1911 and a ship. It was erected by the Jewish inhabitants of East London and is by W. S. Frith.

About a quarter of a mile further on, there is a bronze bust on a granite plinth erected by the Freemasons of the Eastern District, also in 1911. When Prince of Wales, Edward was Grand Master of the English Freemasons.

His most famous statue is the bronze equestrian statue by Sir

Edward VI, by Peter Scheemakers

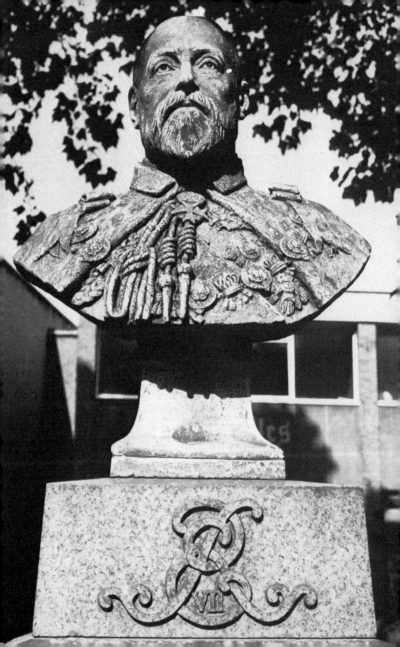

Bertram Mackennal, R.A. which stands in the centre of Waterloo Place. It was erected in 1921 and has a majestic look about it in keeping with the king.

In the middle of Tooting Broadway there is a very recognizable bronze statue by L. F. Roselieb put up in 1911. He is bareheaded, wearing regal robes and looking very much the part.

A stone statue by Richard Garbe R.A. on the top floor of 114 High Holborn is a companion piece to the one of Edward I. 1902.

On the façade of Caxton Hall above the entrance there are terracotta statues of Queen Victoria and Edward VII. The two of them also appear in marble by Sir Joseph Edgar Boehm, R.A. on opposite sides of the Temple Bar Memorial in Fleet Street, dating from 1918. In a niche over the doorway of University College School, Frognal, in Hampstead there is a stone statue of Edward VII wearing state robes and a crown. 1907.

His statue which stood since 1918 in front of the Hearts of Oak building in the Euston Road was moved to their Broadstairs Home in 1979.

Over the 55 Knightsbridge front of the Wilton Place post office there is a small stone bust of Edward VII. It is just under the second floor window, in the pediment of the first floor and at 59 Knightsbridge there is one of Queen Alexandra. They are very difficult to see. 1902.

In King Edward VII Memorial Park, Shadwell (q.v. *under* Memorials) there is a commemorative pillar with a bronze medallion by Sir Bertram Mackennal, R.A. unveiled by George V in 1922.

Queen Elizabeth I

Gloriana, the name given to Elizabeth I (1533–1603), had one of the longest and most successful reigns. Much of this was due to her advisers and to her sea captains. Sir William Cecil, later Lord Burghley, was succeeded by his son Sir Robert and the two of them largely ran the country and gave her admirable advice which she usually took. Sir Francis Walsingham acted as a roving foreign minister and, thanks to a corrupt system of espionage, kept her in

touch with what was going on abroad and at home. He enabled her
to hear of the Babington Plot which led to the execution of Mary
Queen of Scots, her Catholic rival.

Thanks to Drake, Frobisher, Howard and Raleigh England had
command of the seas. The Spanish Armada was routed, Cadiz was
destroyed and Spanish power on the Continent diminished. It was
also a period of great intellectual brilliance with people like
Shakespeare, Sidney and Bacon.

Elizabeth was Henry VIII's daughter by Protestant Anne Boleyn,
who was executed. She succeeded Catholic Mary as Queen when
aged twenty-five and re-established Protestantism. She spoke Latin
and Greek as well as French and German. She was a good musician
and loved dancing. She was parsimonious, she procrastinated.
Politically her aim was to keep the peace. She never married but she
had favourites, the Earls of Leicester, who died, and Essex whom
she had beheaded for treason. Above all she was masterful, adroit
and a successful ruler.

The stone statue of Elizabeth by William Kerwin dating from
1586, was originally on the west side of Ludgate, the City gate which
stood on Ludgate Hill. The statue withstood the Great Fire and
when Ludgate was demolished in 1760–1, Elizabeth was placed
outside the east end of St Dunstan-in-the-West. This Church was
moved further north when it was rebuilt in 1833 and the statue put
in a niche over the vestry porch. Below her, in the porch, there are
now the figures of King Lud and his two sons who had originally
adorned the City side of Ludgate.

There is a statue of her in the north-west corner of the Royal
Exchange which was first built in Elizabeth's reign by Sir Thomas
Gresham. When it was rebuilt a second time M. L. Watson's marble
statue was placed there. She is holding an orb and sceptre. 1847.

In addition Elizabeth and three other sovereigns are on the
memorial column to Westminster Old Boys, she being a second
Founder of the school. It stands in front of the west door of
Westminster Abbey and the figures are by J. R. Clayton.

On the street side of Harrow Speech Room, there is a stone statue
of Queen Elizabeth that came from Ashridge Park in 1925. She
granted the school its charter in 1571.

Stephen Fairbairn

A good example of a man who was big in every sense of the word was 'Steve' Fairbairn (1862–1938). He was a member of a prominent Australian family of Scottish origin. Fairbairn was a superb all-round athlete who rowed for four years in the Cambridge crew and won the Grand at Henley when rowing for Jesus, his Cambridge College, but it is as a rowing coach that he is really remembered. He introduced the Fairbairn style when he returned to England before the First War. Until his death he had international successes and did a lot to make rowing popular. He was a barrister of the Inner Temple, though he did not practise, and was an active Director of Dalgety & Co. He wrote his autobiography and a number of books on rowing.

'Steve' Fairbairn used to watch the Boat Race from the Mile Post on the Surrey bank and it is there that 'an eleven foot high granite obelisk erected in 1963 to the famous Australian whose coaching innovations revolutionized the sport between the two world wars, was unveiled by Viscount Bruce of Melbourne, a former Prime Minister of Australia who rowed in the winning Cambridge eight of 1904'. This is quoted from the *Rowing Almanack* of 1964, which has a picture of a bronze medallion of 'Steve' that was taken from the bust of him by George Drinkwater, a well-known Oxford rowing blue.

Henry Fawcett

Henry Fawcett (1833–84) was blinded in a shooting accident when young but he did not let that prevent him having a remarkable career, especially for a blind man. He became professor of political economy at Cambridge, published works on that subject, entered Parliament and became Postmaster-General under Gladstone when he introduced the parcel post, postal orders and a sixpenny telegram. He and his wife Dame Millicent, a sister of Elizabeth Garrett Anderson, were both strong advocates of female suffrage and reforms.

He is now represented by a fine medallion in the Victoria Embankment Gardens near the Savoy. His blindness is remarkably well portrayed. It was designed by Mary Grant and is part of a fountain, the work of Basil Champneys, 1886. There was also a fine

statue of Henry Fawcett in Vauxhall Park until it was broken up in 1955. He was seated and behind him stood a robed figure of Victory holding a wreath over his head, but the interesting features were the amusing panels on the base alluding to his office of P.M.G.; good news and bad news showed two girls reading letters and their faces were very expressive.

Henry FitzAilwin

Henry FitzAilwin, sometimes spelt FitzAylwin or Fitz-Eylwin, is best known for being the first Mayor of the City of London. He first appears as Mayor in 1193, which office he may have held until his death in 1212. The title of Lord Mayor was not official until 1545, though it was used intermittently from 1283. There have been over 570 Mayors of the City. On the first floor of the house adjoining Holborn Viaduct on the west side, there is a statue of FitzAilwin by H. Bursill dating from 1868.

Marshal Foch, O.M.

Ferdinand Foch was born at Tarbes in 1851. He was a great strategist and rose to become supreme commander of both French and British troops in the First War and directed the March 1918 offensive which finally won the war. Afterwards he was made a Field-Marshal and awarded the O.M. He was elected a member of the Academie and was a Marshal of France. He was buried in Les Invalides in 1929. His saying, 'I am conscious of having served England as I served my country' is on the plinth.

His equestrian statue by G. Malissard in Grosvenor Gardens, facing Victoria Station, was erected in 1930 and unveiled by the Prince of Wales. It is a copy of the one in Cassel, between Calais and Lille, and was presented by the French Government.

Onslow Ford, R.A.

Edward Onslow Ford (1852–1901) was a Victorian sculptor best known for his Shelley Memorial at Oxford. He is represented in the Tate by his Folly but he chiefly specialized in portrait busts. His statue of Sir Rowland Hill stands in front of the G.P.O building in

Henry Fawcett the Blind Postmaster General, by Mary Grant and Basil Champneys

ERECTED TO THE MEMORY OF
HENRY FAWCETT
BY HIS GRATEFUL COUNTRYWOMEN.

King Edward Street. He was elected an R.A. in 1895.

At the corner of Grove End Road and Abbey Road there is a column with a bronze bust by A. C. Lacchesi showing Onslow Ford with his hair *en brosse*, a wide moustache and beard. On the other side is a semi-nude girl with a lyre taken from his Shelley Memorial. The inscription bears Polonius's advice, 'To thyself be true'. It was erected in 1903 by his friends and admirers.

W. E. Forster, P.C.

William Edward Forster (1819–86) was born a Quaker, became an M.P. and a P.C. As a Minister in Gladstone's cabinet he carried out the Elementary Education Act in 1870. He was Chief Secretary for Ireland and had Parnell and other Irish leaders arrested, but resigned when his colleagues in the cabinet voted to release them. He was a strong opponent of Home Rule. In 1850 he married the daughter of Dr. Arnold of Rugby.

His bronze statue by H. R. Pinker was erected in the Temple Station part of Victoria Embankment Gardens in 1890. It carries the inscription, 'To his wisdom and courage England owes the establishment throughout the land of a national system of elementary education'. He holds a book in his hand and is wearing an Albert.

Charles James Fox

Charles James Fox (1749–1806) was one of the great characters of the late eighteenth-century. He was a hard liver, a great gambler and a heavy drinker, but he will be remembered as a man of immense charm and as a superb orator. 'The greatest debater the world ever saw' was praise indeed coming from Burke.

Fox was the third son of the first Lord Holland and was a key figure in the Holland House set. He became an M.P. when only nineteen, being first of all a Tory. After quarrelling with Lord North in whose government he was, he joined the Whigs and consistently attacked Pitt's ministry. Fox was very pro-French even during the Revolution and the Napoleonic Wars. He was particularly brilliant in his speeches against Warren Hastings. He was buried in Westminster Abbey.

Sir Richard Westmacott, R.A. sculpted Fox in bronze, seated in a chair and wearing the robes of a Roman senator. He is bareheaded and in his right hand he holds a copy of the Magna Carta. The statue was erected on the north side of Bloomsbury Square in 1816.

Sir John Franklin

Franklin's fame as an Arctic explorer came through the discovery of the North-West Passage, though he died in the attempt. A relief expedition found the records of his journey, proving he had been successful.

John Franklin (1788–1847) joined the Navy at fourteen and was present at the Battles of Copenhagen and Trafalgar. He went to Spitzbergen in 1818 and then to the Canadian Arctic coast as second-in-command of an expedition. He was knighted in 1829 and made governor of Van Dieman's Land (Tasmania) from 1834–45, in which year he set out in command of the *Erebus* and *Terror* to Baffin Bay to find the North-West Passage. Thick ice enveloped

Sir John Franklin's burial after his death when trying to discover the North-West Passage

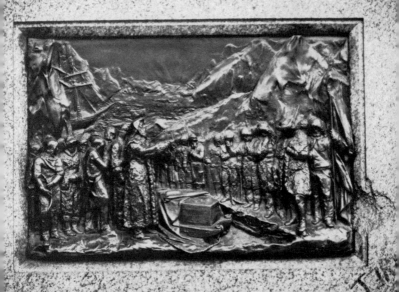

them and Franklin died. The crews tried to walk to a Hudson Bay post but died of starvation. His statue in Waterloo Place by Matthew Noble was erected in 1866. Two plaques on the plinth cut in deep relief, show, on the front, the funeral service being held prior to Franklin's coffin being committed to the deep. Around him are the bowed heads of the crews. At the rear, which is inaccessible now, another relief has a chart of the Arctic region showing the two ships.

Sir Henry Bartle Frere

Henry Edward Bartle Frere (1815–85) entered the East India Company in 1834 and developed Sind. He became Governor of Bombay and was knighted in 1867. Five years later he signed a treaty with the Sultan of Zanzibar abolishing the slave trade. His last appointment was as Governor of the Cape, but troubles with the Boers and the Zulu war of 1878–9 caused him to be recalled.

His bronze statue by Sir Thomas Brock, R.A. shows him standing in Civil Service uniform and wearing the robe of the Order of the Star of India. It was erected in 1888 in the Victoria Embankment Gardens behind Whitehall, at the Charing Cross end.

Sigmund Freud

Few people have had more influence on twentieth-century thought than Sigmund Freud (1856–1939), who is often referred to as the founder of psychoanalysis. His studies in medicine in Vienna and later Paris went through a whole range of subjects including physiology, neurology, hysteria, hypnosis, psychopathology and the effects of infantile sexuality.

In 1910 Vienna produced the first International Psychoanalytical Association with Jung as President. Freud wrote some major works which have been translated and produced in English in a twenty-four volume Standard Edition edited by James Strachey.

Freud came to England in 1938 with diplomatic help and lived in Hampstead, where he died in September 1939, from a long-standing cancer of the jaw.

Beside Adelaide Road and between the Swiss Cottage Library and the Civic Centre there is a statue of Freud sitting in a chair with his

Sigmund Freud, by Oscar Nemon

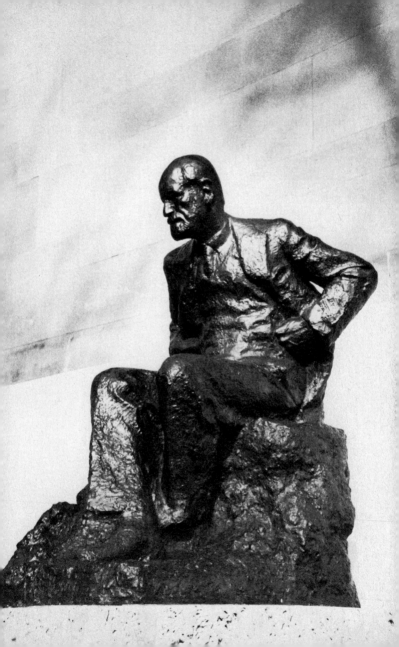

hands on his hips and leaning forward in pensive mood. It was cast
in plaster by Oscar Nemon in Vienna in 1930 when Nemon was
twenty-seven and Freud over seventy and it was only after a
successful appeal to psychoanalysts throughout the world that it was
cast in bronze. This is the only full length bronze statue for which
Freud posed. It was unveiled in 1970 by five of his great-
grandchildren, three of them being the children of Clement Freud,
M.P.

Elizabeth Fry

Two famous people connected with prison reform have medallions
over the entrance to Wormwood Scrubs prison. Elizabeth Fry
(1780–1845) is on the left wearing a form of toque hat. She was the
daughter of John Gurney, a rich Norfolk Quaker, and she married
Joseph Fry, a London merchant who was also a Quaker. She
became a preacher among the Friends and it was probably her visit
to Newgate prison in 1813, where she saw the utter destitution and
squalor of prison life, that made her devote her life to prison reform.
She also organized a number of benevolent enterprises and became a
prominent figure in spite of her husband's going bankrupt. The
other medallion is of John Howard (q.v.). 1874.

Mahatma Gandhi

Mohandas Karamchand Gandhi (1869–1948), better known as
Mahatma Gandhi, (Great Soul), was a dedicated idealist and to
many Indians was the equivalent of a saint. He became a barrister of
the Inner Temple, forsook a £5000 a year practice in Bombay to go
and live on a pound a week helping to improve the lot of his
fellow Indians in South Africa. After twenty-one years he returned
to India and between the wars he conducted campaigns of civil
disobedience, passive resistance and fasts, resulting in his serving
various prison sentences. He was a constant thorn in the side of the
British until India got independence in 1947. He was a great
reformer and did much to improve the lot of Hindu 'untouchables'.

 In spite of his troublemaking he has been given a statue in the
centre of Tavistock Square surrounded by flower beds. He is naked

Mahatma Gandhi, by Fredda Brilliant

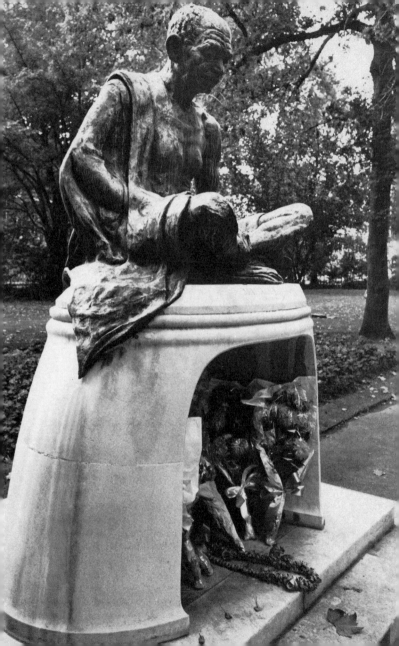

except for a loin cloth and he is squatting with his legs crossed in his traditional meditative way. Fredda Brilliant has set her bronze statue on a circular base with a hollow front which is used for flowers. The one-and-a-half life-size figure cost £10,000; it was unveiled by Harold Wilson when Prime Minister in 1966.

A few yards away Pandit Nehru, when Prime Minister of India, planted a copper beech to mark his visit to Gandhi's statue.

David Garrick

David Garrick (1717–79) was educated at Litchfield where he was a pupil of Samuel Johnson. They went to London together in 1737 when Garrick intended to study law, but he soon gave that up and instead joined his brother as a wine merchant for a couple of years. He was set on becoming an actor and joined some players in Ipswich in 1741. In October of that year he had an immediate success as Richard III. He was the leading actor of his day and probably our most versatile, as he was equally at home in tragedy, comedy or farce. He became co-patentee of Drury Lane in 1747 where he directed plays besides writing a great number. He retired in 1776 and died three years later. He was buried in Westminster Abbey.

From 1750 to 1776 Garrick lived at 27 Southampton Street overlooking Covent Garden market and near Drury Lane theatre. Over the door of the house there is a bronze medallion of him set in a terracotta surround on which are female figures of tragedy and comedy. Surmounting it is a lyre. It was put up by the trustees of the 11th Duke of Bedford and is by H. C. Fehr after a sketch by C. Fitzroy Doll. 1901.

Sir Robert Geffrye

The attractive almshouses in Kingsland Road, E.2. built in 1715 from money left by Sir Robert Geffrye (1613–1704), were bought by the L.C.C. and opened in 1914 as a museum of furniture dating from 1600 to the present day. Sir Robert was a successful City merchant who lost £20,000 on tobacco and other merchandise in the Great Fire but recovered sufficiently to become Master of the Ironmongers' Company and Lord Mayor of London in 1685. He was knighted by Charles II in 1673.

His six-foot-high statue by John van Nost was made in lead
in 1723 and placed in a niche over the entrance to the chapel.
It cost forty pounds. It shows him in full-bottomed wig and
municipal robes and is now with the Ironmongers' Company
almshouses in Hook, Hampshire, but a replica in lead by James
Mande & Co. was erected at the museum in 1913.

George I

The first Hanoverian king was George I (1660–1727). He was the
son of the Elector of Hanover and Sophia, a granddaughter of
James I, and on Queen Anne's death in 1714 he succeeded to the
throne of Great Britain. He had previously commanded the imperial
forces while actively operating with Marlborough against Louis
XIV. In 1682 he married his cousin Princess Dorothea of Zell but
twelve years later obtained a divorce from her and kept her
imprisoned abroad until her death in 1726, during which time he
lived openly with mistresses. His ignorance of English prevented his
taking part in Cabinet councils, a circumstance which had
important results in the growth of constitutional government.
During his reign the Whigs under Sir Robert Walpole did most of
the running of the country and Walpole virtually became our first
Prime Minister. The main events of his reign were the Jacobite rising
in 1715 and the South Sea Bubble five years later. This nearly
brought the country to a state of anarchy, but it was saved by the
genius of Walpole. George I spent much of his reign in Germany
and died there. He is one of the few of our Kings to have been
buried abroad.

George I's only London statue is unique in that he is placed on
top of the steeple of St. George's Church, Bloomsbury and is
dressed in a toga. It was the gift of William Hicks, a prosperous
brewer. Built in 1730 by Nicolas Hawksmoor, the steeple itself is of
very odd design, being a stepped pyramid based on Pliny's
description of the tomb of Mausolus at Halicarnassus (the modern
Bodrum on the Turkish coast) which was one of the Seven Wonders
of the World (the British Museum has part of it). Until 1871 there
used to be lions and unicorns on these steps and they can be seen in
Hogarth's drawing called Gin Lane. Horace Walpole called it 'a
masterpiece of absurdity' and wrote:

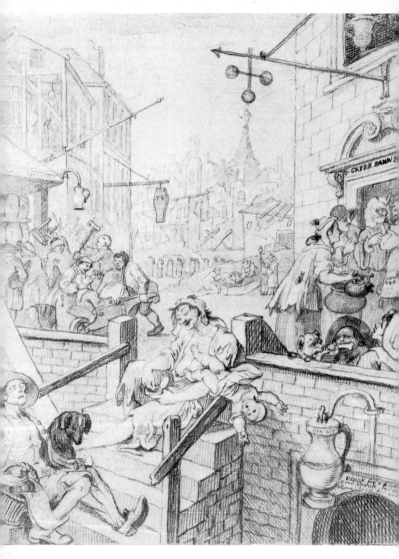

When Henry VIII left the Pope in the lurch,
The Protestants made him head of the Church.
But George's good subjects, the Bloomsbury people,
Instead of the Church, made him head of the steeple.

There is also a fine statue of George I just inside the Public
Record office in Chancery Lane.

George II

George II (1683–1760) was born in Hanover and succeeded his
father as King in 1727, having previously married Caroline of
Anspach, though like his father he also had mistresses. Sir Robert
Walpole continued to run the country during the first half of his
reign and William Pitt, later Earl of Chatham, wielded a lot of
power in the second half, especially in running the Seven Years'
War, which was ended by the treaty of Aix-la-Chapelle. King
George took part in the victory of the British and Hanoverians at
the battle of Dettingen in 1743, this being the last occasion that a
British king commanded an army in a battle. It was an important
reign, as the crushing of the '45 rising at Culloden saw the end of
Jacobite power and, thanks to Wolfe's (q.v.) capture of Quebec in
1759, the English took over Canada from the French. The French
also lost India, thanks largely to Clive (q.v.), who decisively defeated
them at Plessey the same year and so laid the foundation of British
India.

At home, Methodism under Wesley and Whitefield developed and
there was a great surge in literature and art with such people as
Lawrence Sterne, Smollet, Goldsmith and Gray. Dr. Johnson
published his dictionary and Handel composed the *Messiah* while
Hogarth went from strength to strength. Canaletto came to London
in 1746 and spent most of the next ten years painting here.

George II has two statues, both of which are contemporary. The
one by John Nost the elder was erected in Golden Square in 1753
but it was sculpted thirty-three years earlier for the Duke of
Chandos at Canons, Edgware. It is of lead but has been painted

George I on top of the steeple in Hogarth's painting 'Gin Lane'

white. The lizard the King appears to be grasping is part of his ornamental sword hilt.

The one at Greenwich by J. M. Rysbrack was made out of a block of marble found in a French ship captured in the Mediterranean and it was presented by Sir John Jennings, Prefect of Greenwich Hospital, who paid for it. It was set up on the lawn on the river side of the buildings of the hospital in 1735. The king is in Roman dress in both statues.

George III

George III, who was born in 1738, succeeded his grandfather in 1760 and reigned for sixty years until 1820. He married Princess Charlotte of Mecklenburg-Strelitz by whom he had fifteen children. He was born in London and was altogether more English in sentiment and education than his two predecessors, the first two Georges. He was devoted to England and never set foot in his Hanoverian possessions. He was popular with the people in spite of his blunderings and was nicknamed Farmer George. Once he had married he gave up mistresses and was a devoted husband.

The most important event of his reign was the loss of the American colonies largely due to the obstinate policy of Lord North and George III, the last King of America. Warren Hastings's trial began in 1788 and the next year saw the French Revolution, which was followed by the Napoleonic Wars, ending with victory at Waterloo in 1815. By this time the King had had a further spell of madness and the Regency had been set up in 1810. The Industrial Revolution was beginning, thanks to inventions like the spinning jenny. Wilkes helped to gain freedom of the press while Parliament had such brilliant politicians as Pitt, Fox, Burke and Sheridan. Literature was ennobled by Gibbon, Burns, Coleridge, Byron, Shelley and Keats and it was the age of Wellington and Nelson. The National Debt rose from £138,000 to £800 million.

George III has a delightful bronze equestrian statue by Matthew Cotes Wyatt that has stood on an island in Cockspur Street since 1836. It gives the impression that the King is trotting off to St. James's Palace, holding his cocked hat in his hand and with his very

George II, by John Van Nost the Elder

pronounced pigtail tied up in a bow. In the quadrangle of Somerset House there is a large baroque fountain in bronze with Neptune (or Father Thames?) and a group with George III at the back in Roman garb, and parts of ships. It is the work of John Bacon senior and was erected in 1788. When Bacon was asked by Queen Charlotte 'Why did you make so frightful a figure?' Bacon replied 'Art cannot always effect what is ever within reach of Nature—the union of beauty and majesty'. Other medallions of them with their son the Prince of Wales, later George IV, can be seen on the Strand façade of Somerset House. They are the work of Joseph Wilton and date from 1780.

There are also medallions on Coade stone by M. J. Baker of him and his wife on the façade of Trinity House near the Tower of London. They are on either side of the arms of Trinity House and were part of the original building of 1796.

George IV

The 'first gentleman in Europe' was the title given to George IV (1762–1830) who became Regent during the last ten years of George III's reign and succeeded him in 1820. Like all the Georges he quarrelled with his father. At eighteen he had an affair with the actress Mrs. Robinson and at twenty he secretly married Mrs. Fitzherbert, a Roman Catholic, in defiance of the Royal Marriage Act. Finally he got his debt of £650,000 paid when in 1795 he married Princess Caroline of Brunswick. They had a daughter the following year and almost immediately the King abandoned her. On his accession she was offered a pension of £50,000 if she stayed out of the country. George was very handsome when young but became gross. His extravagance was notorious, but thanks to him we have the Brighton Pavilion and some superb pictures and objets d'art.

There are endless portraits of George IV but his only important outdoor statue in London is the equestrian one on a high plinth in Trafalgar Square, by Sir Francis Chantrey, R.A., though it was completed by T. Earle. He is in neo-classical garb and stirrupless and the statue is said to be the earliest sculpture of a horse at rest. It was commissioned the year before he died but it was not erected till

George III. by Mathew Cotes Wyatt

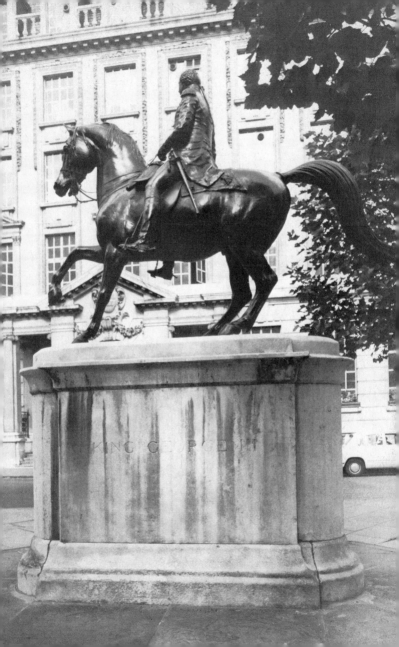

KING C[.] [.] [.] [.]

1843, by which time Trafalgar Square was laid out. Initially it was intended to be placed on the top of the Marble Arch when that stood in front of Buckingham Palace as a triumphal gateway.

A medallion of him when Prince of Wales is on the façade of Somerset House. It is by Joseph Wilton. 1780.

George V

Edward VII's eldest son the Duke of Clarence died in 1892 aged only twenty-eight. His second son George (1865–1936) would have liked to have stayed on in the Navy which he joined in 1877, but had to resign when he became heir to the throne. His interest in the sea never flagged and he was always to be found sailing at Cowes Regatta.

He married in 1893 Princess Mary of Teck who had previously been engaged to his elder brother (*see under* Queen Mary) and had five sons and a daughter. In 1910 he became King and reigned twenty-five years, the chief event being the First World War, during which the House of Hanover was changed to the House of Windsor. The aftermath of the war produced economic turmoil culminating in the General Strike of 1926. The first Labour Governments held office from 1924–5 and 1929–31. His Christmas Day broadcasts to the nation were inaugurated in 1931, by which time wireless sets were beginning to be in general use, though still very primitive. His reign was popular and his popularity reached its zenith at the Silver Jubilee in 1935. There was something very solid and reliable about his character.

King George's stone statue on the Abbey side of Old Palace yard is by Sir William Reid Dick, R.A., who was King's Sculptor in Ordinary. His Garter robes flow out behind him in a majestic line so that it is best seen from the side. He is bareheaded, wearing the uniform of a Field-Marshal and holding in front of him the Sword of State, blade down. The King is standing on a high plinth with an apron, the design of Sir Giles Gilbert Scott, O.M., R.A. His son, George VI, unveiled it on 22 October, 1947.

George VI

Following the dramatic abdication of Edward VIII for the sake of Mrs. Simpson in 1936, his younger brother unexpectedly, and much

against his inclination, became George VI (1895–1952). He, like his father George V, went into the Navy and he was present at the Battle of Jutland in 1916. He also got his Wings when with the R.A.F. An above average tennis player, he qualified and played in the Wimbledon Championships in 1926. His big interest was in Boys' Clubs and Welfare and he started camps for public-school and working-class boys which were a great success. He was created Duke of York and in 1923 he married Elizabeth, the daughter of the Earl of Strathmore, who proved to be very popular and a great help to him. Their example and their many visits to bomb-damaged areas in the Second World War was a great encouragement to the people. He died suddenly in 1952 when his daughter, the future Queen Elizabeth II, was in Kenya.

His stone statue by William Macmillan, R.A. was erected in 1955 on the top of the recently made steps leading from Carlton House Terrace to the Mall. He is in the undress uniform of an Admiral of the Fleet and, like his father, wears the flowing mantle of the Garter. The design of the setting was by Louis de Soissons.

Sir William Gilbert

Over the years few people have given the public more pleasure than Gilbert and Sullivan with their captivating tunes and witty words and it was William Schwenck Gilbert (1836–1911) who was the librettist. He was called to the Bar but forsook it to take up writing. *Bab Ballads* was a collection of his verse which he illustrated. In 1871 he met Sullivan and they produced *Trial by Jury*, which was followed by *H.M.S. Pinafore*, *The Gondoliers*, *The Mikado* and their many other successes. The Savoy Theatre was built for them in 1881 by D'Oyly Carte. Their characters and outlook were quite different. Inevitably they had a row and fell out, though they produced three more pieces before Sullivan died in 1900. Gilbert was knighted in 1907. He was drowned trying to save a girl.

On the wall of Victoria Embankment beside Hungerford bridge there is a bronze medallion by Sir George Frampton, R.A. erected in 1913 and inscribed 'Playwright and Poet' and 'His foe was folly and his weapon wit'. On each side is a small bronze figure, one of comedy and one of tragedy, and at the bottom a most unusual thing—his coat of arms.

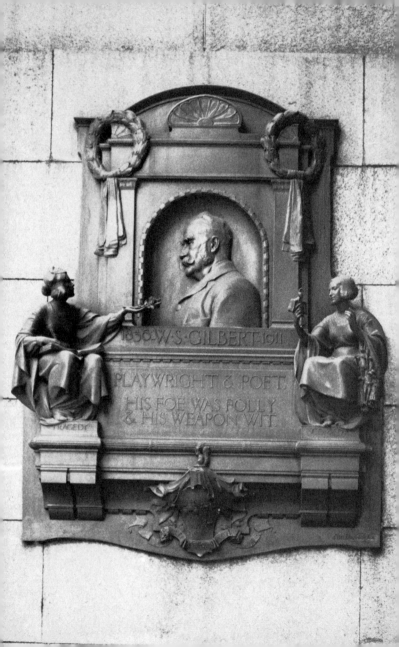

1836 · W·S·GILBERT 1911

PLAYWRIGHT & POET
HIS FOE WAS FOLLY
& HIS WEAPON WIT

TRAGEDY

William Gladstone

If ever a man filled a century politically it was William Ewart
Gladstone, who was born in 1809 and died in 1898. He was a
scholar, one of the greatest orators and debaters of all time and
Prime Minister on three occasions, the last being when he was over
eighty. He started off as a Tory with Peel, but he switched to being a
Liberal and had Disraeli as his opponent. Few legislators have left
behind them such a long and successful record of practical
legislation. He also wrote endless essays of political and theological
criticism.

Gladstone has two bronze statues in London. The main one in the
Strand opposite the Law Courts has him thirty-eight feet up on a
high pedestal in the robes of the Chancellor of the Exchequer. He
alone is sixteen feet high. Around the base are four women
representing education, brotherhood, aspiration and courage, who is
grasping a snake and waving a scimitar. It is by Sir William Hamo
Thornycroft, R.A. and was erected in 1905.

The other one by Albert Bruce-Joy was erected by Bow
Churchyard in 1882 during his lifetime. There he is standing on a
circular granite base with his right arm outstretched as if he was
addressing a meeting.

Frederick Crawford Goodenough

London House in Mecklenburgh Square, W.C.1 is a large Hall of
Residence for overseas male residents attached to the University of
London, based on an Oxford and Cambridge college court. On the
far wall there is a bronze medallion of the donor, F.C. Goodenough,
who was chairman of a number of City companies including
Barclays Bank. It is by William Macmillan and dates from 1936.

William Goodenough, his son (1899–1951) was Chairman of the
Governors for some years, and after the war he founded a sister
trust to provide similar facilities for women and married students,
including students from the United States. A Hall of Residence
called Goodenough House, named after him, is on the opposite side
of the Square.

W. S. Gilbert, by Sir George Frampton, R.A.

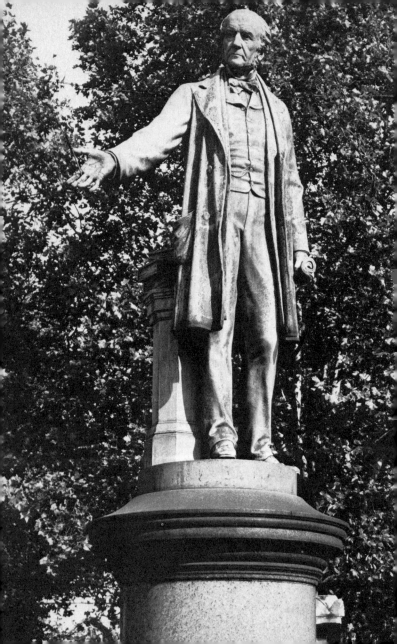

General Gordon

Charles George Gordon (1833–85) was one of those people who had
a very full life and most of it military. He fought at Sebastopol when
he was twenty-two. In 1860 he was in China and took part in the
capture of Peking and the Summer Palace and a series of battles that
earned him the name 'Chinese Gordon'. He later established a chain
of posts up the Nile and Lake Albert in an attempt to suppress the
slave trade. Finally the British government asked him to help relieve
Egypt by pressure from Sudan. He arrived in Khartoum early in
1884 and was soon invested by the Mahdi, but it was not till five
months later that a relief force was organized in England. In
September the advance up the Nile began. Sudan was entered in
early November and an advance guard reached the neighbourhood
of Khartoum on 28 January but Gordon had been murdered on the
palace steps two days before and the town was taken.

His national memorial is the Gordon Boys' School at Woking but
he also has a memorial in St. Paul's. His bronze statue by Sir
William Hamo Thornycroft was erected in Victoria Embankment
Gardens, behind Whitehall, in 1953. It had been in Trafalgar Square
from 1888. He stands in a very contemplative mood with his head
down. In his left hand is a Bible and he carries his cane under his
arm. A pair of binoculars is slung across his side and his left foot
stands on a damaged mortar. There are two bronze plaques of
charity and justice, faith and fortitude.

Thomas Gray

Thomas Gray (1716–71) was born in London and baptized at St.
Michael's, Cornhill which still has one of his walking sticks, but he
was in no way a Londoner. At Eton he met Horace Walpole and
they went together on a Grand Tour, but after two years they
quarrelled and separated, though they later made it up. Gray went
back to Cambridge, where he transferred from Peterhouse to
Pembroke and spent the rest of his life there, becoming Professor of
Modern History.

Gray, who refused the Laureateship, must be considered to be one
of the greatest of English poets, though his output was small. His

W. E. Gladstone, by Albert Bruce-Joy

Pindaric Odes may not be read much, but his *Elegy in a Country Churchyard* has made him immortal and its first line 'The curfew tolls the knell of parting day' is on the tablet on 39 Cornhill where he was born. Below it is a bronze medallion of him by F. W. Pomeroy put there in 1917.

John Richard Green

John Richard Green (1837–83) was a historian who took holy orders. He is best known for his *History of the English People*, which was the first complete history of England that covered such aspects as sociology, geography and antiquities. It was a great success and was rewritten in four volumes. He suffered from tuberculosis and died young.

His bronze statue by E. W. Wyon was erected in the East End where he first worked as a curate and then vicar. He was a great philanthropist, his money coming mostly from shipping, and a bronze relief on the plinth shows ships belonging to his family firm. It stands in the East India Dock Road in front of the Poplar public baths. He is seated and beside him a large friendly dog rests his head on Green's knee. It was erected in 1866.

Sir Thomas Gresham

Thomas Gresham (1519–79) became a rich City merchant and Lord Mayor of London. He acted for Henry VIII and Elizabeth and made over forty visits to Antwerp, where he restored the royal credit. He persuaded the Crown to borrow from London merchants instead of foreign ones. He formulated a monetary thesis known as Gresham's Law. When his son died he spent his money on building the Royal Exchange from 1564 to 1570, founding Gresham College, now at Holt in Norfolk, and arranging for eight almshouses to be built. He was appointed ambassador in Antwerp and Brussels and knighted in 1559.

In a niche by the clock at the east end of the Royal Exchange there is a stone statue by William Behnes put up when it was rebuilt in 1845, following a further fire, the first Exchange having being burnt down in the Great Fire of 1666.

At the top of the Exchange there is an eleven-foot-long gilt grasshopper, the crest of Gresham. His other statue is on the first

floor of Gresham House adjoining Holborn Viaduct, on the City side. It is by H. Bursill and dates from 1868.

Lord Grey of Fallodon

Edward Grey (1862–1933) was a Liberal politician who was Secretary for Foreign Affairs when war was declared in 1914. On 3 August, on the eve of war, he said in the House, 'The lamps are going out all over Europe; we shall not see them lit up again in our lifetime'. He was created a Viscount, was made K.G. and became Chancellor of Oxford University in 1928.

Sir William Reid Dick, R.A. designed a portrait for a stone plaque which was set into the wall of the Foreign Office facing the steps that run down from Downing Street. Around it is put 'Secretary of State for Foreign Affairs 1905–1916' and below it 'By uprightness of character, wisdom in council and firmness in action he won the confidence of his countrymen and helped to carry them through many great dangers'. It was unveiled by Mr. Baldwin in 1937.

Thomas Guy

It is pleasant to think that the South Sea Bubble which brought misfortune and ruin to so many people was also the reason for the founding of Guy's Hospital in Southwark in 1722. Thomas Guy (1644–1724) made a fortune out of the South Sea monopoly, whose shares rose from £200 to £1000 in 1720. He was also a successful bookseller, for when a ban was put on importing Dutch Bibles, he obtained the privilege of printing Bibles for Oxford University. At one time he amassed a fortune of nearly half a million pounds with which he furnished three wards at St. Thomas's before founding his own hospital near by. He also built some almshouses. He was an M.P. from 1695 to 1707. In spite of being so charitable he is said to have been a selfish and avaricious man.

Peter Scheemakers' statue of Guy was erected in the hospital courtyard around 1733. It is probably the only statue made of brass in outdoor London, brass being virtually bronze without tin. The panels on the base refer to the parable of the Good Samaritan and to the Pool of Bethesda where Christ healed an impotent man.

which were by coincidence the same subjects as the two pictures
presented to Bart's by Hogarth a few years later.

Guy of Warwick
One of the great heroes of English romance in the fifteenth century
was Guy of Warwick, who won the hand of the daughter of the Earl
of Warwick by a succession of astonishing feats of valour, but,
repenting of the slaughter he had made, he went on a pilgrimage to
the Holy Land. He returned to his wife disguised as a palmer and
then retired into a hermitage. When he was about to die he sent his
wife a ring, upon which she came and interred him. Fifteen days
later she died and was buried by his side.

Guy had a palace on what is now Newgate Street and Warwick
Lane and inserted into the corner wall there is a stone two-and-a-
half feet high of this medieval knight with his sword and shield and
wearing a helmet. It is dated 1668 but it was restored in 1814. The
present building went up in 1967. The arms are those of the
Beauchamps, Earls of Warwick.

Field-Marshal Earl Haig, O.M., K.T.
Douglas Haig served in the Boer War and in India before becoming
Commander-in-Chief of the British forces in France in 1915. He
later served loyally under General Foch, the Supreme Commander
of the Allied forces, but he had trouble with Lloyd George and came
in for a lot of abuse over the appalling loss of life. He was given
£100,000, the O.M., made an Earl in 1919 and a K.T.

When Haig's equestrian statue by A. F. Hardiman, R.A. was
erected in Whitehall opposite the Banqueting Hall in 1937 there was
a great furore about the horse and *The Times* ran a long
correspondence on it. Cavalry officers and others affirmed that no
horse could synchronize its legs as this one did. In spite of being in
uniform, Haig has no hat.

Alfred Harmsworth, *see* Lord Northcliffe

Thomas Guy, by Peter Scheemakers

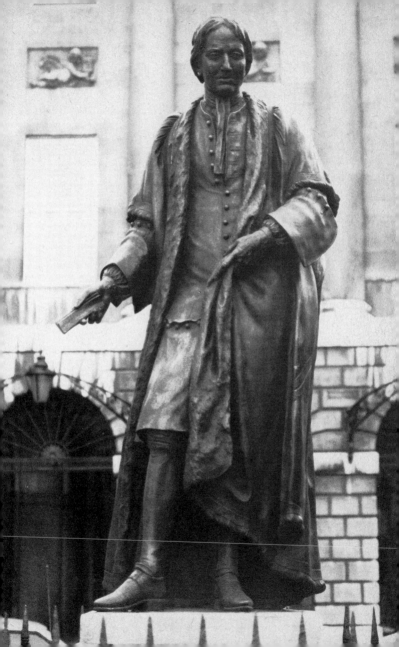

Sir Augustus Harris

Augustus Harris (1852–96), though born in Paris, lived in London and became a very successful theatre manager. He managed Drury Lane in the 80s and 90s and put on spectacular dramas and pantomimes. He became a Sheriff of London and was knighted in 1892.

Beside the main portico of Drury Lane theatre there is an elaborate fountain with marble, terracotta, stone and granite, two putti and columns surmounted by a lyre. In the middle of it is his bronze bust. Among the many decorative motifs on it there are Masonic emblems. The sculptor was Sir Thomas Brock, R.A.

Sir Henry Havelock

Henry Havelock (1795–1857) joined the Army one month after Waterloo, served in India and distinguished himself in the Afghan and Sikh wars. During the Mutiny in 1857 he relieved Cawnpore, where he was beleaguered until relieved by Outram (q.v.), after which they marched to the relief of Lucknow where once more he found himself besieged until he was relieved by Sir Colin Campbell (q.v.). A week after the relief he died of dysentery. He was knighted. His son, who was at one time an M.P., won a V.C.

His statue by William Behnes stands towards the front of Trafalgar Square as a companion piece to Sir James Napier. It is the first statue reputed to be done from a photograph. 1861.

John Heminge *see* Shakespeare

Henry III

Henry III (1207–72) succeeded his father, King John, in 1216 when aged nine. His long reign of fifty-six years showed him up as a weak king, and his only real direct credit would seem to be his building of the east half of Westminster Abbey and both the transepts. Most of this occurred between 1245 and 1270 and then no further work was done on the Abbey until 1377. Henry also built a great deal at Windsor Castle, besides most of the inner wall of the Tower of London.

Indirectly England gained its first parliament as at present constituted with peers, bishops and representatives from counties,

cities and boroughs. This met in January 1265 and was a result of
the Barons' War, which ended when Simon de Montfort, the king's
brother-in-law, defeated and captured Henry at the Battle of Lewes
the previous year and imposed conditions limiting his rule. Henry
married Eleanor of Provence and the court suffered from
unprincipled favourites, many of them French, such as Count Peter
of Savoy (q.v.)

In the open space in front of the west door of the Abbey, there is
an ugly column put up 1861 to the old boys of Westminster School
and at the top are four seated sovereigns, including Henry III, who
faces away from the School. They are in stone and were carved by
J. R. Clayton.

See also War Memorial chapter under Westminster Old Boys

Henry VIII

One of the most glamorous kings of England was Henry VIII
(1491–1547), the son of Henry VII, who died in 1509. His six
marriages, his break with Rome and the dissolution of the
monasteries are too well known. It was a colourful reign and he was
a colourful handsome king who gained glory at Flodden, was
resplendent at the Field of the Cloth of Gold and took the title of
Defender of the Faith. If during his thirty-seven years as monarch
he deposed Wolsey and executed Sir Thomas More and Cromwell
besides two wives, he was no worse than most royals of his time and
he certainly inspired devotion in his people.

He has a stone statue done in 1702 which according to Pevsner
was Francis Bird's first commission after his return from Rome. It is
over the gateway of St. Bartholomew's Hospital which Henry re-
founded in 1546 after having previously purloined it. Above the
statue are figures representing sickness and lameness. They are the
work of Edward Strong, a nephew of Thomas Strong who was
Christopher Wren's chief mason.

Lord Herbert of Lea

Sidney Herbert (1810–61) entered Parliament in 1832 and was
Secretary to the Admiralty and War Secretary under Peel. It was
later when he was War Secretary during the Crimean War that he
became unpopular and was accused of incompetence, but he greatly

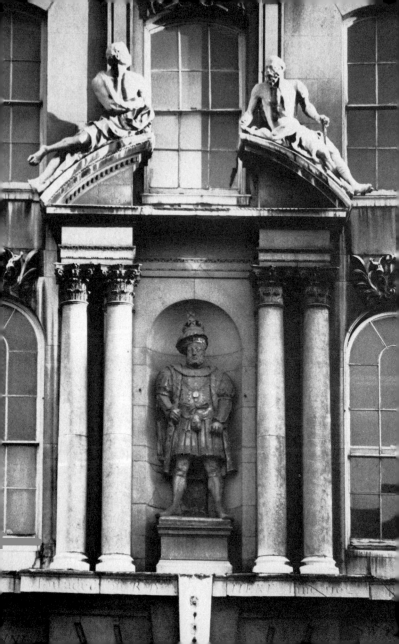

aided Florence Nightingale at Scutari and later when head of the War Office effected many beneficial reforms.

In 1857 his bronze statue by John H. Foley, R.A. was erected near the War Office, but in 1915 when Waterloo Place was altered he was moved to be beside Florence Nightingale.

Sir Rowland Hill

The great feat of Rowland Hill (1795–1879) was the organization of penny postage. He established it in 1840. As ours was the first country in the world to have proper stamps, our stamps have never had the name of the country, England or United Kingdom, on them, unlike all others. He also established book-post. He was a founder member of the Society for the Diffusion of Useful Knowledge, having started off as a teacher. He received £13,000 in 1846 in recognition of his public services. He was buried at Westminster Abbey.

The granite statue of him by E. Onslow Ford, R.A. was originally erected in front of the Royal Exchange in 1882 but moved to King Edward Street in front of the main General Post Office in 1923. It cost £1,800. He is holding a pencil and a notebook.

William Hogarth

William Hogarth (1697–1764) was famous as a painter, a caricaturist and engraver. He was taken into Sir James Thornhill's studio in Leicester Square and repaid him by running off with his daughter, whom he later married. By 1720 he had set up his own studio and later started his famous series of pictures, the best known being *The Rake's Progress* and *Marriage à la Mode*. He painted some wonderful portraits which were less formal than the normal ones of this time, among them his self-portrait with its line of beauty and his dog Trump. He was appointed serjeant-painter to King George II. After his trip to Paris he specialized in pictures of the poor, like *Gin Lane* which, with others were reproduced extensively as prints and had a moral effect in helping to reform the times. Hogarth was barely five feet high and, as anyone under four feet

Henry VIII, by Francis Bird. The figures above representing sickness and lameness are by Edward Strong

eleven qualifies as a midget, it was a near thing.

All this great man has is a stone bust by Joseph Durham set up in 1875 in Leicester Square when the square was replanned.

Quintin Hogg

A polytechnic is to be found in many large towns in England where various branches of technology and applied art are taught. The idea was developed by Quintin Hogg (1845–1903) from his Youths' Christian Institute which he started in Regent Street in 1882. He also organized cheap foreign travel, a branch which has developed into Poly Tours. His son became Lord Chancellor and 1st Viscount Hailsham and his grandson has twice been Lord Chancellor.

A friendly group in Langham Place shows Hogg seated in a chair reading, with a boy on either side, one carrying a football under his arm. It is by Sir George Frampton, R.A. and was erected in 1906. The inscriptions on both sides were added later; one is to his wife and the other to First War Members of Parliament.

Lord Holland

Henry Richard Fox (1773–1840) was a Liberal statesman who became Lord Privy Seal and Chancellor of the Duchy of Lancaster. He voted for the Corn Laws and the abolition of slavery, although he himself owned estates in the West Indies, his beautiful and witty wife being the daughter of a wealthy Jamaican planter. He was the newphew of Charles James Fox (q.v.) and Holland House in Kensington, where he lived, became the meeting-place of the most brilliant wits of the time. He became the 3rd Baron Holland when he was one year old.

In Holland Park, not far from Holland House, there is a bronze statue of him dating from 1872 which was the combined work of G. F. Watts, R. A. and Edgar Boehm. He is seated and holding a walking stick.

John Howard

The greatest name in prison reform must be that of John Howard (1726–90) and the Howard League for Penal Reform still flourishes. He was a noted philanthropist, born at Hackney of rich parents. He knew prison at first hand, as he was captured by a French privateer

when aged thirty and was clapped into Brest prison. In the 1770s, when High Sheriff of Bedfordshire, he started prison reform and after he had made a tour of English country jails, the information he laid before Parliament in 1774 brought about prison reforms such as the payment of jailors, instead of bribes, and some form of enforced cleanliness. He later toured the principal lazarettos on the Continent and even voluntarily underwent the rigours of the quarantine system. While visiting a prison in Russia he caught camp fever and died.

Howard objected to being sculpted. During his lifetime some friends raised a subscription for a sculpture, but Howard refused to sit for one. Since 1874 there has been a medallion of him over the entrance to Wormwood Scrubs prison. He faces Elizabeth Fry (q.v.) on the opposite side.

John Hunter, F.R.S.

The founder of scientific surgery was a Scot, John Hunter (1728–93), who joined his physician brother William in London and rose to being Surgeon and Lecturer to St. George's Hospital. In 1776 he was appointed Surgeon extraordinary to George III and ten years later Surgeon-General to the Army. He was elected F.R.S. His museum, which had 13,682 specimens, was bought by the government after he died and presented to the Royal College of Surgeons. A part of it was destroyed by bombs in the Second World War. Among the many subjects he investigated were aneurism, embryology and the blood, especially in relation to syphilis. He was first buried in St Martin's-in-the-Fields but his remains were later transferred to Westminster Abbey. There is a stone bust of him by Thomas Woolner, R.A. in Leicester Square dating from 1874. The fine bronze bust by Sir Alfred Gilbert, R.A. of 1893 which used to be on the façade of St. George's Hospital was moved to their medical school at Tooting in 1978 and is now indoors.

To celebrate the Silver Jubilee of Queen Elizabeth II, the Royal College of Surgeons has set up an oversize bust of Hunter in the south-west corner of Lincoln's Inn Fields. It is by a young sculptor called Nigel Boonham who has produced a very fine head. Reynolds painted Hunter twice, the first time when he had a beard, which

Hunter removed soon afterwards, and then had a life mask taken. Boonham has modelled his head from the life mask and from Reynolds's second, beardless portrait. 1979.

William Huskisson
To be the first to do anything is one way of achieving fame and William Huskisson (1770–1830) was the first person to be killed in a railway accident (he was even wearing his top hat), which happened when he went to the opening of the Liverpool and Manchester Railway. He was there in his official capacity as M.P. for Liverpool and somehow got crushed and was heard to murmur 'I have met my death', as indeed he had. Wellington, who was present and who disliked him intensely, described it as 'an act of God'. When young he stayed with his uncle at the Embassy in Paris and nearly met an earlier death when he had to flee from mobs the night the Bastille was stormed.

Inevitably he had his marble statue and John Gibson, R.A. a pupil of Canova, had strong views about dress and wrote, 'The human figure concealed under a frock coat and trousers is not a fit subject for a sculptor', so he sculpted Huskisson standing in a sort of toga. His widow gave it to Lloyd's in 1848 and it stood in their Underwriting room in the Royal Exchange although Huskisson had nothing to do with Lloyd's. Their Committee's flowery letter accepting it implied that they did so on account of the sculptor and not Huskisson. Finally Lloyd's gave it to the L.C.C. in 1915 who put it in Pimlico Gardens alongside the Thames, opposite Dolphin Square. But that was not the end of his troubles as Osbert Sitwell must have looked at him on a misty day and, seeing his figure in the folds of a senator's toga, he described it in his *People's Album of London Statues* as 'Boredom rising from a bath'.

Sir Henry Irving
The stage is poorly represented as, apart from Sarah Siddons, only Henry Irving (1830–1905) has a statue, although Garrick has a medallion. He was the leading actor in England and the U.S. towards the end of the century, his particular triumphs being in

John Hunter, by Nigel Boonham

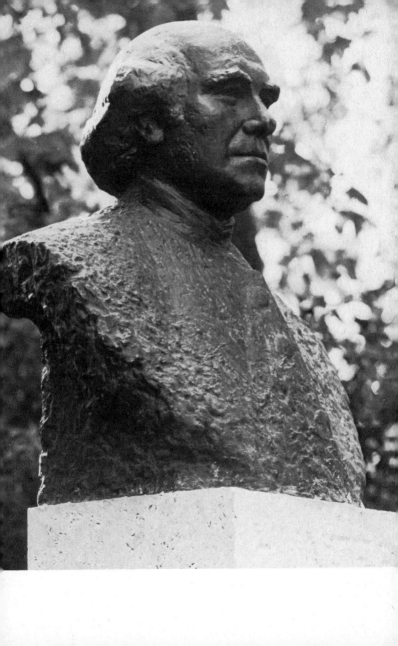

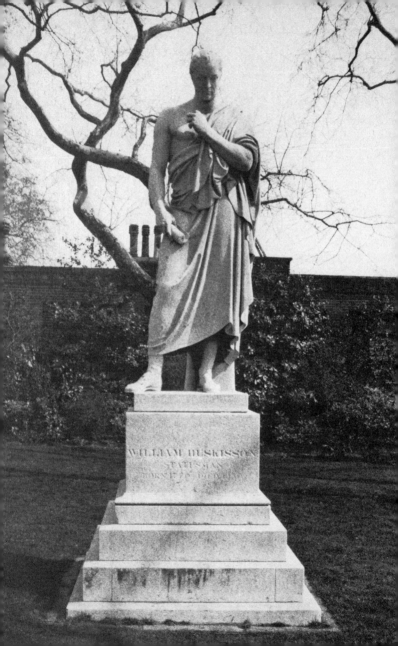

WILLIAM HUSKISSON
STATESMAN
BORN 1770 DIED 1830

Shakespearean roles, his best known being that of Hamlet. He was knighted in 1895, the first actor to receive that honour; he was buried in Westminster Abbey. His real name was John Henry Brodribb.

His bronze statue by Sir Thomas Brock, R.A. was erected by 'English Actors and Actresses and by others connected with the Theatre in this country' and it has stood behind the National Portrait Gallery at the bottom of Charing Cross Road since 1910.

James I

The son of Mary Queen of Scots and Lord Darnley was proclaimed James VI (1566–1625), King of Scotland, when only thirteen months old. He succeeded Elizabeth in 1603 as James I of England, where he was at first popular but forfeited all confidence by his blatant favouritism, in particular towards the infamous Buckingham. He held absurdly high views about the royal prerogative and sold titles freely. Sully called him 'the wisest fool in Christendom' but Macaulay summed him up as 'made up to two minds—a witty well-read scholar who wrote, disputed and harangued and a nervous drivelling idiot who acted'. He married Princess Anne of Denmark and was succeeded by his son Charles I.

At the bottom of the stairs in the entrance hall on the left of the Banqueting House in Whitehall there is a very attractive bronze bust of James I by Hubert le Sueur. The whole work is very fine, especially that of the shoulders and chest. James is wearing a crown. The bust was commissioned by Charles I after he became king and it has always been at the Banqueting House. Originally it was placed over the door.

James II

The companion statue to that of Charles II by Grinling Gibbons stands on the grass in front of the National Gallery. The two brothers are each in Roman dress of the first toga period and holding a baton in their hands. Both statues are work of a very high quality and they are the only remaining full-size outdoor bronze

William Huskisson, by John Gibson, R.A.

sculptures by Gibbons in London. Defender of the Faith is engraved on the socle.

James II, born in 1633, was one of our worst kings and happily had one of the shortest reigns, 1685–8. He had to flee the country in 1688, two years after his sculpture was cast. Louis XV allowed him to set up his own court at St. Germain where he lived until his death in 1701, aged sixty-seven years.

The statue has been in four places; twice just off Whitehall, then in St. James's Park, and the last move was in 1948.

Admiral Earl Jellicoe

The bronze bust of Admiral Jellicoe (1859–1935) by Sir Charles Wheeler, P.R.A. is on the north wall of Trafalgar Square, between his contemporary Admiral Beatty and Admiral Cunningham of Second World War fame and was erected in 1948. He was in charge of the relief of the Peking legations during the Boxer rising of 1900, when he was wounded. At the outbreak of the First World War he was made Commander-in-Chief of the Fleet and took part in the Battle of Jutland. He later became Governor of New Zealand from 1920–4. He was buried in St. Paul's.

Dr. Edward Jenner

One of the most remarkable and much-needed medical discoveries was the use of cowpox as a vaccine for smallpox. Edward Jenner (1749–1823) noticed that people who handled cows seldom got smallpox and, working on this theory, he experimented and finally achieved success in 1796. At first his work met with strong opposition, but soon it was taken up all over the civilized world. The Government even gave him grants of £30,000.

W. Calder Marshall, R.A. made a bronze seated statue of him which was placed in Trafalgar Square but moved to the Water Gardens at the head of the Serpentine in 1862.

Dr. Samuel Johnson 1709–84

Samuel Johnson is famous for his Dictionary which took eight years to compile. He was a founder member of the Literary Club and we

James II, by Grinling Gibbons

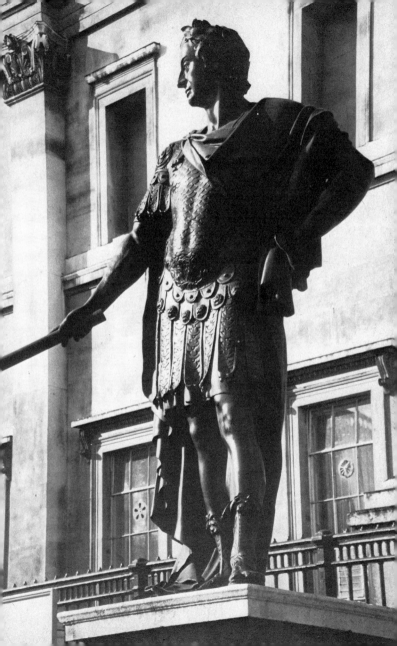

are lucky to have Boswell as his biographer, so that we know more about this man of letters than any writer up to 1800 and very rewarding knowledge it is. In 1773 Johnson, with Boswell, made his famous journey to the Highlands and the Western Isles which were then very remote and wild places. Each wrote his account of it.

He was a friend of Garrick, Reynolds, Goldsmith and most of the famous people of his time and after the death of his wife he spent a great deal of time with Mr. and Mrs. Thrale until, having become a widow, she married Piozzi, an Italian singer. The king granted him a pension of £300 a year in 1762 which he badly needed, as he was never a rich man. He was a staunch Tory. His house in Gough Square off Fleet Street is now a museum and can be visited. He was buried in Westminster Abbey.

Percy Fitzgerald presented the bronze statue he did of Johnson in 1910 and it is placed on a pedestal of black Belgian marble behind the church of St. Clement Danes in the Strand. Johnson used to worship there and in the gallery there is a plaque commemorating this. Johnson is standing looking down Fleet Street holding an open book and there are books and an inkwell at his feet. In the front of the pedestal there is a medallion of James Boswell and on one side Mrs. Thrale, spelt Thrall, is talking to Johnson. The inscription reads, 'Critic, essayist, philologist, biographer, wit, poet, moralist, dramatist, political writer, talker.'

Inigo Jones
Inigo Jones (1573–1652) marked a watershed in English architecture. After centuries of mediocrity there suddenly appeared a new style largely as a result of Jones' having been to Italy, where he studied the Palladian style of architecture, besides painting. On his return James I became his patron and initially he arranged the masques of Ben Jonson and introduced moveable scenery to the English stage. After his second visit to Italy in 1613 he designed the Queens' House at Greenwich and the Banqueting House in Whitehall. He also laid out Covent Garden for the Duke of Bedford, which was the first square to be built in England. He was the first of the great English architects and his influence was extensive and lasting.

Beside the outside staircase of Palladian Chiswick House there is a stone statue of him executed by J. M. Rysback in 1729. Near by is one of Palladio.

President John Kennedy
The thirty-fourth President of the United States, John Fitzgerald
Kennedy was born in 1917 and assassinated in Dallas in 1963. When
he was elected President in 1960 he was not only the first Catholic
but the youngest President ever to be elected. In Marylebone Road,
in the garden of 1 Park Crescent, which is the home of the
International Students' Hostel, there is a bust of Kennedy by
Jacques Lipchitz, a Lithuanian American. It came from
contributions, with a limit of £1, organized by the *Sunday
Telegraph*. It is a copy of his bust done for the Library of Congress
and also Harvard Library. The bust was unveiled in 1965 by Edward
and Robert Kennedy, his brothers.

The Duke of Kent
Edward (1767–1820), the fourth son of George III, was created
Duke of Kent. He was Governor of Gibraltar and as a soldier he
was a martinet, to such an extent that a number of mutinies
occurred and he was recalled. He is best known as being the father of
Queen Victoria. He had married Victoria Mary Louisa, daughter of
the Duke of Saxe-Saalfeld-Coburg, in 1818.
 There is a statue of him in the garden of Park Crescent at the top
of Portland Place by Sebastian Gahagan, an Irishman who was a
pupil of Nollekens. 1827.

Sir John Kirk, J.P.
John Kirk (1847–1922) spent his life trying to alleviate the lot of the
poor and particularly the crippled child. He was secretary of the
Open Air Mission, Director of the Shaftesbury Association and the
Ragged School Union. He was knighted in 1907.
 On the façade of 31 John Street, Bloomsbury, which is called
John Kirk House, there is a bronze medallion of him on a marble
slab. On it is 'Christian Philanthropist. The Children's Friend'.
c. 1925.

Lord Kitchener of Khartoum, O.M.
Like so many of our best generals Horatio Hebert Kitchener
(1850–1916) was born in Ireland. His best campaign was the defeat
of the Khalifa at Omndurman in 1898, thus avenging the death of
General Gordon. He went on to be Commander-in-Chief in South
Africa and later in India. At the outbreak of war in 1914 he was

made Secretary for War and led a great recruiting campaign, but on a journey to Russia in 1916 his ship was sunk by a mine off the Orkneys. He had been given the O.M. and created a Viscount. He was buried in St. Paul's.

His statue by John Tweed was erected on the south side of Horse Guards Parade in 1926, at the back of No. 10 Downing Street. He is wearing a Field-Marshal's service dress with riding boots and with his hands crossed in front of him. There is also a small stone bust of Kitchener in the first floor pediment of 73 Knightsbridge. It is a companion piece to Lord Roberts. 1902.

Charles Lamb

Charles Lamb (1775–1834), the great essayist, served thirty-three years in the East India Office. He wrote poems and some unsuccessful plays. He combined with his sister Mary in writing *Tales from Shakespeare*, which is still read. The success of *The Works of Charles Lamb*, a collection of his poems and prose, got him on to the staff of the *London Magazine*, for which he wrote his immortal essays, later collected under the title of *Essays of Elia*; Elia, his nom-de-plume, being the name of a fellow clerk in the South Sea House where he first worked. They produced comparative wealth for him which he had never had before, but living with his sister, who had stabbed her mother and become mentally deranged, brought sadness. He had many friends and his letters are almost as famous as his essays, which have given him a place in literature that is unique.

In Giltspur Street, across the road from the Old Bailey, there is a bronze bust by Sir William Reynolds-Stephens on the wall of a restored watch-house of 1791, placed there in 1962. In 1935 the bust had stood outside Christ Church, Newgate, which was bombed. Christ's Hospital, Lamb's old school, is referred to in the inscription 'Perhaps the most beloved name in literature, who was a Bluecoat here for seven years', a reference to the fact that the boys of Christ's Hospital wore a long blue coat. In the gardens of Inner Temple there is a statue of a youth known as the Lamb Statue, as he was born in Crown Office Row and lived in the Temple until 1817. (*See* Inner Temple Gardens *under* Monuments)

George Lansbury, P.C.

George Lansbury (1859–1940), in spite of being a pacifist, was a well known and popular Labour politician between the Wars. He opened up the London Parks for games and started public bathing in the Serpentine. He also founded the *Daily Herald* and was editor for some years. A bronze medallion on the side of the Pavilion at the Serpentine was unveiled in 1953 by Mr. Attlee, the former Prime Minister. On it is his name followed by 'who made this bathing shore for our enjoyment'. The sculptor was H. Wilson Parker.

Lord Lawrence

John Laird Mair (1811–79) was created 1st Baron Lawrence on account of his great services in India, particularly in the Punjab, where he so won the esteem of the Sikhs that when the Mutiny took place he was able to disarm the Punjab mutineers, raise 50,000 men and capture Delhi. He became Governor-General of India in 1864 and ruled very successfully.

His bronze statue in Waterloo Place is by Sir Joseph Edgar Boehm, R.A., 1882, and the inscription comes from Shakespeare: 'How youngly he began to serve his country, how long continued.'

Sir Wilfrid Lawson

Wilfrid Lawson (1829–1906) was a passionate temperance advocate and it is nice to think that some civil servant had the sense of humour to put his statue by David McGill next to the intemperate Robbie Burns in Victoria Embankment Gardens. His bronze statue (1909) had bronze figures representing temperance, charity, fortitude and peace but they were stolen in 1979. It was damaged in an air raid in 1917.

Abraham Lincoln

The only American and one of the few non-royal people to have two statues in London is Abraham Lincoln (1809–65), the sixteenth President of the U.S.A. His over-lifesize statue standing in Parliament Square (a most incongruous place for a foreigner) is by Augustus Saint-Gaudens, being a copy of one by him in Chicago. It shows Lincoln standing in front of a chair which is embossed with an eagle with fully spread wings. The statue was presented by the

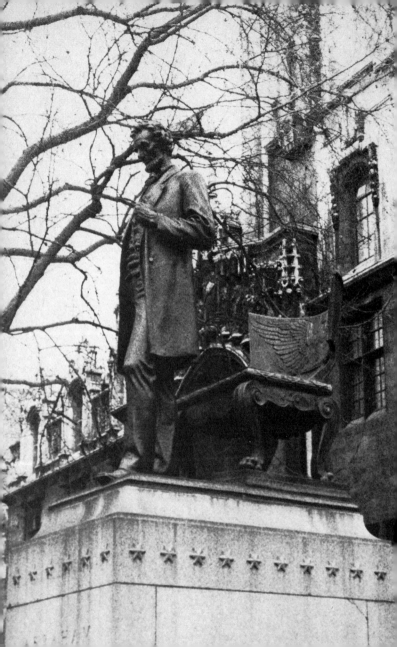

American Government in 1920. The square base has thirty-two stars round it. Saint-Gaudens, (1848–1907) was born in Dublin of a French father. Trained in Europe, he later became the leading American sculptor.

The other statue is a large bust in Indiana limestone by Andrew O'Connor, also an American. It is on the left just inside the Royal Exchange. 1930.

Joseph Lister, O.M.

Joseph Lister (1827–1912) was a successful surgeon, but his main claim to fame is that of being the founder of antiseptic medicine, which completely revolutionized surgery. Honours came his way in profusion. He was made President of the British Association and of the Royal Society, made a baronet in 1883 and the first-ever medical peer five years later. His final honour was being made an original member of the Order of Merit when it was founded in 1902.

There is a bronze bust of him in the middle of Portland Place, not far from where he lived in Park Crescent. It is by Sir Thomas Brock, R.A. and it stands on a large granite plinth with a bronze girl and youth below. At the rear is a bronze wreath with his dates in it and on the sides in gold letters are Science and Surgery. 1924.

David Livingstone

The Royal Geographical Society had their building designed by Norman Shaw. The niches left on two sides have been filled by Shackleton and Livingstone, but not till many years later, 1932 and 1953 respectively. Livingstone is by J. B. Huxley-Jones and he is shown in his explorers outfit leaning on a stick.

David Livingstone (1813–73) was a Scottish missionary and traveller who went to South Africa in 1841 and after several years in Bechuanaland (Botswana) he moved north and discovered the Victoria Falls. The enthusiasm with which he was welcomed on his return to England was astonishing. After a rest he was sent out by the Government to explore the Zambesi in 1858. He made a third visit to Africa, this time partly under the auspices of the Royal Geographical Society, with the intention of finding the watershed of

Abraham Lincoln, copy of Augustus Saint-Gaudens

the Nile. It is nowadays hard to imagine the interest there was in the unknown, uncharted hinterland of Africa. Speke had been out in 1858 and traced the Nile into Lake Victoria Nyanza, which is about the size of Ireland, but he could not affirm that that was the source of the Nile. Livingstone left Zanzibar in 1866 and trekked west beyond Lake Tanganyika and found the source of a river which he though might be the Nile but which turned out to be the Congo. Illness made him go to Ujija where Stanley had the famous encounter with him. There he died, but such was the devotion of his natives that they carried his body 600 miles to the coast where it was shipped home for burial in Westminster Abbey.

Mrs. Ramsay MacDonald
On the north side of Lincoln's Inn Fields there is a seat to the memory of Margaret MacDonald 1870–1911, the wife of the first Labour Premier, who lived nearby at No. 3. Above the seat there is a bronze of Mrs. MacDonald, by Richard Goulden, amid a row of nine cheerful children, and across the top of the bench the following is carved: 'The seat is placed here in memory of Margaret MacDonald who spent her life helping others.' 1914.

Sir James McGrigor Bt.
Sir James McGrigor (1771–1858) was virtually the founder of the Royal Army Medical Corps. He served in Flanders, Grenada, Egypt, Walcheren and then with Wellington in the Peninsular campaign, where he was head of the medical services. His attractive bronze statue by Matthew Noble was erected in the grounds of Chelsea Hospital in 1865 but was moved in 1909 to the R.A.M.C. Hospital in Attenbury Street, next door to the Tate Gallery. He was made Physician Extraordinary to the Prince Regent in 1816 and a Baronet in 1830 and Director-General of the Army Medical Department from 1816 to 1851. McGrigor will be moved again when the Tate takes over these buildings.

Captain Richard Maples
Some of the most attractive almshouses in London are to be found in the Mile End Road just beyond the London Hospital. They date from 1696 and have two sides of red brick buildings and a chapel at

the end. Captain Maples, who was born about 1630, was
'Commander of a ship in the East Indies' and died out there in 1680.
He left £1,300 to Trinity House, which went towards their
construction. His statue originally at Dartford in 1689 was placed
behind the chapel in 1875 and then moved to a room in Trinity House
in 1953. Looking at Maples's pendulous belly makes one recall
Shakespeare's Justice 'In fair round belly with good capon lined'.
He wears a fine peruke and looks a man of substance. One hand lies
on a badly mended compass. It is in lead and painted white. The
sculptor is Jasper Latham and it dates from 1681.

Sir Clement Markham

There is a bronze bust by F. W. Pomeroy, R.A. in the forecourt of
the Royal Geographical Society given by the Peruvian Government
in appreciation of the services of Clement Markham (1830–1916) to
their country. He was a geographer and explorer, especially in Peru
and Abyssinia, besides taking part in the search for Franklin. He
was responsible for the collection of cinchona trees and seeds from
the Andes for growing in India for medicinal purposes. The tree is
named from Chinchon, a Peruvian vice-queen, who was cured by its
bark. He was made K.C.B. in 1896. 1921.

Karl Marx

Most Londoners know that Karl Marx (1818–83) is buried in one of
the Highgate Cemeteries. Swain's Lane climbs up steeply between
the two, Marx being in the one on the right with its entrance at the
top. It is a rewarding visit. After passing mausoleums, broken
columns, crosses engulfed in weeds and some modern tombstones,
one takes the left turn at the fork and then suddenly this enormous
head appears, four times lifesize, on a huge, dark grey granite plinth,
overpowering everything else. It is infinitely more striking than say
Epstein's memorial to Oscar Wilde in Père Lachaise in Paris. The
proportions are excellent. It has exactly the look one would expect
of the man and it is strikingly impressive even without the usual
offerings of red wreathes and flowers lying around. The white
marble tablet set into the centre of the plinth gives the names of
other members of the Marx family buried there.

Apart from his name, there are the last words of his famous

Communist Manifesto of 1848 which reads 'Workers of all lands
unite'. (The German is aller Länder.) Beneath it there is 'The
Philosophers have only interpreted the world in various ways. The
point however is to change it.' It is a pity that the remark Marx
made in his last years, 'At any rate I am not a Marxist' is not also
engraved.

The sculptor is Laurence Bradshaw and it was put up in 1956
after Marx and a number of other graves had been removed in a re-
planning scheme. Marx was originally given a flat white marble slab.

Queen Mary

Princess Mary of Teck (1867–1953) became engaged to Albert
Victor, Duke of Clarence, the eldest son of Edward VII, but when
the Duke died in 1892 at the age of twenty-eight she transferred her
affections to George, the next son and heir and married him the
following year. She thus became Queen Mary in 1910 when George
V succeeded to the throne. On his death she moved to Marlborough
House where she continued to increase her famous collection of
objets d'art. She had a particularly regal figure and was famous for
her hats.

In the garden wall of Marlborough House that faces the Mall
there is a bronze medallion of her by Sir William Reid Dick, R.A.,
1967.

Mary, Queen of Scots

There must be very few royal people who have lived a life so full of
drama and plots as Mary, Queen of Scots, (1542–87), a great-
granddaughter of Henry VII. She was Queen of Scotland before she
was a week old and married at fifteen to the Dauphin, who became
King of France the next year and died a few months later. On her
return to Scotland she married Darnley, who was also a Roman
Catholic, and their son became James I of England. Within two
years of marriage Mary almost certainly connived at Darnley's
murder and she then hurriedly married his murderer. This caused
her to be driven out of Scotland into the hands of Protestant

Karl Marx, by Laurence Bradshaw

Elizabeth. Plot followed plot and the inevitable was that she was
beheaded at Fotheringay for conspiracy after being held prisoner for
nearly twenty years. She was a woman of great beauty.

In a niche on the first floor of 143/4 Fleet Street there is a stone
statue of Mary adorning a fine Gothic building of around 1880. It
was put there by Sir John George Tollemache Sinclair, a Scottish
admirer, in spite of the fact that Mary never came to London.

Earl of Meath
Where Lancaster Gate meets the Bayswater Road there is a square
stone column with the figure of a kneeling boy on top and set into
the front there is a bust of Reginald Brabazon, the 12th Earl of
Meath KP (1841–1929). He was in the Boer and the 1914 War and
became a Brigadier-General. On the back of the plinth is 'One King
One Empire' and there is also inscribed 'To him the British Empire
was a goodly heritage to be fashioned unto the glory of God'. The
sculptor was Herman Cawthra. 1934.

Lord Melchett
Alfred Mond (1868–1930), the British son of a German father, was a
Liberal M.P. who held Cabinet rank, besides becoming an
important industrialist. When head of Mond Chemicals he helped to
form the Imperial Chemical Industries in 1926 and was elected their
first chairman. He was created Baron Melchett two years later.

I.C.I. built, in 1929, what then seemed to be an enormous
building on Millbank as their head offices and instead of the usual
keystone over the centre window on the seventh floor, there is a
forward projecting head of Lord Melchett, four times life size. The
sculptor is W. B. Sagan.

Krishna Menon
Krishna Menon (1896–1974) was a fairly typical product of the
London School of Economics. He went on to read law at the Middle
Temple and became very left wing and anti-imperialist. He served
on the St Pancras Borough Council from 1934–1947 and when India
became independent he was made the first High Commissioner of
India in London and later was India's representative at the United
Nations. He was a great friend of Nehru but when the Chinese

successfully invaded India even Nehru had to remove him from being Minister of Defence.

A bronze head, about half size, was put up on a pedestal in the south-east corner of Fitzroy Square, just outside the enclosed gardens, in 1977. It is by Fredda Brilliant, who also did the sculpture of Gandhi.

John Stuart Mill
There is a seated bronze statue by Thomas Woolner, R.A. of the great philosopher and economist John Stuart Mill (1806–73) erected in Victoria Embankment Gardens near Temple Station, five years after his death. Mill started to learn Greek at the age of three and political economy at thirteen. He went into the East India Company at seventeen, but he soon devoted himself to philosophic discussion and published a number of books which had a profound influence on contemporary thought and reform. He was a godfather of Bertrand Russell.

Sir John Everett Millais, Bt., P.R.A.
Born in Southampton of a Jersey family, John Millais (1829–96) exhibited at the Royal Academy at seventeen. He became a founder with Holman Hunt and Rossetti of the Pre-Raphaelite Brotherhood in 1848, exemplified by his *Ophelia*, but he later changed his style to pictures like *The Boyhood of Raleigh* and *The Northwest Passage*. He married Effie, John Ruskin's wife, after an annulment. He was made a Baronet in 1895, the first artist to be created one, and President of the Royal Academy the year after, but he died during his year in office. In the forecourt of the Tate Gallery there is an imposing statue of him in a wide-brimmed hat holding his palette in his left hand and a brush in the right. It is by Sir Thomas Brock, R.A. 1904.

Viscount Milner
Alfred Milner (1854–1925) was a prominent statesman who became High Commissioner in South Africa, Governor of Transvaal in 1901, and Secretary for War in 1918. He was created Viscount in 1902 for his services before and during the Boer War. He interested himself in Toynbee Hall in Commercial Street, Whitechapel, becoming Chairman of the Council in the First World War. It is an

institution founded by Arnold Toynbee in 1885 for social and
educational work among the poor and still serves an important
purpose.

On a wall in the courtyard of Toynbee Hall there is a bronze
medallion of Lord Milner set in a circular wreath. Around it is
inscribed 'Alfred Viscount Milner Servant of the State 1854–1925'.
It is a replica of the Milner Memorial in the Henry VII chapel in
Westminster Abbey, which was done by Gilbert Ledward in 1930. A
few yards away on the same wall a two-foot-high mother and child
rest on a ledge and below them a plaque reads 'Clare Winsten for
Jane Adams U.S.A'. Jane Adams, who worked there, was so
impressed that she returned to the States and in 1889 founded a
similar concern in Chicago which won her a Nobel Peace Prize.

John Milton

John Milton (1608–74) can lay claim to being one of the greatest
poets in the world. After Cambridge, where he wrote the splendid
Nativity Ode, he composed his enchanting twin poems *L'Allegro* and
Il Penseroso and the longer *Comus*, a play which was first performed
at Ludlow Castle. Then on the death of a great friend came *Lycidas*.
All these were in preparation for his life's work, *Paradise Lost*,
which was largely dictated to his daughters, as he had gone blind in
1652. It was completed in 1663 and was followed by *Paradise
Regained* eight years later.

During the Commonwealth he was made Secretary of Foreign
Tongues and he defended the execution of Charles I. He was
married three times. His bronze statue by Horace Montford was in
the churchyard, but is now in the church of St. Giles, Cripplegate, in
which he was buried. There is also a bust of him in the church by
Bacon dating from 1793. St. Giles's is often shut but it is situated in
a most imaginative setting between two large areas of water and
alongside it is a fine example of the City Roman wall with two
bastions. There is also a statue of Milton on the first floor of the
City of London School almost opposite Blackfriars Bridge. It was
erected in 1882.

Charles Montagu

One of the founders and creators of the Bank of England was

Charles Montagu (1661–1715). He managed to raise £1,200,000 in subscriptions to start the bank. He was a writer and a politician who became Chancellor of the Exchequer when he was responsible for the ill-advised Window Tax. He also caused all half-crowns to be milled. After being created Baron Halifax of Halifax he was impeached over money and struck off the Privy Councillors' list, but in 1714 got back into favour and was awarded the Garter and made Earl Halifax.

In the Central Court of the Bank of England his statue by Sir Charles Wheeler, P.R.A. was erected on the first floor alongside that of Montagu Norman when the Bank was rebuilt in 1932.

Field-Marshal Viscount Montgomery

Bernard Law Montgomery (1887–1976) was one of the outstanding generals of the last war, being particularly associated with the 8th Army (the Desert Rats) in their victorious battles from Egypt to Tunis. He was appointed commander of the ground forces for the Normandy invasion where he took on the main weight of the German counter-offensive. He accepted the capitulation of the Germans at Luneburg Heath in 1945 and after the war became Deputy Supreme Commander of the N.A.T.O. forces. He became Field-Marshal in 1944, K.G. and a Viscount two years later and was affectionately known as Monty to his troops.

A statue by Oscar Nemon, fourteen-feet high was erected in Whitehall in 1980 with Monty in battledress and his famous beret on Raleigh Green at the south-west corner of the Ministry of Defence.

Sir Thomas More

One of the most brilliant and versatile characters in Tudor times was Thomas More (1478–1535). He wrote *Utopia*, a story about an imaginary commonwealth of perfect living. He became Speaker of the House Commons in 1529, succeeded Wolsey as Lord Chancellor of England, but resigned three years later, as his conscience would not let him agree with Henry VIII on the question of divorce, nor would he accept anyone but the Pope as head of the English Church. Henry committed him to the Tower and after a year there he was tried, convicted and beheaded. One of the wisest and best of

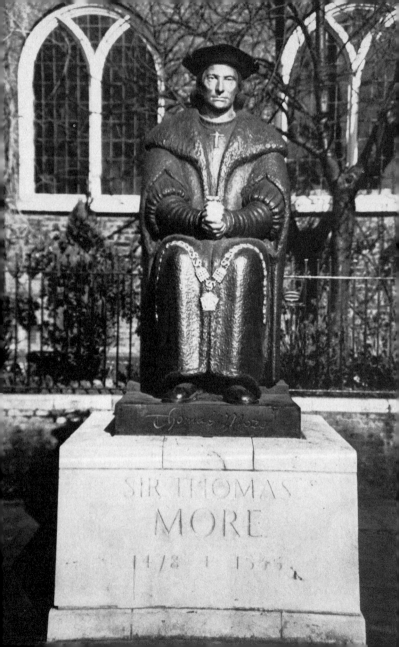

SIR THOMAS
MORE
1478 † 1535

men, he was canonized by the Catholic Church in 1935, just four hundred years after his execution.

He has a very impressive tomb in Chelsea Old Church, and on the Cheyne Walk pavement outside it is his statue by L. Cubitt Bevis, erected in 1969. The sculptor's signature is on the inside of his large hat. It is a striking piece of work. An almost black bronze seated figure has gold hands and face as well as a gold chain of office which lies across his knees. On the plinth is More's name and signature, the only statue to bear one. There are his dates 1478–1535 and on the other three sides are the single words Scholar, Saint, Statesman.

On the corner of Carey Street and Serle Street behind the Law Courts, there is a stone statue of More at first floor level. It is by Robert Smith and dates from 1886. He is in long robes and holding a scroll. Below it are his coat of arms. The wording reads, 'The faithful servant both of God and the King. Martyred July 6th 1535' though some authorities say it was July 7th.

On the John Carpenter Street side of the City of London School on Victoria Embankment, almost opposite Blackfriars Bridge, there is a stone statue of More which was erected in 1882.

Sir Hugh Myddleton

Providing London with water has always been a problem. The first piped supply was in 1237, when Gilbert de Sandford used lead pipes to bring water to the City from Tyburn and Mary le Bourn. A three-and-a-half-mile pipe 'not thicker than a quill' ran from Tyburn to Cheapside in 1378 and there were water rates although the water was cut off much of the time. London Bridge had its first water wheel in 1582 and five of its arches had water wheels until 1822. There were also numerous artesian wells. After the Great Fire of 1666 nine were found in nine adjoining houses in Watling Street.

The man who really gave London her water was Hugh Myddleton (1560–1631). Around 1610 he piped in clean water which he brought thirty-eight miles from the Lea Valley to the New River Head in Islington which is now part of the Metropolitan Water Board. James I took a half share in Myddleton's scheme for 'a pipe of half an inch bore for the service of their kitchine' with 'the smallest

Sir Thomas More, by L. Cubitt Bevis

swan-necked cockes'. There was opposition and Myddleton only got paid £100 and went broke. He was however knighted for his work, the first engineer to be thus honoured.

On Islington Green, just north of the Angel, a statue by John Thomas in marble with, below, a boy on either side and a jar for the flowing water, was unveiled by Gladstone in 1862. There were contributions from the public and the New River Co. gave the princely sum of fifty pounds. He has another statue in stone by Samuel Joseph on the outside of the Royal Exchange facing the Bank at first floor level, dating from 1845 when the Exchange was rebuilt. The other statue on that wall is of Dick Whittington.

He also appears in Hogarth's 'Evening', a drawing with a woman walking beside her short husband, who wears the cuckold horns of a nearby cow. Above them is an inn sign of a man's head and shoulders and under him the name Sir Hugh Middleton (sic). The inn was still going, up to the war. His third statue on a house adjoining Holborn Viaduct was bombed in the last war.

General Sir Charles James Napier

Charles Napier (1782–1853) may be said to have travelled the world at the expense of the Government, like so many nineteenth-century soldiers. He served in crushing a rebellion in Ireland in 1798, he was in the retreat to Corunna in 1808, in Portugal 1810, then to the United States in 1813 and two years later he was storming Cambrai. He twice went to India, ending up as Commander-in-Chief of the Army in India. He was made K.C.B. in 1838.

His bronze statue by George Canon Adams has stood in Trafalgar Square since 1855.

Field-Marshal Lord Napier of Magdala

Robert Cornelis (1810–90) was essentially an engineer, and after compaigns during the Mutiny and the siege of Lucknow he was made K.C.B. After serving in the Chinese War of 1860 he distinguished himself by his brilliant Abyssinian expedition of 1868 when, after a ten-week march, he stormed and captured Magdala, which place he took in his title when created a Baron. He became

The Hugh Middleton in Hogarth's 'Evening'

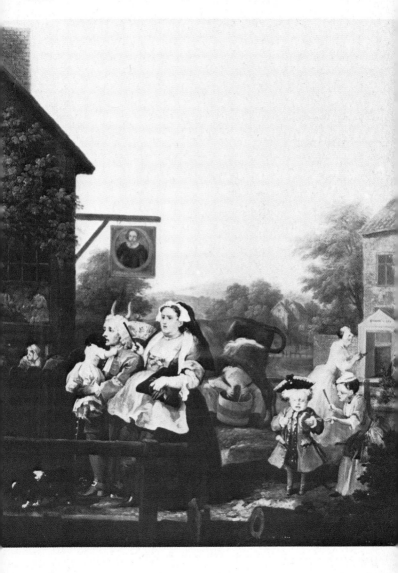

Field-Marshal, Governor of Gibraltar and Constable of the Tower.

His equestrian statue by Sir Joseph Edgar Boehm, R.A. was completed by Sir Alfred Gilbert, R.A. It was erected in 1891 in front of Carlton House Gardens and moved in 1920 to the top of Queen's Gate to make way for Edward VII. He wears a tropical uniform and carries a pair of binoculars in his right hand. There is a replica in Calcutta.

John Nash

George IV, especially when Prince Regent, was much abused for his extravagance, but it is very much thanks to him that central London was transformed and improved, and the man who carried it out so brilliantly was the architect John Nash (1752–1835). It is largely due to them both that London has important streets like Waterloo Place and Regent Street with its graceful curve, though the present buildings have none of the charm of Nash's original design. Regent's Park was planned on a grandiose scale and most of the elegant terrace houses with their columns and statues still remain as one of the best examples of Regency London. Nash turned Buckingham House into Buckingham Palace and placed his Marble Arch in front of it as a main entrance. He was also one of the principal architects of the Pavilion at Brighton, one of the most expensive and delightful follies ever built. As well as being a town planner, Nash must be given much of the credit for introducing steel girders to strengthen his buildings and bridges.

The circular colonnade surmounted by a spire is a feature of Nash's All Souls, Langham Place, and with the church set at an angle it cleverly unites Portland Place and Regent Street, two streets on parallel courses, with a central axis.

William Behnes made a delightfully sardonic marble head of Nash in 1831 and it has been in private possession ever since, but around 1930 Lord Gerald Wellesley, later the 7th Duke of Wellington, had a bust made from it which he put between the first floor windows of his house, No. 3 Chester Terrace, which is the first one on the left after going through the arch at the south end of the terrace. The house and the terrace were built by James Burton, the father of Decimus Burton.

John Nash

In 1956 a bust about one-and-a-half times normal size was taken by Cecil Thomas from a plaster cast of the original and set up on a pedestal in the colonnade of All Souls. That plaster cast is in the R.I.B.A. building, 66 Portland Place.

Admiral Lord Nelson

Trafalgar Square was laid out by Sir Charles Barry in the 1830s and 1840s and it was fitting that England's most popular hero should grace it on a tall column.

Horatio Nelson (1758–1805) was popular with his sailors, as was shown at his funeral, and with the people. He had lost an eye at Calvi and an arm at Santa Cruz but that did not stop him annihilating the French fleet in Aboukir Bay, trouncing the Danes off Copenhagen and finally crushing the combined French and Spanish fleets in his memorable victory off Cape Trafalgar in 1805. Nelson was raised to the peerage as Baron Nelson of the Nile, and the King of Naples made him Duke of Bronté. He was buried in St. Paul's.

The fluted column in granite from Foggin Tor in Devon was designed by William Railton, who based it on a Corinthian column in the temple of Mars Ultor in the Augustan Forum, Rome. It was begun in 1840 but only finished three years later. The overall height is 185 feet. The excellent stone statue is by E. H. Baily, R.A. Nelson is dressed as an Admiral and stands alongside a capstan. At the base of the column are four reliefs in bronze from captured cannon, three depicting scenes from his famous victories: at the Nile, facing the National Gallery; at Copenhagen, facing the Strand; at St. Vincent, facing Cockspur Street: and the fourth, facing Whitehall, his death. They are all by different sculptors, namely W. F. Woodington, J. Ternough, M. L. Watson and J. E. Carew respectively. The four twenty-foot-long and eleven-foot-high lions at the base were an afterthought. They were modelled by Sir Edwin Landseer, R.A. but not erected until 1868. Their paws are those of a cat. A ceremony and wreath-laying take place annually on Trafalgar Day, 21 October.

Cardinal Newman

Just outside Brompton Oratory there is a marble statue of John
Henry Newman (1801–90) holding a cardinal's hat in his hand, by
the Frenchman Léon-Joseph Chavalliaud, dating from 1896. He was
made a Fellow of Oriel College, Oxford, where he met Keble, with
whom he started the Tractarian Movement in 1833, having been
ordained nine years before. In 1845 he left the Church of England
and joined the Church of Rome. Shortly after this he visited Rome
and became a priest. On his return he became head of the
Birmingham Oratory and remained so for over forty years, being
made a Cardinal in 1879. He wrote numerous works but he is
probably best known to the layman for having written 'Lead, kindly
Light'.

Sir Isaac Newton, F.R.S

A very insignificant stone head by William Calder Marshall, R.A.
commemorating Isaac Newton (1642–1727), one of our greatest
philosophers and mathematicians, was placed in Leicester Square in
1874 because from 1710–26 he lived in the adjoining St. Martin's
Street. The famous apple event took place just after he had got his
degree at Cambridge, but he returned to be a fellow of Trinity in
1667 and later Professor of Mathematics. Initially he failed in his
gravitation calculations and switched to telescopes and his theory of
light but subsequently, in his *Principia*, published in 1687, he was
able to expound to the world his theory of gravitation. He became
Master of the Mint. President of the Royal Society and was
knighted by Queen Anne in 1705. Newton died in the same year as
George I and was buried in Westminster Abbey. There is also a
statue of Newton on the first floor of the City of London School
almost opposite Blackfriars Bridge.

Florence Nightingale, O.M.

One of the most dominant and remarkable women of the nineteenth
century was Florence Nightingale (1820–1910), who was given her
Christian name from being born in Florence. The Crimean War
started in 1854 and Miss Nightingale, who had trained in Paris, was
only thirty-five years old when she took out thirty-eight nurses and

arrived at Scutari in November 1895, just in time to receive the
many soldiers wounded at the battle of Inkerman. She soon had
10,000 men to look after and it was her realization that bad sanitary
conditions were largely the cause of death that saved so many lives.
She returned to England the next year when the war was over and
raised £50,000 for training nurses at St. Thomas' and King's College
Hospitals. In 1907 she was awarded the O.M., the first woman to be
given it.

Her statue by Arthur Walker, R.A. stands in Waterloo Place just
in front of the Guards' Crimean Memorial, beside her friend the
Minister of War, Lord Herbert of Lea. Known as the Lady of the
Lamp because of the nightly rounds she made at Scutari, the
sculptor has shown her standing carrying a lamp in her right hand
as if doing her rounds. There is also a very similar statue of her by
Frederick Mancini standing on the north wing terrace of St.
Thomas' Hospital next to Edward VI. She wears a cap and frilled
cuffs and also carries a lamp. The bronze statue was stolen in 1970,
but it has been replaced by a replica in a composite material. In each
case the lamp is more like a Roman oil lamp whereas the lamp
carried by Miss Nightingale was of the concertina shape.

Montagu Norman
The great name in finance between the Wars was Sir Montagu
Norman (1871–1950). He had won the D.S.O. fighting in the Boer
War before becoming a Director of the Bank of England in 1907
and then Governor from 1920–44, besides being an international
figure of repute. He was made a Privy Councillor in 1923 and was
created Baron Norman of St. Clere in 1944. The title died with him.

On the first floor of the Garden Court of the Bank of England
there is a stone statue of him by Sir Charles Wheeler, P.R.A.
sculpted in 1946.

Viscount Northcliffe
Alfred and Harold Harmsworth were two brothers who between
them were due to revolutionize Fleet Street. Both became newspaper
magnates and both became peers. Alfred (1865–1922) was the more

Florence Nightingale, by Frederick Mancini

dominant and took control of the *Evening News* in 1894, the *Daily Mail* two years later and *The Times* in 1908, while with his brother he bought up the *Daily Dispatch* and in 1903 they started a picture paper for women, the *Daily Mirror*. Alfred became Baron, and in 1917 Viscount, Northcliffe. Harold took over the *Mirror* and later the *Mail* and became Viscount Rothermere.

There is a large bronze bust by Lady Scott of Northcliffe in the forecourt of St. Dunstan-in-the-West in Fleet Street dating from 1930.

Viscount Nuffield

One of England's greatest philanthropists was William Morris (1877–1963), who started off repairing cycles, then in 1900 making motor cycles and in 1911 building his first motor car. He was the first British manufacturer to mass-produce cheap cars. In 1936 he gave what was then the vast sum of £2 million to Oxford University to promote medical research and later establish the Nuffield Foundation with an endowment of £10 million. In both wars he had important armament contracts. He was raised to the peerage in 1934 and took the title Viscount Nuffield.

There is a bronze statue of him by Maurice Lambert in Guy's Hospital which also greatly benefited from his generosity. In all he is estimated to have given away over £57 million. The statue stands on the right side of the second court, the left-hand side having an alcove from the London Bridge which was demolished in 1831. 1949.

T. P. O'Connor

Thomas Power O'Connor (1848–1929) was a journalist and politician. He was an ardent Irish nationalist and later became Father of the House of Commons. He founded and edited the *Star*, a popular evening paper, and also other papers such as *T.P.'s Weekly*, named after him, as he was always known as T. P.

There is a bronze bust of him on the wall of 72 Fleet Street opposite the *Daily Telegraph* building and under it a plaque is inscribed 'His pen could lay bare the bones of a book or the soul of a statesman in a few vivid lines'. It is by F. Doyle-Jones and was put up in 1934.

General Sir James Outram, Bt.
Another British soldier to make his name in India was James
Outram (1803–63), who went out there when he was sixteen and was
active there all his life, until his return to England in 1860.

He served in numerous campaigns and became known as the
Bayard of India. When Lucknow had to be relieved he chivalrously
waived his rank as Lieutenant-General and served under Sir Henry
Havelock, his junior in rank. Lucknow was relieved but Outram in
turn found himself besieged. He was finally relieved by Sir Colin
Campbell. Outram was made a baronet and later became a member
of the Supreme Council in Calcutta.

There is a large statue of him by Matthew Noble in Victoria
Embankment Gardens, behind Whitehall. 1871. He is buried in
Westminster Abbey.

Viscount Palmerston
One of the more dominant polital characters of the mid-eighteenth
century, whose gunboat policy usually brought success, was Henry
Temple (1784–1865) who later succeeded as 3rd Viscount
Palmerston. It was his ambition to be minister of a nation rather
than a party and it is with foreign policies that he was most
concerned. Thanks to him England and France acted in concert
after years of hostility, as was exemplified in the Crimean War. He
largely created Belgium, helped Portugal and allied with Austria and
Turkey against Russia. He was twice Prime Minister and his actions
did a lot to establish British prestige in the world. He was also very
popular, except with Queen Victoria. He is buried in Westminster
Abbey.

His statue by Thomas Woolner, R.A. of 1876 stands in
Parliament Square and he looks immaculately dressed.

Emmeline Pankhurst: Dame Christabel Pankhurst
Suffragettes were very much a feature of the early years of this
century, their chief aim being to get votes for women. Their leader
Emmeline Pankhurst (1857–1928) was a remarkable woman who
took a militant line and went to prison, where she underwent hunger
strikes several times for her cause. She achieved part of her
ambition, as in 1918 women of thirty years and over got the vote,

but full suffrage was not granted till just after her death.

In the gardens beside Victoria Tower there is a sensitive standing bronze of her by A. G. Walker R. A., erected 1930, with her right hand held out as if pleading, while addressing a meeting. In her left hand she holds a pair of lorgnettes. On either side of the base there is a low wall ending in plinths, on one of which there is a plaque to her daughter Dame Christabel (1880–1958), who was also a fighter for the cause. On the other plinth there is a bronze replica of the Women's Social and Political Union prisoners' badge, being a portcullis with a broad arrow (the mark of a prisoner) on it. Between 1905 and 1914 over 1000 women were imprisoned and qualified for this badge. This curved extension was put up in 1959.

Emmeline Pankhurst and on right a medallion of Dame Christabel Pankhurst, by A. G. Walker, R.A. (*above*)

Viscount Palmerston, by Thomas Woolner, R.A. (*left*)

Sir Joseph Paxton (1801–65)

Joseph Paxton who became head gardener to the Duke of Devonshire when very young showed an architectural ability in building large glass conservatories and from that developed the famous Crystal Palace of the Great Exhibition of 1851, which was later re-erected at Sydenham. For this he received a knighthood. He wrote on gardening and became a Liberal M.P. in 1854.

Below the site of the Crystal Palace, which was burnt down in 1936, there is a heroic head of Paxton five times life size, with a romantic mane of hair that gives him a classical look, as he gazes over the wide valley below. It is very impressive and is the work of W. F. Woodington, being put up in 1869. It stands high up on a large red brick plinth.

Entry is gained by the recessed stadium entrance on the left near the top of Anerley Hill.

George Peabody (1795–1869)

Scattered about London one can still find a number of tenement buildings on Peabody Estates which were the gift of a very generous American called George Peabody. Part of his plan was to provide homes near people's place of work. He made his fortune as a dry-goods merchant in Baltimore and came over here to be a successful stockbroker in 1837. In his lifetime he gave away over a million-and-a-half pounds for philanthropic purposes, in England. He was given the Freedom of the City of London, but he declined the Grand Cross of the Bath offered by Queen Victoria. Instead he asked for a personal letter from her. Peabody was the only American ever to have been buried in Westminster Abbey, though his body was later returned to the States.

Behind the Royal Exchange there is a large statue of him seated in a chair, which stands on a polished pink granite base. It was sculpted by an American, W. W. Story, and erected in the year he died.

Sir Robert Peel

Sir Robert Peel (1788–1850) got a double first at Christ Church,

George Peabody, by W. W. Story

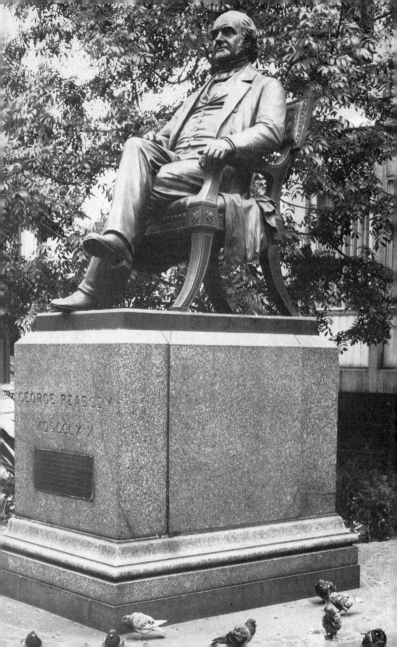

Oxford before getting into Parliament when he was twenty-one. He was soon Secretary for Ireland and his anti-Catholic views earned him the name 'Orange Peel'. In 1822 he became Home Secretary and established the Metropolitan Police Force. Its members soon became known as 'Bobbies' or 'Peelers'. He was Premier for a short time in 1834 and again in 1841 and it was during this ministry that the Corn Laws were repealed. He inaugurated Income Tax at a rate of seven pence in the pound, to be levied for three years only, but it is still very much with us. Peel died as a result of a fall from his horse while riding in Constitution Hill.

Peel has two statues in London. One by Matthew Nobel was first erected in Parliament Square in 1876, much nearer to the Abbey than it is now. In a replanning it was moved to its present place the following year. Initially Baron Marochetti was commissioned to produce his statue, but when his work was shown in New Palace Yard in 1863 it was turned down. Although he did another one free, that too was rejected.

William Behne's bronze was put up in Cheapside in 1855 before being moved to Postman's Park near St. Paul's Station in 1935. It finally ended up in 1971 at the Police College in Hendon Way.

Count Peter of Savoy
The main entrance to the Savoy Hotel is just off the Strand, almost opposite Southampton Street, and on top of the covered canopy there stands a statue of Count Peter of Savoy dressed in medieval clothes with a shield in his right hand and a fourteen foot spear in his left. It is in gilt bronze and by Frank Lynn Jenkins, an American, and erected in 1904.

Peter, Count of Savoy, was an uncle of Henry III's wife Eleanor of Provence, and brother of Boniface the Archbishop of Canterbury. In 1246 Peter was granted a site between London and Westminster 'in a place called the Strande' where it slopes down sharply to the river and here Peter, who had been created Earl of Richmond, built a great palace. For his rent he had to pay 'yearly at the Exchequer three barbed arrows for all services'. He bequeathed his palace to the Hospice of the Great Saint Bernard in Savoy, but it was bought back by Eleanor of Provence two years later.

Admiral Arthur Phillip

A bust that escaped damage when a bomb hit St. Mildred's in Bread Street was that of Admiral Arthur Phillip (1738–1814), who took part in the capture of Havana and was Captain of the first fleet to take prisoners to Botany Bay. Not liking the anchorage, he moved on and founded the first settlement at Sydney in 1788, where he stayed ten years. The memorial, which was unveiled in 1968, calls him the Founder and Governor of Australia. On either side are bronze plaques; one showing him being rowed ashore with his ship lying at anchor, all sails furled but not by any means all shipshape and Bristol fashion. The other depicts him on land, having first hoisted the Union Jack, and claiming the territory.

His bronze bust by Charles Hartwell and the plaques were placed on the side wall of 25 Cannon Street facing St. Paul's in 1968. They were originally presented by Lord Wakefield in 1932.

William Pitt the Younger

William Pitt (1759–1806) was the second son of the great Earl of Chatham and followed his father into politics so successfully that he was Prime Minister at the age of twenty-four. Later on he also had the exceptionally long period of twenty years, apart from one month, as Premier, during which time he greatly raised the importance of the Commons. He stamped out much of the corruption in the House and abolished many sinecures, improved finances and ran a strong peace policy until forced into war with France. After the victory of Trafalgar he was hailed as the saviour of Europe, but his health was now broken and he died the following year.

His bronze statue by Sir Francis Legatt Chantrey, R.A. was put up in Hanover Square in 1831.

Samuel Plimsoll

A man who has left his mark on shipping, in more ways than one, is Samuel Plimsoll (1824–98), a social reformer and politician and known as 'the sailors' friend'. As a result of his efforts, but not without a great deal of opposition, the Merchant Shipping Act of 1874 was passed which, among other things, obliged owners to mark the side of every ship with a circular disc and a horizontal line

drawn through the centre, the Plimsoll line, indicating to what depth a ship may be loaded. The purpose was to save lives at sea and to get rid of what were known as coffin ships, overloaded, over-aged and over-insured hulks.

A bronze bust of Plimsoll is mounted on a stone plinth and below him is a ship and a tablet with small statues of a sailor on either side of him. It was erected on Victoria Embankment in 1929 near the R.A.F. memorial. F.V. Blundstone was the sculptor. The plaque is headed by the famous Plimsoll line.

Princess Pocahontas

The Virginian settlers who first settled on the banks of the Potomac River in 1607 encroached on an Indian preserve, so not unnaturally conflicts arose and a Captain John Smith (q.v.) was made prisoner and would have been clubbed to death had it not been for the

Princess Pocahontas, by David McFall, R.A.

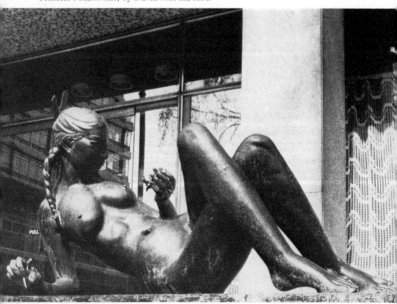

intercession of the Chief's daughter, Pocahontas. She was later inveigled into the English colony, made a Christian and married John Rolfe, and even sailed to England with a dozen Indians in her retinue. Thus she met James I's wife, Queen Anne, a number of times. At the start of her return to America she fell ill and died and was buried at Gravesend in 1617, aged probably twenty-two.

At Gravesend there is an over-lifesize statue of her presented by the people of Virginia. Cassell, the publishers, presented a recumbent statue of her by David McFall, R.A. in 1956. She is opposite their London office on the north side of Red Lion Square and is called La Belle Sauvage. Pocahontas appears as an attractive nude with two pigtails and the two feathers sticking out of her hair are crosswise.

Viscount Portal of Hungerford

'One of the architects of victory in the Second World War' is on the back of the very unusual rough finished five-foot-high triangular slate pedestal on top of which is the bronze figure of Marshal of the Air Force Lord Portal of Hungerford, in R.A.F. uniform, medal ribbons and all the insignia of rank. He is hatless and as if striding to the R.A.F. Memorial on the Victoria Embankment wall. Portal was Chief of the Air Staff from 1940 to 1945.

The sculptor is Oscar Nemon, who is better known for the number of statues and heads of Churchill that he has done. He is a Yugoslav whose adult life has been lived in this country. The very rough finish, not only of the plinth but of Portal's uniform, is unusual but not very effective, while the triangular base hardly achieves a purpose and looks cramped. The statue was unveiled in 1975 by the Rt. Hon. Harold Macmillan.

Joseph Priestley, F.R.S

Not many Presbyterian ministers become important scientists, as was the case with Joseph Priestley (1733–1804). He was an advanced Radical and on one occasion his house was burnt down because of his views. His first important experiment concerned electricity, but it was as a chemist who first isolated oxygen and discovered other gases that he is best known. He was elected F.R.S. in 1766, having first been made a member of the French Academy. All the time he

was getting involved with his religious and other writings, so much so that he went to America to spend his last ten years there in peace.

It is appropriate that his seated stone statue by Gilbert Bayes should be outside the Royal Institute of Chemistry at 30 Russell Square, although it was only put there in 1914. He is perched over the entrance in a most uncomfortable manner.

Robert Raikes

Robert Raikes (1735–1811) helped to print his father's local *Gloucester Journal*. His pity at the misery and ignorance of so many children induced him to start the first Sunday School to enable them to learn to read and to repeat the Catechism, his first one beginning in Gloucester in 1780. The idea spread and during the nineteenth century it became universal throughout the country.

In Victoria Embankment Gardens he has a bronze statue by Sir Thomas Brock, R.A. which was erected a hundred years after his first Sunday School. It cost £1200. He is holding a Bible.

Sir Walter Raleigh

One of the most gallant and romantic Elizabethans was Sir Walter Raleigh (1552–1618). After suppressing a rebellion in Ireland, where he later was made Governor, he became a favourite at Court, although like most Elizabethan courtiers he had his periods of disgrace and imprisonment. He sailed to colonize Virginia, named after the Virgin Queen, in 1578 and again some years later, but he only succeeded in bringing back potatoes and tobacco. He was a deadly enemy of Essex, whose execution he watched from a window of the Armoury in the Tower. He twice sailed to the Orinoco in search of Spanish gold, but the 1617 expedition was a failure and James I had him arrested and beheaded in Old Palace Yard.

William Macmillan, R.A. has done a bronze statue of him in Elizabethan dress with hat and drawn sword. It was placed on the grass near the Banqueting House in 1959, not far from where he was executed. It was donated by Anglo-American societies and unveiled by the American Ambassador.

Baron Paul Julius Reuter

An agency for the collection of news for the press was formed at

Aachen in 1849 by Paul Julius Reuter (1816–99) and moved to London two years later. It became a world-wide service with various national news agencies being affiliated to it. In England the Press Association distributes Reuter telegrams. Reuter was made a Baron by the Duke of Saxe-Coburg-Gotha in 1871.

A granite column in the form of a term ending up in the head of Reuter, who is bald but has very long thick side whiskers, has a curious but impressive effect. The wording under his name is 'born 1816 at Kassel, Germany, died 1899 Nice, France. Founded the world news organization that bears his name in No. 1 Royal Exchange Building in the City of London near this site on the 14 October, 1851'. It was erected in the passage behind the Royal Exchange in 1976 and the sculptor was Michael Black. It is not surprising that Black used a term as his method of sculpting Reuter, as he had been employed in restoring the many that surround the Sheldonian in Oxford.

Sir Joshua Reynolds, P.R.A.
The foremost English portrait painter was almost certainly Joshua Reynolds (1723–92) and when the Royal Academy was formed in 1768 he was elected its first President and the next year he was knighted. He is reputed to have painted over 2,000 portraits, among which his children's faces had especial beauty. His tastes were not limited to painting, as he formed a literary club which included Dr. Johnson, Garrick, Sheridan and others. He also delivered a series of discourses to the students of the Academy, fifteen of which have been published, together with other writings of his.

In 1760 he bought No. 47, a house on the west side of Leicester Square, which was only pulled down just before the war, so it is natural to include a bust of him in the square, together with those of three other residents, all erected in 1874. Henry Weekes, R.A. did the one of Reynolds in stone. Its nose has been badly damaged. It was, however, only in 1931 that a proper tribute was paid and a full-length bronze statue of him by Alfred Drury, R.A. now decorates the courtyard in front of the Royal Academy. He stands with a palette in one hand and a brush in the other, his feet apart and with a purposeful air.

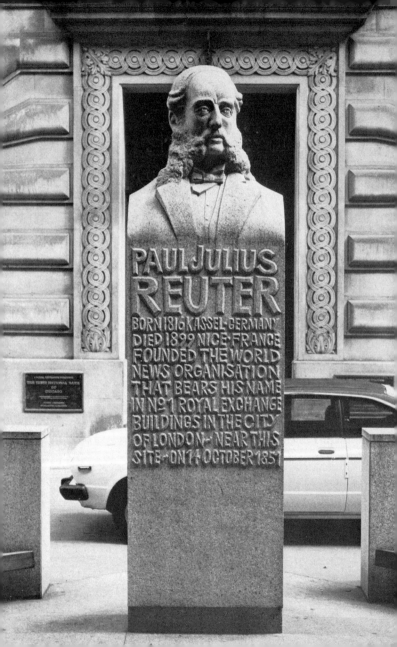

PAUL JULIUS
REUTER
BORN 1816 KASSEL GERMANY
DIED 1899 NICE FRANCE
FOUNDED THE WORLD
NEWS ORGANISATION
THAT BEARS HIS NAME
IN No 1 ROYAL EXCHANGE
BUILDINGS IN THE CITY
OF LONDON ~ NEAR THIS
SITE ~ ON 14 OCTOBER 1851

Richard I

Richard I (1157–99) is always regarded as one of those romantic kings to whom things happened, as indeed they did. He took up arms against his father, Henry II; he went on a successful Crusade; he was captured on the way back; he was ransomed and he even had a nickname, Cœur de Lion. Although he was born in England, it is doubtful if in all his lifetime he spent as much as one year in the country and it is very likely that he could not speak English. One of the very few royal statues between Alfred and the Tudors is the fine equestrian statue of Richard I with his sword raised in a kingly gesture of leadership. During the last war the blast of a bomb bent but did not break the sword. This was thought to be symbolic. Baron Carlo Marochetti, an Italian who worked in England and became an R.A., had made a plaster version of this statue for the 1851 Great Exhibition, which was much admired. His bronze statue was erected in 1860 in front of the House of Lords. It cost £3,000 and the plinth an additional £1650. A large bas-relief on the plinth shows the Crusaders attacking the gates of Jerusalem and the archer who shot Richard being dragged to the death bed where Richard forgave him, but in spite of that he was flayed alive. A charming cat sits peacefully under a chair.

Field-Marshal Earl Roberts of Kandahar and Waterford, V.C.

Frederick Sleigh Roberts (1832–1914) was born in Cawnpore, served through the Mutiny, where he won a V.C. and commanded in the Afghan War and in a series of successful campaigns before becoming Commander-in-Chief in India in 1885, in Ireland ten years later and finally in South Africa. He died of a chill when on a visit to troops in France at the beginning of the Great War. Created an Earl in 1892 he became Field-Marshal three years later. He was popularly known as Bobs. His equestrian statue by Harry Bates, A.R.A., where he sits in his campaign uniform on a fine charger and wearing a sun helmet, was erected in 1924 on Horse Guards Parade on the Downing Street side of the central arch and there is a similar one in Calcutta. There is also a small stone bust of Roberts in the pediment over the first floor window of 69 Knightsbridge. 1902.

Paul Julius Reuter, by Michael Black

The Hon. Charles Rolls, *see under* **Sir Henry Royce**

President Roosevelt

No American did more to help Britain win the war than Franklin Delano Roosevelt (1882–1945), the thirty-second President of the United States. It was by modifying America's neutrality in favour of the Allies and by his great trust and friendship with Churchill that he was able to help us. Their Atlantic Charter established their peace aims and gave priority to the war in Europe. He also established the Lease-Lend plan. Roosevelt was stricken with paralysis, but that did not prevent him from becoming President in 1932 and being re-elected on three further occasions, a record in the U.S.A. He repealed Prohibition and created the New Deal, which involved an overhaul of American economic life. He died three weeks before the Nazis surrendered.

The imposing bronze statue of Roosevelt wearing his familiar cloak and leaning on his stick stands in Grosvenor Square near the American Embassy. The sculptor was Sir William Reid Dick, R.A. and it is part of an attractive piece of landscape gardening with fountains. It was unveiled in 1948 by his widow, Eleanor Roosevelt. There had been a five-shilling limit subscription list opened for British subscribers, which was quickly oversubscribed.

Dante Gabriel Rossetti

Dante Gabriel Rossetti (1828–82), born in England of Italian parents, was best known as a painter but, like William Blake, he was one of those rare combinations of poet and painter. Rossetti, Holman Hunt and Millais were the principal founders of the Pre-Raphaelite Brotherhood in 1848, a movement that had a great effect on Victorian art. Among his chief paintings were *Beata Beatrix* and *Dante's Dream*, while his written works included *Dante and his Circle, Ballads and Sonnets*. His best-known poem is probably '*The Blessed Damozel*'.

His romance with Elizabeth Siddal, whom he married in 1870, ended in her sad death from an overdose of laudanum two years later. This so affected him that he buried the manuscripts of some of his poems with her, though seven years later they were retrieved and published. Latterly he lived at No. 16, one of the most beautiful

houses in Cheyne Walk and known as the Queen's House, and in the large garden behind he kept a small menagerie, much to the consternation of his neighbours. It included a wombat, a marmot, a zebu, a peacock, armadillos and other animals.

In the gardens opposite his house there is a memorial fountain designed by J. P. Sedding with a bronze medallion by Ford Maddox Brown. Rossetti is leaning on a palette and two books. On the back is a bronze plaque with a list of subscribers. It was unveiled by Holman Hunt in 1887.

The Hon. Charles Rolls: Sir Henry Royce

Two people who were satisfied with nothing but the best were Charles Rolls (1877–1910) and Henry Royce (1863–1933). They met in 1904, the year Royce had made his first car, and two years later they set up the famous firm of Rolls-Royce Ltd. which has consistently produced the finest cars in the world and has created a prestige that is unequalled. Charles Rolls was the son of Lord Llangattock and from 1895 he experimented with cars. In 1906 he crossed the Channel in a balloon and in 1910, the year after Bleriot first flew across the English Channel, he flew across it both ways by aeroplane. Soon after, he was killed in an air crash.

Henry Royce was an engineer who was apprenticed to the Great Northern Railway but soon had his own firm of mechanical and electrical engineers. The firm developed into making, besides motor cars, aero engines, including the Merlin which powered the Spitfire and Hurricane and so won for us the Battle of Britain and possibly saved us losing the war. Royce was knighted in 1930.

Inside the glass-fronted entrance to the Rolls-Royce Building at 65 Buckingham Gate there is a bronze bust of each of them on a pedestal. They are by William Macmillan, R.A. and date from 1978, The originals at Derby were sculpted in 1934.

Marquis of Salisbury

The Cecil family has for centuries left its mark on politics but it was not until 1885 that they produced a Prime Minister, an office the third Marquis of Salisbury (1830–1903) held on three occasions. He took over the Conservative party from Disraeli having previously been Foreign Secretary when he accompanied Disraeli to the Berlin

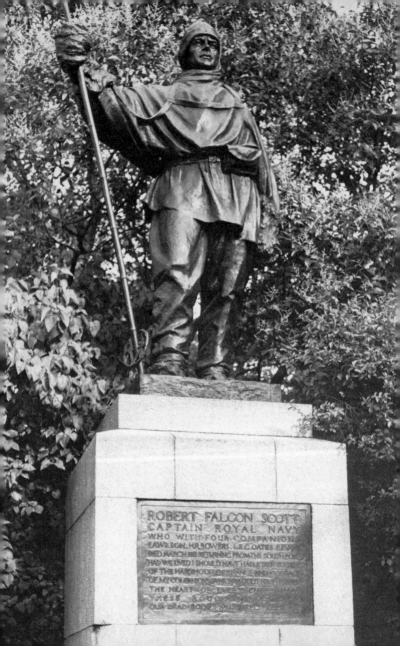

ROBERT FALCON SCOTT
CAPTAIN ROYAL NAVY
WHO WITH FOUR COMPANIONS
E.A. WILSON, H.R. BOWERS, L.E.G. OATES, E. EVANS
DIED MARCH 1912 RETURNING FROM THE SOUTH POLE
HAD WE LIVED I SHOULD HAVE HAD A TALE TO TELL
OF THE HARDIHOOD ENDURANCE AND COURAGE
OF MY COMPANIONS WHICH WOULD HAVE STIRRED
THE HEART OF EVERY ENGLISHMAN
THESE ROUGH NOTES AND
OUR DEAD BODIES MUST TELL

Conference in 1878. He was also Chancellor of Oxford University. There is a large statue of him near the gates of Hatfield House but in London there is only the small stone bust in a pediment over a window on the first floor of 87 Knightsbridge. It was put up in 1902 to commemorate the coronation of Edward VII during his Premiership.

Captain Robert Sandes

Both Captain Sandes (c1660–1721) and Captain Maples (q.v.) were benefactors of Trinity House and both had their statues at Trinity Almshouses in the Mile End Road. When Trinity House was rebuilt in 1953 following bomb damage, both their statues were placed in the front central room. Sandes wears no hat, but he holds a big telescope in his right hand and there is an anchor at his feet beside some bales of cotton. He was an Elder Brother of Trinity House and a friend of Pepys. His statue sculpted in lead by Scheemakers in 1746 is now painted white.

Captain Scott, R.N.

Exploration has always had an appeal and an expedition fraught with misfortune becomes even more dramatic. Robert Falcon Scott (1868–1912) took the *Discovery* to Antarctica on a successful expedition between 1900 and 1904 when he discovered Edward VII Land. Promoted Captain, he returned in the *Terra Nova* in 1910 and with four other men reached the South Pole on 17 January 1912, only to find that a Norwegian expedition under Amunsden had reached it nearly a month before. On their return journey they all perished and they probably did not know they were very near to a store depot. Their bodies and diaries were found eight months later. Scott was knighted posthumously. The *Discovery*, moored in St Katharine's dock, is kept as a Scott Museum besides being a training ship for Sea Scouts. A fine bronze statue executed by his wife (later Lady Kennet) in 1915, stands in Waterloo Place. He is shown wearing Arctic kit.

Captain Scott, by his wife Lady Scott

Statues 192

Their son, Sir Peter Scott, is a world-famous ornithologist, besides being an excellent painter and broadcaster. He founded the Severn Wild Trust Fund and in addition he won an Olympic Gold Medal for yachting.

Sir Ernest Shackleton

A junior officer on the National Antarctic Expedition commanded by Scott in the *Discovery* was Ernest Henry Shackleton (1874–1922). He went out again in 1909 the year he was knighted, this time in command, and reached a point ninety-seven miles from the South Pole. In 1915 he returned in the *Endurance* which became crushed in the ice and he and the crew had to go by land to Elephant Island. Shackleton and five others then made a perilous voyage of 800 miles to South Georgia and organized relief for those left on Elephant Island. He made a fourth expedition and this time died at South Georgia.

At the top of Exhibition Road a statue of Shackleton occupies a niche on the outside of the Royal Geographical Society, from which he received the Society's Gold Medal. It is by C. Sargeant Jagger and was put up in 1932.

William Shakespeare

Our greatest playwright lacks in quality what he makes up for in quantity when it comes to statues. He has a copy by Giovanni Fontana of the Scheemakers statue in Westminster Abbey. This is in the middle of Leicester Square, which was laid out in 1874 by a crook adventurer who called himself Baron Grant, though his real name was Albert Gottheimer. Grant became an M.P. for Kidderminster, owned a paper and went bankrupt, but not before he had paid out £28,000 on the Square. He is reputed to have spent £250,000 on Kensington House standing in seven acres off Kensington High Street, which he never occupied. It was sold for £10,461. He was a company promoter who specialized in circularizing widows and clergymen.

Shakespeare's marble statue shows him in pensive mood, on a high pedestal which has dolphins and fountains around it. Designed by Sir James Knowles.

In addition there is a Shakespeare (1564–1616) monument with a bronze bust by Charles J. Allen on the edge of the churchyard of St.

Mary, Aldermanbury, the City church which was dismantled and re-erected at Fulton, Missouri, as a memorial to Sir Winston Churchill, who there made his celebrated speech that first used the phrase 'iron curtain'.

There is a plaque underneath to the memory of John Heminge and Henry Condell, fellow actors and friends of Shakespeare, to whom the world owes a debt as they collected his dramatic works and were largely responsible for the publication of the first folio in 1623. A representation of the title page is on a plaque on the monument. Their own history is on the back of the monument.

In a niche on the corner of Fouberts Place and Great Marlborough Street where it joins Carnaby Street there is a bust of Shakespeare, who appears to be leaning out of a window. The

William Shakespeare

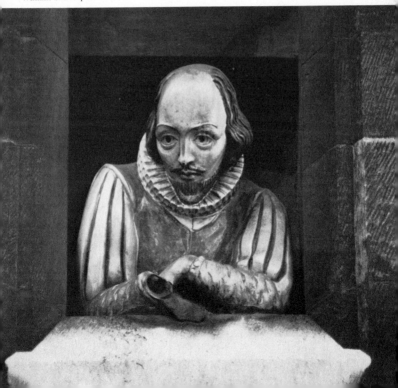

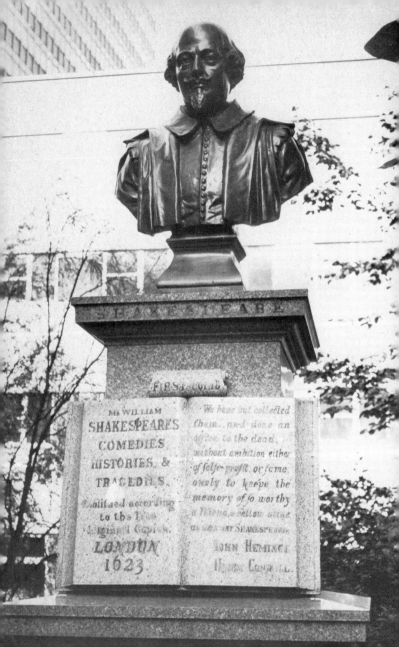

public house is called the 'Shakespeare's Head', but this is probably
due to two brothers Thomas and John Shakespeare who were the
landlords from 1735–44. They were not descendants of the Bard.
There is also a statue of Shakespeare on the second floor of the City
of London School almost opposite Blackfriars Bridge. It was erected
in 1882 with four other stone statues by the builders J. Daymond
and Son.

Norman Shaw

Richard Norman Shaw (1831–1912) has left his mark as an architect
on London. His main cause for fame is that he broke away from the
then universal Victorian designs and taste and created his own style.
Among his few London buildings that remain are the Piccadilly
Hotel (1905) and the former New Scotland Yard (1888–90) on the
Victoria Embankment at the Big Ben end. This is his masterpiece
and his stone medallion by Hamo Thornycroft was inserted on the
second floor frontage in 1914. His private houses, like Swan House
on Chelsea Embankment and his vast Albert Hall Mansions, all have
tall narrow windows, which were such a characteristic of his early
work.

Sarah Siddons

Mrs. Sarah Siddons (1755–1831) was the great tragic actress of her
time, Lady Macbeth being her most famous role. John Kemble, the
famous actor, was her brother. There is a white marble statue of her
by Léon Joseph Chavalliaud on Paddington Green. It is based on
Sir Joshua Reynolds's famous painting of her, *The Tragic Muse*, and
shows her in a dramatic attitude with a dagger in her right hand and
resting a finger on her left cheek. It was unveiled by Sir Henry Irving
in 1897. She was buried in the nearby churchyard of St. James's,
Paddington.

Sir Hans Sloane

On the river side of Royal Hospital Road is the famous Chelsea
Physic Garden, sometimes known as the Apothecaries' Garden,

William Shakespeare with a facsimile of his first folio, by Charles J. Allen

which was founded in 1673, nearly a hundred years before Kew. In the centre of it is a fine white marble statue of Sir Hans Sloane (1660–1753) by John Michael Rysbrack, commissioned in 1732 and not placed in its present position until 1748. The Garden is private but a good view of the statue can be seen from the iron Student Gate in Swan Walk.

Hans Sloane was an indefatigable botanist and collector. His museum and library of 50,000 volumes formed the nucleus of the British Museum. He was President of the Royal Society and was created a Baronet in 1710. In addition he was Physician-General to the Army as well as Royal Physician. His memory is still perpetuated by streets named after him. He lived in the newly-built Bloomsbury Square from 1696 to 1742.

Captain John Smith 1580–1631

There were unsuccessful attempts to colonize America, north of Florida, which was owned by the Spanish, but three ships arrived in the Potomac river mouth in April 1607 and among the passengers was a Captain John Smith (1580–1631), whose book *Travels, Adventures and Observations* had recently been published. He had served the French King Henri IV, fought with distinction against the Turks in Hungary, been captured and sold as a slave but managed to return to England. He was an adventurer, but his energy and tact with the Indians caused him to be elected president of the colony in 1608. On one occasion his life was saved by Pocahontas, a Red Indian Princess (q.v.). He returned to England, but he was back in North Virginia from 1610–17. His book on this settlement is of great historic value. He was buried in St. Sepulchre, Newgate, where there is a tablet to Captain Smith 'sometime Governor of Virginia and Admiral of New England' and underneath a eulogistic epitaph.

A copy, by Charles Renick, of the statue of him by the American William Couper was erected in 1960 in the old churchyard beside St. Mary-le-Bow in Cheapside and was unveiled by the Jamestown Foundation of the Commonwealth of Virginia, who presented it to the City. Smith is in Elizabethan dress with a sword in his left hand and a book in his right. It was to commemorate the 350th

Sarah Siddons, by Léon-Joseph Chavalliaud

anniversary of the return of Smith to England in the winter of
1609–10 and is a copy of the one in Jamestown.

 Mention is also made of him on the tablet to the Virginia Settlers.
This commemorates the sailing of the three ships with settlers for
Virginia among them being Captain Smith. It is now on the
Blackwall power station site and can best be seen from the river, as
permission to view is not easily granted. It had originally been erected at
the entrance of the East India Docks in 1951.

Field-Marshal Jan Smuts, O.M.
One of the most respected South African statesmen was General
Smuts (1870–1950). He was educated at Cambridge, then fought
against the British in the Boer War after he returned home. He
succeeded Botha as President of the Union of South Africa and later
became Prime Minister of the United Party. In the first War he was
elected as a member of the Imperial War Cabinet. He was made
Field-Marshal in 1941 and O.M. in 1947.

 His bronze statue by Sir Jacob Epstein in Parliament Square is
somewhat out of place, not because he was not an English politician
but because of the definite forward lean which contrasts badly with
the row of upright Victorian Prime Ministers alongside him. This
leaning foward with his hands clasped behind his back gives him the
impression, so aptly put by David Piper in his *Companion Guide to
London*, of a man skating on very thin ice. 1956.

Sir John Soane
One of the most interesting private houses in London to be
bequeathed to the nation as a museum was that of Sir John Soane
(1753–1837), who was an architect best known for his remodelling
of the Bank of England. He bought No. 12 and, No. 13 Lincoln's
Inn Fields and later No. 14, where he built the famous Hogarth
room with its many original paintings, including the *Rake's Progress*
series. There are furniture, books, pictures and an important
sarcophagus. He was knighted in 1831. It is an enchanting museum.

 On the north side of the Bank of England there is in a niche a
stone statue of Soane by Sir William Reid Dick, R.A. which was
placed there in 1937 when Soane's work was being mutilated by Sir
Herbert Baker.

W. T. Stead

William Thomas Stead (1849–1912) was well known as a journalist.
He was editor of the *Pall Mall Gazette*, which he turned into a
sensationalist paper. He was sent to prison for three months over his
'Maiden Tribute'. He edited various papers, became a confirmed
Spiritualist and wrote books like *If Christ came to Chicago*. He
became unpopular for being pro-Boer during the war, though he
was a great admirer of Cecil Rhodes. His last journey was on the
Titanic. He was not a survivor.

On the river wall of the Embankment there is a bronze medallion by Sir
George Frampton, R.A. erected by fellow journalists in 1920.

Robert Stephenson

Robert Stephenson (1803–59) was the son of George Stephenson of
Rocket fame and was a competent engineer in his own right. After
helping his father, he worked in engineering in South America and
then returned to manage his father's locomotive works in Newcastle,
but it was for the construction of the Britannia and Conway tubular
bridges that he became famous. He then built bridges over the St.
Lawrence and the Nile and the high-level bridge at Newcastle. He
became M.P. for many years from 1847 and was buried in
Westminster Abbey.

In the forecourt of Euston Station there was a bronze statue of
him by Baron Carlo Marochetti, R.A. from 1871 until Euston was
rebuilt in 1968, when it was moved inside.

Major-General Sir Herbert Stewart

At the Pont Street end of Hans Place there is a red granite basin
and a broken fluted column of stone behind it. Above the fountain is
a bronze medallion of Sir Herbert Stewart (1843–85). He served in
the Army and was promoted Major-General. He commanded a part
of the Expedition that was sent to relieve General Gordon in
Khartoum and was killed in action. The medallion is the work of Sir
Joseph Boehm, R.A. 1886.

There is a further inscription, 'Also his son Geoffrey Stewart,
Coldstream Guards, killed in action in France, 22 December, 1914,
Aged 36.'

Sir Arthur Sullivan

Arthur Sullivan (1842–1900), born of poor but musical parents in a
cottage on the site of Vauxhall Gardens, was a very competent and
prolific composer with a gamut of works ranging from popular
songs to oratorios and an opera. He composed 'Onward Christian
Soldiers' in 1873 and 'The Lost Chord' was the first phonograph
record to be made in England. He was a chorister at the Chapel
Royal at twelve and on one occasion after hearing him sing there,
the Duke of Wellington patted him on the head and gave him a gold
sovereign. He was a shy man who never married, but early on he
became a friend of Queen Victoria, who asked him to edit some of
Albert's compositions.

 Sullivan's first association with the theatre was composing the
music for Morton's *Box and Cox* and soon after, in 1871, there
followed his eighteen-year partnership with Gilbert. Their most
popular comic operas included *The Mikado*, *The Gondoliers* and *The
Pirates of Penzance*. Their last years together were stormy. Sullivan
was knighted in 1883 and he was also given the Legion of Honour.
Unlike Gilbert, he was buried in St. Pauls.

 There is a bronze bust of Sullivan by Sir William Goscombe John,
R.A. in Victoria Embankment Gardens, opposite the Savoy Hotel,
the Savoy Theatre behind it having been the scene of most of their
triumphs. A weeping girl with a long trailing skirt and bare above
the waist, leans against his stone plinth. 1903. A quotation from
W. S. Gilbert is on the column:

 'Is life a boon?
 If so it must befal (sic)
 That death when'er he call
 Must call too soon.'

Sir Henry Tate

Henry Tate (1819–99) made a fortune as a sugar refiner and
patented a method for cutting sugar loaves into small cubes. He was
an 'upright merchant, wise philanthropist', as his inscription says, for
besides founding the University Library of Liverpool he built the

Sir Arthur Sullivan, by Sir William Goscombe John, R.A.

IS LIFE A BOON?
IF SO, IT MVST BEFAL
THAT DEATH, WHENE'ER HE CALL
MVST CALL TOO SOON.
W.S. GILBERT.

Tate Gallery on the site of the Millbank Penitentiary and presented it to the nation in 1897, together with his collection of pictures. He was made a baronet the next year.

His over-large bronze bust by Sir Thomas Brock R.A. was erected on a high column in the forecourt of the Public Library at the bottom of Brixton Hill and opposite Lambeth Town Hall. 1905.

Archbishop Temple
Not many fathers and sons have been Archbishops of Canterbury but Frederick Temple (1821–1902) and his son William achieved this. The father, born in the Ionian Islands, spent much of his life being a schoolmaster but in spite of writing some heterodox essays he was appointed to the See of Exeter and later London. In 1897 he became Archbishop of Canterbury and acted at the coronation of Edward VII shortly before he died. A small bust of him is in the pediment of the first floor window of 87 Knightsbridge. 1902. His son became Archbishop forty years after the death of his father.

William Makepeace Thackeray *See* Brontë Sisters

Mrs. Thrale
At the bottom of Dr. Johnson's (q.v.) statue in the Strand there is a small plaque to his great friend Mrs Thrale (1741–1821), the wife of a Southwark brewer. Their friendship lasted over sixteen years until soon after the death of her husband, when she got interested in an Italian musician called Piozzi whom she married in 1784. Johnson is shown talking to her and her name is given as Thrall.

Dr. Bentley Todd 1809–1860
One of the founders of King's College Hospital in 1853, when it was off the Strand, was Dr. Bentley Todd (1809–60). A marble statue by Matthew Noble was erected in 1862. This was taken to Denmark Hill when the Hospital was moved in 1913 and placed in front of it.

Air Chief Marshal Viscount Trenchard, O.M.
Hugh Montague Trenchard (1873–1956) served in the Boer War; in 1914 he was in charge of the Central Flying School and in 1927 he was Air Marshal of the R.A.F. On retirement he became

Commissioner of Metropolitan Police, during which time he inaugurated the Police College at Hendon. In 1936 he was created Viscount and received the O.M. in 1951. He was known as the 'Father of the R.A.F.' and had the nickname 'Boom'.

At the Westminster end of Victoria Embankment Gardens his is the first statue and he looks across to the Thames. It is by William Macmillan, R.A. 1961

Richard Trevithick

The development of high-pressure steam engines was largely the work of a Cornish mining engineer, Richard Trevithick (1771–1833). He invented a steam carriage in 1801 which did trips from Camborne in Cornwall, at between four and nine miles per hour. On the occasion when he and his friends put it upright after it had toppled over, they repaired to an inn and left it running until the water evaporated and it blew up. The next year, Trevithick made another one which he took to London and carried passengers from Leather Lane in the City to Paddington. He also went to Peru in 1820, where his stationary engines worked in the mines and this coincided with his bankruptcy.

Trevithick stayed near Gower Street in 1808 and in an adjoining field he set up an engine called *Catch me who can*, charged one shilling entrance and gave rides. On one occasion his promoters offered 'to match the engine to run a greater number of miles in twenty-four hours than any horse', but there were no takers.

On the wall of University College, London, in Gower Street, which faces University Street, there is a bronze tablet with a medallion of Trevithick. It was put up by a centenary memorial committee and the inscription states that he was the 'Pioneer of High Pressure Steam. Ran in the year 1808 the first steam locomotive to draw passengers.' Below it is a model of his engine, which looks not unlike the *Rocket*, which was built over twenty years later. Put up in 1933, it was by L. S. Merrifield, who did the large statue of him at Camborne.

Joseph Mallord William Turner, R.A.

One of England's most brilliant painters was a curious mixture of simplicity and self-confidence. He was a barber's son who hardly

became literate, yet he had a shrewd head for business. He travelled extensively, yet he was in many ways a loner and he died in a tawdry house and was known to his neighbours as Mr. Booth.

Turner (1775–1851) had rapid success, becoming A.R.A. at twenty-four and R.A. at twenty-eight and in 1808 he was Professor of Perspective at the Academy. He started off in watercolours, particularly when working with Girtin, but by 1797 he had started in oils. In 1802 he made use of a temporary peace with France and went to Paris, where he saw many of the Italian and Flemish paintings looted by Napoleon. His output was prodigious and, apart from being influenced by such masters as Claude and Poussin, he developed his own significant use of light and contrast in such masterpieces as *Rain, Storm and Speed* (1844) and the many others now to be seen in the Tate, which greatly influenced the Impressionists.

The Pre-Raphaelites were in the offing and Victorian taste was changing, but he had a valued champion in Ruskin. At his death, Turner left 300 of his paintings and 20,000 watercolours and drawings to the nation under terms which have been scandalously disregarded by an ungrateful country.

The first known mention of Queen Anne Street comes in a letter of his dated 12 December 1810, where he says he had bought a house adjoining his place in Harley Street, where he held exhibitions from 1804 on.

In Finberg's *Life of J. M.W. Turner* we read of a visit by a Miss Rigby in 1846 to Queen Anne Street and how she was showed 'into a dining-room, which had penury and meanness on every wall and article of furniture. Then into a gallery; a fine room indeed, one of the best in London, but in a dilapidated state; his pictures the same. The great *Rise of Carthage* all mildewed and flaking off, another with all the elements of an uproar, Of which I incautiously said "The End of the World, Mr. Turner?" "No Ma'am; Hannibal crossing the Alps".' She added that 'The old gentleman was in great fun'.

After Turner's funeral on 30 December 1851 his will was read in Queen Anne's Street.

Lord Howard de Walden rebuilt 23 Queen Anne Street in 1937 and over the garage there is a stone medallion of Turner by W. C. H. King.

Madame Tussaud

One of London's great institutions is Madame Tussaud's (1760–1850) waxwork exhibition. She was a Swiss who inherited her uncle's wax museum in Paris. During the Revolution she had to take death masks of various severed heads including Marie Antoinette's. She married Tussaud, a French soldier, left him and toured England in 1800 with her collection and in 1835 set up a permanent exhibition. In 1925 the building caught fire and was gutted but it has been rebuilt in the Marylebone Road. One of its most popular features is the Chamber of Horrors.

On the façade of the new building is a fibreglass medallion of her by Arthur Pollen. It was placed there in 1969.

William Tyndale

In the same part of the Victoria Embankment Gardens as Trenchard there is a statue by Sir Joseph Edgar Boehm R.A. of William Tyndale (c1490–1536) known for his translation of the Bible. He was a friend of Erasmus and Luther who helped him in his work at Wittenborg, near Hamburg, but he was forced to flee to Worms where 3000 copies were printed but many were burnt. He was seized at Antwerp by Henry VIII's agents and martyred by strangling and burning. He was one of the most learned people of his age. His statue was only erected in 1884. It shows his right hand on an open New Testament which is resting on an early type printing press. Tyndale's last words were 'Lord, open the King of England's eyes'. It is said that within a year of his death a Bible was placed in every parish church at the King's command.

Queen Victoria

Alexandrina Victoria in 1837 became Queen at the age of eighteen of what was to become the greatest Empire the world has ever known. She was a granddaughter of George III and was born in 1819 the year before he died. In the twenty-one years of her married life with Prince Albert she had nine children, and her grandchildren included Emperor William II of Germany and Csar Nicholas II of Russia, besides many other European royalties. Her sixty-three-year reign saw the success of the industrial revolution and the rise of the middle classes. It was a time of great riches and great poverty.

The Victorian world had its own art, architecture and furniture which have since been much denigrated, but latterly a definite revival has taken place. It also had a sense of loyalty and security which has never been surpassed. The Queen died in 1901.

Not unnaturally Victoria is commemorated in many ways and there are nine statues of her, 2 medallions and 2 busts. The largest statue is on the Victoria Memorial of 1911 (q.v.) in front of Buckingham Palace. The thirteen-foot-high seated marble figure by Sir Thomas Brock, R.A. looks down the Mall to Admiralty Arch. Looking very regal, she wears a crown and holds a sceptre that is different from all others in that it is surmounted by a St. George and Dragon. In deference to her husband she is wearing her wedding ring on her right hand, a German custom still prevalent.

The first statue to be erected to Victoria was in the centre of the Royal Exchange, which she opened in 1844. The building had no roof until 1883, and the statue deteriorated so much that it had to be replaced in 1895 with a marble one by Sir William Hamo Thornycroft, R.A. which now stands in the left-hand corner of the building.

Other statues erected during her reign include C.B. Birch's oversize standing bronze (1896) on an island at the end of Victoria Embankment by Blackfriars Bridge. It was re-sited nearer the Bridge in 1967. There is also the very fine seated white Carrara marble figure by her talented daughter Princess Louise, erected near Kensington Palace where she was living when she became Queen. It is on the Broad Walk facing the Round Pond in Kensington Gardens. It was sculpted in 1893, but portrays Victoria as she was at the time of her succession.

After Temple Bar was removed from Fleet Street in 1879 a memorial (q.v. Memorials) was put up the next year and on it there is a statue of Victoria on one side by Sir Joseph Edgar Boehm, R.A. and one of Edward Prince of Wales on the other. The other contemporary statue is a small insignificant seated figure by J.R. Clayton on the Westminster Old Boy column in front of Westminster Abbey. 1861.

Queen Victoria, by her daughter Princess Louise

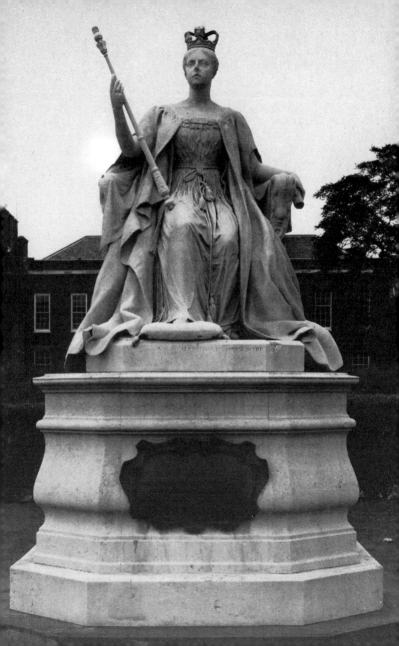

Over the entrance to Caxton Hall, just off Victoria Street, there are terracotta statues of Victoria and King Edward VII dating from 1902.

A very regal-looking marble Queen, also by Sir Thomas Brock, R.A., has stood in the porchway of the National Portrait Gallery annexe in 15 Carlton House Terrace since 1973. This was sculpted in 1897 and used to be in the Constitutional Club.

In the railings of the Temple Gardens in Victoria Embankment there is a marble medallion by C. H. Mabey, erected in 1902, to mark the last visit of Queen Victoria to the City two years before. It was presented by the Corporation of London and above her head are the Royal arms and those of the Corporation. Beside it is one of the two dragons that mark the boundary of the City. (*See under* Monuments)

Her other medallion is in bronze by F. L. Florence, and is on one side of a twenty-three-foot-high red granite column surmounted by a flambeau. On the wreath encircling it is engraved 'Queen Victoria Empress'. This was presented in 1904 by the inhabitants of the Royal Borough of Kensington. It originally stood at the corner of Kensington High Street and Church Street but was later moved in 1934 to its present setting in Warwick Gardens.

A white marble bust of Victoria stands in a niche over the shop entrance of 121 Mount Street to celebrate her jubilee, as it has the date 1887 below it. Just round the corner there is a companion bust of the first Duke of Westminster, who presented them.

A head of Victoria is on the fountain in the Broad Walk, Regent's Park, given by a Parsee. 1869.

Viscount Wakefield of Hythe

On the front wall of 41 Coopers Row there is a bronze medallion of Viscount Wakefield of Hythe by Cecil Thomas, O.B.E. and above him is a small Toc H lamp in bronze. This house is the headquarters of Toc H, an organization of Christian fellowship that started in the 1914 War. All Hallows-by-the-Tower, which is near by, is the church of Toc H. Across the road is Trinity House. Under the medallion is just the word 'Wakefield' and on a separate plaque it mentions that in 1937 Lord and Lady Wakefield 'gave this house for good to church and people'.

Edgar Wallace

A classic example of 'rags to riches' is the story behind Edgar
Wallace, who was found abandoned in Greenwich when nine days
old in 1875 and who died in Hollywood in 1932. He started as a
London newsboy, a race that has died out, being replaced by elderly
men selling newspapers. He was a factory hand, a Grimsby trawler
boy and a milk boy. He fought in South Africa, where he became a
war correspondent, and then a journalist in London. His first book
The Four Just Men was a great success, as was *Sanders of the River*.
He wrote over 170 novels, mostly thrillers, and some plays,
including *The Ringer*.

In Ludgate Circus at ground floor level there is a bronze
medallion of Edgar Wallace on the last building on the left in Fleet
Street, by F. Doyle-Jones, which was erected two years after he died.
The inscription reads: 'He knew wealth and poverty yet had walked
with kings and kept his bearing. Of his talents he gave lavishly to
authorship—but to Fleet Street he gave his heart.'

President George Washington

The fine bronze statue of the first President of the United States,
George Washington (1732–99), stands in front of the National
Gallery. His grandfather came from Northamptonshire and settled
in Virginia. Washington first fought the French, then the English,
whom he finally beat at Yorktown in 1781. When the British
evacuated New York, America virtually achieved independence. He
then resigned from being Commander-in-Chief and was elected the
first President in 1789.

His statue, which is a copy of the one in Richmond, Virginia, by
Jean-Antoine Houdon, the famous French sculptor who went to
America in 1785 to execute a monument to Washington, was
presented 'to the people of Great Britain by the Commonwealth of
Virginia' in 1921.

Sir Sydney Waterlow, Bt.

The only man among the London statues to carry an umbrella is
Sydney Waterlow (1822–1906). He was Lord Mayor of London and
lived just off Highgate High Street, where he had a thirty-acre estate
which he gave to the London County Council. It is now known as

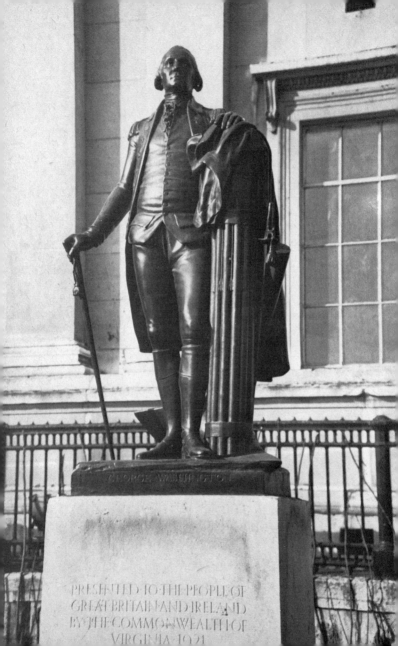

GEORGE WASHINGTON

PRESENTED·TO·THE·PEOPLE·OF
GREAT·BRITAIN·AND·IRELAND
BY·THE·COMMONWEALTH·OF
VIRGINIA·1921

Waterlow Park. In it near the top is his bronze statue by Frank Taubman, 1900, who also did a copy which stands in front of Westminster City School in Palace Street off Victoria Street. 1901. Sir Sydney looks relaxed as if going for a walk, carrying his unfurled umbrella and a soft hat in one hand and a key in the other.

George Frederick Watts, O.M.

One of the most popular and successful painters of the Victorian era was George Frederick Watts (1817–1904), whose working life corresponded with the reign. At times he epitomized Victorian taste with such paintings as *Sir Galahad*, *Hope*, *Love Triumphant*, which nowadays seem sugary and sentimental. These achieved a world-wide fame and decorated thousands of homes largely through monochrome reproductions. His first great success was in 1843 with his cartoon of 'Caractacus led in triumph through the streets of Rome' submitted in the competition for the murals of the rebuilt House of Lords. His portraits were probably his best work and he presented 150 to the National Portrait Gallery the year he died. He also executed some works of sculpture, his best known being *Physical Energy* (q.v. Sculpture) in Kensington Gardens. In 1864 he married the famous actress Ellen Terry but they separated within a year. He was twice offered a baronetcy but refused it, though he did accept the O.M. when it was originated in 1902.

In the old churchyard of St. Botolph Aldersgate, off Aldersgate Street, which is now known as Postman's Park because it is next to the Head Post Office, there is a tile-roofed shelter on the wall of which there are fifty-three plaques with inscriptions describing some act of heroism or tragedy such as a bargeman drowned saving a girl, a boy saved from being crushed under a cart. In the centre of it all is a tiny eleven-inch-high statue in wood by T. H. Wren of Watts, who planned it. The wording reads, 'G. F. Watts who desiring to honour heroic self-sacrifice placed these records here'. In fact Watts only erected thirteen plaques, the remainder being put up by his widow. 1905.

George Washington, copy of Jean-Antoine Houdon

The Duke of Wellington, K.G.

Arthur Wellesley, the third son of the Earl of Mornington, an Irish peer, was born in 1769, the same year as Napoleon. His first successes came when he commanded forces in India prior to being sent to Lisbon in charge of the Army, where he drove the French out of both Portugal and Spain. The Peninsular War ended with the defeat of the French at Toulouse in 1814. On his return he was made Duke of Wellington and Field-Marshal as well as being given £400,000. The next year saw the rout of Napoleon at Waterloo and since 1815 there has been peace with France. He was presented with Stratfield Saye, an estate in Hampshire, by a grateful nation.

Wellington resumed politics, having previously been M.P. for Rye and Irish Secretary in 1807. He became Prime Minister twice. He was a Tory opposed to the Reform Bill and so became unpopular, but he voted for the Catholic Emancipation Act, which caused him to fight a duel with the Earl of Winchelsea. Every honour came his way; Constable of the Tower; Chancellor of the University of Oxford; Commander-in-Chief of the Army for life; Lord Warden of the Cinque Ports. He retired to Walmer Castle, where he died in 1852. He was buried in St. Paul's. His sobriquet was the 'Iron Duke'.

Apsley House at Hyde Park Corner, which he bought from his brother in 1820, is now the Wellington Museum but was his London home. It is known as No. 1 London, being the first house inside the old turnpike gate coming from the west. In front of it is the bronze equestrian statue of Wellington riding his famous horse Copenhagen. At the four corners of the red granite plinth there are soldiers representing the four countries, namely a British Grenadier, a Black Watch Highlander with a fine determined face, a sergeant of the Welsh Fusiliers and an Inniskilling Dragoon trooper. The bronze is from captured French guns. It was erected in 1888 and sculpted by Sir Joseph Edgar Boehm, R.A. Wellington is in Field-Marshal's uniform and he holds a telescope.

This replaced the large statue of the Duke of Wellington wearing a top hat, by M.C. Wyatt which originally surmounted Wellington

Head of a Black Watch Sergeant, one of the four soldiers at the corners of the Duke of Wellington's Statue, by Sir Joseph Edgar Boehm, R.A.

arch. It was moved in 1887 to the top of Constitution Hill, but originally it stood near Apsley House opposite the main gates of Hyde Park. When the Arch was removed to its present position in 1883, the Wellington statue was transferred to Aldershot (*See also under* Memorials).

The City of London erected an equestrian statue of the Duke in 1844 in front of the Royal Exchange in recognition of his help in getting a bill through Parliament allowing the rebuilding of London Bridge. It was begun by Sir Francis Chantrey, R.A. who died in 1841 before he had done more than the maquette and finished by Henry Weekes, R.A. Although Wellington is in a kind of patrol uniform with a cloak hanging from him, he has no stirrups and there is only a saddle cloth. He is the only person to have two equestrian statues in London. It was made from captured cannon and cost £10,000.

Sir Julius Wernher

Julius Wernher (1850–1912) was a German who fought in the Franco-Prussian War before moving to South Africa, where he and his brother made fortunes in gold and diamonds. He was associated with Cecil Rhodes. He made England his home and became an important philanthropist. Created a baronet in 1905 he died worth £5 million. Over the door of the old College of Mines, now part of the Imperial College of Science in Prince Consort Road, there is a stone bust of him by Paul Montford, beside one of Otto Beit (q.v.) his business partner. 1910.

The Rev. John Wesley

The founder of Methodism was John Wesley (1703–91). It began when he and his brother Charles, the writer of over 5000 hymns, were at Oxford. They and some dedicated friends were referred to as the Holy Club or Methodists, a name John took up. They went to America in 1735 with some Moravians whose piety impressed them, but the visit was not a success. On his return John began preaching all over the country, mostly to miners and workers, and in due course people flocked to him in spite of opposition from ecclesiastical authority. He is reputed to have travelled 250,000 miles, mostly on horseback, and to have preached 40,000 sermons,

besides writing a number of books, grammars and hymns which made him over £30,000, nearly all of which went to charities. When aged seventy-four he laid the foundation stone of the Wesley Chapel which still stands at 47 City Road. He lived next door during his last years and is buried in the churchyard.

His bronze statue by J. Adams Acton was erected in the churchyard on the centenary of his death. He appears as if preaching with arms outstretched and a book in one hand. On the plinth is written, 'The World is my Parish'. 1891.

Duke of Westminster

Hugh Lupus Grosvenor (1825–99) was the third Marquess of Westminster and was owner of vast estates in Cheshire, where he was Lord Lieutenant, as well as being the biggest private landlord in London and the owner of vast properties elsewhere. He was Liberal M.P. for Chester and was appointed Master of the Horse after he had been created a Duke in 1874, the last English Duke to be created.

To celebrate the Queen's Jubilee in 1887, he put up a marble bust of Victoria over the door of 121 Mount Street and a similar one of himself round the corner of the building in Carpenter Street.

Field-Marshal Sir George White, V.C., O.M.

Very few people win a V.C. and to win one twice is more than remarkable, but George Stuart White (1835–1912), who became a soldier at eighteen, achieved just this. He served in the Indian Mutiny, fought in the Afghan Campaign of 1879, was in the Nile Expedition 1885 and the Burmese War of 1885–7. He was made Commander-in-Chief in India in 1893, distinguished himself in the defence of Ladysmith and ended up being Governor of Gibraltar. He became a Field-Marshal in 1903 and received the O.M. two years later.

His bronze equestrian statue by John Tweed in Portland Place shows him in Field-Marshal's uniform and plumed hat holding a Field-Marshal's baton. It was erected in 1922.

Richard Whittington

Dick Whittington (1358–1423) probably walked from

Gloucestershire to London in about 1371 to earn a living. His father was Sir Richard Whittington. He became apprenticed to a cousin, Sir John Fitzwarren, a merchant adventurer. Seven years later his name was on the roll of the Mercers' Company and he had a quick rise to prosperity, becoming Lord Mayor in 1397 and being re-elected the next year, an office he held twice again, in 1406 and 1419. He is the only person to have been Lord Mayor of London four times.

On the Threadneedle Street side of the Royal Exchange there is a statue of him in a niche on the first floor. It is by J.E. Carew and was erected in 1845. He also has a stone statue at Whittington College, Highgate dating from about 1827.

In the Monument chapter the story of Dick leaving London with his cat and then returning to a successful career is recounted, and his stone on Highgate Hill is referred to in detail.

William III

More than one English king has been born abroad and been a foreigner to his adopted country. William (1650–1702) was born at the Hague and was Dutch, being the son of William of Orange and of Mary daughter of Charles I. He became Stadholder of the United Provinces and showed great valour and wisdom fighting Louis XIV. He married his cousin Mary, the daughter of James II who fled when William landed with an army at Torbay. William defeated the Scots at Killiecrankie in 1689 and the Irish at the Boyne the next year. He was an able ruler and his reign saw numerous constitutional advances. He died when his horse stumbled over a molehill, which became the basis of many Jacobite toasts.

The Bank of England and the National Debt started during William's reign and in the Princes Street entrance of the Bank of England there is a fine stone statue of him carved by Sir Henry Cheere in 1735. William made Kensington Palace his home, as he suffered from asthma and found Whitehall Palace too damp—it was burnt down in 1698—and he has a statue in the gardens on the south side of Kensington Palace. This oversize bronze by Herr Baucke was 'presented by William II, German Emperor and King of Prussia to King Edward VII for the British Nation' and erected in 1907.

Perhaps his finest statue is the equestrian one in St. James's

Square. He is wearing Roman dress and is stirrupless. The molehill is portrayed. The money for this was left by a Samuel Travers in 1724, but it was not erected until 1808, though the pedestal was put up in 1732. It is the work of John Bacon Junior, but it was designed by his father John Bacon, R.A.

William IV

'The sailor king' was the nickname given to William IV (1765–1837), the third son of George III. He entered the Navy in 1779 and saw service in America and the West Indies under Rodney and Nelson. He later became Lord High Admiral. He was created Duke of Clarence and lived with Mrs. Jordan, a famous actress, for twenty years, during which time she had ten children. Soon after becoming King in 1830 William made their eldest son Earl of Munster. He later married Adelaide of Saxe-Meiningen. His reign was distinguished by the passing of the Reform Bill in 1832—to which he was violently opposed—the abolition of colonial slavery 1833, reform of the Poor Laws 1834 and the Municipal Reform Act 1835.

A very large statue in Foggin Tor granite by Samuel Nixon stood at the bottom of King William Street from 1844 until it was moved beside William Walk at the bottom of Greenwich Park in 1938. William is wearing the uniform of a Lord High Admiral and a Garter sash. It is fifteen feet five inches high and stands on a twenty-five-foot granite pillar designed by Richard Kelsly.

General Wolfe

Another man with a statue in Greenwich Park is General James Wolfe (1727–59) who lived at Macartney House adjoining the Park. He was the son of a general and took part in the battles of Dettingen, Fontenoy, Falkirk and Culloden. Pitt appointed him to command in Canada, first at Cape Breton and Louisburg and the next year, 1759, at Quebec, where he routed the French on the Heights of Abraham but died at the moment of victory. While being rowed up river the night before the battle he recited Grey's *Elegy*, after which he is quoted as saying, 'I would have rather written that poem, gentlemen, than take Quebec'.

His statue by the old observatory, and overlooking much of London, is by Dr. Tait Mackenzie and was presented by the

Canadian people. It was unveiled in 1930 by the Marquis de
Montcalm, who was a descendant of General Montcalm whom
Wolfe defeated at Quebec.

Field-Marshal Viscount Wolseley

Another of those successful soldiers who never seemed to be out of
the wars was Garnet Joseph Wolseley (1833–1913). He joined up in
1852 and immediately fought in Burma where he was badly
wounded. Then came the Crimea, followed by the Indian Mutiny
and the Chinese War of 1860. Then it was Canada, followed by the
Ashanti War where he commanded, and on his return received the
thanks of Parliament and £25,000. Following that it was Natal, the
Indian Council, Cyprus, Natal again and the Egyptian expedition of
1882, after which he was created Viscount Wolseley of Cairo and of
Wolseley in Stafford and received another money grant. He became
Field-Marshal of the entire Army in 1895.

Standing in Horse Guards Parade there are bronze equestrian
statues on either side of the central archway. On the right is Lord
Roberts and on the left is that of Viscount Wolseley, which was
made from captured cannon. It is by Sir William Goscombe John,
R.A. and was erected in 1920.

The Duke of York

George III's second son Frederick Augustus (1763–1827) was
created Duke of York and Albany. He saw service in some
Netherlands campaigns against the French, but as a commander he
failed to follow up any successes he had. When appointed
Commander-in-Chief in 1798 he carried out some very necessary
reforms and became known as the 'soldier's friend' but on his death
he was very unpopular, as every officer and man was docked a day's
pay to help pay the £30,000 required for his monument. He was the
Duke of York in the rhyme who marched his 10,000 men up to the
top of the hill and marched them down again. He did however
inaugurate the Duke of York Military School in Chelsea. He
married the Princess Royal of Prussia but his mistress Mary Anne
Clarke trafficked in army commissions. Although exonerated from
complicity he resigned from being Commander-in-Chief, though he
was later reinstated.

The 112 foot high Aberdeen granite column at the bottom of
Waterloo Place named after him, is on the site of his brother's
Carlton House. It was designed by Benjamin Wyatt and built between
1831 and 1834. On top is his thirteen-foot-high, seven-ton bronze
statue by Sir Richard Westmacott, R.A. who was paid £7000. The
question of which way he should stand was solved by the Duke of
Wellington who said that as he had been Commander-in-Chief of
the Army he must not turn his back on the War Office in Whitehall,
so he faces it. He is in uniform resting a hand on his sword.

The Duke was permanently impecunious, and wits remarked that
he was placed high so that his creditors could not reach him, that his
reputation never stood so high and that the pointed lightning
conductor on his head was there to take his unpaid bills.

ADDENDUM

Bertrand Russell O.M., F.R.S.
An attractive bronze bust of Bertrand Russell (1872–1970) was
erected in Red Lion Square in 1980. The sculptor was Marcelle
Quinton.

2 Sculpture

One of the features of post-war London is the great increase in the number of pieces of sculpture. A few are on buildings, like the Barbara Hepworth on John Lewis, but most are in parks or in the City, which should be congratulated on its achievement. There is also the sharp difference between the modern realist school of people like Gilbert Ledward and Derwent Wood and the abstract groups headed by Henry Moore. In addition there has been a series of sculpture exhibitions since the war, initially in Battersea Park and latterly there have been annual showings in Regent's Park, Moore in Kensington Gardens and various loans in Hyde Park. This is a vast step forward from Eros, Peter Pan, Achilles and Physical Energy which were the four best-known pieces of sculpture before the First World War and are splendid in their own way. Achilles is essentially a memorial (as is Eros), beside being something very successfully adapted from Roman sculpture.

Most of the modern fountains are pieces of sculpture and although architects continue to produce much the same sort of matchbox building it is very refreshing to find that sculpture varies enormously in texture or design.

Once more there is a list of outdoor sculptures in London with the name of the sculptor, the site and the date and in most cases a description of it, but the sculptors with many exhibits, like Epstein have their works listed on a separate page at the end of the Sculptors chapter.

Sculpture starts off with Animals both north and south of the river and the chapter is then divided into the following areas:

Central London: Kensington, Chelsea and Belgravia
Central London: The Embankment to the Euston Road
City Sculpture, City Fountains, Green Park, Greenwich, Hammersmith, Holland Park, Hyde Park, Kensington Gardens, Kenwood, North London, Regents Park, St James's Park, South of the River, Tower Hamlets.

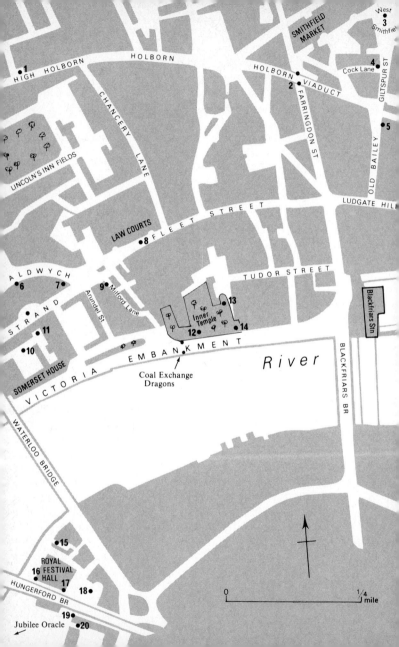

HIGH HOLBORN • 1

HOLBORN

SMITHFIELD MARKET

West 3 • Smithfiel

HOLBORN VIADUCT
2 •

Cock Lane 4 •

GILTSPUR ST

OLD BAILEY

5 •

FARRINGDON ST

CHANCERY LANE

LINCOLN'S INN FIELDS

LUDGATE HILL

LAW COURTS

8 • **FLEET STREET**

TUDOR STREET

ALDWYCH
6 • 7 •

9 • Milford Lane

STRAND

Arundel St

11 •

10 •

Inner Temple
13 •
12 • 14 •

Blackfriars Stn

SOMERSET HOUSE

VICTORIA EMBANKMENT

River

BLACKFRIARS BR

Coal Exchange
Dragons

WATERLOO BRIDGE

15 •

ROYAL
16 • **FESTIVAL**
HALL
17 •

18 •

HUNGERFORD BR

19 •

Jubilee Oracle

20 •

0 1/4 mile

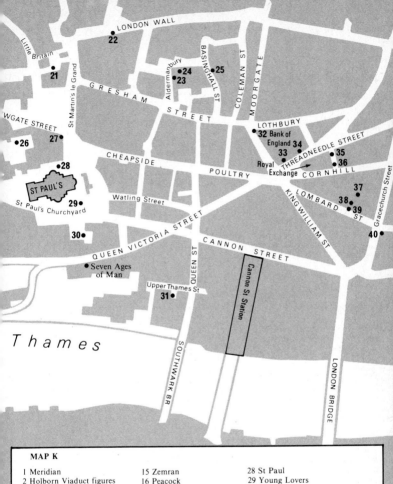

MAP K

1 Meridian
2 Holborn Viaduct figures
3 Peace
4 Pie Corner cherub
5 Justice
6 Youth
7 Horses of the Sun
8 Griffin, Temple Bar
9 Winged Form
10 Somerset House fountain
11 Ultimate Form
12 Lamb Statue
13 Kneeling Negro (sundial)
14 The Wrestlers

15 Zemran
16 Peacock
17 The Cellist
18 The Motorcyclist
19 Shell ball
20 Shell fountain
21 The Minotaur
22 The Gardener
23 The Glass fountain
24 Beyond Tomorrow
25 Ritual
26 Paternoster, Shepherd and Sheep
27 Panyer Boy

28 St Paul
29 Young Lovers
30 Icarus
31 Vintry Schoolboy
32 Ariel
33 Bank of England façade
34 Old Lady of Theadneedle Street
35 Motherhood (fountain)
36 Cattle Trough Association
37 Poseidon Group fountain
38 Hercules and the Lion
39 St George and the Dragon
40 Spirit of Enterprise

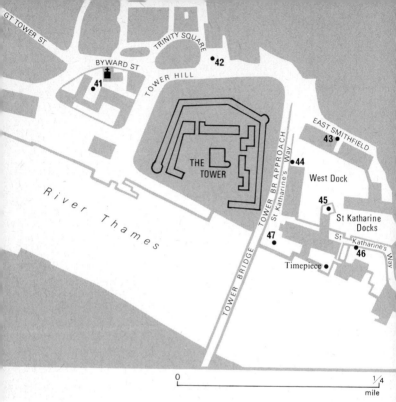

0 1/4
 mile

MAP L

41 Hammer Thrower
42 Trajan?
43 Elephants
44 Peace and Harmony
45 The Coronarium
46 Good Fun
47 Girl with Dolphin

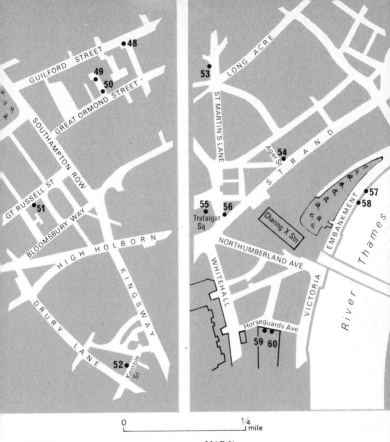

0 ¼ mile

MAP M

48 The Water Bearer
 (Francis Whiting fountain)
49 St Christopher
50 St Nicholas and children
51 Spirit of Trade Unionism
52 Nude Girl

MAP N

53 Spirit of Electricity
54 Men and Women
55 Trafalgar Square fountains
56 Springbok
57 Sphinxes
58 Cleopatra's Needle
59 Water
60 Earth

MAP O

62

CAVENDISH

SQUARE

63

OXFORD

NEW BOND S

BROOK ST

GROSVENOR

GROSVENOR ST

US **65**
Embassy

SQUARE

BERKELEY

SQUARE

MOUNT ST

68

PARK LANE

67

HYDE

PARK

CURZON STREET

75

77

SERPENTINE RD

76

PICCADILLY

Constance
Fund Fountain

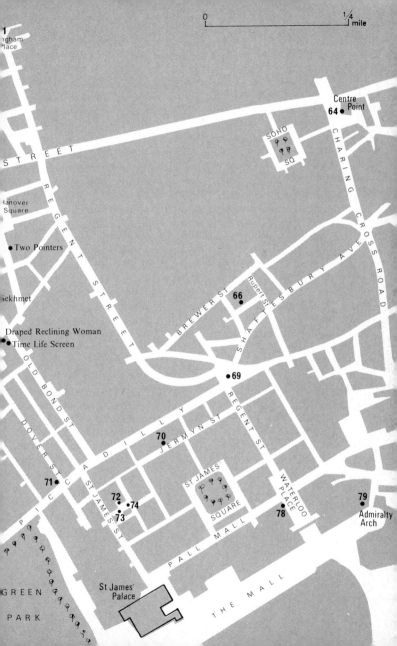

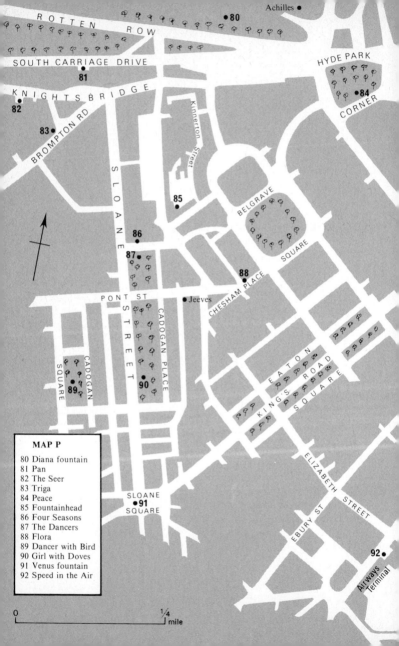

ROTTEN ROW

Achilles •

• 80

SOUTH CARRIAGE DRIVE

• 81

HYDE PARK
CORNER

KNIGHTSBRIDGE

82 •

BROMPTON RD

83 •

• 84

SLOANE

Kinnerton Street

• 85

BELGRAVE

SQUARE

• 86

• 87

• 88

PONT ST

• Jeeves

CHESHAM PLACE

STREET

CADOGAN PLACE

EATON

KING'S ROAD

SQUARE

CADOGAN

SQUARE

89 •

• 90

ELIZABETH STREET

SLOANE

• 91

SQUARE

EBURY ST

92 •

Airways Terminal

MAP P

80 Diana fountain
81 Pan
82 The Seer
83 Triga
84 Peace
85 Fountainhead
86 Four Seasons
87 The Dancers
88 Flora
89 Dancer with Bird
90 Girl with Doves
91 Venus fountain
92 Speed in the Air

0 ¼ mile

MAP Q

Sculpture

NAME	MAP	SITE	MATERIAL	SCULPTOR	ERECTED
Achilles	o	Hyde Park	Bronze	Sir Richard Westmacott, R.A.	1822
Africa		Albert Memorial	Marble	W. Tweed	1876
Agriculture		Albert Memorial	Marble	W. Calder Marshall, R.A.	1876
America		Albert Memorial	Marble	John Bell	1876
Amorini Figures (6)		St. John's Lodge, Regent's Park	Portland Stone	Sir William Goscombe John, R.A.	1894 and later
Andromeda *see* Perseus					
The Arch		Kensington Gardens	Marble	Henry Moore	1980
Archimedes		Lombard Rd., Battersea, S.W.11	Fibreglass	Edwin Russell	1962
Ariel	κ	Bank of England, Lothbury Corner	Gilt	Sir Charles Wheeler, R.A.	1937

Name		Location	Material	Sculptor	Date
Ariel (3 reliefs) *and see* Prospero	o	B.B.C. Langham Place	Stone	Eric Gill, A.R.A.	1932
The Arts and Sciences—8 figures		Vauxhall Bridge	Bronze	F. W. Pomeroy, R.A. and Alfred Drury, R.A.	1907
Asia		Albert Memorial	Marble	J. H. Foley, R.A.	1876
Aspiration		Marks and Spencer Edgware Road	Bronze	E. Bainbridge Copnall	1959
Atalanta	Q	Cheyne Walk at Albert Bridge	Bronze	Derwent Wood, R.A.	1929
Awakening	Q	Roper Gdns., Chelsea	Bronze	Sir Gilbert Ledward, R.A.	1965
Bank of England façade	κ	Threadneedle St., E.C.2	Stone	Sir Charles Wheeler, P.R.A.	c. 1932
La Belle Sauvage—*see* Pocahontas *under* Statues					
Beyond Tomorrow	κ	Guildhall Piazza	Bronze	Karin Jonzen	1972
Bird-cage		Kenwood	Metal	Reg Butler	1951

NAME	MAP	SITE	MATERIAL	SCULPTOR	ERECTED
Birth of Life		British Oxygen, Hammersmith	Marble	David Wynne	1962
The Black Friar		The Blackfriar, 174 Queen Victoria Street, E.C.4	Fibreglass	Unknown	1970
Blind Beggar and his Dog		Roman Rd., Bethnal Green	Bronze	Elizabeth Frink	1957
Bow Town Hall panels		Bow Rd., E.3	Stone	David Evans	1938
Boy with Bear Cubs		Holland Park, Dutch Garden	Bronze	J. M. Swan, R.A.	1902
Boy with Cat	Q	Cheyne Walk, S.W.3	Bronze	P. Lindsay Clark	1925
Boy and Dolphin Fountain		Regent's Park	Marble	Alexander Monro	1962
Boy with a Dolphin	Q	Albert Bridge, Chelsea	Bronze	David Wynne	1975
Boy with Frog Fountain		Regent's Park, Queen Mary's Gardens	Bronze	Sir William Reid Dick, R.A.	1936

NAME	MAP	SITE	MATERIAL	SCULPTOR	ERECTED
The Coronarium	L	St. Katharine's Dock	Perspex	Arthur Fleischmann	1977
4 Cripples		St. Thomas' Hospital	Stone	Thomas Cartwright	1976
The Dancers	P	Cadogan Place Gardens, S.W.1	Bronze	David Wynne	1971
Dancer with Bird	P	Cadogan Square Garden, S.W.1	Bronze	David Wynne	1975
David	Q	Cheyne Walk, S.W.3	Fibreglass	E. Bainbridge Copnall	1975
Day		St. James's Park Station	Stone	Jacob Epstein	1929
La Délivrance		North Circular and Regent's Park Road	Bronze	Emile Guillaume	1927
Diana		34 Chiswell Street, E.C.1	Gilded	Arthur Fleischmann	1953
Diana Fountain	P	Rotten Row, Hyde Park	Stone	Feodora Gleichen	1906
Dirce and the Bull		Tate Gallery	Bronze	Sir C. Lawes-Wittewronge	1911

Divided Circle *see* Two Forms

The Dockers	East India Dock Road	Fibreglass	Sydney Harpley	1962
Two Dogs	Victoria Park	Sandstone	Unknown (after Myron)	1912
Two Dragons	Victoria Embankment	Painted metal	Unknown	1963
Draped Reclining Figure	o Terrace of 153 New Bond Street, W.1	Bronze	Henry Moore	1953
Draped Seated Woman	Jamaica Road, Stepney	Bronze	Henry Moore	1958
The Eagle Slayer	Bethnal Green Museum	Bronze	John Bell	1927
Earth	N Ministry of Defence entrance, Horse Guards Avenue, S.W.1	Portland stone	Sir Charles Wheeler, P.R.A.	1953
East Wind	St. James's Park Station, West Block, north side	Stone	Eric Gill, A.R.A.	1929
East Wind	West Block, south side	Stone	Allan Wyon	1929

NAME	MAP	SITE	MATERIAL	SCULPTOR	ERECTED
Elephants	L	St. Katharine's Dock	Fibreglass	Peter Drew	1973
Empyrean *see* Monolith		Kenwood	Limestone	Barbara Hepworth	1959
Engineering		Albert Memorial	Marble	John Lawlor	1876
Eros *see under* Memorials	o	Piccadilly Circus	Aluminium	Sir Alfred Gilbert, R.A.	1893
Europe		Albert Memorial	Marble	P. MacDowell, R.A.	1876
Euterpe	o	14 Archer Street, W.1	Stone	Charles Petworth	1921
Family of Man (on loan)	o	Hyde Park	Bronze	Barbara Hepworth	1977
Fathom 1976	o	St. James's, Boodle's piazza	Metal	Anthony Caro	1976
The Fawn		108 Old Brompton Road, S.W.7	Stone	Cecil Thomas, O.B.E.	1974
La Fileuse Arabe		Westfield College, Kidderpore Avenue, N.W.3	Marble	Enrico Astori	1971

Flora	P	Chesham Place, S.W.1	Bronze	F. Koenig	1978
Fountainhead	P	Halkin Arcade, S.W.1	Bronze	Geoffrey Wickham	1971
Four Seasons	P	Carlton Towers Hotel	Copper	Elizabeth Frink	1961
The Gardener	K	Brewers' Hall garden, London Wall, E.C.2	Bronze	Karin Jonzen	1971
Girl with a Dolphin	L	Tower Hotel, St. Katharine's Way	Bronze	David Wynne	1973
Girl with Doves	P	Cadogan Place Gardens, S.W.1	Bronze	David Wynne	1970
The Glass Fountain	K	Guildhall Piazza, Aldermanbury, E.C.2	Glass	Allen David	1969
Goatherd's Daughter		Regent's Park	Bronze	C. L. Hartwell, R.A.	1932
Goetze Memorial Fountain		Regent's Park	Bronze	William Macmillan, R.A.	1939 and 1950
Good Fun	L	St. Katharine-by-the-Tower	Steel	Peter Drew	1973

NAME	MAP	SITE	MATERIAL	SCULPTOR	ERECTED
Goslar Warrior Lent by Reid and Lefevre Ltd.	O	Boodle's Club Piazza, St. James's, S.W.1	Bronze	Henry Moore	1979
Greek Boy Fountain		St. James's Park	Stone	Unknown	1883
Greek Runner		St. Peter's Square, Hammersmith	Bronze	Sir William Richmond, R.A.	1927
Griffin	K	Temple Bar	Bronze	Charles Birch, R.A.	1880
Guy the Gorilla		Crystal Palace	Marble	David Wynne	1962
Hall of Commerce Frieze		Napier Terrace, Islington	Stone	M. L. Watson	1975
Hammerthrower	L	Tower Place, E.C.3	Bronze	John Robinson	1973
The Hampstead Figure		Winchester Road, Swiss Cottage	Bronze	F. E. McWilliam, R.A.	1964
Hercules and the Lion	K	Barclays Bank, 54 Lombard Street, E.C.3	Bronze	Sir Charles Wheeler, P.R.A.	1962

Name		Location	Material	Artist	Year
Holborn Viaduct Figures	κ	Holborn Viaduct parapet, E.C.1	Bronze	H. Bursill	1868
Horse and Rider		Forecourt, I.P.C. Ltd, Sutton	Bronze	David Wynne	1981
Horse and Rider	o	Piccadilly, Dover Street	Bronze	Elizabeth Frink	1975
Horses of the Sun	κ	Australia House, Strand	Bronze	Sir Bertram Mackennal, R.A.	1919
Hylas		St. John's Lodge, Regent's Park	Bronze	Henry Pegram, R.A.	1933
Icarus	κ	Old Change Court, Cannon Street, E.C.4	Bronze	Michael Ayrton	1973
Image		Waterlow Park, N.2	Bonded bronze	Naomi Blake	1979
Jeeves		Pont Street, S.W.1	Black cement fondu	Kate McGill	1971
Joy of Life Fountain	o	Hyde Park	Bronze	T. B. Huxley-Jones	1963
Jubilee Oracle	κ	Jubilee Gardens, S.E.1.	Bronze	—Alexander	1980

NAME	MAP	SITE	MATERIAL	SCULPTOR	ERECTED
Justice	K	Old Bailey	Gilt	F. W. Pomeroy, R.A.	1907
Kneeling Negro (sundial)	K	Inner Temple	Bronze	Unknown	c. 1905
Knife Edge Two-Piece		Abingdon Street Gardens, S.W.1	Bronze	Henry Moore	1967
Lamb Statue	K	Inner Temple Gardens	Fibreglass	Margaret Wrightson	1971
Large Spindle Piece	O	The Mall	Bronze	Henry Moore	1980
Large Totem Head		Tate Gallery Garden	Bronze	Henry Moore	1978
The Leaning Lady		Great West Road	Concrete	Karel Vogel	1959
The Lesson		Avebury Estate, Turin Street, E.2	Bronze	Franta Belsky	1958
		Rosa Bassett School Wandsworth, S.W.17	Cast concrete	Franta Belsky	1959
Lightning Conductor		Kensington Town Hall	Gilded Copper	William Macmillan, R.A.	1960

Lions: *see under* Animals in text

Locking Pieces	Riverside House, Millbank, S.W.1	Bronze	Henry Moore	1958
The Lost Bow	Regent's Park	Bronze	A. H. Hodge	1939
Madonna and Child	o Cavendish Square, W.1	Lead	Jacob Epstein	1953
Man and Woman	Albany House, 98 Petty France, S.W.1	Bronze	Willi Soukop, R.A.	1963
Man, sixteenth century	Holland Park, Dutch Garden	Stone	Unknown	
Manufacture	Albert Memorial	Marble	Henry Weekes, R.A.	1876
Mary of Nazareth	St. James's, Piccadilly	Stone	Sir Charles Wheeler, P.R.A.	1975
Mater Ecclesiae	Convent of Sisters of Providence, Haverstock Hill	Fibreglass	Michael Verner	1977
Matilda	By Gloucester Gate and Albany Street, N.W.1	Bronze	Joseph Durham	1878

NAME	MAP	SITE	MATERIAL	SCULPTOR	ERECTED
Men and Women	N	429 Strand	Stone	Jacob Epstein	1908
Meridian	K	State House, Holborn	Bronze	Barbara Hepworth	1960
Mighty Hunter		Regent's Park	Bronze	A. H. Hodge	1939
The Minotaur	K	Postman's Park, E.C.1	Bronze	Michael Ayrton	1973
Monolith (Empyrean)		Kenwood	Limestone	Barbara Hepworth	1959
Motherhood (fountain)	K	Behind Royal Exchange	Bronze	Jules Dalou	1879
The Motorcyclist	K	Gardens opposite the Festival Hall, Belvedere Road, S.E.1	Stone	Siegfried Charoux, R.A.	1962
The Neighbours		Highbury Quadrant, N.5	Cemented iron	Siegfried Charoux, R.A.	1959
Night		St. James's Park Station	Stone	Jacob Epstein	1929
North Wind		St. James's Park Station, South Block, west side	Stone	A. H. Gerard	1929

Name		Location	Material	Artist	Date
North Wind		St. James's Park Station, South Block, east side	Stone	Eric Gill, A.R.A.	1929
Nude Girl	Q	Roper Gardens, Chelsea	Stone	Jacob Epstein	1972
Nude Girl	M	Fortune Theatre façade, W.C.2	Bronze	E. Schaufelberg	1924
Nude Girl	O	Berkeley Square, W.1	Stone	Alexander Munro	c. 1858
Nude Man		St. James's Hospital, Tooting	Bronze	D. Wain-Hobson	1952
Old Lady of Threadneedle Street	K	Bank of England façade	Stone	Sir Charles Wheeler, P.R.A.	1932
Orpheus see Theme on electronics					
Pallas Athena	O	Athenaeum Club, Waterloo Place, S.W.1	Gilded	E. H. Baily, R.A.	1829
Pan	P	Edinburgh Gate, Hyde Park, S.W.1	Bronze	Jacob Epstein	1959
Panyer Boy	K	Panyer Alley, St. Paul's	Stone	Unknown	1964

NAME	MAP	SITE	MATERIAL	SCULPTOR	ERECTED
Parsee Fountain		Regent's Park	Granite and Marble	Unknown	1869
Paternoster, Shepherd and Sheep	K	St. Paul's Shopping Precinct	Fibreglass Bronze finish	Elizabeth Frink	1975
Peace	K	Smithfield Fountain, E.C.1	Bronze	J. B. Philip	1873
Peace	P	Quadriga, Wellington Arch, Hyde Park Corner	Bronze	Adrian Jones	1912
Peace *see* Regimental War Memorials chapter	O	St. James's Churchyard, Piccadilly	Bronze	A. F. Hardiman, R.A.	1946
Peace and Harmony	L	Japanese garden at St. Katharine-by-the-Tower	Perspex	Arthur Fleischmann	1980
Peacock	K	Terrace of Festival Hall	Wood	Brian Yale	1978
Pelican Group		Horniman Gardens, Dulwich	Stone	J. de Vaere	1956
Perseus and Andromeda		Tate Gallery	Bronze	Henry C. Fehr	1897

Peter Pan	Kensington Gardens	Bronze	Sir George Frampton, R.A.	1912
Physical Energy	Kensington Gardens	Bronze	G. F. Watts, R.A.	1906
Pie Corner Cherub	к Giltspur Street and Cock Lane, E.C.1	Gilt	Unknown	1910
Pied Piper	Elmington Housing Estate, Edmund Road, S.E.5	Cement	Willi Soukop, R.A.	1969
Pilgrimage of Life	Kennington Park, S.E.11	Terracotta	George Tintworth	1869
Play up, Play up	Lord's, Wellington Road, N.W.8	Stone	Gilbert Bayes	1934
Two Pointers	O St. George's, Hanover Street, W.1	Cast iron	Adrian Jones	1940
Poseidon Group Fountain	к George Yard, Lombard Street, E.C.3	Bronze	Sir Charles Wheeler, P.R.A.	1969
Prehistoric Monsters	Crystal Palace	Plaster and Brick	Professor Owen	1854

WITHDRAWN-UNL

NAME	MAP	SITE	MATERIAL	SCULPTOR	ERECTED
Prospero and Ariel	O	B.B.C. Langham Place, W.1	Stone	Eric Gill, A.R.A.	1932
The Quadriga		Hyde Park Corner	Bronze	Adrian Jones	1912
Queen Mother's Commemorative Fountain		Bessborough Gardens, S.W.1	Aluminium	Sir Peter Shepheard	1980
R.I.B.A. columns see Obelisk and Column Chapter		Portland Place, W.1	Stone	James Woodford	1934
R.I.B.A. figure and reliefs		Weymouth Street, W.1	Stone	E. Bainbridge Copnall	1934
Rima		Hyde Park	Stone	Jacob Epstein	1925
Ridirich		Wingate House Aldgate	Bronze	Keith McCarter	1980
Ritual	K	Basinghall Street, E.C.2	Stainless steel	Antonas Brazdys	1969
Riverform		Kensington Town Hall	Bronze	Barbara Hepworth	1977

St. Christopher	M Great Ormond Street Hospital	Bronze	Gilbert Ledward, R.A.	1952
St. Christopher and Child	Bank of England, Centre Court	Bronze	Richard Goulden	1921
St. George and the Dragon	K Barclays Bank, 54 Lombard Street, E.C.3	Bronze	Sir Charles Wheeler, P.R.A.	1962
St. Joan	Shaw Theatre, Euston Road, N.W.1	Concrete and Stainless Steel	Keith Grant	1971
St. John the Baptist	By St. John's Church, Prince Albert Road, N.W.1	Fibreglass	Hans Feibusch	1979
St. Nicholas and Children	M Gt. Ormond St. Hospital	Bronze	Gilbert Ledward, R.A.	1952
St. Paul	K St. Paul's Cross, St. Paul's Cathedral	Bronze	Sir Bertram Mackennal, R.A.	1910
Sasparella	Lambeth Palace Road, S.E.1	Stainless Steel	P. Schollander	1975
Seated Boy	Stanhope Institute, Longford Road, N.W.1	Aluminium and Brass	Jean Bullock	1976

NAME	MAP	SITE	MATERIAL	SCULPTOR	ERECTED
The Seer	P	197 Knightsbridge, S.W.7	Bronze	Gilbert Ledward, R.A.	1957
Sekhmet	O	Sothebys, 34 New Bond Street	Diorite	Egyptian	1917
The Seven Ages of Man	K	Baynard House Queen Victoria Street, E.C.4	Aluminium	Richard Kindersley	1980
Semi-nude Girl		Holland Park, Dutch Garden	Stone	Eric Gill, A.R.A.	1940
Shell Ball	K	Belvedere Road, S.E.1	Stone	Eric Aumonier	1959
Shell Fountain	K	South Bank Gardens, S.E.1	Bronze	Franta Belsky	1961
Shepherd Boy		Sydenham Wells Park, S.E.26	Bronze	Mortimer Brown	1964
Silver Jubilee Fountain		New Palace Yard, Westminster	Painted galvanized steel and gilt crown	Valenty Pytel	1977

Single Form		Battersea Park	Bronze	Barbara Hepworth	1963
Smithfield *see* Peace					
Somerset House fountain	K	*and see* George III	Bronze and Stone	John Bacon, R.A. (Senior)	1788
South Bank Lion		Westminster Bridge, south side	Coade stone	W. F. Woodington, A.R.A.	1966
South Wind		St. James's Park Station, North Block, east side	Stone	Eric Gill, A.R.A.	1929
South Wind		St. James's Park Station, North Block, west side	Stone	Eric Aumonier	1929
Speed in the Air	P	Airways Terminal, Buckingham Palace Road, S.W.1	Stone	E. R. Broadbent	1935
Sphinxes *See* Cleopatra's Needle *under* Obelisks	N	Victoria Embankment	Bronze	G. J. Vulliamy and C. H. Mabey	1882
Spirit of Electricity	N	Thorn E.M.I., St. Martin's Lane, W.C.2	Bronze	Geoffrey Clarke	1961

NAME	MAP	SITE	MATERIAL	SCULPTOR	ERECTED
Spirit of Enterprise	K	Midland Bank, Gracechurch Street, E.C.3	Bronze	W. H. Chattaway	1962
Spirit of Trade Unionism	M	Great Russell Street, W.C.2	Bronze	Bernard Meadows	1958
Springbok	N	S. Africa House, Trafalgar Square, S.W.1	Gilt	Sir Charles Wheeler, P.R.A.	1934
Stag		Stag Place, Victoria	Aluminium	E Bainbridge Copnall	1962
Standing figure and Knife-Edge		Greenwich Park	Bronze	Henry Moore	1979
The Street Orderly Boy		Paddington Street Gardens, W.2	Stone	Donato Barcaglia	1943
The Sun Worshipper		Courtyard of Kensington and Chelsea Town Hall	Stone	Sir Jacob Epstein	1980
The Swanupper		I.C.L., Putney Bridge Approach, S.W.6	Fibreglass	Jose Alberdi	1960

Title	Location	Material	Artist	Year
Teamwork	Taylor Woodrow, Southall	Aluminium	David Wynne	1959
Teamwork	Taylor Woodrow, Western Avenue	Granite	David Wynne	1958
Theme on Electronics (Orpheus)	Mullard Ltd., Torrington Place, W.C.1	Brass with strings	Barbara Hepworth	1956
Three Elm Trees	Hyde Park	Wood	Chelsea College of Art	1978
Three Standing Figures	Battersea Park	Stone	Henry Moore	1948
Time-Life Screen	o 157 New Bond Street, W.1	Stone	Henry Moore	1953
Timepiece	Tower Hotel, St. Katharine's Way, E.C.1	Metal	Wendy Taylor	1973
Torsion (fountain)	St. Thomas' Hospital, S.E.1	Steel	Naum Gabo	1976
Trafalgar Square Fountains	N East side	Bronze	William Macmillan, R.A.	1948
	N West side	Bronze	Sir Charles Wheeler, P.R.A.	1948

NAME	MAP	SITE	MATERIAL	SCULPTOR	ERECTED
Trajan?	L	Wakefield Gardens below Tower Hill Station, E.C.3	Bronze	Unknown	1980
Triga	P	44 Brompton Road, S.W.1	Bonded concrete	Franta Belsky	1958
Two Forms (Divided Circle)		Dulwich Park	Bronze	Barbara Hepworth	1970
Two-piece Reclining Figure No. 1	Q	Chelsea School of Art, Manresa Road, S.W.3	Bronze	Henry Moore	1969
Two-piece Reclining Figure No. 3		Branden Estate, Kennington	Bronze	Henry Moore	1971
Two-piece Reclining Figure No. 5		Tate Gallery Garden	Bronze	Henry Moore	1979
Two-piece Reclining Figure for Lincoln Centre		Charing Cross Hospital, Hammersmith	Bronze	Henry Moore	1979
Ultimate Form (on loan)	K	King's College, Strand, W.C.2	Bronze	Barbara Hepworth	1972

		Location	Material	Sculptor	Date
Upright Motive Nos 1, 2, 7		Tate Gallery	Bronze	Henry Moore	1979
U.S. Embassy Eagle	O	Grosvenor Square, W.1	Gilded aluminium	Theodore Roszak	1960
Vauxhall Bridge Figures		On sides of the piers	Metal	F. W. Pomeroy, R.A. and Alfred Drury, R.A.	1907
Venus Fountain	P	Sloane Square, S.W.1	Bronze	Gilbert Ledward, R.A.	1953
View II		Fitzroy Square, W.1.	Bronze	Naomi Blake	1977
Vintry Schoolboy	K	West wall of Vintners' Hall, Upper Thames Street, E.C.4	Coade stone	Unknown	1946
The Watchers		Garnet College, Roehampton Lane	Fibreglass	Lynn Chadwick	1963
Water	N	Ministry of Defence entrance, Horse Guards Avenue	Portland stone	Sir Charles Wheeler, P.R.A.	1953
The Water Bearer (Francis Whiting Fountain)	M	Guilford Place, W.C.1	Stone	Unknown	1870

NAME	MAP	SITE	MATERIAL	SCULPTOR	ERECTED
West Wind		St. James's Park Station, East Block, north side	Stone	Henry Moore	1929
West Wind		St. James's Park Station, East Block, south side	Stone	F. Rabinovitch	1929
Winged Figure	O	John Lewis, Holles Street, W.1	Bronze	Barbara Hepworth	1963
Winged Form	K	Milford Lane, Strand, W.C.2	Resin bronze	Geoffrey Wickham	1968
Woman with Fish		Cambridge Heath Road, Bethnal Green	Cement fondu	Frank Dobson	1963
The Woman of Samaria Fountain		Clapham Common, north side	Stone	Sir Charles Barry, R.A.	1894
The Wrestlers of Herculaneum		Holland Park Orangery	Bronze	School of Lysippos fourth century	1960
The Wrestlers	K	Inner Temple Gardens	Lead on stone	Unknown	1937

Yalta Victims Memorial *See chapter 5*	Between Thurloe Square and Victoria and Albert Museum	Hopton Stone	Angela Conner	1981
Young Lovers	κ St. Paul's Churchyard	Bronze	Georg Erlich, R.A.	1973
Youth	κ Bush House facing Aldwych, W.C.2	Stone	Malvina Hoffmann	1925
Zemran	κ Queen Elizabeth Hall terrace, S.E.1	Stainless Steel	William Pye	1972

ADDENDA

Abstract	Charing Cross Hospital	Marble	Taddeo Koper	1980
Bull	255 King Street, Hammersmith	Coade stone		1904
Camdonian	Lincoln's Inn Fields	Steel	B. Flanagan	1980
Dolphin	Lloyd's Register of Shipping Railway Place, E.C.3	Marble	R. Kindersley	1974
Foxhound	Kennel Club 1 Clarges Street, W.1.	Bronze	Aidrian Jones	1956

Animals (N. of River)

Trafalgar Square Lions
The most famous animals in London are the four large lions at the base of Nelson's column, erected as an afterthought in 1868. They are twenty feet long and eleven feet high and were designed by Sir Edwin Landseer P.R.A. Their paws are those of a cat.

British Museum Lions
Many lions serve as guardians to entrance gates such as the pair in front of the north wing, the King Edward VII building, of the British Museum. These two stone lions are the work of Sir George Frampton, R.A. and were placed there in 1914.

Imperial College Lions
A large part of Imperial College was rebuilt after the last War but luckily Calcott's fine campanile was saved. A pair of lions dating from about 1890 which were on the old Imperial Institute were rescued and placed at the foot of the campanile.

Marylebone Road Lions
Another pair sit as guardians of what used to be the Marylebone Town Hall designed by Edwin Cooper, in the Marylebone Road, at the top of Gloucester Place. They were modelled by R. Ratman and carved by J. Whitehead. 1919.

R.S.B.S. Lion
There is a stone seated lion on a pillar in front of the Royal Society of British Sculptors, and on its base is the name Alfred Stevens, who was a member. Stevens did a number of similar lions. This one was not by him, but by an assistant of Cecil Thomas whose house it was. 1960.

York Water-Gate Lions
The attractive Water-Gate in the Embankment Gardens was built in 1626-7 by Balthazar Gerbier for the Duke of Buckingham. Its pediment is flanked with lions 'couchants'.

College of Arms: Lion and Unicorn

Another lion, this time wearing a royal crown, is on view in the
City. Its companion is a unicorn, which has twice lost its horn and is
still deprived of it, something that is not at all in keeping with the
College of Arms, on whose steps they sit, which their esoteric language
describes as being 'sejant'. The unicorn presumably has become
improper. What is extraordinary for a seat of exactitude is that the
College know neither the name of the sculptor nor their date, though
they are thought to be late eighteenth century. To make up for this a
Herald composed a charming ditty on the occasion of their being
moved when alterations took place. It started off:

> 'The Lion and the Unicorn had stood till very lately,
> The Herald's College to adorn, on pillars tall and stately,

The College of Arms is an attractive building in Queen Victoria
Street which was rebuilt in 1673 after being burnt down in the Great
Fire of 1666.

The Tate Gallery: Lion and Unicorn

One of the conditions made by Sir Henry Tate when he gave his
money to build the Tate was that there must be a statue of Britannia
over the portico, flanked by a lion and a unicorn. The lion is holding
a royal coat of arms. 1897.

Kensington Palace: Lion and Unicorn

Another very attractive stone lion and unicorn which are even older,
adorn the pillars that mark the entrance to Kensington Palace from
Kensington Road. They date from William III's reign and each
holds the arms of William of Orange with an escutcheon of pretence
for Orange. The lion wears a crown and the unicorn has a short
twisted horn.

Kensington Town Hall: Lion and Unicorn

A modern stone lion and unicorn adorn the south side of the vast
Kensington and Chelsea Administrative Headquarters just behind
Kensington High Street. They too are sitting and each holds a shield
of the arms of the Borough. They are by William Macmillan and
were put up in 1960.

Admiralty House: Seahorses

Admiralty House is one of the more attractive houses in Whitehall, both inside and out. Its screen with its fine seahorses on the gateposts is the work of Robert Adam and dates from 1760.

South Africa House: The Springbok

Over the door at the bottom corner of South Africa House there is a fine gilt springbok, the emblem of South Africa. It was sculpted by Sir Charles Wheeler, P.R.A. in 1934.

United States Embassy: Eagle

A predominant feature of Grosvenor Square is the gilded aluminium eagle with its wings spread out, on the roof of the American Embassy building. It is based on a wooden Bald Eagle in a New England Museum and is the work of Theodore Roszak, an American of Polish birth. It has a thirty-five-foot wing span and was erected in 1960. It faces the opposite way to the official American eagle.

Australia House: The Horses of the Sun

Near roof level over the entrance to Australia House there is an impressive bronze group by the Australian sculptor Sir Bertram Mackennal, R.A. It is called 'The Horses of the Sun'. A central figure, Phoebus, has two horses on either side of him in different positions. 1919. The groups on either side of the entrance door are mentioned further on in this chapter under Australia House.

Kensington Gardens: Doe and Fawn

On top of the Queen's Gate entrance into Kensington Gardens there are attractive bronze groups of does and fawns which were executed by P. Rouillard in 1919.

R.S.B.S: Fawn

Another animal in front of the Royal Society of British Sculptors which occupies the old home of Cecil Thomas, O.B.E. at 108 Old Brompton Road, is a stone fawn by Thomas which he did in 1931. but which was not put there till 1974.

St. George's, Hanover St.: Two Pointers

Many passers by must have admired two seated dogs in the porch of
St. George's, Hanover Street. They are pointers and one has a snipe
at his feet and the other dog harness. The sculptor was Adrian
Jones, better known for his Quadriga at Hyde Park Corner, and they
are in cast iron. Originally they stood outside a tailor's shop in
Conduit Street, which was bombed in 1940 and were then moved to
St. George's for protection.

Foxhound

An Adrian Jones bronze modelled from a hound in the Berkeley
pack sits in front of the Kennel Club, 1 Clarges Street, W.1. 1956.

Victoria Park: Dogs

There are two stone dogs at the western end of the Park which were
presented by Lady Regnant in 1912. Though of normal size they
have an Alsatian type head with a coarse ruff round their necks.
They were taken from copies of works by the famous Greek sculptor
Myron which are at Dunscombe Park, the home of Lord Faversham.

Stag Brewery: The Stag

The Stag Brewery near Victoria covered an enormous area and, as a
memento of this, a very large aluminium stag sculpted in a modern
manner, sitting on its haunches, has been put up on a high plinth. It
was the work of E. Bainbridge Copnall and dates from 1962. It
stands in Stag Place surrounded by modern blocks.

Brompton Road: Triga

Three large prancing horses stand on one of the ugliest modern
buildings in London, 44 Brompton Road, almost opposite Harrods.
The three stone horses are called Triga and are by Franta Belsky.
1958.

Elephants

The Ivory House, the building with the clocktower, in St.
Katharine's Docks was built by Aitcheson in 1854 and was used to
store ivory with port in the cellars. The Ivory House Gates in East
Smithfield, the one-way road beside the Mint, have a pair of
fibreglass elephants designed by Peter Drew and put up in 1973.

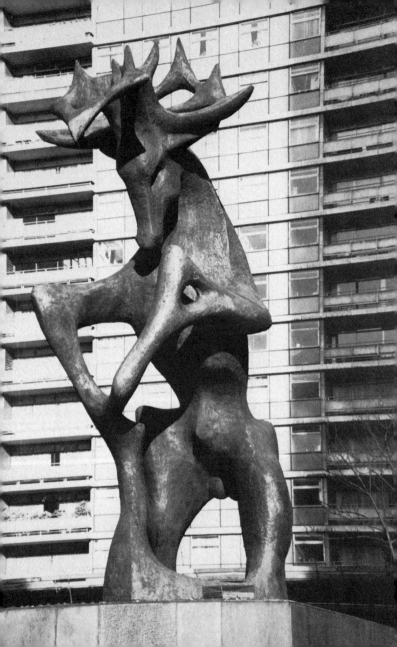

Animals (S. of River)

Prehistoric Monsters
One of the great features of the opening of the Crystal Palace by
Queen Victoria in 1854 after it was moved to Sydenham was the
collection of prehistoric monsters. They were made of brick and iron
and covered with stucco and were scattered about the gardens below
the Palace. Waterhouse Hawkins, under the guidance of Professor
Richard Owen, was responsible for their construction. The previous
year a somewhat ghoulish but hilarious dinner party for twenty
professors and historians was held in the partly completed
iguanodon, Professor Owen being seated in the chair of honour in
the skull. Twenty-nine of these remarkable monsters can still be seen
round the lake at the southern bottom end of the Palace grounds.
They are very well sited, each one is different and their colours vary.

Guy the Gorilla
The best animal sculpture in London is almost certainly Guy the
Gorilla by David Wynne. It is in the south-east corner of the Crystal
Palace grounds beside the large lake and is best approached by an
entrance in Thicket Road. It was put there in 1962.
 The gorilla is on all fours and the smooth marble has a realistic
colour about it. Furthermore, it looks very natural from whatever
angle one approaches it. Guy is named after one of the greatest
favourites of the London Zoo. He originally went in 1946 from the
French Cameroons to Paris before being transferred to Regent's
Park when about 18 months old. He died in 1978 aged thirty-two,
much younger than is usual in a gorilla.

The Bull
Continuing south to the end of Roehampton Lane where it widens
out, Danebury Avenue is on the right, turning in amongst the high
block flats. On the right of it in an open space there is a bronze bull
given by the G.L.C. in 1961. It is a semi-figurative work by
R. E. Clatworthy done in 1957 and has considerable charm.

The Stag, by E. Bainbridge Copnall

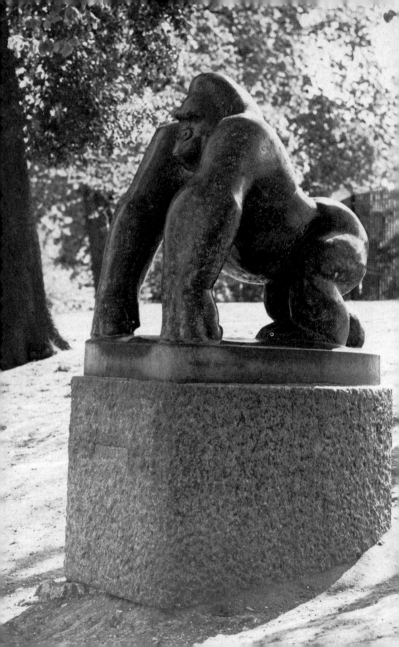

The South Bank Lion
There are many lions on display in London and the largest and
probably the most important is the white Coade stone lion on the
South Bank just across Westminster Bridge. Originally it was at the
Old Lion Brewery near Waterloo station, which was pulled down in
1950. The lion then became a feature of the Festival of Britain the
following year and was preserved at the request of George VI. It is a
very large example of Coade stone which was made by a secret
process in a factory that shut down in 1840. They provided a lot of
decorative heads to go over entrance doors of London houses, as for
instance in Harley Street, as well as on the façade of Trinity House
and the twenty-nine vases on the parapet of Somerset House. One of
the lion's paws in inscribed 'W. F. W. Coade 24 May 1837'. The artist
was W. F. Woodington, A.R.A. It deteriorated badly but was
repaired in 1980. 1966.

Peacock
At the G.L.C. end of the waterfront terrace of the Festival Hall
there is a sculpture in wood called Peacock. Four peacocks are set at
right angles to each other, their open fretwork tails displayed. It was
the work of Brian Yale and put there in 1978.

Other Animals
Sphinxes became popular in England in the eighteenth century and
there is a fine pair on the gate posts that support the impressive iron
gates bordering Green Park, opposite Bolton Street. They originally
came from Devonshire House. The best-known sphinxes are the
ones on either side of Cleopatra's Needle, which are described in the
Obelisk chapter.

Camel *See* War Memorials, Imperial Camel Corps
Dragons *See* Sculpture, Coal Exchange Dragons
Griffin *See* City Sculpture, Temple Bar

Guy the Gorilla by David Wynne

There are many other statues of animals, such as the two begging dogs at the Battersea Dog's Home, too numerous to record and when it comes to lions, the reader should get *Lion Hunting in London* by Frank J. Manheim, which illustrates scores of them, although it seldom gives details of the sculptor or their history. Numerous sphinxes are also included and so are lions and unicorns with and without royal coats of arms.

St Peter's Square, Hammersmith has a delightful collection of lions and eagles.

Central London: Kensington Chelsea and Belgravia

River Form (Town Hall)
This vast complex of red brick buildings behind Kensington High Street has an interesting piece of modern sculpture on loan from the Barbara Hepworth Museum at St. Ives since 1977. It is a six-foot-two-inch long oval bronze called River Form, which is sited by the entrance to the Town Hall. It is not one of Hepworth's most satisfying pieces, especially as the central hollow becomes a collecting place for water and rubbish. It was cast in 1973.

The Sun Worshipper (Town Hall)
An unfinished work by Sir Jacob Epstein from the 1910–16 period, when he was at his greatest, was presented to the Kensington and Chelsea Council by his widow in 1971. After being hidden in their cellars, it has been brought out and set up in the Town Hall Courtyard in 1980. It is called The Sun Worshipper and is a stone relief of a man with his hands straight up in the air, standing on a tapering background. It is one of the works he started in 1910 at the same time as his large Sun God which is now in the U.S.A.

A Lightning Conductor (Town Hall)
It is delightful to find that an architect was given *carte blanche* in designing a lightning conductor and such was the case at the most southerly building of the giant new Kensington and Chelsea Town Hall complex, completed in 1960. The result is enchanting. William Macmillan has produced a gilded form in the shape of a dancing figure waving a mysterious emblem. It would be ungracious to mention the number of noughts in the cost of the entire project. This idiosyncrasy is fully justified.

Atalanta
An attractive nude bronze called Atalanta was put up on Cheyne Walk by Albert Bridge in 1929. It is the work of Francis Derwent Wood R.A. and was erected as a tribute to him by his many friends, particularly those in the Chelsea Arts Club. He died three years before it was put up.

David

Derwent Wood designed a model for his Royal Machine Gun Corps
Memorial in the form of David the giant-slayer. He had his sword in
his right hand, Goliath's head at his feet and a pouch for stones slung
at his waist. It varies in detail from the larger and very impressive
David at Hyde Park Corner, who holds a much heavier sword in his
left hand.

The bronze prototype was placed in Cheyne Walk in 1963 but
vandals sawed it off at its ankles and stole it. A replacement in
bronze fibreglass by E. Bainbridge Copnall was placed on a tall
granite column in 1975 alongside the remaining feet, which had an
appealing charm, but in 1979 even they were removed. The
replacement was presented by the Kensington and Chelsea Borough
and the Old Comrades' Association of the Machine Gun Corps.

Fountainhead

When the area between Lowndes Street and Kinnerton Street was
developed and made into Halkin Arcade, an eleven-foot-high bronze
was put up in 1971 over a small pool. It is called 'Fountainhead' and
is by Geoffrey Wickham. It is not a fountain in the ordinary sense of
the word but water comes out of the top and cascades over the
sculpture.

Opening of Chelsea Embankment

There are two rather large, cumbersome columns with cherubs
climbing over them, erected in 1874 to commemorate the
completion of Sir Joseph Bazalgette's Chelsea Embankment. One is
by the river wall just east of Albert Bridge and the other, which has
a lamp-post on top of it, is on the opposite pavement at the bottom
of Old Church Street.

Speed in the Air (British Airways)

On top of the entrance to the British Airways building in
Buckingham Palace Road there is a very large sculpture done in
1935 by E. R. Broadbent out of sixty tons of Portland Stone. It is

Venus Fountain, by Gilbert Ledward

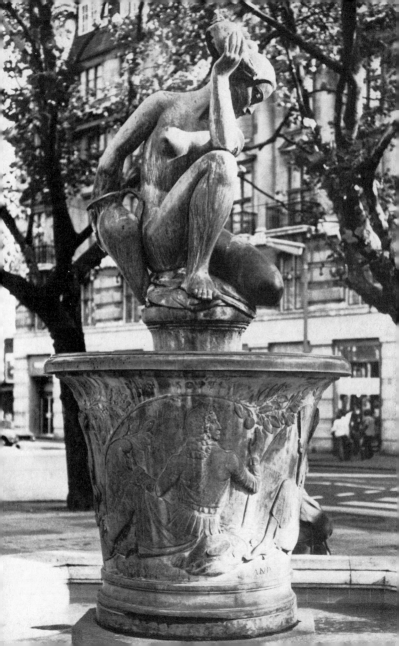

called 'Speed in the Air' and may be described as two godlike figures with extended wings enveloping the world.

Venus Fountain

One of the nicest fountains in London is the bronze Venus Fountain by Gilbert Ledward O.B.E., R.A. It stands near the middle of Sloane Square. From a basin a classical urn rises up, its sides chased with figures. Above it a nymph kneels on a central pedestal with in one hand a conch shell while the other holds an urn, both of which spout water. It is a very attractive work whether it is playing or not. The water cascades down the sides of the urn. It was erected in 1953. *See also under* Ledward in *Sculptors chapter.*

The following sculptures which belong to this section will be found at the end of the Sculptors chapter under the sculptor's name:

Pan	see under Epstein
The Awakening	see under Ledward
The Seer	see under Ledward
Two-piece Reclining Figure	see under Moore
Boy with a Dolphin	see under Wynne
Dancer and Bird	see under Wynne
The Dancers	see under Wynne
Girl and Doves	see under Wynne

Boy with a Dolphin, by David Wynne

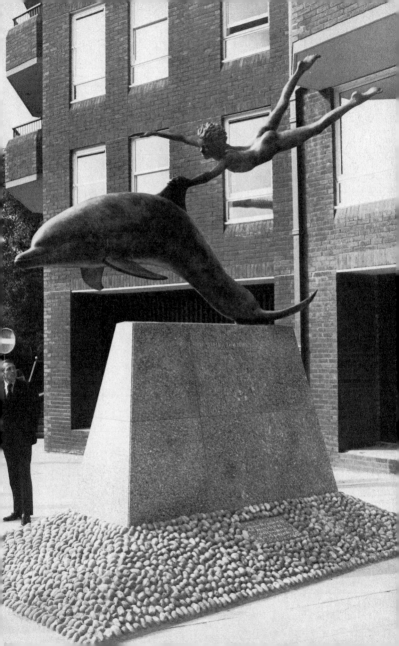

Central London

Aspiration

On the façade of Marks and Spencer halfway up the Edgware
Road there is a large male figure by E. Bainbridge Copnall
somewhat in the style of Epstein. It was a nude, but after local
complaints the artist added a form of sporan six months later to
assuage public opinion. It was put up in 1959. The man now looks
more like a Red Indian. It is twenty-five feet high.

Australia House Groups

In addition to the 'Horses of the Sun' which is described under
'Animals' in this chapter, there is a large stone group on either side
of the entrance to Australia House. On the right, on entering, is
'Awakening of Australia' and on the left 'Prosperity of Australia'.
They are the work of an Australian, Harold Parker, and were
erected in 1918.

Berkeley Square Nude

One of the more charming fountains, though it is a number of years
since any water flowed from her urn, is the delightful nymph at the
bottom of Berkeley Square. It is the work of Alexander Monro and
was presented about 1858 by Henry, third Marquess of Lansdowne
who lived in nearby Lansdowne House, now adapted as a club.

The Burghers of Calais

One of the really romantic stories of history concerns the Burghers
of Calais who in 1347, when they realized they would have to
capitulate to Edward III, came out with the keys of the town and
halters round their necks, putting themselves at the mercy of King
Edward in the hope that the town would be spared. Calais was not
only saved but, due to the pleas of his Queen, Philippa of Hainault,
who was so struck by their heroism, the lives of the Burghers were
also saved. Auguste Rodin, the most celebrated sculptor of the late
nineteenth-century, created his life-size group of the six burghers
between 1884 and 1886, but the town of Calais refused it. Later,
though, it was accepted, and can be seen in that open space near the

most hideous and ill-proportioned building in Europe, the Town
Hall of Calais. A replica, erected in 1915, is in the Victoria Tower
Gardens. It is the only outdoor statue by Rodin in London.

Cleopatra's Needle *See under* Memorials

Dirce and the Bull (Tate Gallery)
On the left of the entrance to the Tate there is a large involved
bronze scupture of Dirce being tied to a bull by the sons of Antiope,
prior to the bull's being driven away. It was Antiope's revenge for
having been tormented by Dirce. It is the best-known work of Sir
Charles Lawes-Wittewronge and was placed there in 1911. The
original, of which this is a copy in bronze, was marble and won a
first prize in the Franco-British Exhibition of 1908. See Lawes-
Wittewronge under Belt in Sculptors' chapter.

Earth and Water
Two enormous Portland stone figures decorate the main entrance to
the Ministry of Defence in Horse Guards Avenue. They are the
work of Sir Charles Wheeler P.R.A. and were put up in 1953. They
give a cumbersone effect. *See* **Wheeler** *in Sculptors chapter*.

Eros see under Memorials

Euterpe
It is a pity that such a charming piece of sculpture should be in such
a sordid street as Archer Street, which runs parallel to Shaftesbury
Avenue behind the Lyric and Apollo Theatres. Over the first floor
window of the Orchestral Association at No. 14, there is a delightful
reclining draped nude looking very sad. Euterpe, who is the Muse of
lyric poetry and who is usually represented holding a flute, is the
work of Charles Petworth. It is in stone and dates from 1921.

Fathom 1976
This modern piece of sculpture by Anthony Caro is called 'Fathom
1976'. It consists of two eighteen-foot lengths of metal set in
different planes and is in the piazza beside Boodles off St. James's
Street. It is by no means the best example of his work. It is on loan.

Flora
A short distance away, in front of the German Embassy in Chesham
Place, there is a tall bronze column of the lamp-post school. It is
called Flora and is by F. Koenig. 1978.

Francis Whiting Fountain: The Water Bearer
In Guildford Place opposite the Lodges of the old Foundling
Hospital (*see* Sir Thomas Coram *under* Statues) there is a pleasant
sculpture of a kneeling girl pouring water from a jug. It is called the
Francis Whiting Fountain and was put up in 1870.

Jeeves
A sculpture that is different is also the trade mark of Jeeves and it
stands in Pont Street (Chesham Place end) on the pavement in front
of their shops. Two seven-foot-high girls in fluffy dresses carrying
parcels are out shopping. They are in pitch black cement fondu. It
weighs one ton and is the work of an Irish sculptor, Kate McGill.
The design was by Derek Holmes. 1971.

Madonna and Child
One of the finest outdoor sculptures in London is the lead
Madonna and Child on the wall of the Convent of the Holy Child
on the north side of Cavendish Square. It is also Epstein's finest
outdoor work. Following the praise this achieved, unlike the abuse
caused by Night and Day and Rima, it was called his Passport to
Eternity. It was put up in 1936.
　　See also Epstein in Sculptors chapter.

Man and Woman
On either side of the entrance to Albany House, 98 Petty France
there are bronze figures, Man and Woman, in semi-abstract form.
The sculptor was Willi Soukop, R.A. 1963.

Pallas Athena
Athena was the Greek virgin goddess of wisdom. Though it might

Madonna and Child, by Sir Jacob Epstein

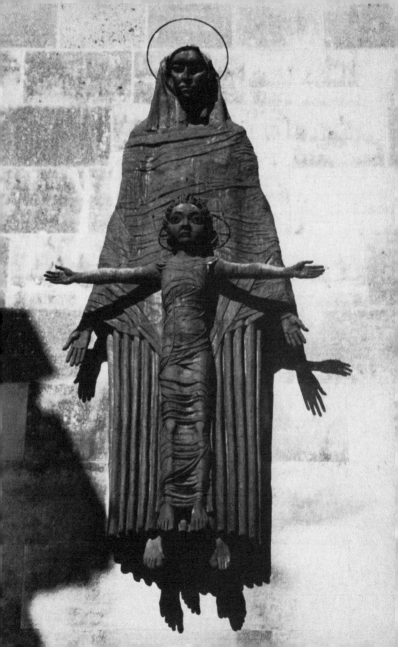

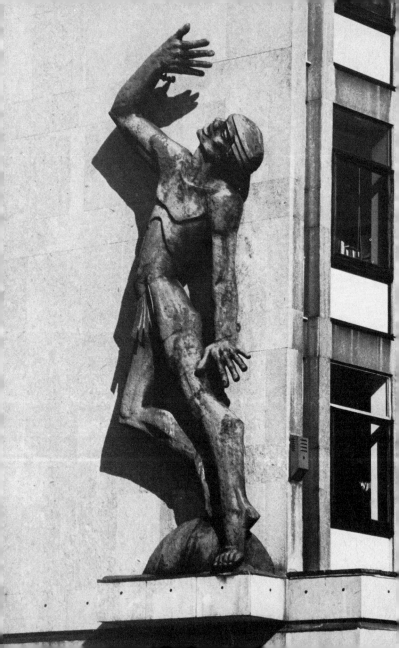

seem pretentious on other clubs, nobody would cavil at the attractive gilt Athena being placed over the entrance to the Athenaeum club, an 'athenaeum' being a temple in ancient Athens dedicated to Athena and used as a meeting-place of philosophers. She wears a helmet and bears on her left arm the ægis, or goat's skin with Medusa's head. Her spear has almost certainly been added. Athena is made of stone and is covered in gold leaf. The club, opened in 1830, was designed by Decimus Burton. Athena, the work of E. H. Baily, better known for his figure of Nelson, was erected at the end of the previous year. She was to have been the only classical adornment to the club, but one of the founders, an M.P. called Croker, decided that being the Athenaeum there should be something more, so he misappropriated a considerable sum of money subscribed for an ice-house, and in its place put a frieze round the building which produced the following jingle:

> I'm John Wilson Croker,
> I do as I please.
> You asked for an ice-house,
> I gave you a frieze.

The frieze was designed by John Henning and is based on the figures on the Parthenon. It was completed in 1830 and cost £2,165 1s 10d. The members never got their ice-house.

The Quadriga and Peace

On top of the large Wellington Arch at Hyde Park Corner there is a fine bronze sculpture done on a heroic scale to suit the arch. It is the work of Adrian Jones, M.V.O., a retired Captain of the 3rd Hussars who was also a qualified vet. The four hourses have all their forefeet in the air and have an air of movement. They are driven by a small crouching youth, the model being the donor's eleven-year-old son, behind whom stands a huge figure of peace, larger than any of the horses, with arms outstretched. The quadriga is the type of two-wheeled, four-horse chariot used by the Romans in their chariot races. It took four years to complete. Before it was finished Captain

Man, by Willi Soukop, R.A.

Jones held a dinner party for 8 people in one of the horses.

It was presented in 1912 at a cost of £17,000, by Lord Michelham, a Jewish financier and philanthropist, in memory of King Edward VII, who had befriended him.

Perseus and Andromeda (Tate Gallery)
The bronze sculpture on the right of the entrance to the Tate Gallery is a fairly classical version of Perseus and Andromeda dating from 1897. Andromeda looks rather more overpowered than usual lying under the dragon's wings. Medusa's head held by Perseus is beautiful and young and she has no snakes in hair. It is the work of H. C. Fehr.

Royal Institute of British Architects
It is only right and to be expected that the R.I.B.A. should adorn their building, built in 1934, with sculpture. On either side of the entrance there are tall pillars, and James Woodford, R.A. has surmounted them with a male and a female figure. (See also under Obelisks and Columns chapter). The fine bronze entrance doors are also the work of Woodford. They depict in relief well-known scenes of London and the Thames. There is a large Portland stone relief of a male figure high up in the centre of the building, representing Architecture. This and the other five over life-size stone figures on the Weymouth Street side of the building are all by E. Bainbridge Copnall. *See* **Copnall** *in Sculptors chapter.*

St. Christopher and St. Nicholas
By the door of the out-patients' wing of Great Ormond Street Hospital there is a bronze figure of St. Christopher with the infant Christ on his shoulder and with a staff in his hand. It was put there in 1952. Legend has it that St. Christopher carried the Child across a river.

The out-patient department is in a cul-de-sac on the north side of Great Ormond Street, at the entrance of which there is a statue of St. Nicholas with three children which is also by Gilbert Ledward, R.A. (*See also* in Sculptors chapter under Ledward).

St Nicholas and children, by Gilbert Ledward, R.A.

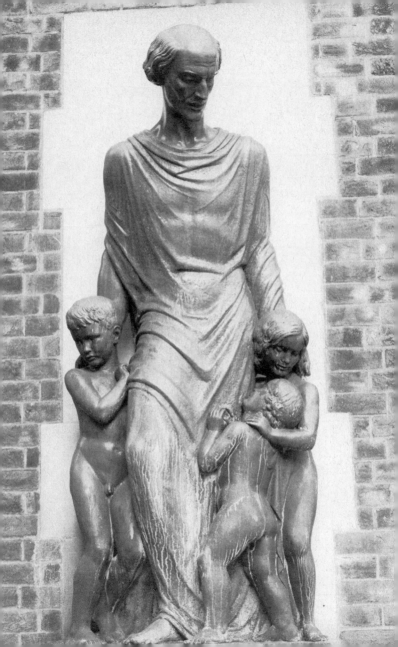

St. Joan
An original form of sculpture stands on the Euston Road pavement outside the Shaw Theatre. Its uprights are of concrete and the mesh-like globe surmounting it is in stainless steel. It is called St. Joan and is by Keith Grant. 1971. Few passers-by would realize that this was a sculpture.

Sekhmet
People who regularly walk along New Bond Street can hardly fail to have noticed a dark Egyptian sculpture over the entrance to Sothebys at No. 34. It is a statue of the goddess Sekhmet (it has various spellings such as Sekh Met or Sekhet), a fierce goddess of war who was sometimes in the form of a lion, but more often as a woman with the head of a lion or lioness. Sekhmet dates from around 1600 B.C. which makes this the oldest outdoor statue in London, or indeed monument, as it pre-dates Cleopatra's Needle by about 150 years. The goddess is made of diorite, an igneous rock. It was put up on the present building in 1917.

Sotheby's acquired it following the important Egyptian sale of Consul Salt in 1835, in which were included ten lots from Madame Belyoni, the widow of an Egyptologist. Among them was the Sekhmet which was unsold and which Sothebys later bought.

Silver Jubilee Fountain, Westminster
The underground car park for the House of Commons in New Palace Yard was more or less finished in time to erect a fountain to celebrate the Silver Jubilee of Queen Elizabeth's reign. A Polish sculptor, Valenty Pytel, has produced a series of animals standing erect and surmounted by a gilt St. Stephen's crown. The birds and beasts represent six continents, namely a unicorn for Europe, a lion for Africa, an eagle for America, a tiger for Asia, a kangaroo for Australia and a penguin for Antarctica. It was unveiled by the Queen on 4 May 1977. The sculpture is in galvanized steel strips and painted black. The whole structure rotates on its axis.

Somerset House Fountain
The huge courtyard of Somerset House has an appropriately large fountain with Neptune and behind him a statue of George III (q.v.)

forming a bronze baroque group on a stone pedestal. It is described under George III in the Statues chapter. There is a lot of sculpture involved and it was the work of John Bacon senior. Erected in 1788.

Spirit of Electricity
The façade of Thorn E.M.I. in St Martin's Lane has an eighty foot high, seven ton sculpture. A slender bronze arc springs out from the wall and to it are affixed bronze units and filaments representing parts of lamps. Low voltage lights have been built into the texture of the metal to give a glow at night. The sculptor of the Spirit of Electricity was Geoffrey Clarke. 1961.

Spirit of Trade Unionism
In front of the large Trade Union Congress headquarters in Great Russell Street Bernard Meadows has created an over lifesized sculpture of two men called 'The Spirit of Trade Unionism'. One man has seemingly collapsed—from overwork?—and his companion has his arm under him supporting him. 1958.

See under Epstein for the sculpture in the courtyard of the building.

The Street Orderly Boy
Paddington Street Gardens is a small oasis of quiet between Baker Street and Marylebone High Street. Between 1731 and 1857 it was St. George's burial ground, and there still remains a delightful mausoleum. There is also a sentimental stone statue of a seated street urchin, very intent on removing a thorn from his foot. It is by Donato Barcaglia and it won him a gold medal in Milan in the last century. It was erected in 1943. He was given the Légion d'honneur.

Trafalgar Square Fountains
The two Trafalgar Square basins erected in 1845 were part of the main plan of the square as designed by Sir Charles Barry, the architect of the Houses of Parliament. In 1948 they were given to Ottawa and were replaced by larger Portland stone basins designed by Sir Edwin Lutyens, the one on the east or Strand side having a fountain by William Macmillan and the west basin by Sir Charles Wheeler.

Vauxhall Bridge

For once a bridge was built and there was money over. This was the happy case of Vauxhall Bridge, costing £600,000, which was built between 1902 and 1906 by Sir Alex Binnie. As a result, huge statues were placed on both sides of each of the four piers, to absorb part of the surplus money. They are of eight women, at least twice life-size, representing the Arts.

The four upstream women are by F. W. Pomeroy, R.A. and they represent: Agriculture with a scythe; Architecture, the second on the right from Vauxhall Bridge Road, is well worth leaning over the parapet to look at as the woman is holding a huge model of St. Paul's Cathedral with great detail; Engineering; Pottery with an urn.

The figures on the downstream side are by Alfred Drury, R.A. and represent Local Government, Science, Fine Arts (with a palette) and Education (with books). They are all in bronze and were put up in 1907.

View II

A large bronze sculpture by Naomi Blake has been placed at the south end of Fitzroy Square, which has been turned into a walkabout. It is clearly derivative of Hepworth, but it makes a nice addition to the square. It was erected in 1977 and is called View II.

The Winds (St. James's Park Station)

When St. James's Park Underground station had what was in 1929 a very modern building erected above it the public had the additional shock of Epstein's two figures 'Night and Day' as well as eight stone carvings of Winds. It is a cruciform building and so each of the four wings has two sides. Let into the wall on the seventh floor are eight oblong stone reliefs. The sculpture seems very complicated, but it is best listed as follows:

 North Block East side has South wind by Eric Gill
 North Block West side has South wind by Eric Aumonier
 East Block North side has West wind by Henry Moore
 East Block South side has West wind by F. Rabinovitch

Architecture, holding a model of St Paul's, on Vauxhall Bridge, by Alfred Drury, R.A.

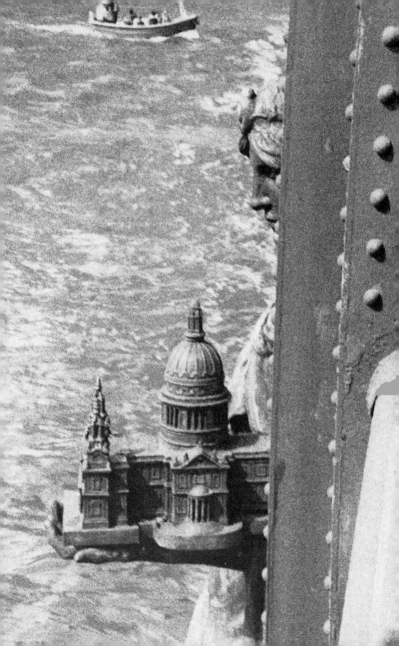

South Block East side has North wind by Eric Gill
South Block West side has North wind by A. M. Gerard
West Block North side has East wind by Eric Gill
West Block South side has East wind by Allan Wyon

Each sculpture is about eight feet long.

Various authoritative books write that Henry Moore sculptured
the North wind and even Henry Moore himself was under that
impression until recently, but he now realizes that it is one of the
West Winds that is his. It is almost Moore's first mature outdoor
work.

Broadway runs along two sides of the building but coming from
Queen Anne's Gate and looking up you will see Henry Moore's
West Wind on the left face of the building.

Winged Figure
A successful bronze of openwork and wire was erected on the Holles
Street façade of John Lewis in 1963. It is unmistakably the work of
Barbara Hepworth. See also in Sculptors under Hepworth.

Winged Form
Milford Lane, off the Strand, is a very scruffy, backs-of-houses
street and it is surprising to find a piece of modern sculpture in it.
Putting the 'Winged Form' by Geoffrey Wickham there, which is
dumped on an electric transformer housing, and then badly fixed
with guy cords, is an insult to any sculptor. It is in resin bronze and
was fixed there in 1968.

Youth
Bush House, which fills up all the river side of Aldwych, was built in
the twenties by an anglophile American, Edgar Bush, as a World
Trade Centre. The enormous arch that faces up Kingsway has two
twelve-foot male figures representing England and America and
each has an outstretched hand holding a torch between them,
which symbolizes civilization. Beneath it in big letters is, 'To the
friendship of the English speaking peoples'.

Large Spindle Piece, by Henry Moore

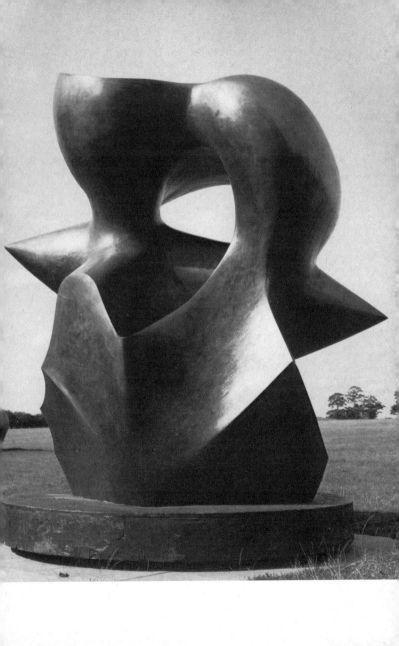

It was the work of Malvina Hoffman, an American sculptor, and was unveiled in 1925. During the last war, part of a flying bomb broke most of the American's arm, which killed a number of people when it fell, but the Indiana Limestone Company, who originally made the stature, kindly replaced the missing three-foot, two-hundredweight piece of arm as a gesture to mark the Queen's Jubilee in 1977.

Tate Gallery
See under Statues *for* Sir Henry Millais.
See under Sculpture: Animals for the lion and the unicorn with Britannia.
See under Sculptors for Henry Moore's works.

The following sculptures which belong to this section will be found at the end of the Sculptors chapter under the sculptor's name:

Day and Night	see under Epstein
Horse and Rider	see under Frink
Prospero and Ariel	see under Gill
Meridian	see under Hepworth
Ultimate Form	see under Hepworth
Draped Reclining Figure	see under Moore
Knife-Edge Two Piece	see under Moore
Large Spindle Piece	see under Moore
Locking Piece	see under Moore
Reclining Mother and Child	see under Moore
Time-Life Screen	see under Moore
The four groups in the garden of the Tate Gallery	see under Moore
One piece on loan in the Boodle's Piazza, St James's	see under Moore
Mary of Nazareth	see under Wheeler

City Sculpture

The City has erected a number of modern statues and pieces of sculpture since the war and especially since 1969. They are nearly all interesting and worthwhile.

Bank of England
Ariel and the figures on the façade of the Bank of England, including the Old Lady of Threadneedle Street, are described in the Sculptors chapter under Sir Charles Wheeler, P.R.A. The small St. Christopher in the Centre Court of the Bank is by Richard R. Goulden. It is in bronze and was unveiled in 1921. Tradition has it that there had been an early church on that site.

Thomas à Becket
In the old cemetery on the south side of St. Paul's there is Bainbridge Copnall's bronze of St. Thomas à Becket. (1118–70). The emaciated Archbishop has fallen and is resting on one foot and his left elbow, his head and one arm in the air. There is a deathly look about his face and pose. (*See also under* Statues.)

Beyond Tomorrow
Karin Jonzen's 'Beyond Tomorrow' on the Guildhall Piazza was the gift of Lord Blackford, a former Chairman of the Guardian Insurance. It shows a nude man and woman on a high plinth sitting side by side in opposite ways, but both looking in the same direction. It is a very composed piece and has great charm. It was erected in 1972.

Coal Exchange Dragons
The boundaries of the City of London are marked by various objects. Starting at the Thames there are two painted dragons on pedestals at the west end of the gardens of Inner Temple; one on either side of the Victoria Embankment. They are almost all that remains of the Coal Exchange which was pulled down in 1963, an act of vandalism that has been compounded by no use having been made of the site in Lower Thames Street for seventeen years. It was

a circular building, inside and out, and the various galleries had very fine examples of cast-iron work. The dragons were unveiled by the Lord Mayor in 1963.

Diana

There is a charming sculpture of Diana, with a hound under each arm, over the door of Diana House, 34 Chiswell Street. It is in concrete that has been gilded. The sculptor is Arthur Fleischmann and it dates from 1953.

The Gardener

Another work by Karin Jonzen is in the garden of the Brewers' Hall on the edge of London Wall, dating from 1971. It is a bronze called 'The Gardener' and is of a young man weeding.

Beyond Tomorrow, by Karin Jonzen

The Glass Fountain
A short way away there is a fountain in a square basin comprised of rising columns of different heights of green fused glass. When playing, it is very attractive. Allen David was the sculptor. 1969.

The Hammerthrower
The Hammerthrower, a bronze nude by John Robinson, stands in Tower Place in front of the Bowring Building. This muscular but very skinny man is leaning far back and the hammer is almost at the moment of release. The sculpture has a brick base. The work was presented to the City Corporation by the chairman of the Trees, Garden and City Open Space Sub-committee. 1973.

St. George and the Dragon: Hercules and the Lion
Barclays Bank in Lombard Street has a bronze sculpture on the first floor where the road goes up to George Yard, of St. George and the Dragon, and on the corner facing George Yard there is one of Hercules and the Lion. Both were the work of Sir Charles Wheeler, P.R.A. and date from 1962 when that part of the Bank was completed. The fountain of Poseidon (*see under* City Fountains) was also by Wheeler and was presented by Barclays Bank.

Holborn Viaduct Figures
One of the great road improvements of the Victorians was the construction of Holborn Viaduct between Holborn Circus and Newgate Street. Each side of the bridge is decorated with two draped bronze figures representing Agriculture and Commerce by H. Bursill and Science and Fine Arts by Farmer and Brindley. They are of very poor quality. 1868.

Icarus *see* Minotaur

Inner Temple Gardens
At the river end of the large Inner Temple Gardens, there is a statue of a youth holding an open book on which is written Charles Lamb's quotation, 'Lawyers, I suppose, were children once'. It is known as the Lamb statue and is a fibreglass replica of the original. It is by Miss Margaret Wrightson and was erected in 1971 to replace

the original lead statue of 1775, which was placed in the gardens in 1928 and stolen in 1970.

Near (Blotting*) Paper Buildings is a kneeling life-size figure of a Negro supporting a sundial. It is said to have been brought from Italy in 1700 and to have come from Clement's Inn about 1905.

At the City end of the Gardens, by the railings and below the end of King's Bench Walk, there is a group called 'The Wrestlers'. Two lead wrestlers are locked in a grip. They are on a stone base and were presented in 1937. Sculptor unknown.

Justice
On the City side of Holborn Viaduct is the massive building of Old Bailey which has a large bronzed figure of Justice standing on a ball. Contrary to general opinion she is not blindfolded, but wears a five-pointed star on her head, not unlike the one on the Statue of Liberty. Her arms are outstretched; her right one holds a sword and the left a pair of scales. It was the design of F. W. Pomeroy, R.A. and was put up in 1907. Pomeroy also sculpted the large figures over the main entrance, The Recording Angels on one side and Fortitude and Truth on the other.

Lloyd's Reliefs
A good example of how not to commission sculpture was shown by Lloyd's when they built their 1956 building in Lime Street. At the very top of the towers surmounting the building James Woodford has produced four reliefs—Air, Sea, Fire and Land—symbols of the insurances covered by Lloyd's. They are virtually out of sight.

Minotaur *and* Icarus
Michael Ayrton also has two sculptures in the City, the better known being 'The Minotaur', a bronze erected in Postman's Park, just behind the General Post Office, in 1973. The other is his slightly less successful bronze, 'Icarus', of the same year. It stands in Old

*Entering Inner Temple from Temple Lane, the road that runs from the Embankment to the Strand, the first building after the open gardens is called Paper Buildings. When the Embankment was completed in 1874 the gardens were extended and Paper Buildings had a small addition built on towards the river. This new bit was named Blotting Paper Buildings.

Change Court almost behind the *Financial Times* building and is in memory of Bernard Sunley. Ayrton, a very competent painter and portraitist, took up sculpture fairly late in life.

The Panyer Boy
Not very far away in Panyer Alley, a passage that leads from St. Paul's Shopping Precinct down to Newgate Street and St. Paul's Station, there is a charming stone relief of a small boy sitting on a pannier, a basket used for selling bread. He is known as the Panyer Boy, and under it the inscription reads:

> When ye have sought the City round,
> Yet still this is the highest ground.

Technically, this is said to be inaccurate: Cornhill is slightly higher.

It is dated 29 August 1688 and it was re-erected in 1964.

Paternoster—Shepherd and Sheep
In Paternoster Square on the north side of St. Paul's, Elizabeth Frink has a sculpture of a nude sexless male holding a shepherd's crook in his left hand and driving four sheep and a ram. It is in a fibreglass mixture with a bronze finish and is called Paternoster. It was unveiled by Yehudi Menuhin in 1975.

The Pie Corner Cherub
The Great Fire is said to have stopped near Pie Corner after having started in Pudding Lane and, whether it did or not, a fat little cherub with arms folded and covered in gilt has been set up on the angle of Cock Lane and Giltspur Street, where Pie Corner stood, to commemorate this. Its present position dates from 1910. In a window below, it tells the story relating Pudding and Pie to Gluttony and the fat boy. In a print of 1791 the figure had wings. The notice also states that the previous building was an inn where body snatchers laid out their wares while awaiting the Surgeons from nearby Bart's Hospital. It was called 'The Fortunes of War'.

Ritual

A very modern stainless steel sculpture called Ritual by Antanas Brazdys won the prize for the best British sculptor under thirty-five years old. It is about twelve-feet high and is a series of geometric forms, one on top of another. It stands in front of Woolgate House in Basinghall Street. 1969.

St. Paul's Cross

Just round the corner of the north side of St. Paul's churchyard there is a modern St. Paul's Cross on the site of a former one destroyed by the Puritans. It marks the place where sermons were preached and papal bulls proclaimed.

The present one is a tall Doric column surmounted by a bronze statue of St. Paul with a gilt cross. Sir Reginald Blomfield designed it and Bertram Mackennal was the sculptor. It was put up in 1910.

Paternoster—Shepherd and Sheep, by Elizabeth Frink

The Seven Ages of Man
A sculpture in aluminium costing £10,000 was erected in the well of
the Baynard House, G.P.O. building in Queen Victoria Street, when
it was completed in 1980. It was unveiled by Sir Bernard Miles
which was appropriate as the building is adjoining the site of his
former Mermaid Theatre. Sculpted by Richard Kindersley, it
consists of seven heads, one on top of each other, giving the effect of
a totem pole.

The Spirit of Enterprise
On the wall of the Midland Bank at the corner of Gracechurch
Street and Fenchurch Street there is a nude bronze of a man who
seems to be hurrying away. He is holding a hand to his forehead and
is called the Spirit of Enterprise, but the cynics call it 'The man who
has just seen his bank statement'. 1962. The sculptor was W. H.
Chattaway.

The Vintry Schoolboy
There is a charming coloured statue of a schoolboy in the uniform
of his day which dates from about 1840. He belonged to the Vintry
Ward School and his badge shows that his number was thirty. It
is in painted Coade stone and he stands on a cherubic corbel on the
west wall of the Vintners' Company in Vintners' Place, E.C.4 off
Upper Thames Street. It was put there in 1946 after they repaired
the bomb damage to their hall.

Young Lovers
Across the road behind St. Paul's there is a stone wall with three
lion mask fountains in it, which is part of the garden laid out by the
Worshipful Company of Gardeners. Behind it is a bronze statue by
Georg Erlich of a seated man and woman entwined and aptly
called Young Lovers. 1973.

The Vintry Boy (*overleaf*)

City: Fountains

Cattle Trough Association
At the Cornhill end of the passage behind the Royal Exchange a
fountain by J. Whitehead commemorates the Jubilee in 1911 of the
Metropolitan Drinking Fountain and Cattle Trough Association. A
red granite base has four fluted pillars and a canopy and inside these
is a bronze nude girl.

Motherhood
Behind the Royal Exchange there are two fountains. One is a
charming bronze group of a seated mother and two children called
Motherhood by Jules Dalou. It is on a stone base which has a
fountain and was erected in 1879.

The Poseidon Group
In George Yard off Lombard Street there is an important fountain
presented by Barclays Bank in 1969 to the City of London. It is the
work of Sir Charles Wheeler, P.R.A. The central figure is Poseidon,
who is partly draped by a mantle embossed with fishes. He wields a
trident and on the sides of the multicoloured basin there is a
mermaid (modelled from his second, very much younger, wife) and
a merman. Numerous jets of water play on the figures.

Smithfield: Peace
In the centre of the public gardens by Smithfield Market at the top
of Giltspur Street there is a large granite based fountain with four
marble basins and in the centre, standing on a copper hemisphere, is
a bronze figure of a girl holding a large branch in her left hand. The
draped figure has copper feet. It was the design of J. B. Philip and
was erected in 1873. She is sometimes referred to as Fertility but
more often as Peace.

Cattle Trough Association Jubilee fountain, by J. Whitehead (*overleaf*)
Motherhood, by Jules Dalou (*overleaf*)

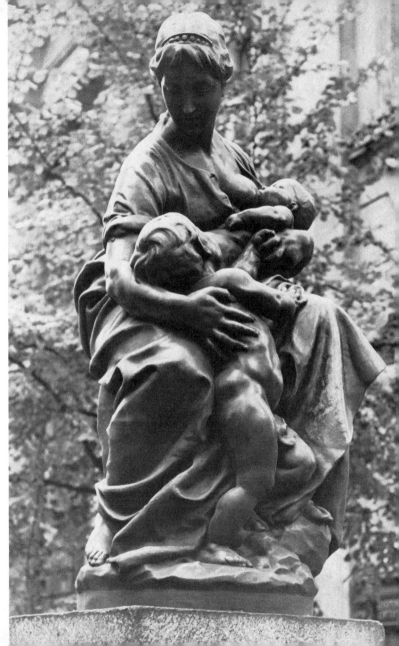

Green Park

The Constance Fund Fountain
In 1954 a structure was erected made of three granite basins
surmounted by twisted bronze branches forming fountains. They
rise up to support a miniature girl holding a leash and beside her a
greyhound. It is a gift of the Constance Fund, a legacy of Mr.
Sigismund Goetz, who gave a number of fountains to Regent's
Park. The sculptor is E. J. Clack.

Hammersmith

The Leaning Lady
The majority of people driving into London from Heathrow cannot
help noticing a modern statue of a woman. It gives the impression
she is resting on an unseen support. It is shortly before the
Hammersmith flyover and beside St. Peter's Church. The leaning
lady, which is not her official title, is by Karel Vogel and she has
remained in that position since 1969, though there are signs that the
concrete is deteriorating. It is sometimes called the Flyover.

The Greek Runner
In the attractive St. Peter's Square on the other side of the church by
the Leaning Lady there is an oversize bronze statue of a Greek
Runner. It is by Sir William Richmond, R.A., who was essentially a
painter, and was erected in 1927, six years after his death.

Birth of Life
Marble column at British Oxygen *see* David Wynne in Sculptors
chapter.

Holland Park

Holland House dates from 1606 and John Thorpe was the builder. It was named after Lord Kensington, who became Earl of Holland. Its great days were around 1800 when Charles James Fox, a son of the first Lord Holland, was the leading figure. In 1874 it became Ilchester property and after being badly bombed in the last war it was bought by the L.C.C. in 1952. There are extensive grounds and gardens. Apart from Lord Holland, by G. F. Watts, which is mentioned in the Statue chapter, and the sixteenth-century man, the rest of the sculpture was put there in the fifties and sixties.

There is a work of Eric Gill in the Dutch Garden. A woman, naked to the waist, is standing with her hands clasped behind her head. It was begun in 1910 and finished very much later.

On the south side of the Dutch Garden there is a bronze of a nude boy figure standing on a rock with a bowl under his arm; leaning back to fondle the bear cubs which are climbing up the rock. The sculptor is John MacAllen Swan, R.A. and it dates from 1902. It is on loan from the Tate Gallery.

In addition, there is a stone statue of a man on the opposite, north wall of the Dutch Garden. Neither the sculptor nor the date is known, but he is in sixteenth-century costume and is in rather poor condition.

In the Orangery there are two bronze boy wrestlers, each leaning forward with hands out ready to lunge into a hold. They are fourth century A.D. of the school of Lysippos and were presented by A.F. Buxton, who became chaiman of the L.C.C. They were first placed in the Embankment Gardens in 1894 and moved to Holland Park in 1960. They are known as Wrestlers of Herculaneum and they are three-feet-nine inches high.

Hyde Park

Achilles
Quite the largest, and in some ways the most impressive, statue is the eighteen-foot-high, thirty-three ton Achilles in Hyde Park near

Hyde Park Corner which, with its massive base reaches up thirty feet. It was a tribute from the ladies of England to the Duke of Wellington and Achilles looks across to Apsley House, the London home of the Duke. Sir Richard Westmacott, R.A. was the sculptor and it was cast from French twenty-four-pounders captured at Salamanca, Vittoria, Toulouse and Waterloo. It was unveiled in 1822 and erected where it is by command of George IV.

The name Achilles, was the sculptor's idea. The original had nothing to do with Achilles, the work being a variation of one of the two horse-tamers on the Monte Cavallo at Rome, which were originally brought from Alexandria, possibly by Constantine. The round shield was added for effect as was the short sword. It was the largest sculpture cast in bronze for 1800 years.

Achilles had a figleaf from the very beginning but even in that permissive period he was considered too nude, especially by the 'gentlewomen' subscribers, but fortunately their complaints were disregarded and no drapery was added, but even the figleaf was not sacrosanct as it was chipped off in 1870 and again in 1961. The present one dates from two years later.

The Colton Memorial
Near the Dell restaurant at the east end of the Serpentine there is a small fountain which unfortunately no longer sends out water. A winged child carrying a long fish under his arm stands on a pink marble basin. It was designed by W. R. Colton, R.A. in 1896 but crumbled badly and was replaced in artificial stone in 1975. It was known as the Colton Memorial and also as Little Nell.

Diana
Just to the west of the Cavalry Memorial and north of Rotten Row there is a fine classical fountain erected in 1906. Diana, drawing a bow, stands in the centre of a marble basin supported by four caryatids. It was the design of Feodora Gleichen.

The Family of Man
See in Sculptors chapter *under* Barbara Hepworth for details of this bronze group opposite the Dorchester Hotel.

Achilles, by Sir Richard Westmacott, R.A.

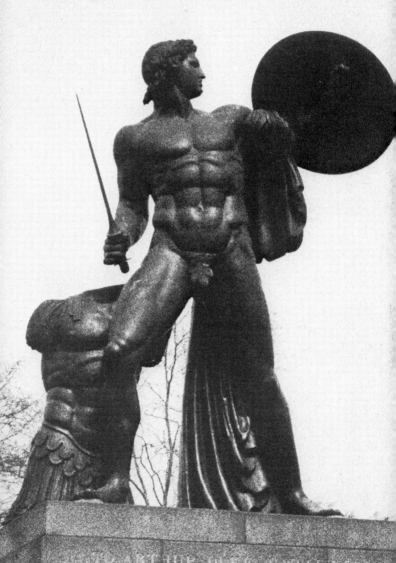

Joy of Life

A concrete modernistic fountain has replaced the delightful classical Dolphin fountain that was almost opposite Grosvenor House, the Dolphin one having gone to Regent's Park in 1963. The new one, called the Joy of Life, is in the form of a four-star pool imposed on a much larger four-star pool, the smaller one having a bronze cherub at each point, while in the centre a nude man and woman hold hands in rather unconvincing bacchanalia. The sculptor is T. B. Huxley-Jones and it was unveiled in 1963. It is one of the many fountains presented to London by the Sigismund Goetz fund.

Pan

See under Jacob Epstein in Sculptors chapter for details of Pan at the Edinburgh Gate, under Bowater House.

Rima

See under Epstein in Sculptors chapter. North of the Serpentine.

The Three Elm Trees

An original form of modern sculpture was shown by the Chelsea College of Art, who transformed three condemned elms just off the Ring Road, between the Magazine and Rima in Hyde Park. They have squared off the trunks to make a pattern of the trees. A plaque remarks that they were sponsored by Capital Radio, 1978, and that more than 9,000 elms in the Royal Parks had died of Dutch elm disease.

Kensington Gardens

Albert Memorial *See under* Memorials

Peter Pan

James Barrie created the immortal Peter Pan and George Frampton sculpted his version of him. It stands beside the Serpentine in

Peter Pan, by Sir George Frampton, R.A.

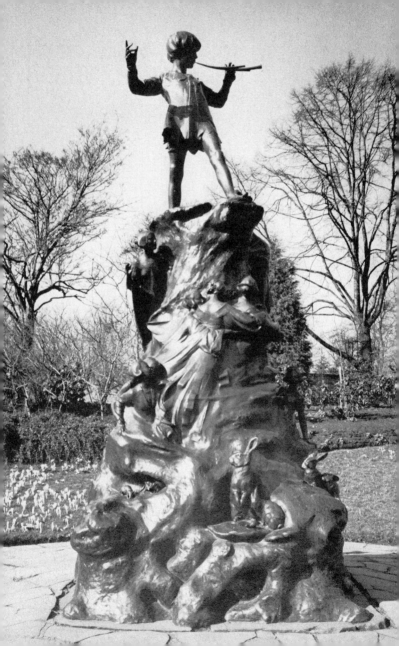

Kensington Gardens. Peter is playing a pipe on a bronze rock which
has various animals, birds and fairies, many of which are worn
smooth by children who flock to play there. The tableau is in fact
largely taken from Barrie's *The Little White Bird* which he wrote
about Kensington Gardens. The model was Miss Nina Boucicault,
who in 1904 was the first in a long line of famous actresses to play
Peter Pan, who is always played by a woman, though the sculpture
was not erected till eight years later.

The donor remains anonymous.

Physical Energy

When Londoners first saw Physical Energy it was the first really
non-classical equestrian statue on view and it must have caused
comment. It is a remarkable piece of work by any standards, all the

Physical Energy, by G. F. Watts, R.A.

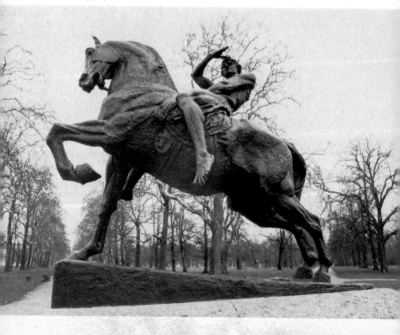

more so as it was the work of George Frederick Watts, who was essentially a painter and not a sculptor.

A nude bronze rider leaning back, with one hand up, scanning the horizon and the other holding the single rein, sits on a saddle-cloth on a champing horse. There is a grandeur about it which is helped by the bronze horse being close to one. It is only four feet from the ground on a granite base. It has stood in Kensington Gardens since 1906 in the walk that runs from the Albert Memorial to Lancaster Gate, having previously been shown at the Royal Academy two years before.

This is a replica of a section of the Memorial to Cecil Rhodes which was erected near Cape Town on the slopes of Table Mountain in 1902, but going back to 1870. Watts originally made this equestrian statue for Hugh Lupus Grosvenor, who became the 3rd Marquis of Westminster and in 1874 the first Duke, and it still stands outside the shell of Eaton Hall in Cheshire. Grosvenor was of course clothed.

Ninety years later, a cast was made for the British South Africa Company and it is in Zimbabwe.

North London

Bird-cage *see* Kenwood

La Délivrance
Perhaps the only London Statue to be sexy is the work of a Frenchman, Emile Guillaume. It was unveiled by Lloyd George in 1927 before a lot of red faces according to the papers. Nudity itself is not necessarily sexy but this bronze girl on tiptoe, fully stretched, holding a sword up to the sky, her pointed breasts and a feeling of vitality exuding from her, certainly ensures a second look.

La Délivrance, presented by Lord Rothermere, 'symbolizes the emotion inspired among allied nations when the armed forces of Britain and France defeated the invading German armies at the battle of the Marne September 1914'. It stands at a road junction a hundred yards beyond where Finchley Road meets the North Circular Road. There is a small replica in the Senate in Paris.

Empyrean *see* Kenwood

La Fileuse Arabe
In front of Westfield College, which is a branch of London
University in Kidderpore Avenue, off the Finchley Road, there is a
marble figure of an Arab woman seated as if spinning. It is called La
Fileuse Arabe and it won a gold medal at the 1900 Paris Sculpture
Exhibition. It is the work of Enrico Astori and was erected by the
Physics Building in 1971.

The Hall of Commerce Frieze
The last thing one would expect to find in a cul-de-sac off Upper
Street, Islington is a seventy-foot frieze in a sunken garden. It was
set up in Napier Terrace in 1975, having originally come from the
Hall of Commerce in Leadenhall Street, which later became Parr's
Bank. The building was pulled down in 1922 and the pieces, which
weigh eight tons, were left with University College. A winged figure
with outstretched arms representing Commerce is in the centre. On
her right are the intellectual figures representing Music and
Literature and on her left are shown the corn and fruits of physical
labour. The sculptor was Musgrave Watson.

The Hampstead Figure
Behind Swiss Cottage library off Winchester Road there is a bronze
figure in abstract shapes and very unlike the usual work of F. E.
McWilliam, R.A., who usually brings in a considerable sense of the
unexpected and a definite sense of humour. It is not helped by being
used as a clothes horse for the displays of the local stallholders.
1964.

Image
On the upper lake in Waterlow Park, an attractive thirty acre park
in North London, there is a bonded bronze sculpture seven-foot-six-
inches high by Naomi Blake that is in the style of Barbara
Hepworth. A hollow oval form has a solid ball at the top of the
opening. It is well sited on a little island amid a huge colony of

La Délivrance, by Emile Guillaume

mallard. The Park used to belong to Sir William Waterlow (q.v.) a former Lord Mayor of London. The sculpture is called Image and was erected in 1979.

Kenwood
Bird-cage is a work in metal vaguely recognisable as being by Reg Butler if one knows his prize-winning 'Monument to the Unknown Political Prisoner' of 1953. It dates from two years before and lacks the conciseness of the latter.

Monolith, also called Empyrean, is the earliest outdoor work of Barbara Hepworth in London. It is in Corrib Limestone and was sculpted in 1953, six years before being erected at Kenwood.

Mater Ecclesiae
Another Convent with an attractive statue on its façade is the Convent of Sisters of Providence in Rowland Hill Street, Haverstock Hill. A twenty two foot high all white figure of a woman robed to her ankles shows up well against the red brick church. Its title is Mater Ecclesiae which was the latest title given to the Virgin Mary by the Pope Paul VI. It is the work of Michael Verner and made of fibreglass. 1977.

Monolith *see* Kenwood

The Neighbours
A sculpture by Siegfried Charoux, R.A. shows two men sitting on a bench chatting in a very friendly way, both leaning foward with shoulders touching. It is in a housing estate in Highbury Quadrant, just off Green Lanes. It dates from 1959 and is in cemented iron.

Play up! Play up! and play the game!
A very unusual work called 'Play up! Play up! and play the game!' is at the corner of Wellington Road and St. John's Wood Road on the wall of Lords. The quotation is from Henry Newbolt. Gilbert Bayes, the sculptor, has done a bas-relief in stone of various athletes in the clothes of 1934. He has portrayed tennis players, two golfers in plus fours, cricketers, footballers, swimmers and an oarsman. It was presented by Alderman Isaacs.

St. John the Baptist
At the beginning of Prince Albert Road there is a statue of St. John the Baptist in traditional attire standing between St. John's church and hall. It is in fibreglass and is the work of Hans Feibusch, a naturalized Briton of German birth who is better known as a mural painter. 1979.

Seated Boy
A young boy seated on a bench in a small garden in front of the Stanhope Institute just off Albany Street is the work of a Yorkshire sculptor Jean Bullock. It is unusual in appearance and in construction, being a mixture of aluminium and brass. It was put up in 1976.

Regent's Park

The lay-out of Regent's Park, which covers 410 acres, was begun in 1812 and originally the Prince Regent, after whom it is named, was to have a palace in the north-east part, near the present Zoo. There is an outer road and an inner circle with a small lake adjoining which all forms part of Queen Mary's Garden.

There are various houses on the inner circle, one being St. John's Lodge. Its garden contains the following items:

Hylas
Hylas was a youth who was a favourite of Hercules. He was later abducted by the Naiads. Here he is represented in bronze as a graceful naked youth looking down at a mermaid, whose hands are grasping his legs. The group is on a stone pedestal in the centre of a lily pond. The sculptor was H. A. Pegram, R.A. and it was a gift of the Royal Academy through the Leighton Fund. 1933.

The Goatherd's Daughter
Near by, a half-naked girl is holding a goat under her right arm. It is in bronze and her bare feet are on a Portland stone pedestal. The

inscription reads, 'To all Protectors of the Defenceless' and 'This statue was erected in honour of Harold and Gertrude Baillie-Weaver by the National Council for Animal Welfare, with the generous co-operation of the sculptor', who was C. L. Hartwell, R.A. 1932.

The Amorini Figures
In the garden of St. John's Lodge, which used to belong to the Bute family but is now Government property, there are six stone piers surmounted by cherub-like boys, each holding an armorial shield including those of Crichton and Stuart, the Bute family names. They are called the Amorini figures and the first three by Sir William Goscombe John, R.A. were put up about 1894, the fourth by Harold Youngman in 1938 and the others later. They are very dull.

Boy and Dolphin Fountain
A charming piece of marble statuary consisting of a boy on a rock holding a dolphin was originally erected in Hyde Park as a drinking fountain in 1862 beside Park Lane and almost opposite where Grosvenor House now stands. It had been put on the site of an old reservoir. In 1962 it was moved to Regent's Park and placed in the Broad Walk as a replacement of the old Swan Fountain which was damaged beyond repair. The boy and dolphin are six-feet high, and a single bowl replaced the two original ones. Alexander Monro was the sculptor of the original.

Boy with Frog Fountain
In the begonia garden on the Bedford College side of Queen Mary's garden there is a naked bronze boy gazing down at a frog which is sitting on a black pedestal of Finnish granite, in the middle of a small pool. It was a present from Sir William Reid Dick, R.A., the sculptor, in 1936.

Goetze Memorial Fountain
Most of the Regent's Park statues are the gift of Sigismund Goetze who was a great benefactor of the Park. His main memorial is a bronze group of a merman and two mermaids by William Macmillan, R.A. forming a fountain in a large round pool, forty-five feet across. In 1950, when additional statuary was added, the

gold medal for the best sculpture of the year was awarded for this work. The dedication to Mr. Goetze, who died in 1939, is around the pool.

The Lost Bow and The Mighty Hunter
By the lake in Queen Mary's Garden there are two small bronze sculptures, both by A. H. Hodge. Both were presented by Sigismund Goetze in 1939. The Lost Bow is a naked helmeted boy sitting astride a turkey which is looking up at him. In his raised right hand he holds an arrow.

The Mighty Hunter is also a naked boy, but he is wearing armour leggings and a belt which look very out of place. He is holding a large goose on his shoulder. The whole effect is very clumsy.

Matilda
On the edge of Regent's Park by the Gloucester Gate, there is a very odd fountain. A large pile of big rocks from Cornwall forms a sort of grotto, and the fountain, which still works, is on the left side. Standing on these rocks is a young girl dressed like a milkmaid, with her hand up to her eyes as though searching out to sea, and just below her feet a milk pail is embedded in a rock. A brass plate refers to St. Pancras and a date 1878. It is by Joseph Durham and is called Matilda.

Mighty Hunter *see* Lost Bow

The Parsee Fountain
There is a large fountain given by an Indian. At the Zoo end of the long Broad Walk a sixteen-foot-high four-sided fountain of granite and marble was 'the gift of Sir Cowasjeen Jehangir, a wealthy Parsee gentleman of Bombay as a token of gratitude to the people of England for the protection enjoyed by him and his Parsee fellow countrymen under the British rule in India'. There is a small head of Queen Victoria and also of the donor and there used to be a water clock, but it ceased to work and was removed. Erected 1869.

St. James's Park

Greek Boy Fountain
Opposite Queen Anne's Gate there is an entrance to St. James's Park and beside it there is a stone fountain known as the Greek Boy. He stands on a plinth with an arm beside him. It dates from 1883.

South of the River

Archimedes
Where Lombard Road joins York Road, Battersea there is a fibreglass sculpture called Archimedes. A nude muscular man with a very long metal rod is levering a miniature world. Inscribed below is the quotation from Archimedes, the great mathematician from Syracuse, 'Give me a point to stand upon and a lever—I could move the world'. It was the work of a young sculptor, Edwin Russell, and erected in 1962.

The Cellist
On the terrace at first-floor level and over the stage door entrance to the Festival Hall there is a piece of sculpture by Siegfried Charoux called The Cellist. It is in cement and fibreglass and is a figurative work, but not as successful as the Motorcyclist. It was put up in 1958.

Female Figure
In the Sceaux Estate off the Peckham Road, there is in front of Colbert House, an under life-sized stone statue of a draped woman with her right hand resting on a sword. It is early nineteenth-century and was put there when the housing estate went up in the 1960s.

Matilda, by Joseph Durham

Jubilee Oracle
Between Hungerford Bridge and County Hall there is a bronze gilt-lined sculpture called Jubilee Oracle with a flowery inscription on the granite base by Alexander, 1980.

The Motorcyclist
Further along Belvedere Road, just after Hungerford Bridge, a stone sculpture of a one-wheel motorcyclist is set back from the road against a building. This somewhat imaginative work is by Siegfried Charoux, R.A. and was put there in 1962.

Nude Man
St. James's Hospital, Tooting suddenly appeared in all the papers when the Bulgarian B.B.C. broadcaster, Georgios Markov was admitted in 1979. He had been stabbed with a poison that proved fatal. In the forecourt of the Hospital there is a competent bronze of a nude man though his position is unusual. 1952.

The Pelican Group
The Horniman Museum between Dulwich and Forest Hill is not just the collection of musical instruments for which it is famous. On the ground floor there is a fine range of Polynesian and other native masks, weapons and regalia. Behind the Museum at the bottom of Horniman Gardens, there stands a form of pediment in Coade stone. There is a tall central figure, who might be a deity, holding a pelican, and various men, women and children. Originally, it stood over the entrance to the Pelican Life Insurance Office in Lombard Street in 1792. In 1915 the Pelican Life amalgamated with the Phoenix Insurance Co. and it was moved to their Sherborne Lane Office, where it stayed fifteen years, before being sent to the Geffrye Museum. Finally it went to Horniman Gardens in 1956. The sculptor was J. de Vaere.

Pied Piper
In the centre of the Elmington Estate in Camberwell the Caretaker's house has had a wall of brick and stone covered in abstract patterns

The Motorcyclist, by Siegfried Charoux, R.A.

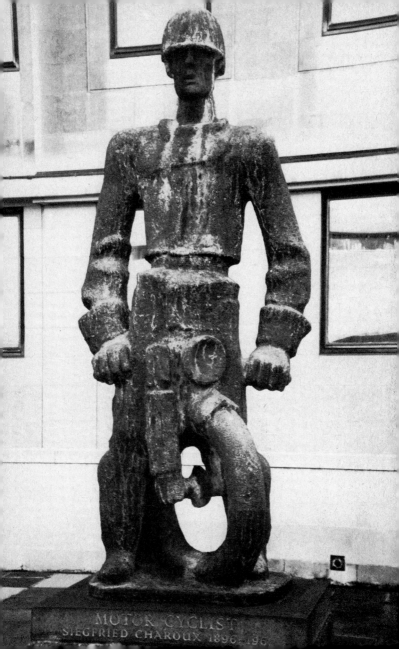

MOTOR CYCLIST
SIEGFRIED CHAROUX 1896–196

of rough cast cement. It is the work of Willi Soukop, R.A. and is called the Pied Piper. It is by no means an important work, but every devotee who insists on seeing it should make for Edmund Street, 1969.

The Pilgrimage of Life
In Kennington Park near the Oval there is a curious tall slender terracotta work called The Pilgrimage of Life. It was presented by Doulton and Co., the makers, in 1869, the designer being George Tintworth. At the top is a small model of a man and a woman with a child following behind them.

Sasparella
Across the road from the new St. Thomas' Hospital buildings there is a large stainless steel construction in two parts. They look a bit like enormous propellers of a ship and are called Sasparella, the reason for which is probably best known to Mr. Schollander, the sculptor. There is something that is compelling about them and they show a successful imagination.

Sasparella, by Peter Schollander

The Shell Ball

On the side of Belvedere Road by a garage entrance of Shell House there is a six-foot high ball made up of rings of granite and stone, the latter having a large number of carvings of shells, the trade mark of the Shell Company. They were carved by Eric Aumonier. The Ball was given by Easton and Robertson, the architects of Shell House, when it was completed in 1959.

Shell Fountain

In the courtyard beside the Shell building there is a thirty-foot-tall bronze sculpture that spirals down in delightful curves and shell-like forms that catch the cascading water, but unfortunately it is not often switched on, but even when it is not being a fountain it catches the eye. One can imagine each layer to be an oyster shell, and at other angles one sees a series of seabirds taking off. This imaginative and successful work is by Franta Belsky. 1961.

Shepherd Boy

There is a small bronze statue in Sydenham Wells Park called Shepherd Boy. It is the work of Mortimer Brown and dates from 1964.

Torsion

A large round pool in an attractive sunken garden has been made beside St. Thomas' Hospital. In the centre is a fountain of curved steel bands by Naum Gabo entitled Torsion. It was put up in 1976. The fountain rotates. There is a maquette of it in the Tate.

The Watchers

At the top of Roehampton Lane, Garnet College is on the right and in the grounds there are three separate figures in semi-abstract geometric form, called The Watchers. They are fibreglass copies of a work by Lynn Chadwick, erected in 1963.

The Woman of Samaria

The United Kingdom Temperance and General Provident Institution, now the U.K. Provident, erected a fountain opposite Adelaide House by London Bridge in the 1860s which proved very

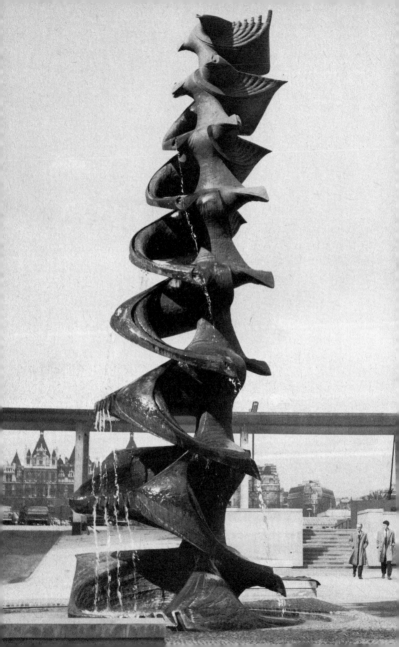

popular, but it deteriorated and a larger one called the Woman of Samaria replaced it in 1884. It proved too heavy for the vaults underneath and so it was moved to Clapham Common North Side ten years later.

It was designed by Sir Charles Barry, R.A., architect of the Palace of Westminster who lived at No. 29 North Side, and has a girl holding a pitcher giving a cup of water to an old man who has a crutch beside him. Four lion masks providing water have been replaced by Spring taps that throw up jets. The title is taken from the gospel of St. John 4: 9–11, where there is dialogue between Christ and the Woman of Samaria.

Zemran

Between the Festival Hall and Queen Elizabeth Hall there is a somewhat mystical sculpture of Chopin (*See under* Statues) and on the terrace of the Queen Elizabeth Hall there is a stainless steel sculpture by William Pye. Two wavy tubes curl up at an angle from a large half-globe. It is called Zemran and was put there in 1972, being presented by Nadia Nerina, who was the principal ballerina of the sixties at Covent Garden.

Shell Fountain, by Franta Belsky (*left*)
Torsion, with Coade lion framed in it, by Naum Gabo (*below*)

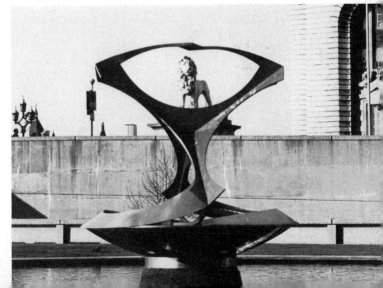

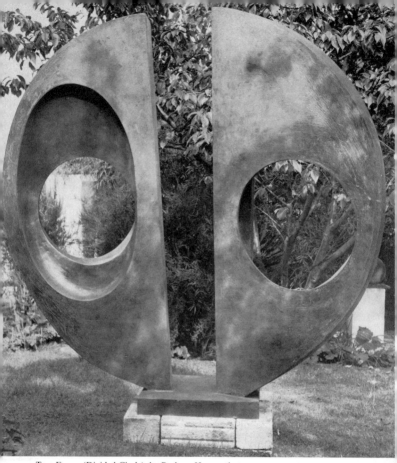

Two Forms (Divided Circle), by Barbara Hepworth

The following sculptures which belong to this section will be found
at the end of the Sculptors chapter under the sculptor's name.

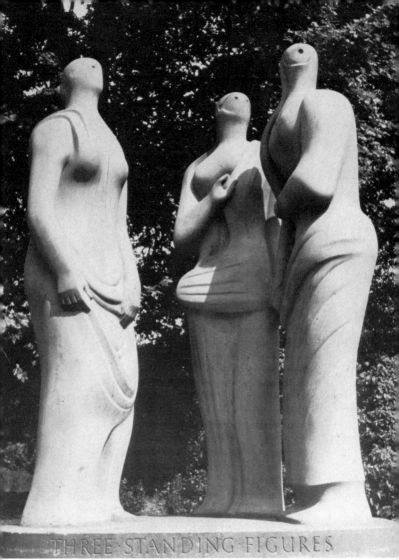

THREE STANDING FIGURES

Three Standing Figures, by Henry Moore

Tower Hamlets

Tower Hamlets is a very large Borough stretching from the City and
Hackney along the Thames to West Ham and it has a surprising
number of sculptures in it as well as half-a-dozen statues.

Blind Beggar and his Dog
On a small housing estate in Roman Road there is the Blind
Beggar and his Dog, a sensitive bronze by Elizabeth Frink. The man
has his right hand stretched out and is following his dog. It was her
first public commission and was put up in 1957. The story of the
Blind Beggar and his Dog is Bethnal Green lore that goes back to
the fifteenth century.

Bow Town Hall Panels—The Builders
Mile End Road becomes Bow Road. Before Bow Church is reached,
with its fine statue of Gladstone there is Bow Town Hall on the left,
which has across its façade five panels carved by David Evans,
F.R.B.S. in 1938. They are called The Builders and are
representative of the craftsmen who constructed the building such
as the carpenter, the welder, the draughtsman and two builders.

The Dockers
Going further south-east there is a sculpture called The Dockers in
Trinity Gardens alongside East India Dock Road. It is an eight-
foot-six high work sculpted by Sydney Harpley and it was erected in
1962. It is in fibreglass reinforced resin with a concrete centre.
 The dockers are supposed to be carrying a load, but they give the
impression not of working but of having a fight.

Draped Seated Woman
The most important sculpture in the east end of London is
undoubtedly the Draped Seated Woman by Henry Moore. It was
erected on the Stifford Estate in Jamaica Road, Stepney in 1958. It
shows a considerable degree of realism for a Moore of that period.
 See also under Moore in the Sculptors chapter.

The Eagle Slayer
Near the top of Cambridge Heath Road there is the Eagle Slayer in
the grounds of Bethnal Green Museum. A bronze nude of a man
with a bow aims at the sky and at his feet is a dead sheep. It is the
work of John Bell and was erected in 1927. Unfortunately the bow
was of wood and one half of it has been broken off. The Eagle
Slayer was exhibited at the 1851 Great Exhibition having been
sculpted four years earlier.

Eric Gill Reliefs
Near the end of Mile End Road the People's Palace, rebuilt 1937, is
part of St. Mary's College. Across the building are five stone reliefs
by Eric Gill representing the dance, music, theatre, boxing and what
might be two oarsmen. Each side door has a relief over it; one has a
boy playing a pipe and over the other there is an Egyptian-looking
figure with a book on which is 'Unto this last'.

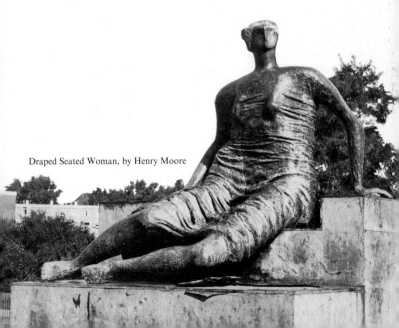

Draped Seated Woman, by Henry Moore

The Lesson, by Franta Belsky, who is standing on the right

The Lesson
In Turin Street off Bethnal Green Road there is an attractive piece
by Franta Belsky. It is called The Lesson and a nude mother is
bending over, teaching her very small child to walk. It was placed
there in 1958 and is in reinforced concrete coated with metal.

Ridirich
A three-meter high bronze piece of modern sculpture was
commissioned by Messrs. George Wimpey & Co. to celebrate their
centenary in the construction industry. It was erected in 1980 on the
new Wingate Centre site almost opposite Aldgate tube station. The
sculptor is Keith McCarter, a Scot. Ridirich is Gaelic for The Knight.

Peace and Harmony
A work in perspex by Arthur Fleischmann called Peace and Harmony
is in the Japanese Garden at St. Katharine-By-The-Tower. In 1980 it
was put in the sunken landscaped area where the pedestrian passage
from Tower Hill Underground joins this informal garden, having
previously been exhibited at the World Exhibition at Osaka in 1970.
This fourteen-foot-high water sculpture gives out a bluish light due
to the water that flows over it and the effect of the light on it.

Girl and a Dolphin
In front of the Tower Hotel and almost beside Tower Bridge there is
a bronze fountain by David Wynne called Girl and a Dolphin. It is
not as successful as his Boy and a Dolphin opposite Albert Bridge
(q.v. *under* Wynne *in* Sculptors) which has a particularly happy feel
of movement about it. Erected 1973.

Timepiece
Beside the Tower Bridge is Tower Hotel, and just beyond the figure
of the Girl with a Dolphin there is a sundial by Wendy Taylor called
Timepiece. It is not only attractive and original in conception, but it
is also functional. The twelve-foot diameter stainless steel face is set
at about fifty-six degrees to put it in the same plane as the equator,
and the bronze gnomen or pointer is parallel to the earth's axis and
points true north. The three hand-forged steel chains that support
the sundial without sagging are what give it its charm and make it so
much a part of its surroundings. It was erected in 1973.

Good Fun
The visitor to St. Katharine's Docks, alongside the Tower of
London, after passing under part of the hotel, may not notice that
he is crossing a lock bridge of unusual design. If he does, he may be

reminded of Van Gogh paintings of bridges near Arles, which are what inspired the designer, Peter Drew, the Chairman of St. Katharine-By-The-Tower Ltd. Just beyond it there is a shot-blasted multi-coloured iron section cut out from the old swing-bridge which formerly spanned the exit to the docks. It is called Good Fun. 1973.

The Coronarium
In a part of the yacht basin just behind the hotel there is a coronarium or circular precinct of seven white pillars, their tops joined by a thick circle of stone, in the middle of which is a huge two ton piece of perspex called the Coronarium. It is suspended between the pillars. Arthur Fleischmann is the sculptor. It was unveiled by the Queen in 1977 as a Silver Jubilee Memorial. It serves as an ecumenical centre for services which take place occasionally. The coronarium precinct is going to be covered over and the spaces between the pillars are to be filled with glass.

Trajan?
A Doctor Clayton found a statue of a Roman Emperor in a Southampton scrap metal merchants yard in the nineteen fifties. Unfortunately it was not an original piece. Had it been so it would be in a museum and not in the garden below Tower Hill station where the steps lead down under the road to the Tower of London. Instead it is probably a late eighteenth century Italian copy which may be Trajan with the body of Augustus. It is an attractive work. He is bareheaded and wearing the short tunic of a Roman General with the famous short sword under his left arm. The statue was previously placed in Wakefield Gardens, beside the fine remnant of the Roman wall, in 1968 but moved to its present site in 1980.

Woman with Fish
On Cambridge Heath Road there is a small pool on the corner of Malcolm Place with a seated woman holding a large fish which was a fountain. One of her legs has been broken off at the knee and shows the wire netting frame for the cement fondu. The sculptor was Frank Dobson. It was put up in 1963.

3 Memorials

Like statues, memorials were a part of ancient life. The Chinese and later the Assyrians built large memorials to commemorate their victories. The Romans too built some magnificently proportioned triumphal arches like the Arch of Triumph at Orange in southern France, which was put up to celebrate the victories of Caesar's legions, and in Rome there is Trajan's majestic column with bas-reliefs of his victories. Over 1800 years later Napoleon also built an Arch of Triumph.

Our memorials take many different shapes and forms. Sometimes they are columns like the Monument and sometimes they are parks, like the Edward VII Memorial Park at Shadwell, or a garden such as the adaptation of the churchyard of St. James's, Piccadilly. It might be a tablet on a wall, such as William Wallace has at Smithfield, or some gates like the ones to Dr. W. G. Grace and Jack Hobbs, the famous cricketers.

Only a few of the more important items on the list that follows are described.

Memorials have been arranged alphabetically and, as far as possible, geographically:

Central London
Chelsea
City of London
Cricketers
Kensington Gardens
North London
South of the River
Tower Hamlets

Memorials

CENTRAL LONDON

NAME	SITE	SCULPTOR	ERECTED
Admiralty Arch	The Mall	Sir Aston Webb, R.A.	1911
Buxton Memorial	Victoria Tower Gardens	S. S. Teulon	1865
Constitution Arch	Hyde Park Corner	Decimus Burton	1883
Eleanor Cross	Charing Cross	E. M. Barry and Thomas Earp	1863
Eros	Piccadilly Circus	Sir Alfred Gilbert, R.A.	1893
King's Reach	Victoria Embankment		1935
The Quadriga *see under* Sculpture			
Rima—*see under* Sculpture			
St. James's Church Garden	Piccadilly		1946
Lady Henry Somerset	Embankment Gardens		1897
Suffragette Scroll	Christchurch Gardens, Victoria Street	Edwin Russell	1970
Victoria Memorial (*and see* Victoria statue)	The Mall	Sir Thomas Brock, R.A.	1911

CHELSEA

NAME	SITE	SCULPTOR	ERECTED
Boy with Cat	Cheyne Walk	P. Lindsay Clark	1925
Damer Dawson bird bath	Cheyne Walk	Charles Pibworth	1933
Roper Gardens	Cheyne Walk		1964

CITY OF LONDON

Coal Exchange Dragons	Victoria Embankment	1963
Holborn Bars	Holborn	
London Stone	Cannon Street	The Romans
Temple Bar	Strand	Sir Horace Jones 1962
The Monument	Monument Street	Sir Christopher Wren 1880
Protestant Martyrs	Smithfield	1677
William Wallace	Smithfield	1870
		1956

CRICKETERS

Dr. W. G. Grace	Lords	Sir Herbert Baker 1923
Jack Hobbs	The Oval	1934

KENSINGTON GARDENS

Albert Memorial		Sir George Gilbert Scott 1876
Speke		1866

NAME	SITE	SCULPTOR	ERECTED
	NORTH LONDON		
Whittington Stone	Highgate Hill		1821
	SOUTH OF THE RIVER		
Braidwood Memorial	Tooley Street	S. H. Gardner	1862
Bristow Memorial	Brockwell Park		1892
David Copperfield	Old Kent Road		1931
Felix Mendelssohn	Ruskin Park		1842
	TOWER HAMLETS		
Baroness Burdett-Coutts	Victoria Park	H. A. Darbishire	1867
Edward VII Memorial Park	Shadwell		1922
Sixteenth Century Navigators			
Virginia Settlers Memorial	Brunswick Wharf		1971

Central London

Achilles *see* Sculpture

Admiralty Arch
The Admiralty Arch, which shuts off the Mall from Trafalgar
Square, is part of the grand design of Sir Aston Webb, R.A., when
he redesigned that part of London in 1910. It was put up as a
memorial to Queen Victoria and at the top of the Mall side is a
Latin inscription which reads, 'In the tenth year of King Edward
VII's reign from the most grateful citizens to Queen Victoria. 1911.'
It has three large iron gates, the centre one being opened only on
ceremonial occasions. The building ends on both sides with large
stone statues of women representing Navigation and Gunnery.

Queen Alexandra *See under* Statues.

Buxton Memorial
Probably the most hideous memorial is the Buxton Memorial
perpetrated by S. S. Teulon and happily his only exhibit in London
apart from his churches. What this gothic horror lacks in taste it
makes up for in the variety of materials used, including polished
pink granite; and the good cause it stood for. Charles Buxton, M.P.
erected it in memory of his M.P. father, Sir Thomas Fowell Buxton,
who successfully organised an anti-slavery drive in which he was
helped by Wilberforce Macaulay, Brougham and Dr. Lushington.
 Originally there was a motley collection of figures around it:
Constantine, Caractacus, Canute, Alfred, William the Conqueror,
Henry VII, Charles I and Queen Victoria. They all disappeared in
1960 but were replaced in fibreglass twenty years later, when the
roof was also restored to its former glory and other repairs done. It
is a typical period piece of 1865, being magnificently ugly and
complete with dog bowl. The memorial which was originally put up
in Parliament Square, was taken down when the Square was
replanned in 1949 but not erected in Victoria Tower Gardens until
1957.

Constitution Arch, *formerly* **Wellington Arch**
The large arch at Hyde Park Corner has only stood at the top of
Constitution Hill since 1883. It was also known as The Green
Park Arch and was erected in 1828 opposite an exit of Hyde Park,
very near Wellington's London home, Apsley House, which he had
bought from his brother in 1820. The arch was the work of Decimus
Burton, who also designed the nearby classical screen with its three
entrances into Hyde Park. An equestrian statue of the Duke in
keeping with the size of the arch stood on top, but it was moved to
Aldershot when the arch was moved. The sculptor was M. C. Wyatt.
For details about the present Quadriga *see under* Sculpture. A part
of it is used as a police station.

Eleanor Cross
Standing in the forecourt of Charing Cross Station, there is a
seventy-foot stone and granite gothic memorial designed by E.M.
Barry, a son of Sir Charles, and sculpted by Thomas Earp. There
are eight figures of Queen Eleanor in different stages and it is
surmounted by a cross. It is the 1863 version of an Eleanor Cross.
 Eleanor of Castile was the much-loved wife of Edward I who
accompanied him on his Crusade. She died at Harby in Lincolnshire
and her body was brought to Westminster Abbey in stages, where
she was buried in a beautiful tomb. Twelve crosses were afterwards
erected to mark the various stopping-places, the last one being built
at 'Cherringe juxta Westmonasterium' in 1291, the year after her
death, this being on the site of the present Trafalgar Square.
 Some authorities have said that the present name Charing was
derived from *chère reine*, the beloved queen of Edward, but there is
clear evidence in earlier manuscripts, such as the MS *Liber de
Antiquis Legibus* of 1274, which refers to an event at Cherringe in
1260. This must dispose of this legend started by Thomas
Walsingham and perpetuated by others up to the middle of this
century, when *chère reine* was given as the attribution of the place
name.
 The Eleanor Cross at Charing was built by Richard and Roger de
Coverdale on the site of the present Charles I statue. They were paid
the vast sum of £500 and £90 7s 5d respectively. Reproductions of it
vary greatly, but it would seem to have had a domed top and to

have been about forty feet high. It was demolished in 1647 following an edict of the Puritan Parliament of 1643.

The other London Cross which stood at Cheapside was much less elaborate.

Eros

Eros is probably the best-known statue in London. Its real name is the Angel of Christian Charity and it was commissioned as a tribute to the great Antony Ashley Cooper, stateman and philanthropist, who became the 7th Earl of Shaftesbury and after whom Shaftesbury Avenue was named when it was opened up in 1877–8, seven years before his death.

Steps lead up to the fountain basins. Above them is a band of allegorical figures and above that an inscription by Gladstone saying that the memorial was erected by public subscription, followed by a eulogy of Lord Shaftesbury. When the Underground station was being rebuilt in 1923, Eros was moved to Victoria Embankment Gardens and on his return to a replanned Piccadilly Circus in 1931 Eros was mounted two steps higher.

During World War II Eros was moved to Egham but came back in 1947. Old flowergirls with huge baskets used to sit round Eros and be a feature of the place. After the war a couple returned but they did not stay long.

The sculptor was Sir Alfred Gilbert, R.A. and it was the first London statue to be made of aluminium. The leg Eros balances on is solid and the rest is hollow. It was put up in 1893.

King's Reach

On the Victoria Embankment wall opposite the dragons that mark the City boundary there is a large stone arch and on it a brass tablet which reads, 'In commemoration of the twenty-fifth anniversary of the accession of King George V this reach of the river between London Bridge and Westminster Bridge was with his Majesty's permission named by the Port of London Authority King's Reach'. It was put up in 1935.

Rima *See* Epstein *in* Sculptors chapter.

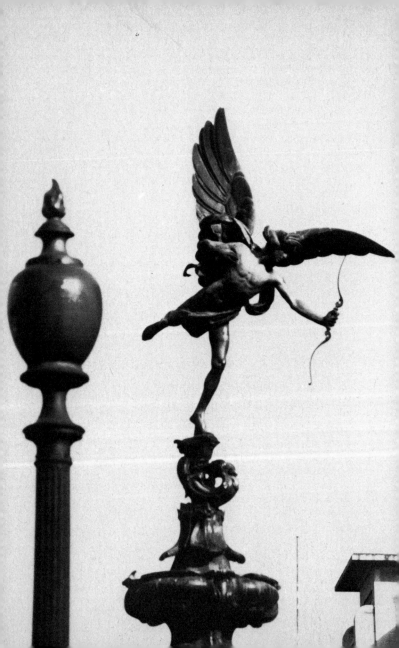

St. James's Churchyard *See in* Regimental War Memorials chapter.

Lady Henry Somerset

In Victoria Embankment Gardens near the Savoy there are the remains of a memorial to Lady Henry Somerset, who was a social reformer and an advocate of temperance. In 1897 there was erected a bronze statue of a young girl with both hands held out holding a bowl which was also a bird bath. Below it was a fountain and a plaque, but all the bronze has been stolen, leaving just the block she stood on and her feet cut off at the ankles.

Suffragette Scroll

A very unusual memorial is in the form of a tall upright scroll in fibreglass finished in cold cast bronze on which is inscribed, 'This tribute is erected by the Suffragette Fellowship to commemorate the courage and perseverance of all those men and women who in the long struggle for votes for women selflessly braved derision, opposition and ostracism, many enduring physical violence and suffering'.

The scroll by Edwin Russell was set up in 1970 on a round stone column in Christchurch Gardens at the end of the passage opposite Caxton Hall, the scene of so many of their meetings. There is also the Woman's Suffragette prison badge.

Victoria Memorial

In front of Buckingham Palace there stands the large eighty two feet high Victoria Memorial designed by Sir Aston Webb, R.A. as part of his replanning of the Mall. A seated, thirteen-foot-high, marble figure of Queen Victoria (q.v. under Statues) with Regina Imperatrix incised beneath, looks down the Mall and on the opposite side an oversize mother and three children face the Palace. The two remaining sides have groups of Truth and Justice. Between them a large square pillar rises up to gilt figures representing Courage and Constancy and above them there is a gilt ball on which stands a winged figure of Victory resplendent in gilt, facing down the Mall.

The base has two large fountain basins fed from bronze masks in

Eros, by Sir Alfred Gilbert, R.A.

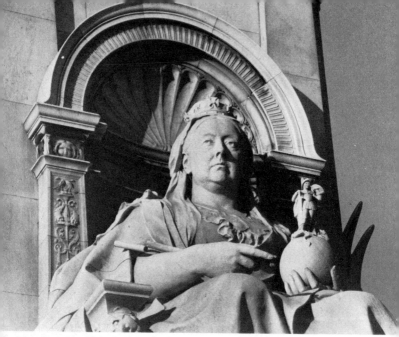

Queen Victoria holding an orb surmounted by a St George and Dragon, by Sir Thomas Brock, R.A.

the corners with, on one side, a bronze mermaid and on the other a merman. Between the fountains, tiers of steps rise up to the centre piece; each is guarded by bronze lions with, on the Mall side, a man holding a torch, Progress, and a woman with a branch, Peace, while on the other side a woman with a scythe, Agriculture, is beside the lion and the man in a long blacksmith's apron holds a heavy hammer, Manufacture. There are some charming marble bas-reliefs of Neptune and his horses besides numerous statues and prows of boats.

The whole impression is that it was designed on a grandiose scale such as one would expect of a Memorial to a Queen of a vast empire and it cost the enormous sum of £325,000. It was made out of 2300 tons of marble. Begun in 1906, it was opened by George V in 1911, when he knighted Thomas Brock the sculptor, although it was not finally completed until 1924.

Chelsea

Boy with Cat
Across Oakley Street there are some gardens in front of the big
Cheyne Walk houses and beyond the bust of Rossetti (q.v. under
Statues) there is a charming child holding a cat nearly as big as
himself. It was put there in memory of Jacqueline Theodora
Cockburn (1894–1948) in 1925 and is by P. Lindsay Clark.

Damer Dawson O.B.E.
At the extreme west end of the gardens in Cheyne Walk there is a
small stone birdbath to the memory of Miss Damer Dawson
(1876–1920), who used to live near by at 10 Cheyne Row. She was
the founder, in 1915, and first head of the Woman's Police Force,
for which she was given the O.B.E. It was designed by Charles
Pibworth and put up in 1933. In the same garden is the statue to
Carlyle (*see under* Statues).

Roper Gardens
Opposite the entrance to Chelsea Old Church some public gardens
were opened in 1964. They are on the site of buildings destroyed by
a parachute mine that fell on 17 April 1941 and are called Roper
Gardens, as they are on the site of part of the land that formed a
marriage gift from Sir Thomas More to his favourite daughter
Margaret, when she married William Roper in 1544. There is a
bronze plaque on the wall recording this.
 In the Gardens there is a stone nude by Epstein (q.v.) and
Awakening, a nude on a tall column by Gilbert Ledward, also a special
dog pole, the first public convenience for dogs in London.

City

Holborn Bars
A third City boundary mark is in Holborn near the bottom of
Gray's Inn Road. On either side of the road are small pillars called
Holborn Bars. They mark the site of former toll gates. The original
ones date back to 1222.

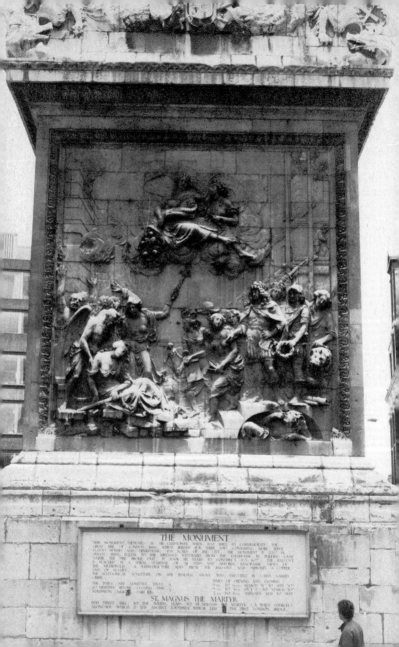

London Stone

The Romans specialized in measuring distances on all their roads, and something that looks like a large milestone is behind an iron grille on the front of the building at 111 Cannon Street opposite the station. It is said to be a *miliarium*, a Roman milestone, and that all distances from London were measured from this point. Previously the stone was on the south side of the street. When the street was widened, it was put in St. Swithin's church in 1869. The church was badly bombed in the Second World War and then demolished, but the stone was saved and it was moved to its present site on the north side in 1962.

Being at street level it tends to become a rubbish dump and it is a pity that neither the authorities nor the occupiers of the building do much about it.

The Monument

The tallest monument is the Monument which was erected between 1671 and 1677. It was designed by Sir Christopher Wren to commemorate the Great Fire of London which started on 2 September 1666 in Pudding Lane and ended near Pie Corner five days later. It devastated over 13,000 houses, 89 churches and 460 streets covering an area of 436 acres which included St. Paul's Cathedral.

The Monument, near Monument station, is sited 202 feet from where the fire started and is 202 feet high. The fluted Doric column of Portland stone is surmounted by a golden ball of flame. Three hundred and eleven steps take one up to a platform that was enclosed in 1842 to prevent any further suicides. The total cost was £13,700.

The north side of the base has a description of the fire in Latin. In 1681 a further inscription attributing the cause of the fire to Papists was added saying that 'Popish frenzy which wrought such horrors is not yet quenched'. Catholic James II had it obliterated, but Protestant William III had it replaced and incised even deeper. It was finally removed in 1830, the year after the Catholic Emancipation Act. The east side has a list of the Lord Mayors and

Panel on the west side of the Monument, by Caius Gabriel Cibber

the south a tribute, also in Latin, to Charles II, who was king at the
time. There are translations beneath each. The interesting side is on
the west, towards London Bridge, which has a bold relief depicting
various mythical figures and Charles II in Roman dress arriving at
the scene of the fire. His right arm is outstretched and his fingers are
resting, not for the first time, on a naked breast. It is the work of
Caius Gabriel Cibber and was sculpted in 1672.

The Protestant Martyrs (Smithfield)
People who died here include some Protestant martyrs who were burnt
at the stake by Bloody Mary. A granite plaque put up in 1870 in the
wall of Bart's near the Wallace Memorial mentions three by name as
having 'suffered death by fire for the faith of Christ in the years 1555,
1556, 1557'. Foxe in his *Book of Martyrs* refers to them.

Part of a panel on the Monument. The penultimate line is the provocative one

Temple Bar

Opposite the Law Courts at the Fleet Street end of the Strand there stands Temple Bar, which was put up in 1880. It is thirty-one-and-a-half feet high and cost £10,000. It marks the City boundary and replaced the important gateway of the same name designed by Sir Christopher Wren and erected in 1672. This had been removed in 1877 because of traffic problems and later erected in Theobald's Park near Cheshunt, where it no longer has traitors' heads to adorn it, as shown in old prints.

The present memorial was designed by Sir Horace Jones who designed Billingsgate Market. The figures of Queen Victoria and Edward, Prince of Wales, were by Sir Joseph Edgar Boehm, while the griffin surmounting it is by Charles Birch, R.A. There are bronze reliefs, one of which shows Queen Victoria being driven through the old Temple Bar. Another shows Queen Victoria in a state coach on her way to the Guildhall in 1837. It is the usual stopping-place for

ANY AS 436 ACRES, EXTENDED ON ONE
OF THE THAMES TO THE CHURCH OF
THE NORTH—EAST GATE ALONG THE
RCILESS TO THE WEALTH AND ESTATES
THEIR LIVES, SO AS THROUGHOUT TO
THE WORLD BY FIRE. THE HAVOC WAS
SAME CITY MOST PROSPEROUS AND NO
IT HAD NOW ALTOGETHER VANQUISHED
THE BIDDING, AS WE MAY WELL BELIEVE
COURSE AND EVERYWHERE DIED OUT.
SUCH HORRORS, IS NOT YET QUENCHED.)
1681 AND FINALLY DELETED IN 1830.

royalty going to the City and the sovereign is offered a sword by the Lord Mayor, but custom demands that it is returned.

William Wallace (Smithfield)

On the Wall of Bart's, London's oldest hospital, founded in 1123, there is a memorial to that great Scottish patriot Sir William Wallace, who was such a thorn in the side of the English and whom he defeated at Stirling Bridge. His national monument stands on Abbey Craig near Stirling. He successfully raided the north of England but retribution came and Edward I routed his army at Falkirk in 1298, thanks partly to his cavalry having deserted him. After being convicted in Westminster Hall he was hanged, drawn and quartered near this tablet on 23 August 1305 and his quarters were sent to Perth, Stirling, Berwick and Newcastle. The memorial is adorned with a lion of Scotland, two St. Andrew's crosses and *Bas Agus Bueardh*, which is Gaelic for 'Death and Victory'. It was put up in 1956. On his anniversary, flowers with sympathetic messages are left below it and one year a banner proclaimed, 'Wallace was right'.

Cricketers

Dr. W. G. Grace and Sir Jack Hobbs Gates

Two famous cricketers have had memorial gates put up to them. The main entrance gates at Lords were designed by Sir Herbert Baker in 1923 'to the memory of William Gilbert Grace the great cricketer 1848–1915'. At the top of the stone central pillar are the initials W. G. G. and above that a set of stumps and bails. Below is a ball, and on each side there is a bat, while a lion sits on top.

At Kennington Oval Sir Jack Hobbs is commemorated by a single iron gate with his name above and 'in honour of a great Surrey and England cricketer'. Hobbs scored more runs and made more centuries than any other cricketer before or since. 1934.

Kensington Gardens

Albert Memorial

By far the most controversial memorial is Prince Albert's, which
stands in Kensington Gardens opposite the Albert Hall. It is the
epitome of mid-Victorian art being gothic, florid, grandiose and
telling a story. It is big in conception and of superb workmanship. It
cost £120,000 and took from 1864 to 1872 to complete though it was
not unveiled until 1876. Sir George Gilbert Scott, R.A. was the
architect.

Starting from the bottom, steps lead up to a square enclosure with
very fine marble groups at the four corners representing Europe,
Asia, Africa and America, each with their symbolic animal, namely
bull, elephant, camel and bison. Although by different sculptors
(Macdowell, Foley, Theed and Bell respectively) they have a
homogeneous effect. More steps take one to the podium of the main
structure, where we find one of the most interesting features, the one
hundred and sixty-nine portrait figures, all named, of those who
were in 1863 considered to be the world's greatest in the realms of
poetry and music, painting, architecture and sculpture. One sees
how values have changed if one looks at the architects' panel with
Wren, Inigo Jones, Mansard, Thorpe and Palladio next to each other.
Why Thorpe in that august company? Similarly, the painting group
has Fra Angelico, Giotto, Orcagna and Cimabue. Was Orcagna
every really considered in that class? The podium sculptors were
H. H. Armstead, R.A. and J. B. Philip. Giotto is the only person to
appear on two panels.

Above these are four projecting groups, Agriculture by Calder
Marshall, Manufacture by Henry Weekes, Commerce by Thomas
Thornycroft and Engineering by John Lawlor and in ascending tiers
there are over twenty figures running up to the 175 foot high cross.
As Scott said, but in different words, the higher the holier, and so he
put Faith, Hope, Charity and Humility under the cross.

There is every type of material; granite from Cornwall and Mull,
sandstone from Derbyshire, besides limestone, slate, marble and
mosaics from Murano. This Memorial is probably more hated or
loved than any other. Epstein, who lived nearby, doffed his hat to it

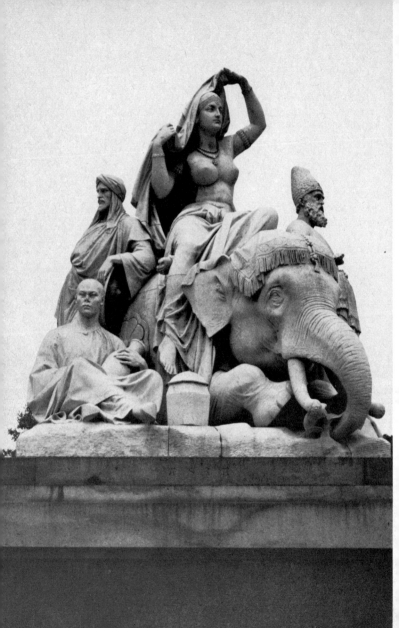

when passing.

About the only damage it received in the last war was an absolutely clean removal of Asia's right breast.

The statue by Foley is described in the Statue chapter.

John Hanning Speke

The source of the Nile had been a matter of speculation for centuries, but it had to wait till Victorian times before it was discovered. John Hanning Speke (1827–64) served in India before joining Richard Burton on a most hazardous expedition into Somaliland in 1854. Three years later the two set out from East Africa to search for the Equatorial Lakes. While going off on his own, Speke discovered the Victoria Nyanza which he thought might prove to be the source of the Nile, but it was not till he went out again in 1860 with Captain Grant that he found the lake and the river flowing out of it.

On the morning of a day when Speke was to argue about the source with Burton at a British Association meeting at Bath, he shot

Asia (Albert Memorial), by J. H. Foley, R.A. (*left*)

Part of podium of Albert Memorial depicting poets, by H. H. Armstead (*below*)

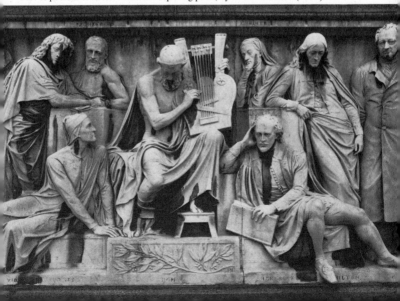

himself, presumably accidentally, when partridge shooting.

Beside the Lancaster Walk in Kensington Gardens there is a granite obelisk with his name and dates, placed there in 1866. Children who have been told it was a monument to Speke have been known to approach it and say 'Speak'.

North London

Whittington Stone

One of the most romantic stories that concern the City of London is the one about Dick Whittington and his cat. According to the old tale, Dick decided that London had no future for him, so he left with his bundle and a cat and, seeing Highgate Hill ahead of him, rested on a stone. It was then that he heard Bow Bells pealing and sounding like, 'Turn again Whittington, thrice Lord Mayor of London'. Dick did return, prospered and became Lord Mayor four times. A stone, though probably not the original one, was there until around 1795, when it was replaced by one marked 'Whittington Stone'. This in turn was replaced by the present one in 1821 which is on the left at the bottom of Highgate Hill. It is now surrounded by railings. His cat, which is such a feature of his pantomime, was not put on the stone until 1964. Its head is turned towards London as if listening to the bells.

South of the River

Braidwood Memorial

One of the more serious fires of London occurred in Tooley Street in 1861 when a vast quantity of timber caught fire. The damage was assessed at £2 million, and in the struggle to control it a wall fell down, killing James Braidwood, the chief officer of the Metropolitan Fire Brigade. He was a highly respected man and a memorial has

been put up to him on the side wall of 33 Tooley Street, at the corner of Hay's Lane. Important reforms took place as a result of this catastrophe. A marble slab depicts houses belching out smoke and below are firemen's helmets and tools. Inside a wreath it tells how Braidwood died. Braidwood Street is the next street away. 1862. By S. H. Gardner.

The Bristow Memorial
Brockwell Park, opposite Herne Hill Station, is one of the largest parks in London. One of the leading lights in planning the Park was T. L. Bristow, M.P. who died during the opening ceremony in 1892. A fountain was erected in his memory.

David Copperfield
On the Southwark side of the Old Kent Road there is the tiny David Copperfield Garden. A very small stone child holding up a conch shell was placed there in 1931 by the Dickens Fellowship 'to connect the spot with the flight of David Copperfield to his Aunt at Dover'. He was recorded as having stopped in the Old Kent Road and been given a drink of water.

Felix Mendelssohn-Bartholdy
Mendelssohn (1809–47) paid ten visits to Britain, one of which produced his famous song-cycle Fingal's Cave, named after that remarkable cave on the Isle of Staffa.

During one London visit Mendelssohn composed his 'Spring Song' whilst staying in Denmark Hill in 1842 and this is commemorated by a sundial in Ruskin Park, named after John Ruskin, the famous art critic who lived nearby from 1823–71. It was put there when the Park was opened in 1907.

Tower Hamlets

Baroness Burdett-Coutts (in Victoria Park)
Angela Burdett-Coutts was a remarkable woman, besides being one
of the richest, and also a great philanthropist. Her father was Sir
Francis Burdett, a famous liberal-minded M.P. and her mother the
daughter of Thomas Coutts, head of the famous Bank. At his death
in 1822 he left the Bank and its future entirely to Angela, although
she was only aged eight, but it was a wise decision as she was
extremely astute and successful. She later added Coutts to her
surname.

She was a great friend of Charles Dickens and with him founded a
home for fallen women. The great Duke of Wellington, although
fifty-five years older, fell in love with her and she with him, and it is
just possible that they married secretly.

Queen Victoria created her Baroness Burdett-Coutts of Highgate,
in 1871, the first woman to be made a Baroness in her own right,
and then to everyone's surprise she married in 1880 an obscure
American, William Ashmead Bartlett, half her age. She died aged
ninety-two and hers was the last body to be buried in Westminster
Abbey. Since then only ashes have been accepted. Apart from her
plaque by the west door she is best remembered by the elaborate
gothic-style fountain she gave to Victoria Park in 1867. It cost
£7,000 and is impressive. H. A. Darbishire was the architect.

Edward VII Memorial Park: 16th-century Navigators
Part of the King Edward VII Memorial Park in Shadwell is over the
Rotherhithe Tunnel. It is on the site of the old Shadwell Fish
Market and it was from here in 1553 that a number of ships set sail
under the command of Sir Hugh Willoughby to search for a north-
east passage to India. A storm separated the ships and Willoughby
and his crew died off the north of Russia. Sir Martin Frobisher in
1576 set off to find the north-west passage but failed, though he
made two other unsuccessful attempts. The names of crews and
other officers are on a tablet. The Park, opened in 1922, runs along
The Highway. There is a monument to Edward VII with a
medallion (*See under* Statues).

Virginia Settlers Memorial
The Virginia settlers of 1606 sailed to America in three small boats:
the Susan Constant, 100 tons; Godspeed, 40 tons; and Discovery,
20 tons. They named the place they landed at Jamestown after
James I. Although at one time the settlers were down to only fifty
people they established Virginia and ensured the future of America.
The sailing is recorded on a tablet at Brunswick Wharf which was
presented by the people of Virginia in 1928 and moved to its present
site, where it can best be seen from the river, in 1971. Permission to
view can at times be obtained from the London Electricity Board.

See also Princess Pocahontas and Captain Smith under Statues.

4 Obelisks and Columns

There is something very attractive about the obelisk form; that tapering monolith which has a pyramidic shape whether it be four or three sided. There are very few in London but much the finest is the brass Crosby obelisk in the garden of the Imperial War Museum, near St. George's Circus. It has a glorious proportion, well in keeping with it's square base. The Andrew Miller one in the King's Road is also very graceful. Both the Chillianwallah and the Katyn obelisks come under war memorials.

Cleopatra's Needle does not look nearly as important as it obviously is and its present setting hardly does it justice.

When it comes to columns there are even fewer. The important ones are huge and either commemorate the Great Fire, like the Monument, or they have a statue of Nelson or the Duke of York on top of them. The less said about the pillar at Orme Square the better, so one is really only left with the two columns in Portland Place outside the Royal Institute of British Architects, which are by James Woodford and have a modern motif; or the British Oxygen pillar at Hammersmith.

Obelisks

NAME	SITE	MATERIAL	ERECTED
Joseph Réné Bellot	By Greenwich Pier	Granite	1855
Brass Crosby	Imperial War Museum grounds	Stone	1905
Chillianwallah	Chelsea Hospital	Granite	1853
Cleopatra's Needle	Victoria Embankment	Stone	1878
Samuel Gurney	High Street, Stratford	Granite	1851
Katyn *see under* Regimental War Memorials	Gunnersbury Cemetery	Granite	1976
Andrew Miller	Kings Road, S.W.3	Stone	1751
J. H. Speke	Kensington Gardens	Granite	1866
Robert Waitham	Salisbury Square, E.C.4	Granite	1833
Metropolitan Board of Works	City Road, E.C.1	Granite	1876

Columns

NAME	SITE	MATERIAL	ERECTED
Birth of Life	near Hammersmith Broadway	Marble	1962
Brentford Column	Ferry Lane, Brentford	Granite	1909
Duke of York's	Waterloo Place, S.W.1	Granite	1834
Monument	Monument Street, E.C.3	Portland Stone	1677
Nelson's	Trafalgar Square	Granite	1843
Orme Square	Orme Square, W.2	Stone	1814
Royal Institute of British Architects.			
Westminster Old Boys *see* Regimental War Memorials	Portland Place, W.1.	Stone	1934

Obelisks

Cleopatra's Needle

The oldest monument, Cleopatra's Needle, dates from about 1450 B.C. when it was erected as one of a pair at Heliopolis. One side of the column records some of the history of Rameses the Great. The Emperor Augustus moved them to Alexandria in 23 B.C., seven years after the death of Cleopatra, so it has never been anything to do with her, although as she died in Alexandria she became associated with it. The French were routed by Nelson at the Battle of the Nile in 1798 and on land three years later by Sir Ralph Abercrombie. The troops thought the column would make a good war trophy, but as it is 186 tons of pink granite there were difficulties in moving it. It was not till 1819 that the Viceroy of Egypt, Mohammed Ali, officially presented it to Britain, though its journey here did not take place until 1878. It was crated and the sixty-eight foot column was towed, but it was twice abandoned in the Bay of Biscay because of storms. A bronze plaque on the base records the adventurous journey. The obelisks in the Place de la Concorde, Paris and Central Park, New York, are companion pieces, but comparing the majestic setting of the one in Paris with this one makes one realize that an opportunity has been missed.

The bronze nineteen-foot-long sphinxes on either side face inward. They were designed by George Vulliamy, modelled by C. H. Mabey and erected in 1882. They are copies of the basalt sphinxes from the time of Thothmes III. The bomb scars visible on them are from the First World War. British coins of 1878, the year it was erected, Bradshaw's Rail Guide, a picture of Queen Victoria, a case of cigars and the newspapers of the day were buried under the Obelisk together with an extraordinary collection of hairpins, children's toys and endless bric-à-brac.

In 1979 the Needle was cleaned and it took on a pinkish colour. An Arab who wishes to remain anonymous contributed generously toward the cost.

Andrew Miller
Almost opposite the top of Oakley Street in the King's Road there is
an open space with a graceful tapering stone obelisk. This was
erected in 1751 in memory of a well-known bookseller, Andrew
Miller, and others of his family. There are inscriptions on three sides
of the base, but almost the only name not effaced by age is Mrs.
Margaret Johnston. The fourth side has an achievement of arms and
a motto. It is surmounted by an urn.

Brass Crosby Obelisk
The best proportioned of all the obelisks is the stone one that was
erected in 1771 in the centre of St. George's Circus near the
Elephant and Castle. It was moved a few yards to the edge of the
grounds of the Imperial War Museum in 1905. Deeply incised on
one side of the square base it says, 'One mile XXXX feet from
London Bridge' and on the other sides, 'One mile from Palace Yard
Westminster Hall' and, 'One Mile CCCC feet from Fleet Street'. At
the base of the front it states, 'The Right Hon. Brass Crosby Esquire
Lord Mayor'.
 Brass Crosby (1725–93) was a staunch supporter of liberty. He
was prepared to back his principles, so much so that on one
occasion he found himself committed to the Tower for resisting the
authority of Parliament. He was a friend of Wilkes.

Robert Waitham
A granite obelisk with a gilt top stands in the centre of Salisbury
Square in the shadow of St. Bride's, Fleet Street as a memorial to
Robert Waitham, Lord Mayor of London 1823–4. He was M.P.
1823–4 and again 1826–33, the year of his death. It was erected by
his friends and fellow citizens in 1833 with the words, 'The friend of
Liberty in evil times'.

Joseph Réné Bellot
On the river front near Greenwich Pier there is a thirty-five-foot
high obelisk of red Aberdeen granite to a Frenchman, Joseph Bellot
(1826–53). It was the work of Philip Hardwick, who was famous for
designing the original Euston Station and Arch, and it was erected
in 1855.

Joseph Bellot, born in Paris, distinguished himself in the expedition to Madagascar and was made a member of the Legion of Honour. He served in South America and later in 1852 joined Captain Inglefield in the search for Sir John Franklin (q.v.). He discovered Bellot Strait, and the next year he was drowned attempting to carry dispatches over the ice. He was held in great esteem by both the English and the French.

Samuel Gurney
The obelisk at the junction of West Ham Lane and High Street, Stratford, was erected by the fellow parishioners and friends of Samuel Gurney in 1851. The obelisk, which is also a fountain, is in granite and stands on an island.

Metropolitan Board of Works
At the junction of City Road, Old Street and East Street there is a form of obelisk. It is a granite column with a ball on top and was put up in 1876 by the Metropolitan Board of Works.

Chillianwallah, Royal Hospital, Chelsea *See under* War Memorials

Katyn, Gunnersbury Cemetery *See under* War Memorials

John Hanning Speke *See under* Memorials

Columns

Brentford Column
If you follow Kew Bridge Road away from London for about three-quarters of a mile from Kew Bridge, there is a small turning down to the River called Ferry Lane. At the bottom on the right there is a tall granite cylinder with the most unexpected items of history inscribed on it. There is a small creek and wharves beside it. The most important item states that in '54 B.C. at this ancient fortified ford the British tribesmen under Cassivellaunus bravely

opposed Julius Caesar on his march to Verulamium'. Moving on to
A.D. 780–1, 'Nearby Offa King of Mercia with his Queen and
Bishops and Principal Officers held a council of the church.' Then at
the top of the rear part of the column we read, 'A.D. 1642: Close by
was fought the Battle of Brentford between the forces of King
Charles I and the Parliament'. There is no mention of the result, but
the Cavaliers, largely thanks to Prince Rupert, won the day. Below
this we find, 'A.D. 1909: The identity of the place has been recently
established by the discovery of the remains of lines of oak palisades
extending both along this bank and in the bed of the river.'

Royal Institute of British Architects
Two stone columns were put up in front of the entrance to the
R.I.B.A. in 66 Portland Place. On top of each is a carving by James
Woodford, R.A. of a man and a woman referred to in the Sculpture
chapter. 1934.

Orme Square
In Orme Square, off the Bayswater Road, there is a column with a
bird on top that is not a very convincing eagle. It is supposed to
commemorate the visit of Czar Alexander I and some Allied leaders
to London in 1814, but the eagle is certainly not a double-headed
Russian eagle.

The Birth of Life
See also under David Wynne in the Sculptors chapter for details of
the column in front of the British Oxygen building, near
Hammersmith Broadway.

The Monument *See* Memorials 1677: 202 feet high

Nelson's Column *See* Statues 1843: 185 feet high

Duke of York's Column *See* Statues 1834: 137½ feet high

Westminster Old Boys Column *See* War Memorials.

5 Regimental and other War Memorials

Wars inevitably produce war memorials and most parishes, especially in the country, have something commemorating the last two world wars, but these are not included. What follows is largely in chronological order and the memorials to the various campaigns and wars are described. Some, like the Machine Gun Corps and the Royal Artillery of the First World War, are works of art of very high quality. Their contrast in design is extreme, but something utterly different is H.M.S. *President*, moored to Victoria Embankment, which is a memorial to the Royal Naval Volunteer Reserve. Then again there are the touching tributes to the members of the Women's Transport Services and of the Free French who went to Europe to contact the Resistance, many of whom did not return.

The War Memorial that probably impresses the most with its simplicity is the Cenotaph. It serves its purpose admirably and has a dateless look about it that is a great credit to Sir Edwin Lutyens, its

The Cadiz Memorial, Horse Guards Parade. The equestrian statues behind are, first, Lord Roberts and, beyond, Viscount Wolseley

designer. The word 'cenotaph' is given in the dictionary as meaning 'a sepulchral monument to person whose body is elsewhere'.

The Cadiz Memorial
The earliest one is the fascinating Cadiz Memorial on Horse Guards Parade near Lord Roberts's statue. An enormous mortar is supported by an even bigger dragon with wings which coil round it. The rectangular base has large Prince of Wales' feathers in front, and at the back it says that it was constructed by the carriage department of the Royal Arsenal in 1814. One side mentions the relief of Cadiz and how 'this mortar cast for the destruction of that great port with powers surpassing all others and abandoned by the besiegers on their retreat was presented by the Spanish Nation to his Royal Highness the Prince Regent'. There is a somewhat fuller description in Latin on the other side.

It is a magnificent piece and it is a pity it is hidden away in this remote corner.

Chillianwallah
At the river end of the main court of Chelsea Hospital there is a granite obelisk by Charles Cockerell commemorating the battle of Chillianwallah in 1849, after which the Sikhs accepted British rule, it being the decisive battle of the second Sikh War. It lists the 255 officers and men killed. Erected in 1853.

Westminster Old Boys
In front of the west front of Westminster Abbey there is a bad example of Victorian Gothic in the form of a tall column of red granite. It is to the old boys of Westminster School who were killed in the 'Russian-Indian' wars and to Lord Raglan the incompetent Commander-in-Chief in the Crimean War, who was also an Old Boy. High up this column are four small seated stone statues of Edward the Confessor (facing the Abbey) and Henry III, the two principal builders of Westminster Abbey, Elizabeth I, the second Founder of the school which she faces, and Queen Victoria (facing Victoria Street), by J. R. Clayton. The four lions at the base are by J. Birnie Philip and the overall design was by Sir George Gilbert Scott. 1861.

Crimean War

Guards Crimean
The Guards have a monument in Waterloo Place to their 22,162
guardsmen who fell in the Crimean War. John Bell, who designed it,
used captured cannon to cast the figures, and at the back there is a
trophy of captured guns actually used at Sebastopol. The bronze
figures show a Grenadier, a Fusilier and a Coldstreamer. Beside it
are statues of Florence Nightingale and Sydney Herbert, the then
Secretary of War. (q.v.)

Boer War

The Royal Marines
Near Admiralty Arch and opposite Captain Cook there is a bronze
Marine in a defiant pose with his rifle and bayonet as if defending
the fallen comrade beside him. At the rear are names of those fallen
in China and South Africa and on the sides are battle scenes from
both areas of war, one being the repulse of the Chinese attack on the
Peking Legation and the other an action at Graspan in South
Africa. Both are by Sir Thomas Graham Jackson, R.A. Adrian
Jones was the sculptor of the Marines. Erected in 1903.

The Carabiniers (sic)
At a corner of the Embankment opposite Chelsea Bridge there is a
Victorian-looking memorial. On a red brick surround, Adrian
Jones's large bronze plaque has a relief of a mounted officer holding
three horses and the three troopers climbing up the hill in the
background on a scouting patrol. Above is a bronze trophy of flags
and the regimental badge surmounted by a plumed helmet. Beside
it are lists of the 6th Dragoon Guards, the Carabiniers, officers and
men who died in the Boer War. It was erected in 1905.

Royal Artillery, South Africa
On the south side of the Mall near Admiralty Arch there is a large
stone memorial with over 1000 names of gunners killed in the Boer
War. In the centre, on a high stone pedestal, there is a bronze frieze
and on top a bronze winged figure of Peace trying to control a steed.
William Colton R.A. 1910.

First and Second World Wars

The Cenotaph
The word 'cenotaph' means 'monument to someone who is buried
elsewhere' and the original temporary plaster one by Sir Edwin
Lutyens, P.R.A. was erected in the centre of Whitehall for the
Victory march-past in 1919. It was so appreciated that he produced
the present one in Portland stone the following year. There are no
religious symbols on it, as soldiers of all creeds are commemorated.
The wording on it is 'To the Glorious Dead' and refers to both
World Wars.

Every second Sunday in November there is a service of
Remembrance attended by members of the Royal Family, the
Cabinet and the Forces, when a two-minute silence is observed at
11 a.m.

Guards Division
In St. James's Park exactly opposite the Horse Guards building
there is a 36-foot-high, 170-ton form of cenotaph in Portland stone
designed by H. C. Bradshaw, to the memory of the men of the
Guards Division killed in the 1914–18 War. The heavy casualties
included 14,760 killed and 28,398 wounded out of 2,007 officers and
61,544 men which represents nearly 70 per cent casualties.

Bronze statues by Gilbert Ledward of guardsmen of the five
regiments, namely Grenadiers, Scots, Welsh, Irish and Coldstream,
line the front. They were cast from German guns captured by the
Guards Division. Other regiments like the Artillery and Engineers
are represented in the plaques on the sides and rear of the

monument. It was unveiled in 1926 by the Duke of Connaught in
the presence of General Higginson, a centenarian Grenadier.

The marks of a bomb from the last war can still be seen, but the
three soldiers damaged have been repaired.

Royal Navy: Submarines
On the Thames Embankment wall opposite the Temple Gardens
there is a large bronze plaque commemorating those lost in
submarines in the two Great Wars. The centre has a relief of the
control room of a First War submarine, and on either side are
ethereal figures which seem to be floating about the ocean bed.
There are lists of the submarines lost in each war, and at each end
are figures of Truth and Justice, who is blindfolded. Underneath
there is a First War submarine on the surface. The original design
dated from 1922 and was by F. Brook Hatch and A. H. Ryan
Tenison. Alterations were added to include the Second War.

Royal Naval Volunteer Reserve: H.M.S. *President*
One of the most original War Memorials is H.M.S. *President*, a
2,200 ton convoy vessel which was moored alongside Victoria
Embankment very near to Blackfriars Bridge in 1929. It serves as a
memorial to the Royal Naval Volunteer Reserve, and bronze panels
at the top of the steps bear the inscription: 'Honour and remember
those officers and men of the London Division Royal Naval
Volunteer Reserve who gave their lives 1914–1919'. There are five
columns of names on each panel. In both wars the R.N.V.R. was
known as the Wavy Navy, as the rings of rank the officers wore on
their sleeves were wavy instead of being straight, as in the Royal
Navy. A 1939–45 inscription is below the First War panel.

Cavalry Memorial
The Cavalry Memorial was erected in 1924 at Stanhope Gate, Hyde
Park, in front of the Dorchester Hotel. When Park Lane was
replanned, the whole memorial was moved in 1961 about 300 yards
towards Serpentine Road, not far from the bandstand. It was put on
a large plinth with a back wall with lists of Cavalry Regiments

Royal Artillery Memorial 1914–18, by C. S. Jagger, A.R.A. and Lionel Pearson

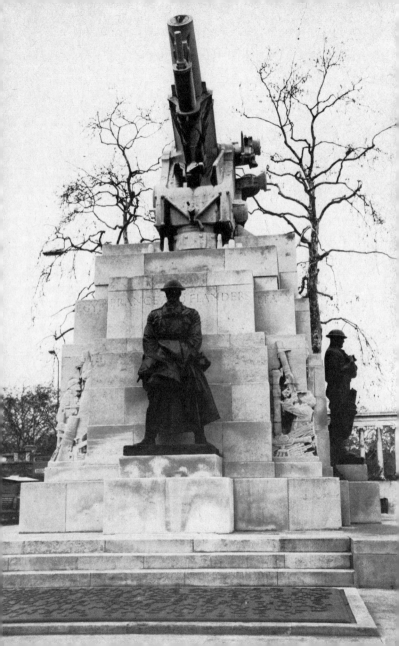

involved in the Great War, including Yeomanry and those of
Australia, Canada, New Zealand and South Africa, which greatly
improved it.

St. George holds his sword up in the air. The dragon is dead, with
a broken lance projecting from him. Round the plinth there is a
bronze frieze of various cavalrymen.

The sculptor was a cavalryman, Captain Adrian Jones, M.V.O.

The sculpture was taken from a very rare set of late fifteenth
century Gothic armour in the Wallace Collection which was
designed for both horse and man and which originally came from
the Hohenaschau castle in Bavaria.

Royal Artillery

One of the most impressive war memorials is the large Portland
stone erection to the Royal Artillery at Hyde Park Corner. A life-
size 9.2 inch howitzer points to the sky. Below it at each side and in
front are bronzes of three soldiers dramatically portrayed, while
behind it, beneath the Royal Arms, is a dead gunner with the words,
'Here was a royal fellowship of death' inscribed. The sides of the

The Rifle Brigade Memorial, by John Tweed

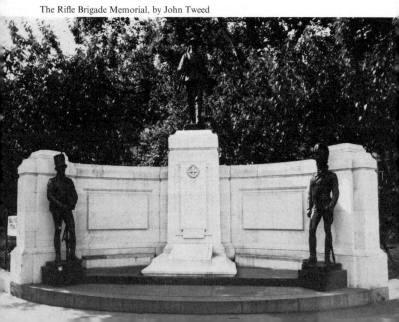

memorial are incised with battle scenes and theatres of war. C. Sargeant Jagger was the sculptor, with Lionel Pearson doing the base. It is a superb work. 1925.

Rifle Brigade

One of the best war memorials is 'In memory of the 11,515 officers, Warrant Officers, Non Commissioned Officers and Riflemen of the Rifle Brigade who fell in the Great War 1914–1918'. A further slab has been added to the 1,329 casualties of the 1939–45 War. There is a high curved stone wall with a bronze First War rifleman in the centre on top, while standing on the floor of the memorial is an oversize bronze rifleman in the uniform of 1806 on the left and an officer of 1800 on the right. It stands at the corner of Grosvenor Gardens and Hobart Place (at one time known as Suicides' Corner) and is a beautifully balanced memorial with bronzes by John Tweed 1924.

Machine Gun Corps

The imposing Machine Gun Corps Memorial of 1925 at Hyde Park Corner was moved from below the Royal Artillery Memorial to its present place behind it in 1953. Derwent Wood has had cast a very fine eight-foot bronze nude of David holding a sword nearly as tall as himself. On either side on the marble plinth are wreathed Vickers machine guns and the apt inscription, 'Saul hath slain his thousands, and David his ten thousands'. A copy of the prototype is in Cheyne Walk.

Royal Fusiliers

The City of London Regiment of the Royal Fusiliers has a monument in the middle of Holborn at the bottom of Gray's Inn Road. A soldier carrying his rifle and bayonet is standing on top of it. The model was a First War Sergeant of the Regiment who died of wounds on VE Day of the Second War. Alfred Toft. 1924.

24th Division

Battersea Park has the only modern First War memorial. Eric Kennington, A.R.A. has bunched together three soldiers with rifles and tin hats on a small round plinth. It all looks very uncomfortable, and to make it more complicated their feet are entwined in a fat serpent. 1924.

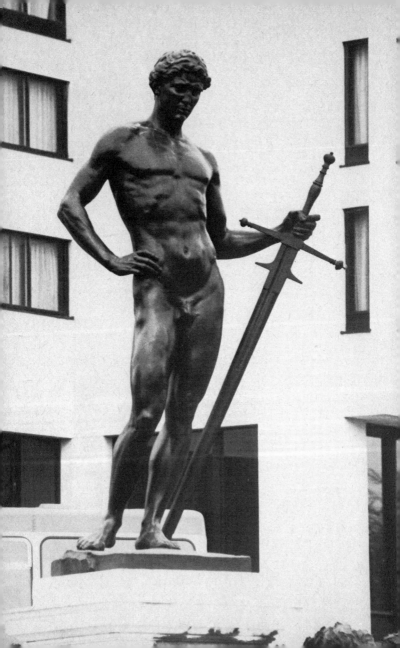

London Troops
Just in front of the Royal Exchange there is a monument to London Troops of both wars designed by Sir Aston Webb with figures by Alfred Dury. A bronze soldier stands on either side and on top of it there is a lion holding a shield.

Imperial Camel Corps
An unusual but charming memorial is to the Imperial Camel Corps. It is in the Victoria Embankment Gardens and has a soldier riding a miniature bronze camel. The sculptor, Major Cecil Brown, had first-hand knowledge of camels. On the side of the plinth are campaign scenes. 1920.

Civil Service Rifles
In the courtyard of Somerset House there is a memorial to the 15th County of London Battalion, the London Regiment, the Prince of Wales' Own Civil Service Rifles. A tall square stone column with an urn on the top has regimental colours hanging from two sides. It is in memory of the 1,240 members who fell in the Great War of 1914–18 and was put up in 1919.

The Rangers
In the First War the 2nd County of London Regiment was known as The Rangers and saw service in most of the great battles in France. In the Second War they were part of the K.R.R.C. and fought in Greece, Crete and the Western Desert. Their memorial in Chenies Street off Tottenham Court Road has a bronze copy of the regimental badge.

Royal Air Force
The Royal Flying Corps and the R.A.F. of both wars are commemorated by Sir Reginald Blomfield's stone pedestal surmounted by a gilded eagle, the design of Sir William Reid Dick, R.A. It was erected in 1923 on Victoria Embankment on the site of Whitehall Stairs.

David, by F. Derwent Wood, R.A.

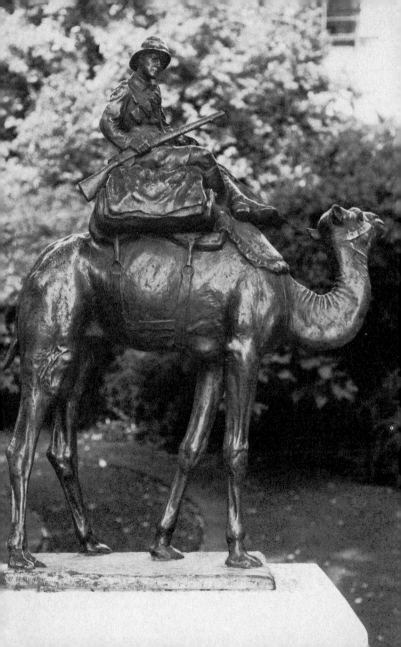

Women's Transport Service (First Aid Nursing Yeomanry)
The Women's Transport Service (F.A.N.Y.) has a memorial on the
north wall outside St. Paul's, Knightsbridge to commemorate those
members who died in the Second War, thirteen as secret agents in
Occupied Europe. Two were awarded the George Cross and six the
Croix de Guerre.

Nurse Cavell
Nurse Edith Cavell, 1865–1915, has her own statue and memorial
on an island opposite the National Portrait Gallery (*see under*
Statues).

Southwark War Memorial
One of the nicest First War memorials is in Borough High Street
near Union Street. It is dedicated 'to the men of St. Saviour,
Southwark who gave their lives for the Empire 1914–1918'. A
bronze soldier with tin hat and rifle slung seems to be plodding
through mud. On the front of the stone plinth there is a dismal-
looking knight in armour, probably St. George, and at the back a
weeping woman and a child. What is of great interest are the bronze
side panels. One depicts biplanes in aerial combat, and the other
shows a battleship with, in the foreground, the foredeck of another
battleship and two gun turrets each with twin guns. It is the work of
P. Lindsey Clark and was erected in 1924.

Merchant Seamen
Very near the Tower of London there is an impressive memorial to
the merchant seamen of both wars. It is in the form of a large
garden with a stone pavilion in the front entirely covered with the
names of the ships and crews lost in the 1914 War. The inscription
reads, 'To the glory of God and to the honour of 12,000 of the
Merchant Navy and Fishing Fleets who had no grave but the sea.
1914–1918.' This was designed by Sir Edwin Lutyens in 1928,
whereas the sunken garden behind it, also with ships' and crews'
names, was the work of Sir Edward Maufe. Its wording reads,
'1939–1945. The 24,000 of the Merchant Navy and Fishing Fleets

The Imperial Camel Corps Memorial, by Major Cecil Brown

whose names are honoured on the walls of this garden gave their lives for their country and have no grave but the sea.'

The Belgian Memorial
A large memorial on the Victoria Embankment almost opposite Cleopatra's Needle was put up as a mark of gratitude by the thousands of Belgians who spent the First World War in England. Sir Reginald Blomfield was the designer and Victor Rousseau the sculptor of the bronze figures.

Free French Forces
Some of the bravest people of the last war were to be found among those who spent their last night in England at 1 Dorset Square, a modest house just off Baker Street. After months of training, these dedicated men and women who were prepared to go to France on missions, often never to return, would be taken up to Dorset Square before being parachuted or flown over to their rendezvous. In peacetime this house had been the headquarters of Bertram Mills's circus.

On its wall is a plaque 'To commemorate the deeds of men and women of the Free French Forces who left this house on special missions to enemy-occupied country and to honour those who did not return'. A version in French is beside it.

General De Gaulle's Message
The Free French Headquarters in London were in 4 Carlton Gardens and on a wall of it there is, below the cross of Lorraine, a copy of de Gaulle's famous broadcast to the French people on 18 June 1940, in which he said, 'France has lost a battle but France has not lost the war'.

Polish Air Force
One of the most efficient Air Force units during the last war was provided by the Poles, who were based at Northolt aerodrome. They were mostly fighter squadrons flying Spitfires and then Mustangs, though they also had four bomber squadrons. They had a very fine record but, as the memorial shows, they suffered very heavy losses. Out of a total of 2,408 they lost 1,241 in operational flights.

Their memorial was designed by M. Lubelski, Polish sculptor who was liberated by the Allies from a forced labour camp in Germany.

A stone base with lists of their squadrons and the zones of battle in which they partook is surmounted by a bronze eagle as if about to take off. It was unveiled in 1948 and it stands at the corner of Northolt aerodrome where West End Road meets Western Avenue.

The Katyn Memorial

Quite the most tragic, besides being the most controversial, monument is the twenty-foot polished black Nubian granite obelisk rising from white steps, erected in 1976 in Gunnersbury Cemetery, which is part of Gunnersbury Park and is near the start of the M4 motorway. On one of its four sides is 'Katyn 1940' and beneath it, on the plinth, is a Polish inscription which, roughly translated, means, 'The Conscience of the World calls for a verification of the truth'. Below in English is, 'In remembrance of 14,500 Polish prisoners of war who disappeared in 1940 from camps at Kozielsk, Starobielsk and Ostaszkow of whom 4,500 were later identified in a mass grave at Katyn near Smolensk.' On the obelisk are two crossed wreaths, and at the point of crossing there are symbols of the three religions most prevalent in Poland, a Christian cross, the crescent of Islam and crossed triangles, the Magen David of Israel. It was designed by Mr. Louis Fitzgibbon and Count Stefan Zamoysky, a stalwart Pole who wore a black tie every day of his life since the war, until his death in 1977.

There was trouble over getting the memorial accepted in some places and the Foreign Office were emphatic that there should be no mention of Russia as being the culprits, although the mention of 1940 clearly indicates their guilt. The Foreign Office also refused an embossed Polish eagle, crowned as in pre-war days and surrounded by a wreath of barbed wire, emblematic of enslaved Poland, as it was considered too provocative.

Norwegian Stones of Commemoration

One of the nations that suffered badly after the Germans occupied their country in April 1940 was Norway. Luckily for Britain, nearly all of her vast fleet of merchant ships decided to make for British bases while in Norway a secret army trained in a remote part of the country where some types of rock were formed some 900 million years ago in the Precambrian age, the oldest period in the earth's

history. One of the granite rocks, nearly seven feet high, has been placed on three smaller ones behind the boat houses on the Serpentine in Hyde Park. The inscription on the back reads 'This boulder was brought here from Norway where it was worn and shaped for thousands of years by forces of nature—frost, running water, rock, sand and ice until it obtained its present shape' and on the front, 'This stone was erected by the Royal Norwegian Navy and the Norwegian Merchant fleet in the year 1978. We thank the British people for friendship and hospitality during the Second World War. You gave us a safe haven in our common struggle for freedom and peace.' A similar stone was unveiled two days before, in Edinburgh, as a token of thanks from the Norwegian Army.

Yalta Memorial

One of the iniquitous results of the Yalta Conference, unfortunately was the tragic agreement between a sick and dying President Roosevelt and Stalin by which all Russians and their dependants who had served in the war—and this included hundreds of thousands of prisoners—were to be returned to Russia whether they wanted to go or not. Some units escaped going back, but most of those who returned were murdered as soon as they arrived in Russia.

Following an appeal many people thought that a memorial should be erected. The sculptor chosen was Angela Conner who is perhaps better known for her portrait sculptures which are on display at Chatsworth and other places of importance. Her design is highly symbolic. Semicircular arms sweep up from a small pool with a span of over fifteen feet and curve round in opposing directions. From their ends jets of water play on a spherical ball that represents the earth and rock it and buffet it about just as the Great Powers pushed the Yalta victims about at the end of the last war. The controversy over the wording proved even more acute than in the Katyn case.

The work, which is in a Hopton stone mix, stands on the small grass island in the Cromwell Road in front of the Victoria and Albert Museum. 1981.

British Medical Association
In the courtyard of the British Medical Association in Tavistock
Square there are some fine iron gates which are the memorial to
doctors who lost their lives in the First World War. Beside them in
the centre of the quadrangle there is a formal pool with a fountain,
and statues by James Woodford, R.A. are placed round it
representing Sacrifice, Cure, Prevention and Application. This was
the Second World War memorial which was completed in 1954.

Spirit of Trade Unionism
Memorial to both World Wars. *See under* Sculpture: Central
London.

St. John's Wood
A very attractive St. George and Dragon on an island site at the
Lord's end of Albert Road, was presented in 1907 by Mr. Sigismund
Goetze, who has given so many fountains to Regent's Park. It later
became a war memorial and is inscribed to 'the men and women of
St. Mary-le-Bone who by their service and sacrifice for King and
Country freely played their part in both Wars'. The sculptor was
C. L. Hartwell.

St. James's Churchyard
The bomb-damaged churchyard of St. James's, Piccadilly was
turned into a restful garden full of benches at the expense of the
newspaper proprietor and philanthropist Viscount Southwood. His
name appears on the stone surround to the fountain by A. F.
Hardiman, which consists of two boys riding dolphins. Behind that
is a bronze figure of Peace holding an olive branch, and near by
stands a stone statue of Mary of Nazareth presented by Sir Charles
Wheeler's widow in 1975 (*and see* Wheeler in Sculptors chapter).
The gardens were opened by Queen Mary on 12 May 1946.

The First City of London Bomb
A stone tablet let into the wall of Fore Street, just round the corner
from Wood Street, says, 'On this site at 12.15 a.m. on the 25th
August, 1940 fell the first bomb on the City of London in the
Second World War'. Many more were to fall.

Holocaust
The Board of Deputies of British Jews organized the erection of a
symbolic piece of sculpture called 'Holocaust' to commemorate the
mass killing of Jews in the last war. They tried to have it placed in
Whitehall itself near the Cenotaph but that was quite rightly
refused. Instead they were given a plot in front of Richmond
Terrace near by.

Woolwich

It would be surprising if there were not a number of military
memorials at Woolwich, but some of them, like the one to Louis
Napoleon, the Prince Imperial, who was a cadet there, have been
moved, as have those of Wellington and Queen Victoria.

The Victory Memorial
The Crimean Memorial was put up in 1860. A bronze figure made
from cannon captured at Sebastopol holds out a laurel wreath, as
if crowning her heroes. It is known as Victory and is the work of
John Bell. It stands on a tall granite pedestal by the Parade Ground
in front of the Royal Artillery Barracks, which has a frontage 1080
feet long, one of the longest in Europe. It commemorates those
members of 'the Royal Regiment of Artillery who fell during the
war with Russia in the years 1854, 1855, 1856'.

Afghan and Zulu War
Just off the Repository Road and not far from the Rotunda there is
the Afghan and Zulu Memorial. There is also a cairn of rough
granite blocks about eighteen feet high. On one side of the central
tablet there is a bronze trophy of Zulu shields and assegais, and on
the other side a similar group of Afghan arms. It was designed by
Count Gleichen and put up in 1882.

Royal Field Artillery
It is also known as the South African War Memorial. On the other
side of Woolwich Common there is a red granite obelisk just south

of St. George's Garrison church in Grand Depot Road. It is to the
memory of the non-commissioned officers and men of the 61st
Battery Royal Field Artillery killed in the South African War.

The Victoria Cross Memorial

Over the altar of old St. George's there is a memorial 'To the glory
of God and in memory of all ranks of the Royal, and late Indian
Artillery who won the Victoria Cross'. It was dedicated in 1920 and
survived the damage caused by a flying bomb in 1944 which
destroyed the Garrison church.

Army Ordnance Corps

Just off Artillery Road behind the Barracks there is a memorial to
the members of the A.O.C. who lost their lives in the Boer War. On
a granite pedestal which serves as a fountain there is a bronze figure
in A.O.C. uniform modelled by F. Coomans which was unveiled in
1905. The monument was designed by C. M. Jordan.

6 Sculptors

Over 280 sculptors with over 600 works are mentioned in the various categories. Only a few of those who have produced statues also appear in the Sculpture section, but they include Sir Charles Wheeler, P.R.A. who, besides sculpting statues of Montagu Norman and others, also did the figures on the façade of the Bank of England, Mary of Nazareth in the churchyard of St. James's, Piccadilly and a modern fountain in George Yard off Lombard Street. The greatest extreme in style comes from Franta Belsky, whose classical bust of Admiral Cunningham in Trafalgar Square is a long way removed from his tall Shell Fountain in South Bank Gardens near the Shell building. The latter is a very original fountain and dates from 1959 to 1961. His sculpture, 'The Lesson', in Bethnal Green is enchanting.

Some people take up serious sculpture late in life, a good example being Capt. Adrian Jones, M.V.O. who, besides being a qualified veterinary surgeon, served as a cavalryman for over twenty years and clearly knew a lot about horses. He sculpted the Cavalry Memorial in Hyde Park and two other war memorials besides the equestrian statue of the Duke of Cambridge in Whitehall. His most important work was the Quadriga at Hyde Park Corner, where his four prancing horses are very effective.

Grinling Gibbons was born in Rotterdam but worked in England nearly all his life. He was discovered by John Evelyn in 1671 and put into the Board of Works. As a carver in wood he is unsurpassed, while his bronze statues of Charles II and James II are superb, as is his stone one of Sir Richard Clayton at St. Thomas's Hospital. Those interested in his work should also see his font in St. James's, Piccadilly.

Caius Gabriel Cibber (1630–1700) was a Dane from Schleswig who did a contemporary statue of Charles II in Soho Square as well as a relief on the Monument. He was made Royal Carver to the King's Closet by William III. Cibber lived in London and his son Colley Cibber (1671–1757) was not only a famous actor but became Poet Laureate.

London is lucky to have works of some of the finest Flemish sculptors, some of whom came over to England and made London their home. Jan van Nost, whose name is sometimes spelt Ost, carved an excellent stone statue of George II looking like a high-ranking Roman, which stands in Golden Square. He also executed a fine lead statue of Sir Robert Geffrye, and its replica at the Geffrye Museum gives one a good idea of his quality. His dates of birth *c*. 1620 vary with different authorities, but there is agreement about his death in 1670.

Peter Scheemakers (1691–1781) was born and died in Antwerp. In his determination to get to Rome he walked there, On his return he came to London, where he stayed till 1771. He was Nollekens's master during most of that period. He worked for Francis Bird and his best-known work is probably Shakespeare's monument in Westminster Abbey, 1741. His two outdoor statues are of Edward VI at St. Thomas' Hospital and Thomas Guy at Guy's.

The third very important Flemish sculptor is Michael Rysbrack (1693–1770), who came to London in 1720 and died there fifty years later. He worked with Gibbs the architect and was, with Roubillac, the most important English sculptor until the arrival of Scheemakers. His Isaac Newton monument in Westminster Abbey is one of his best-known pieces. His London outdoor statues are of George II at Greenwich, also dressed as a Roman, Sir Hans Sloane and Inigo Jones.

Among the French sculptors of this period we are lucky to have some good examples of their earlier sculptures. Louis-François Roubillac settled in London in his thirties and his Sir John Cass (q.v.) is superb. Jean Antoine Houdon went to America to execute a monument to Washington, and there is a copy of this fine work outside the National Gallery. Before both of these, Hubert le Sueur came over to England about 1628, staying till 1642. His splendid equestrian statue of Charles I (q.v.) stands in Trafalgar Square. Moving on nearly three centuries, we come to the incomparable Auguste Rodin, who is represented by a copy of his Burghers of Calais (q.v.). In 1914 Rodin presented a collection of his bronzes to the British nation, but they are all indoors.

The work of the more recent French sculptors includes Léon-Joseph Chavalliaud's Cardinal Newman and Sarah Siddons (q.v.),

G. Malissard's equestrian statue of Foch (q.v.) and a very exciting nude called La Délivrance by Emile Guillaume. (*See under* Sculpture).

Giovanni Fontana sounds and was Italian. Baron Carlo Marochetti, who became an R.A., was a Piedmontese. (*See under* Marochetti in this chapter).

The Germans are represented by Baucke, whose oversized William III was given by the Kaiser to the British Nation. There is also a modern German work of the lamp-post school that stands outside the new German Embassy. It is by F. Koenig.

Austria has Vienna-born Joseph Edgar Boehm, who has more statues than anyone else, namely nine, two of which are equestrian, and a medallion. His best work is probably the seated Carlyle in Cheyne Walk. Boehm was educated in England and worked there. He became an R.A. in 1882 and was knighted seven years later. Siegfried Charoux, R.A. is also Vienna-born, but he came here in 1935.

Oscar Nemon, who has done a number of statues of Churchill but not the Parliament Square one, is a Yugoslav who has lived in England since before the last war. His Freud at Swiss Cottage is superb. His Portal and Monty are less good.

The statue of Chopin is by Kubica, a compatriot, and the Queen's Jubilee fountain in New Palace Yard, Westminster, is also by a Pole, Valenty Pytel. Another Pole, Theodore Roszak, did the eagle of the American Embassy.

Czechoslavakia is represented by Franta Belsky.

Hugo Daini, the sculptor of Bolivar, was born in Venezuela, as was Bolivar.

Bertram Mackennal, an Australian, became an R.A. and was knighted after sculpting the equestrian statue of Edward VII.

American sculptors represented include Andrew O'Connor, who did a bust of Lincoln, Jacques Lipchitz one of Kennedy and the famous Augustus Saint-Gaudens, who was Irish-born of a French father, Paris and Italian trained, but settled in New York. A copy of his Lincoln statue is in Parliament Square. W. W. Story, who sculpted George Peabody, is also American, as are William Couper, the sculptor of Captain John Smith and F. L. Jenkins, whose Count Peter presides over the entrance to the Savoy Hotel. Malvina

Hoffman, who did the huge figures of Youth in Bush House, is the only American woman sculptor represented.

By far the greatest of the women sculptors is Barbara Hepworth, who achieved international fame. She has a section to herself in this chapter, which describes her work. Among other women sculptors we find Princess Louise producing a very professional statue of her mother, Queen Victoria, when young, and Captain Scott of Antarctic fame was sculpted by his widow, who has also done the bust of Northcliffe. Lady Scott—the title was given posthumously to Scott—later became Lady Kennet. Kate McGill is an Irish girl whose Jeeves in Pont Street is original. Jean Bullock, who works in Yorkshire, experiments in interesting media. British born Karin Jonzen's Beyond Tomorrow near the Guildhall is very competent. Feodora Gleichen was a very experienced sculptor, as one can see from her Diana fountain by Rotten Row in Hyde Park. The most important English woman sculptor now living is probably Elizabeth Frink (*see* further on in this chapter under 'Frink'). There is also Angela Conner.

The Victorian public tended to think that artists often led immoral lives and, like Lautrec, drank absinthe all the time and so died young but in fact longevity is a feature of artists and so it is of sculptors. Apart from those still living and excluding the ones without dates there are 164 listed with dates and among them there are 38 octogenarians and 11 nonagenarians, which is well above the average for that number of everyday lives.

When it comes to honours, only a few have been knighted, and relatively fewer than painters, but among them are Richard Westmacott (Achilles), George Frampton (Peter Pan), Alfred Gilbert (Eros), Francis Chantrey, who afterwards left an important legacy to the Royal Academy, Jacob Epstein and Charles Wheeler. G. F. Watts, who twice refused a knighthood, accepted the O.M. but that was for painting, while the only painter or sculptor to be given the O.M. and the C.H. is Henry Moore.

Sculptors

When a person has more than one statue the sites are given.

* = living in 1980 *fl.* = floruit(he flourished) F = fountain

J. Adams Acton known as John Adams until 1868	1834–92	Wesley
George Canon Adams	1821–98	Sir Charles Napier
*Jose Alberdi		The Swanupper
*Alexander	1927–	Jubilee Oracle
Charles J. Allen	1862–1956	Shakespeare (City)
Henry Hugh Armstead, R.A.	1828–1905	Albert Memorial, Podium, Poets and Musicians, Painters
Enrico Astori	1858–	La Fileuse Arabe
*Eric Aumonier	*fl.* 1930–1970	South Wind, Shell Ball
Michael Ayrton	1921–75	Icarus; The Minotaur
Charles Bacon	1821–85	Albert (Holborn)
John Bacon, R.A. father of	1740–99	William III (St. James's); George III (Somerset House), Fountain
John Bacon (the younger)	1778–1859	William III (St. James's)
Edward Hodges Baily, R.A.	1788–1867	Nelson, Pallas Athena
Sir Herbert Baker, R.A.	1862–1946	Grace Gates
M. J. Baker	1849–	George III and Queen Charlotte (both Trinity House)
Donato Barcaglia	1849–	Street Orderly Boy
Sir Charles Barry, R.A.	1795–1860	The Woman of Samaria (F)

E. M. Barry (with Earp)	1830–80	Eleanor Cross
Henry Bates, A.R.A.	1850–99	Roberts
Heinrich Baucke	1875–	William III (Kensington Palace)
Gilbert W. Bayes	1872–1953	Priestley, Play up! Play up!
William Behnes	1795–1864	Gresham (Royal Exchange); Havelock; Peel (Police College); Nash *see further on in this chapter*
John Bell	1811–95	Guards Crimean Memorial; America (Albert Memorial); Victory Memorial; Eagle Slayer
*Franta Belsky	1921	Cunningham; Shell Fountain; Triga; The Lesson
Richard C. Belt	1850–1928	Queen Anne (St. Paul's); Byron (Hyde Park) *and see further on in this chapter*
*L. Cubitt Bevis	1891	More (Chelsea)
Charles Bell Birch, R.A.	1832–93	Queen Victoria (Blackfriars); Griffin (Temple Bar)
Francis Bird	1667–1731	Henry VIII
*Michael Black	1928–	Reuter
*Naomi Blake	1924	View II; Image
Sir Reginald Blomfield	1856–1942	R.A.F. and Belgian Memorials
Ferdinand Victor Blundstone	1882–1951	Plimsoll
Sir Joseph Edgar Boehm, R.A.	1834–90	Burgoyne; Carlyle; Laurence; Lord Napier; Holland;

		Stewart; Tyndale; Wellington (Hyde Park Corner); Queen Victoria and Edward Prince of Wales (Temple Bar) *and see further on in this chapter*
*Nigel Boonham	1953	Hunter (Lincoln's Inn Fields)
H. C. Bradshaw	1893–1943	Guards Memorial
Laurence Bradshaw	1899–1978	Marx
*Antonas Brazdys		Ritual
Fredda Brilliant		Gandhi, Menon
E. R. Broadbent		Speed in the Air
Sir Thomas Brock, R.A.	1847–1922	Cook; Frere; Irving; Millais; Raikes; Tate; Queen Victoria (Memorial and Carlton House Terrace); Lister; Harris *and see further on in this chapter*
Major Cecil Brown	1867–1926	Imperial Camel Corps
Ford Maddox Brown	1821–93	Rossetti
Mortimer Brown		Shepherd Boy
Albert Bruce-Joy	1842–1924	Gladstone (Bow)
*Jean Bullock	1923–	Seated Boy
H. Bursill	fl. 1855–70	FitzAilwin; Gresham, Agriculture and Commerce (Holborn Viaduct)
Decimus Burton	1800–81	Wellington Arch, Hyde Park Screen, Athenaeum
*Reg Butler	1913–	Birdcage
Thomas Campbell	1790–1858	Bentinck
John Edward Carew	c1785–1868	Whittington (Royal

		Exchange); a plaque on Nelson's Column
*Anthony Caro	1924–	Fathom 1976
Thomas Cartwright	1617–1702	Edward VI, 4 Cripples
Herman Cawthra	1886–1973	Meath Affection
*Lynn Chadwick	1914–	The Watchers
Basil Champneys (with Grant)	1842–1935	Fawcett
Sir Francis Chantrey, R.A.	1781–1841	George IV (Trafalgar Sq.); Dickson; Pitt (Hanover Sq.); Wellington (Royal Exchange) and see further on in this chapter
Siegfried Charoux, R.A.	1896–1967	The Motorcyclist; The Cellist; The Neighbours
*W. H. Chattaway		Spirit of Enterprise
Léon-Joseph Chavalliaud	1858–1921	Newman; Siddons
Sir Henry Cheere	1703–81	William III (Bank of England); Shakespeare (City)
Chelsea College of Art		3 Elm Trees
Caius Gabriel Cibber	1630–1700	Charles II (Soho Square); Monument bas-relief
Eastcourt J. Clack		Constance Fund Fountain (Green Park) Dickens (Marylebone)
P. Lindsay Clark	1889–	Boy with Cat; Southwark War Memorial
*Geoffrey Clarke	1925–	Spirit of Electricity
George Clarke	1796–1842	Cartwright
*R. E. Clatworthy	1928–	The Bull
J. R. Clayton	fl.1859–	Edward the Confessor;

		Henry III; Elizabeth; Victoria (Westminster Old Boys)
Eleanor Coade	1733–1821	
William Colton, R.A.	1867–1921	Colton Fountain Royal Artillery Memorial (The Mall) (Hyde Park)
*Angela Conner		Yalta Victims Memorial
E. Bainbridge Copnall, M.B.E.	1903–73	Becket; David; Marks and Spencer male; Stag; R.I.B.A. reliefs *and see further on in this chapter*
William Couper	1853–1942	Captain Smith
Walter Crane	1845–1915	
B. Creswick	*fl.*1888–1930	Carlyle (Medallion) Cheylesmere (surround)
Hugo Daini	1919–76	Bolivar
Jules Dalou	1838–1902	Motherhood (F)
H. A. Darbishire	1839–1908	Burdett-Coutts (F)
*Allen David		The Glass Fountain
J. Daymond and Son	*fl.* 1882–	Bacon; Milton; More; Newton; Shakespeare
J. de Vaere	1754–1830	Pelican Group
Sir William Reid Dick, R.A.	1879–1962	George V; Grey; Roosevelt; Soane; Queen Mary: Eagle of R.A.F. Memorial; Boy with Frog (F) *and see further on in this chapter*
Frank Dobson	1888–1963	Woman with Fish (F); Churchill (Cannon Street)
*John Doubleday	1947–	Chaplin

F. Doyle-Jones	1873–1938	O'Connor; Wallace
*Peter Drew	1927–	Elephants; Good Fun
G. C. Drinkwater	1880–1941	Fairbairn
Alfred Drury, R.A.	1857–1944	Reynolds (Royal Academy); London Troops, Vauxhall Bridge Statues, downstream side
Joseph Durham	1814–77	Albert (Albert Hall); Hogarth; Matilda (F)
Thomas Earp (*with* Barry)	*fl.*1860–80	Eleanor Cross
Georg Erlich, R.A.	1897–1966	Young Lovers
Sir Jacob Epstein	1880–1959	*See* further on in this chapter
David Evans	1895–	Coram; Bow Town Hall Panels
Harold Charles Fehr	1867–1940	Garrick; Perseus and Andromeda
*Hans Feibusch	1898–	St. John the Baptist
Percy Fitzgerald		Dickens (Prudential); Boswell; Johnson
Louis Fitzgibbon (*and* Samoysky)		Katyn Memorial
*Arthur Fleischmann	1896–	Diana; Coranarium
F. L. Florence		Queen Victoria (Warwick Gardens)
John Henry Foley, R.A.	1818–74	Albert and Asia (both Albert Memorial); Herbert *and see further on in this chapter*
Giovanni Fontana	1821–93	Shakespeare (Leicester Square)
E. Onslow Ford	1852–1901	Hill
Sir George Frampton, R.A.	1860–1928	Peter Pan; Besant; Cavell; Gilbert; Hogg; Stead; Lions at British Museum *and see*

		further on in this chapter
*Elizabeth Frink	1930–	*See further on in this chapter*
W. S. Frith	1850–1924	Edward VII (Mile End Road)
Naum Gabo	1891–1977	Torsion (F)
Sebastian Gahagan	*fl.*1800–35	Duke of Kent
Richard Garbe, R.A.	1876–1957	Bunyan; Edward I and Edward VII (Holborn)
S. H. Gardner		Braidwood Memorial
A. H. Gerrard	1899–	North Wind, St. James's Park Station
Grinling Gibbons	1648–1721	Charles II (Chelsea); James II; Clayton
John Gibson, R.A.	1790–1866	Huskisson
Sir Alfred Gilbert, R.A.	1854–1934	Eros; Queen Alexandra's Memorial; Hunter (Tooting)
Walter Gilbert	1871–1946	Brontë Sisters; Thackeray
Eric Gill, A.R.A.	1882–1940	*See further on in this chapter*
Feodora Gleichen	1861–1922	Diana (F)
Count Victor Gleichen	1833–91	Afghan and Zulu Memorial
Richard Goulden	1877–1932	Mrs. Macdonald; St. Christopher and Child (Bank of England)
*Keith Grant	1930–	St. Joan
Mary Grant (with Champneys)	1831–1908	Fawcett
Emile Guillaume	1867–	La Délivrance
Herbert Hampton	1862–1929	Devonshire
Alfred Frank Hardiman, R.A.	1891–1949	Haig; Fountain and Peace (St. James's, Piccadilly)
Philip Hardwick	1792–1870	Bellot

Sydney Harpley		The Dockers
C. L. Hartwell, R.A.	1873–1951	Goatherd's daughter; Phillip; St. George and Dragon
F. Brook Hatch		Submarines
Nicolas Hawksmoor	1661–1736	George I
Barbara Hepworth	1903–75	*See further on in this chapter*
A. H. Hodge	1875–1918	Lost Bow; Mighty Hunter
Malvina Hoffman	1887–1966	Youth
Jean-Antoine Houdon	1741–1828	Washington
J. B. Huxley-Jones	1908–69	Livingstone; Joy of Life (F)
Sir Thomas Graham Jackson, R.A.	1835–1924	Panels, Royal Marines Memorial
C. Sargeant Jagger, A.R.A.	1885–1934	Shackleton; Royal Artillery Memorial
Frank Lynn Jenkins	1870–1927	Count Peter of Savoy
Sir William Goscombe John, R.A.	1860–1953	Sullivan; Wolseley; Amorini figures
Capt. Adrian Jones, M.V.O.	1845–1938	Cambridge; Royal Marines; Carabineers, Cavalry; Quadriga, (Peace); 2 Pointers
Sir Horace Jones	1819–87	Temple Bar
*Karin Jonzen	1914–	Beyond Tomorrow; The Gardener
C. M. Jordan		Army Ordnance (Woolwich)
Samuel Joseph	1791–1850	Myddleton (Royal Exchange)
Eric Kennington, R.A.	1888–1960	24th Division Memorial
William Kerwin	–1594	Queen Elizabeth (Strand)
*Richard Kindersley	1939–	The Seven Ages of Man

W. C. H. King	1884–	Turner
Sir James Knowles	1831–1908	Shakespeare's fountains and plinth, Leicester Square
*Fritz Koenig	1924–	Flora
*B. Kubica	1936–	Chopin
A. C. Lacchesi	1925–	Onslow Ford
Maurice Lambert, R.A.	1901–64	Nuffield
Sir Edwin Landseer, P.R.A.	1802–73	Trafalgar Square Lions
Jaspar Latham	1693	Maples
Sir C. Lawes-Wittewronge	1843–1911	Dirce and the Bull *and see under* Belt *in this chapter*
J. Lawlor	1820–1901	Engineering (Albert Memorial)
Gilbert Ledward, R.A.	1888–1960	The Seer; St. Nicolas; St. Christopher; The Awakening; Milner; Guards Memorial Figures; Venus (F) *and see further on in this chapter*
Jacques Lipchitz	1891–1973	Kennedy
John Graham Lough	1798–1876	Albert (Royal Exchange)
Princess Louise	1848–1938	Queen Victoria (Kensington Gardens)
M. Lubelski		Polish Air Force Memorial
Sir Edwin Lutyens, P.R.A.	1869–1944	Cenotaph; Merchant Seamen (W.W.1); Cheylesmore; Aldrich-Blake surround; *see further on in this chapter*
Charles H. Mabey	*fl.*1863–1905	Queen Victoria

		(Temple railings); Sphinxes; *see* Vulliamy
Patrick MacDowell, R.A.	1799–1870	Europe (Albert Memorial)
*David McFall, R.A.	1919–	Pocahontas
David McGill	*fl.*1889–1910	Lawson
*Kate McGill		Jeeves
Sir Bertram Mackennal, R.A.	1863–1931	Edward VII (Waterloo Place and Shadwell); Curzon; St. Paul's Cross; Horses of the Sun
Dr. R. Tait Mackenzie	1867–1938	Wolfe
William Macmillan, R.A.	1887–1977	*See further on in this chapter*
*Keith McCarter	1936	Ridirich; Untitled
*F. E. McWilliam, R.A.	1909–	Hampstead Figure
G. Malissard	1877–	Foch
*Frederick Mancini	1905–	Nightingale (St. Thomas's)
Baron Carlo Marochetti, R.A.	1805–68	Brunel; Campbell; Richard I; Stephenson *and see further on in this chapter*
Sydney Marsh		Bevington
Joshua Marshall	1629–78	Plinth of Charles I statue
William Calder Marshall, R.A.	1813–94	Jenner; Newton (Leicester Square); Agriculture (Albert Memorial)
Sir Edward Maufe, R.A.	1883–1974	Merchant Seamen (W.W.II)
*Bernard Meadows	1915–	Spirit of Trade Unionism
L. S. Merrifield	1880–1943	Trevithick
Alexander Monro	1825–71	Nude (Berkeley

		Square) Boy with Dolphin (F) Regent's Park
Horace Montford (father of Paul)	*fl*.1900–12	Milton (St. Giles, Cripplegate)
Paul Montford	1868–1936	Beit; Wernher
*Henry Moore O.M. C.H.	1898–	*See further on in this chapter*
*Oscar Nemon	1906–	Portal, Montgomery, Freud, Sir Winston and Lady Churchill
Samuel Nixon	1803–54	William IV
Matthew Noble	1817–76	Derby; Franklin; Outram; McGrigor; Todd; Peel (Parliament Square)
Jan van Nost	1720–80	George II (Golden Square); Geffrye
Andrew O'Connor	1874–1941	Lincoln (Royal Exchange)
Professor Owen	1804–92	Prehistoric Monsters
A. Pallitser		Ashfield
*Tom Painter	1950–	Byron (John Lewis)
Harold Parker	1873–1958	Awakening and Prosperity of Australia
H. Wilson Parker	1896–1980	Lansbury
Lionel Pearson		Royal Artillery Memorial, Rima surround
Henry Pegram, R.A.	1863–1937	Hylas
Charles Petworth		Euterpe
John Birnie Philip	1820–75	Peace (Smithfield); Lions (Westminster Old Boys); Albert Memorial Podium Sculptures 'Architects'
Charles Pibworth	1878–1958	D. Dawson bird bath
Henry Richard Pinker	1849–1927	Forster

Arthur Pollen	1899–	Tussaud
Frederick W. Pomeroy, R.A.	1857–1924	Bacon; Gray; Markham; Vauxhall Bridge (with Drury), upstream; Justice
*Donald Potter		Baden-Powell
*William Pye	1938–	Zemran
*Valenty Pytel		Queen's Silver Jubilee (F); House of Commons.
F. Rabinovitch		West Wind, St. James's Park Underground
William Railton	c.1801–77	Nelson's Column
R. Ratman		Marylebone Town Hall lions
Mario Razzi	1821–1907	Beaconsfield
Charles Renick		Smith
Sir William Reynolds-Stephens		Lamb
Sir William Richmond, R.A.	1842–1921	Greek Runner
*Ivor Roberts-Jones	1916–	Churchill
*John Robinson		Hammerthrower
Auguste Rodin	1840–1917	Burghers of Calais
L. Fritz Roselieb (changed name to Roslyn)	1865–	Edward VII (Balham)
*Theodore Roszak	1907–	U.S. Embassy Eagle
Louis-François Roubillac	c.1695–1762	Cass
P. Rouilland	1820–1881	Doe and Fawn
Victor Rousseau		Belgian War Memorial
*Edwin Russell	1939–	Suffragette Scroll; Archimedes
John Michael Rysback	1693–1770	George II (Greenwich); Sloane; Inigo Jones
W. B. Sagan		Lord Melchett

Augustus Saint-Gaudens	1848–1907	Lincoln (Parliament Square)
E. Schaulberg		Nude (Fortune)
Peter Scheemakers	1691–1781	Edward VI; Guy; Sandes
*Peter Schollander		Sasparella
Sir George Gilbert Scott, R.A.	1811–78	Albert Memorial; Westminster Old Boys
Sir Giles Gilbert Scott, O.M., R.A.	1880–1960	Plinth of George V
Lady Scott	1878–1947	Scott; Northcliffe
George Simonds	1844–	Bazalgette
Robert Smith		More (Carey Street)
John Spiller (the younger)	1763–94	Charles II (Royal Exchange)
*Willi Soukop, R.A.	1907–	Man and Woman, Pied Piper
Sir John Steell	1804–91	Burns
*Coert Steynborg	1905–	Diaz
William Wetmore Story	1819–95	Peabody
Hubert le Sueur	1595–1650	James I; Charles I
J. M. Swan, R.A.	1847–1910	Boy with bear cubs
Frank Mowbray Taubman	1868–1946	Waterlow (Waterlow Park and Westminster City School)
*Wendy Taylor	1945–	Sundial
A. H. R. Tenison		Submarine Memorial
John Ternouth	*fl*.1819–49	A plaque on Nelson's Column
S. S. Teulon	1812–73	Buxton Memorial
W. Theed (junior)	1804–91	Africa (Albert Memorial)
Cecil Thomas, O.B.E.	1885–1976	Wakefield; Faun; Nash (All Souls)
John Thomas	1813–62	Myddleton (Islington)
Thomas Thornycroft	1815–85	Boadicea; Commerce

		(Albert Memorial) *and see further on in this chapter*
Sir William Hamo Thornycroft, R.A.	1850–1925	Colet; Cromwell; Gladstone (Strand); Gordon; Shaw; Queen Victoria (Royal Exchange) *and see further on in this chapter*
George Tintworth	1845–1913	Pilgrimage of Life
Alfred Toft	1862–1949	Royal Fusiliers Memorial
John Tweed	1869–1933	Clive; Kitchener; White; Rifle Brigade; part of R.A. memorials
*Michael Verner	1912–	Mater Ecclesiae
Karel Vogel	*fl.*1940	The Leaning Lady
C. F. A. Voysey (and B. Creswick)	1857–1941	Carlyle (Cheyne Walk)
G. J. Vulliamy	1813–86	Sphinxes (*and see Mabey*)
George Edward Wade	1853–1933	Queen Alexandra (London Hospital), Booth (3); Mrs. Booth
*Douglas Wain-Hobson	1918–	Nude Man (St. James's Hospital)
Arthur George Walker, R.A.	1861–1939	Nightingale (Waterloo Place); Pankhurst; Aldrich-Blake
Musgrave Leftwaite Watson	1804–47	Queen Elizabeth I (Royal Exchange); Hall of Commerce Frieze; Relief on Nelson's Column

George Frederick Watts, O.M., R.A.	1817–1904	Holland; Physical Energy
Sir Aston Webb, R.A. R.A.	1849–1930	Victoria Memorial Admiralty Arch
Henry Weekes, R.A.	1807–77	Reynolds (Leicester Square); Wellington (Royal Exchange); Manufacture (Albert Memorial)
Sir Richard Westmacott, R.A.	1775–1856	Bedford; Canning; Fox; Achilles, York *and see further on in this chapter*
Sir Charles Wheeler, K.C.V.O., O.B.E., P.R.A.	1892–1974	*See further on in this chapter*
J. Whitehead	*fl.*1889–1919	Cattle Trough Jubilee (F); Marylebone Lions
E. Whitney-Smith	1880–1952	Bevin
*Geoffrey Wickham	1919	Fountainhead; Winged Form
W and T. Wills (brothers)	*fl.*1856–84	Cobden
Joseph Wilton	1722–1803	George III and IV; Queen Charlotte (all Somerset House)
F. Derwent Wood, R.A.	1871–1926	David (Machine Gun Memorial); Atalanta
*James Woodford, R.A.	1893–	B.M.A. (F); Lloyd's bas-reliefs; R.I.B.A. columns
William Frederick Woodington, A.R.A.	1806–98	Paxton; South Bank lion; Relief on Nelson's Column
Thomas Woolner, R.A.	1825–92	Hunter (Leicester Square); Mill; Palmerston

*John Wragg	1937–	King's Road Precinct (Sainsbury sculpture)
Sir Christopher Wren	1632–1723	The Monument, Charles I plinth
T. H. Wren		Watts
*Margaret Wrightson		Lamb's statue (Inner Temple)
Benjamin Wyatt	c.1775–1850	Duke of York's column
Matthew Cotes Wyatt	1777–1862	George III; Wellington
*David Wynne	1926–	See further on in this chapter
Allan Wyon	1882–1962	East Wind (St. James's Park Station)
Edward William Wyon	1811–85	Green
*Brian Yale		Peacock
Lady Hilton Young		See Lady Scott
Harold Youngman (and Goscombe John)	1886–1972	Amorini figures
Count Stefan Zamoysky (and Fitzgibbon)		Katyn Memorial

ADDENDA

*Barry Flanagan	1941–	Camdonian
*Marcelle Quinton		Bertrand Russell
*Sir Peter Shepheard	1913–	Queen Mother's Commemorative Fountain
J. Wedgwood		Sculpture in Bishop's Park, Fulham

Specially listed sculptors

Richard Belt and Sir Charles Lawes-Wittewronge, Bt.

Richard Belt (1850–1928) has two outdoor London statues and both are of inferior quality: Queen Anne outside St. Paul's and Lord Byron in Hyde Park. He also did a number of busts and gained some public acclaim, but among his fellow sculptors he was regarded as an impostor who used other people to do his work. Following a vitriolic broadside in 'Vanity Fair' by Charles Lawes, who had employed Belt to work for him, there followed a two-year libel case. It was the last English trial of importance to be held in Westminster Hall (1882) and the appeal was the first case to be heard in Street's new Law Courts (1884). Belt won and was awarded £5,000 damages but it is doubtful if he got it. Soon after this he was sent to prison for obtaining money by false pretences through selling worthless jewellery.

The defendant Charles Lawes, born in 1843, was a very different type of person. He was born to riches and was heir to a baronetcy. He was a superb athlete, being a great runner, stroke of the Cambridge eight, winner of the Diamond sculls at Henley and holder of the twenty-five-mile amateur cycling record. He was a dedicated if not very talented sculptor, his best-known work being the large involved bronze sculpture of Dirce and the Bull on the left side of the entrance to the Tate. Lawes's father died in 1900, and two years later he changed his name to Lawes-Wittewronge. He spent a fortune on the family house and died in 1911 almost penniless, so that his thirty-three-page Will was meaningless.

William Behnes

William Behnes, the son of a pianoforte maker from Hanover and an English mother, was probably born in 1795. As a sculptor he became an immediate success, his particular forte being the ability to sculpt busts of people with both the likeness and character of the subject. Although he exhibited over 150 busts at the Royal Academy between 1815 and 1865, he never became even an A.R.A., but that was largely due to the dissipated life he lived. This finally led to bankruptcy in 1861 and his death three years later.

He had been appointed Sculptor in Ordinary to the Queen the year she came to the throne, but no royal commissions followed. His

statues include the one of Sir Henry Havelock in Trafalgar Square,
Sir Thomas Gresham at the Royal Exchange and Sir Robert Peel at
the Police College, Hendon. His most famous work was probably
his colossal bust of Wellington, of which he made two copies.

Sir Joseph Edgar Boehm, R.A. (1834–90)

One of the most popular and prolific sculptors was Joseph Edgar
Boehm, who virtually became the keystone of Establishment
sculpture during Victoria's reign. He had a number of pupils, among
them the talented Princess Louise, a daughter of Queen Victoria
who made a favourite of Boehm. Born in Vienna, he went to school
in England and spent the rest of his life there. The Queen's effigy on
the Jubilee coins of 1887 was the work of Boehm, who was knighted
two years later, having been made R.A. in 1882. His best work is
probably the statue of Carlyle on the Embankment, though some of
the soldiers round the Wellington equestrian piece at Hyde Park
Corner are excellent, particularly the head of the Highlander. Both
the Wellington and Napier statues are equestrian.

Sir Joseph Edgar Boehm, R.A. (1843–90)

SUBJECT	SITE	MATERIAL	ERECTED
Field-Marshal Sir John Fox Burgoyne	Waterloo Place, S.W.1	Bronze	1877
Thomas Carlyle	Cheyne Walk	Bronze	1882
Lord Holland (with G. F. Watts, R.A.)	Holland Park	Bronze	1872
Lord Lawrence	Waterloo Place, S.W.1	Bronze	1882
Lord Napier	Queen's Gate	Bronze	1920
Major-General Sir Herbert Stewart	Hans Place	Bronze	1886
William Tyndale	Victoria Embankment Gardens	Bronze	1884
Queen Victoria and Edward Prince of Wales	Temple Bar	Marble	1880
Duke of Wellington	Hyde Park Corner	Bronze	1888

Sir Francis Chantrey, R.A. 1781–1841

One of the greatest English sculptors of the nineteenth century, if not the greatest, was Francis Chantrey, who was born in 1781, the son of a carpenter. He started off as a carver in wood and then as a painter before becoming a sculptor. In 1814 he went to Rome and on the way back bought some marble at Carrara. He exhibited at the Royal Academy from 1804–41 and became A.R.A. in 1816 and R.A. the next year. He was knighted in 1835.

Chantrey has two equestrian statues in London—George IV in Trafalgar Square and Wellington at the Royal Exchange, although he died some time before the latter was sculpted; it being completed by Henry Weekes. His other London statues include Pitt in Hanover Square and James Watt and Raffles in Westminster Abbey, besides Dickson at Woolwich. He also made the Minerva seal for the Athenaeum Club.

Chantrey left a fortune amounting to £150,000, which went to his wife for her lifetime and then became the Chantrey Bequest, to be used for the purchase of pictures for galleries. When he died in 1842, his wife went into his studio and knocked off the noses of many completed busts, hoping in the process to reduce the number of his works on the market. Chantrey had little education but great native intelligence. He lived well and liked shooting and fishing. Following a visit to Holkham in 1834, he became a legend as he shot a brace of woodcock with one shot. He made a marble sculpture of them which he gave to his host, Mr. Coke, later Lord Leicester.

Edward Bainbridge Copnall, M.B.E.

Bainbridge Copnall (1903–73) started off as a painter but in 1929 took up sculpture and became both successful and versatile. He was given the M.B.E. and became a President of the Royal Society of British Sculptors. He is represented by works in bronze, fibreglass, marble and stone. Perhaps his best work is the moving statue of Thomas à Becket in the south churchyard of St. Paul's. This stricken, dying figure resting on two points must have taken a lot of thought when designing it (q.v. *under* Statues).

In complete contrast are his sculptures on the Weymouth Street wall of the R.I.B.A. in Portland Place, of a painter, a sculptor, an architect (Wren), an engineer and a working man. His large, nude

male figure, Aspiration, on the front of Marks and Spencer in
Edgware Road has been turned into something like a Red Indian to
appease the local prudes, while in Cheyne Walk there is a fibreglass
figure of David on a high pedestal. It is taken from the prototype
model made by Derwent Wood for his fine Machine Gun Corps
Memorial at Hyde Park Corner which was stolen from a plinth
beside the present statue. An utterly different concept is shown in his
aluminium twenty-foot stag on the site of the old Stag Brewery by
Victoria, 1962.

Copnall specialized in reliefs and among them are his four works
in Carrara marble on balconies in King Street, St. James's. They
depict theatrical people and the lowest balcony shows Laurence
Olivier and Vivian Leigh in Caesar and Cleopatra which they played
in the charming St. James's Theatre that stood on that site but
which was demolished in the fifties, in spite of violent controversy,
by a vandal, now dead, so that he could build profitable business
blocks. He commissioned these reliefs as a sop to his conscience.

Sir William Reid Dick K.C.V.O.

William Reid Dick, born in Glasgow in 1879, was one of the
prominent sculptors of the first half of the twentieth century. He
became A.R.A. in 1921, R.A. in 1928 and was knighted seven years
later. He was Sculptor to King George VI and Queen's Sculptor in
Ordinary for Scotland. Besides being a sculptor, mostly of people,
he did a number of royal portraits. Reid Dick died in 1961.

The lion on the Menin Gate Ypres was one of his first important
commissions. Other animals include the large beasts flanking
Unilever House opposite Blackfriar's Bridge as well as the eagle on
top of the Royal Air Force memorial on the Embankment. He also
sculpted George V opposite the House of Lords and a medallion of
Queen Mary. One of his most important works was the statue of
Roosevelt in Grosvenor Square. Other works include the medallion
of Lord Grey of Fallodon on a wall of the Foreign Office and the
statue of Sir John Soane on the Bank of England. He presented
Regent's Park in 1936 with a fountain called Boy with Frog.

Sir Jacob Epstein, K.B.E. (1880–1959)

The first modern statues to be erected in London were the eighteen

stone figures on the second floor of the building on the corner of 429 Strand and Agar Street. It was the first important commission of twenty-eight-year-old Jacob Epstein (1880–1959) and not for the last time his work caused a public outcry. The figures represented men and women in various stages from birth to death, which was very appropriate, as the building was put up in 1908 to house the British Medical Association. The press, apart from *The Times* which defended them, had a heyday. A religious society on the other side of the street even replaced their clear class windows by frosted ones to prevent their staff's morals being corrupted. Perhaps the only amusing result was the jingle:

> I don't like the family Stein.
> There's Gert, there is Ep, there is Ein.
> Gert's writings are punk,
> Ep's statues are junk,
> Nor can anyone understand Ein.

Epstein unfortunately used a sandstone, and when the odd piece fell down in 1937, the year Rhodesia took over the building, there was a further outcry by the philistines and some offending parts were removed for moral reasons, but time and decay have now left nothing that could dismay even the most prudish.

All this was nothing compared to the rumpus Rima caused in 1925. The great naturalist W. H. Hudson died in 1922 and it was proposed to create a bird sanctuary near the Serpentine in his memory. Behind a small pool, Epstein's Rima rises up on a stone panel representing the Spirit of Nature in Hudson's book *Green Mansions*. This slightly Egyptian-looking girl with formal flowing hair soars up like a bird from the water, surrounded by an eagle and other birds. The surround was designed by Lionel Pearson. Instead of being two floors up, Rima was at ground level. The press had a field day and created trouble, with the result that Rima was twice tarred and feathered. It had been unveiled by the Prime Minister, Ramsay MacDonald. Four years later, the public had

Night, by Jacob Epstein. Compare this with the next T.U.C. photograph

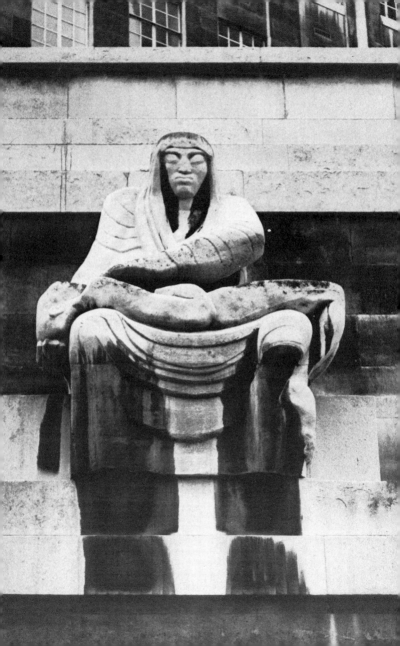

another shock when what was then a very modern block went up above St. James's Park Underground station. Over the first floor Epstein had two works. Night depicts a mother passing her hand over the face of her child laid across her lap, the age-old sign of inducing sleep. Day consists of a father and his son. One of these had a pot of paint thrown at it, not because it was indecent—it certainly was not—but because it was modern.

Epstein's most enduring work is probably the moving Madonna and Child, a large lead on the wall of the Convent of the Holy Child on the north side of Cavendish Square. It dates from 1953, by which time the public had got accustomed to his work and it was even praised, so much so that it was called his 'Passport to Eternity'. Epstein's first commission after the War was for the statue of General Smuts standing in Parliament Square. It would probably look much better in a different setting and away from upright Victorian Premiers. 1956. *See also under* Statues.

At the same time he was working on the Memorial to Trade Union victims of two World Wars for the new T.U.C. Headquarters going up in Great Russell Street. This consists of a larger-than-life figure of a man with arms outstretched holding a corpse-like figure. It was carved from a ten-ton block of Roman stone. Behind them, the entire wall consists of slabs of green Carrara marble running up to the roof. It has a wonderful dignity and feeling about it and one cannot help comparing it with his 'Night' done twenty years previously. It is then that one realizes the enormous progress Epstein had made. It was unveiled when the building was opened in March 1958 but being in the central courtyard, it can only be seen by request.

In 1959 Epstein completed Pan, his last important work, and died almost immediately afterwards. It was not a success as it completely lacks sensibility and it is probably his only London failure. It was set up under Bowater House at the Edinburgh Gate to Hyde Park in 1961.

Two of Epstein's works have been put on show since his death. The Sun Worshipper dating from about 1910 is described in the Sculpture chapter in the Central London, Kensington section. The

Spirit of Trade Unionism, by Jacob Epstein

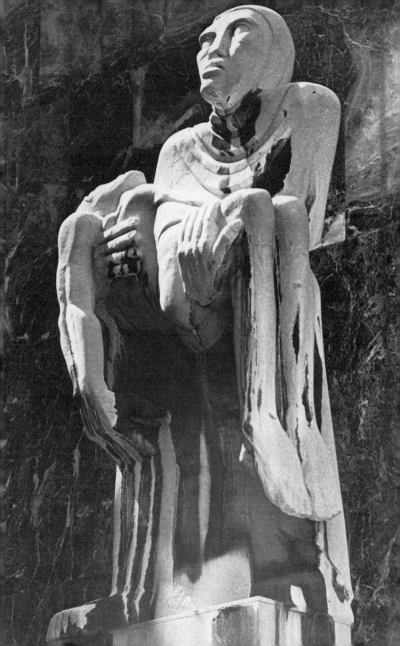

other, an unfinished nude girl carved in relief on a large slab of stone, is a sensitive work. It is in Roper Gardens opposite Chelsea Old Church and was unveiled in 1972 by Admiral Sir Caspar John, a son of Augustus John.

Epstein was famous for his bronze busts, besides being an impressive painter with a strong sense of colour. His flower watercolours were very popular. A Russian-Polish jew, Epstein was born in New York, though he early became a British subject. He was made a K.B.E. in 1954.

Sir Jacob Epstein, K.B.E. 1880–1959

SUBJECT	SITE	MATERIAL	ERECTED
Men and women in stages between life and death, eighteen figures	429 Strand and Agar Street	Stone	1908
Rima. Memorial to W. H. Hudson	Hyde Park	Stone	1925
Night	St. James's Park Underground Station, Broadway	Stone	1929
Day	ditto	Stone	1929
Madonna and Child 'Passport to Eternity'	Convent of the Holy Child, Cavendish Square	Lead	1953
Field-Marshal Smuts	Parliament Square	Bronze	1956
Spirit of Trade Unionism Memorial to both Wars	Trades Union Congress central court, Great Russell Street, W.C.1	Stone	1958
Pan	Bowater House, Edinburgh Gate, Hyde Park	Bronze	1961
Nude	Roper Gardens, Chelsea Embankment	Stone	1972
The Sun Worshipper	Courtyard of Kensington and Chelsea Town Hall	Stone	1980

John Henry Foley, R.A.

One of the few sculptors to be buried in St. Paul's is J. H. Foley (1818–74) who is best known for his very fine seated figure of Prince Albert in the Albert Memorial. He died before it was completely finished and so he never saw his masterpiece erected, although in 1870 his full-sized model was temporarily placed *in situ* to study the effect on the surrounding work. It was finished off by G. F. Teniswood. He also sculpted the large Asia group that adorns one of the corners.

Foley was Dublin born, but he came to London in 1834 and had a successful career, becoming A.R.A. in 1849 and R.A. nine years later. His statue of Lord Herbert is in Waterloo Place, but it was his works on Burke, Mill and Goldsmith that brought him fame. He was a fastidious sculptor, and his equestrian statue of Outram which went to Calcutta took him fifteen years to complete.

Sir George Frampton, R.A.

George Frampton (1860–1928) will always be remembered for his Peter Pan in Kensington Gardens, which has been described under Sculpture. He will also be remembered for his awkward heavy-looking memorial of Nurse Cavell which caused considerable criticism at the time, largely because of its 'modern' aspect.

Frampton, who had been a pupil of Frith, who was not a sculptor, was a versatile artist. His other work includes the lions in front of the North side of the British Museum, busts of George V and Queen Mary, the W. S. Gilbert medallion, the statue of Quintin Hogg, and figures on St. Mary's spire, Oxford. He was made an R.A. in 1902 and knighted six years later. Frampton was also buried in the crypt of St. Paul's where his Monument has a figure of Peter Pan.

Elizabeth Frink

One of England's most important post-war sculptors is Elizabeth Frink, who was born in 1930. She was chosen, among others, to represent Great Britain in the International Sculpture Competition for the Unknown Political Prisoner in 1953. Her first London commission at the age of twenty-seven was her Blind Beggar and his Dog, a sensitive work that is on the edge of Roman Road in a

Bethnal Green housing estate. The man is holding out a hand and following the dog.

A less successful work was the Four Seasons, a series of bronze shapes across the façade of the Carlton Towers Hotel which opened in 1961, but this was more than made up for by the lectern she was commissioned to do for the new Coventry Cathedral, a superb building involving many great artists. The lectern which took the usual form of an eagle showed her individuality of style. Birds and animals have been a very important part of her life, having been brought up in the Suffolk countryside, and the Tate bought some of her early bird bronzes. Her other London works concern animals. In Cathedral Place by St. Paul's, Frink has a nude shepherd driving a small flock of sheep called Paternoster. This was unveiled by Yehudi Menuhin in 1975, the same year that her Horse and Rider—both are entire—was put up in Piccadilly at the corner of Dover Street. It was commissioned by Trafalgar House Investments Ltd.

Horse and Rider, by Elizabeth Frink

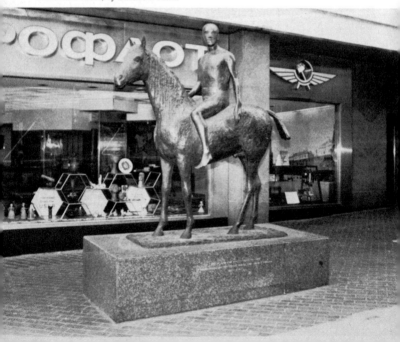

Elizabeth Frink Born 1930

SUBJECT	SITE	MATERIAL	ERECTED
Blind Beggar and his Dog	Roman Road, Bethnal Green	Bronze	1958
Four Seasons	Carlton Towers Hotel, Cadogan Place, S.W.1	Copper	1961
Paternoster, Shepherd and Sheep	St. Paul's Shopping Precinct	Fibreglass, bronze finish	1975
Horse and Rider	Piccadilly and Dover Street, W.1	Bronze	1975

Eric Gill, A.R.A.

A contemporary of Epstein was Eric Gill (1882–1940), who was famous as a calligrapher and a sculptor, but he was essentially a carver. He was the great figure of the English arts and crafts tradition nurtured by Ruskin and William Morris. He was a Catholic and was commissioned to execute the Stations of the Cross in Westminster Cathedral in 1913. When the important modern building went up over St. James's Park Underground station in 1929 he carved three of the eight stone Winds let into the walls on the seventh floor of the building, namely the North Wind, the East Wind, and the South Wind. (*See* 'The Winds' in 'Sculpture' chapter *under* Central London.)

Gill did all the sculpture on the B.B.C. building in Langham Place when it was completed in 1932. Over the main entrance his 'Prospero, Ariel's master, sending Ariel out into the World' caused a lot of abuse to be thrown at him, as it was in a form of sculpture to which the public was not accustomed. Less obtrusive are his three stone bas-reliefs on the same level; two on the west side being 'Ariel between Wisdom and Gaiety' and 'Ariel hearing Celestial Music', while that on the east side is 'Ariel piping to children'.

In the Dutch Garden of Holland Park, Gill has a stone statue of a woman, naked to the waist, leaning back and with her hands clasped

behind her head. He started it in 1910, but did not complete it till many years later, and it was not put there until after he died in 1940.

Some way along Mile End Road, on the left leaving London, there are five deep-cut reliefs on the street wall of the People's Palace which forms part of St. Mary's College. There is also a relief over both doors. These works of Gill date from 1937, when the People's Palace was rebuilt and replaced the original one of 1887. They are very typical of his neat and precise work.

Eric Gill, A.R.A., 1882–1940

SUBJECT	SITE	MATERIAL	ERECTED
North Wind	St. James's Park Underground Station South Block, East Side	Stone	1929
East Wind	West Block, North Side	Stone	1929
South Wind	North Block, East Side	Stone	1929
Prospero, Ariel's Master, sending Ariel out into the World	B.B.C. Langham Place	Stone	1932
Ariel Between Wisdom and Gaiety	B.B.C. Langham Place	Stone	1932
Ariel hearing Celestial Music	B.B.C. Langham Place	Stone	1932
Ariel piping to Children	B.B.C. Langham Place	Stone	1932
Bas-reliefs	People's Palace, Mile End Road	Stone	1937
Semi-nude girl	Dutch Garden, Holland House	Stone	1976

Dame Barbara Hepworth, D.B.E.

Barbara Hepworth was born in Wakefield in 1903, and early on established herself as one of the leading sculptors in England. With Ben Nicholson, whom she married in 1933, the St. Ives School of Art developed. The Tate and the Museum of Modern Art in New York, among other museums, have bought examples of her sculpture, and her work is to be found in most of the London Parks. She was made D.B.E. in 1965. She died tragically in a fire in 1975.

An early London piece was erected in 1953 in Kenwood and is called Monolith (Empyrean) and carved from blue Corrib limestone. Before that, in 1956, Mullard Limited commissioned what turned out to be one of her most delightful small works, and it can be seen in their window in Torrington Place off the top of Tottenham Court Road. It is called appropriately Theme on Electronics (Orpheus) and it is in brass which opens out into a divided cone, both sides being connected with strings. It is forty-seven inches high, and the tapering end has been set into a drum that can be made to rotate. It is a most successful piece. The tall bronze Meridian that stands in the courtyard of State House in Holborn went up in 1959. Four years later John Lewis erected Winged Figure on the Holles Street wall of their store, a very typical open-work piece with wire. Battersea Park got her bronze, Single Form, in 1963, the original of which is in New York. Divided Form, also a bronze, went to Dulwich Park in 1970. The setting of both these pieces on the edge of lakes is superb and shows them both off admirably. The Battersea one is on the south side of the Park and the Dulwich one on the south-west.

The Family of Man, cast in 1970, is an imaginative work that grows on one. It is on the grass in Hyde Park almost opposite the Dorchester Hotel and is loaned by Mr. and Mrs. Nigel Broakes. The nine figures represent two parents, a girl and a youth, the bride and bridegroom, two ancestors and Ultimate Form. A copy of Ultimate Form stands in the entrance to King's College in the Strand. It is 118 inches high and was put there in 1972, but it is also on loan.

Single Form, by Barbara Hepworth (*overleaf*)

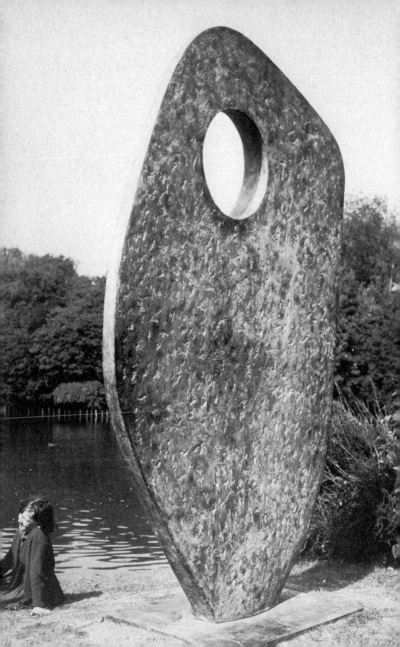

Dame Barbara Hepworth, D.B.E.

SUBJECT	SITE	MATERIAL	SCULPTED	ERECTED
Theme on Electronics (Orpheus)	Mullards, Torrington Place, W.C.1	Brass with strings	1956	1956
Monolith (Empyrean)	Kenwood	Corrib Limestone	1953	1959
Meridian	State House, Holborn	Bronze	1958–9	1960
Winged Figure	John Lewis, Holles Street, W.1.	Bronze	1962	1963
Single Form	Battersea Park	Bronze	1961–2	1963
Two Forms (Divided Circle)	Dulwich Park	Bronze	1969	1970
Ultimate Form (on loan)	King's College, Strand	Bronze	1970	1972
Family of Man (on loan)	Hyde Park	Bronze	1970	1977
Conversations with Magic Stones (on loan)	Regent's Park	Bronze	1973	1977
River Form	Kensington Town Hall	Bronze	1973	1977

Gilbert Ledward, O.B.E., R.A.

Gilbert Ledward (1888–1960) was the son of a sculptor and won the
first British School of Rome scholarship in 1913 and the R.A.
Travelling Scholarship and Gold Medal in the same year. An early
London commission for Ledward was to do the five bronze
guardsmen on the Guards Division Memorial in St. James's Park.
Each regiment is represented in First War uniform and they are very
impressive.

Ledward did the medallion of Viscount Milner for the Henry VII
Chapel in Westminster Abbey in 1930 and a replica of it in bronze is
on a wall at Toynbee Hall in Whitechapel.

On a wall of Great Ormond Street, at an entrance to the
Children's Hospital, there is a bronze statue of St. Nicholas with
three children round him. It was unveiled in 1952 by the Princess
Royal and is 'in grateful memory of Viscount Southwood and all
those who helped in the building of the present hospital'. Another
work of his is St. Christopher, round the corner at the entrance to
the Outpatients Department. Small studies of both are by the chapel
door. The Seer, which stands on a high plinth in the forecourt of 197
Knightsbridge, consists of a nude bronze man kneeling by a large
ball with three children in front of him.

In Roper Gardens opposite Chelsea Parish Church there is a tall
stone column and on it an expressive nude girl with her hands held
up, as if just waking up. It is called Awakening.

What must surely be Ledward's most important work is his very
fine bronze fountain set up Sloane Square in 1953. A form of bronze
goblet rises from the mosaic floored basin. Its sides are chased as in
a classical vase with figures and animals. Above it is a bronze nude
in a kneeling position and water comes out of the conch shell she is
carrying and falls down to give a film of water down the side of the
vase. It is called the Venus Fountain and is very impressive. It was
presented by the Royal Academy of Arts through the Leighton
Fund. *See* description *in* Sculpture chapter.

Ledward, who was a President of the Royal Society of British
Sculptors, was made an R.A. in 1937 and O.B.E. in 1956.

Gilbert Ledward, O.B.E., R.A. 1888–1960

SUBJECT	SITE	MATERIAL	ERECTED
Five Guardsmen	Guards Division Memorial, St. James's Park	Bronze	1926
Viscount Milner	Toynbee Hall, Commercial St, E.1	Bronze	1931
St. Nicolas and Children	Great Ormond Street Hospital, W.C.1	Bronze	1952
St. Christopher	by Outpatients Department in the Drive	Bronze	1952
Venus Fountain	Sloane Square	Bronze	1953
The Seer	197 Knightsbridge	Bronze	1957
Awakening	Roper Gardens, Cheyne Walk	Bronze	1965

Sir Edwin Lutyens, O.M., P.R.A.

Sir Edwin Lutyens (1869–1944) was a man of great charm and wit. He was a poor man, being one of the fourteen children of an Army officer, but he married a titled lady, having got round the Countess of Lytton by saying, 'I would wash your feet with my hair. It is true that I have very little hair, but then you have very little feet'. He was a big man with a phenomenally round head. He has been called the greatest architect since Wren. Besides a number of important private houses and the Cenotaph, his chief works were the Liverpool Roman Catholic Cathedral and the Government House at Delhi. He designed the memorial to merchant seamen of the First World War near the Tower of London and redesigned the fountains in Trafalgar Square (q.v. *under* Sculpture chapter).

Lutyens was knighted, became P.R.A. and received the Order of Merit in 1942.

William Macmillan, C.V.O., R.A.

William Macmillan was born in Aberdeen in 1887 and lived to be ninety. He was very successful and at thirty-seven was the youngest sculptor ever to be elected A.R.A. Eight years later he became R.A. and in 1956 he was made a C.V.O. That followed the completion of his full-length statue of George VI on the steps of Carlton House Terrace, looking over St. James's Park.

Just after the last war, he sculpted the bronze fountain on the east side of Trafalgar Square and a bust of Admiral Beatty that went on the wall near by. In Whitehall there is his statue of Raleigh and on Victoria Embankment is his Lord Trenchard. Alcock and Brown are seen by thousands at Heathrow, and busts of Rolls and Royce are clearly seen through the all-glass entrance of Rolls-Royce Ltd. in Buckingham Gate, though the originals are at Derby. A pre-war fountain of a Triton and Dryads is in Regent's Park, but his most bizarre piece in London is the lightning conductor for one of the buildings of the new Kensington and Chelsea Town Hall. It is a gilt figure standing on one foot.

Baron Carlo Marochetti, R.A. 1805–68

Carlo Marochetti was born in 1805 in Turin, the capital of Piedmont and from 1859–65 the capital of Italy as well. Following his successful equestrian statue of the King of Sardinia he was made a Baron and as he was of French parentage he went to Paris. There he got in with Louis Philippe and soon obtained important commissions such as one of the panels of the Arc de Triomphe and part of the high altar of the Madeleine. When the Revolution of 1848 took place and Louis Philippe abdicated, he came to London.

The first big work he did was a full-size cast of Richard I which started off in a comparatively remote part of the Crystal Palace. After he complained sufficiently, it got put outside and became a popular part of the 1851 Exhibition. He then did the bronze of it which was put in front of the House of Lords in 1860 (*see* 'Richard I' *under* 'Statues') and was paid £3,000.

Soon afterwards he was commissioned to do a statue of Sir Robert Peel and after it had been put up in New Palace Yard in 1863 it was rejected. He did another one free, but that too was rejected. Owing to the success his Richard I had at the Exhibition,

William Macmillan, R.A., 1887–1977

SUBJECT	SITE	MATERIAL	ERECTED
F. C. Goodenough	Mecklenburgh Square	Bronze	1936
Goetze Memorial Fountain, Triton and Dryads	Regent's Park	Bronze	1950
Admiral Earl Beatty	Trafalgar Square	Bronze	1948
Fountain on east side of	Trafalgar Square	Bronze	1948
George VI	Carlton House Terrace	Stone	1955
Sir Walter Raleigh	Whitehall	Bronze	1959
The Lightning Conductor	Kensington Town Hall	Gilt	1960
Lord Trenchard	Victoria Embankment	Bronze	1961
Sir Thomas Coram	Brunswick Square	Bronze	1963
Sir John Alcock	Heathrow Aerodrome	Stone	1966
Sir Arthur Brown	Heathrow Aerodrome	Stone	1966
The Hon. Charles Rolls Sir Henry Royce	Rolls-Royce Ltd., 65 Buckingham Gate	Bronze	1978

he was also invited to sculpt a statue of Prince Albert for his memorial, but the full-size model he produced was not accepted, and he died before completing another version of it for the Committee. In spite of this, he did statues of Brunel, Stephenson and Lord Clyde, better known as Sir Colin Campbell, though they were not put up until after his death. He did the bust of Bazalgette on the Embankment and various busts in the National Portrait Gallery. He also produced a number of works in polychrome.

When Prince Albert died, Marochetti was asked to design the tomb and make recumbent marble effigies of both Albert and Queen Victoria to go on a large sarcophagus at Frogmore, where their bodies were to lie. Albert's was laid on when it was completed in 1868 and Victoria's had to wait until 1901. The four bronze angels at the corners were also designed by Marochetti.

Marochetti was made A.R.A. in 1861, R.A. in 1866 and he died two years later.

Henry Moore, O.M., C.H. Born 1898

London is very lucky to have so many examples of works by Henry Moore, who is by far the greatest living English sculptor and certainly in the top three in the world. Apart from the works in Museums, the majority being in the Tate Gallery, there are fifteen out of doors in London including the four in the garden of the Tate.

His earliest important public work is not easy to see, as it is set into the wall on the seventh floor of the St. James's Park Underground Station, completed in 1929. It is a stone bas-relief of the West Wind and can be seen from Broadway looking up to the left face of the building when standing with one's back to St. James's Park.

The first sculptures to rock the public after the last war were in the fascinating exhibition of modern sculpture in Battersea Park in 1948. Henry Moore's exhibit Three Standing Figures has remained there ever since and has done much to cultivate modern taste. His next piece called the Time-Life Screen, is at the end of a terrace overlooking 157 New Bond Street, but as it is at second-floor level it is virtually unnoticed by the public. It consists of four stone shapes not unlike Mexican motifs. Time-Life occupy the upper floors of 153 New Bond Street which has its entrance in Bruton Street and there

they have a bronze maquette of the Screen in a wooden frame. On their terrace there is a life-size bronze, Draped Reclining Figure, dating from 1952–3.

The first of his modern trend was his bronze Two-piece Reclining Figure No.1 which he gave to the Chelsea School of Art. It dates from 1959 and originally it was erected in the garden at the back of the School but was moved to the forecourt in 1969.

The Stifford Estate in Jamaica Street, Stepney has his Draped Seated Woman of 1957–8 erected in 1958 and the Brandon Estate off Cook's Road, Kennington has a Two-piece Reclining Figure No. 3 of 1961. Another 1961 work is the bronze Mother and Child which is in the garden of Mineral Separation Limited, 36 Queen Anne's Gate, and which can easily be seen from Birdcage Walk. This was placed there in 1966.

Henry Moore gave his 1963–4 Locking Piece to the Tate and they found a permanent site for this bronze in 1968 on the open area at the Vauxhall Bridge end of Millbank, adjoining Riverwalk House.

Moore's finest work is probably his Knife-Edge Two-Piece in Abingdon Street Gardens, almost opposite the House of Lords, sculpted in 1962–5. This gift to the nation by the Contemporary Art Society and Henry Moore himself was erected in 1967. It consists of two pieces of bronze with a dull gold finish about 12 feet long and 9 feet high. The pieces weigh 19 and 23 tons respectively. At the sculptors request it was turned the other way round after three years and also moved about 45 yards nearer the Abbey.

This is the second casting of this work, the first having been bought by Nelson Rockefeller.

In 1977 Moore's globular Three Piece Point of 1964–5 was put up in Spring Gardens, an open space at the end of the Mall adjoining the British Council. This was restored after it had been toppled over and damaged by hooligans, but it was finally removed early in 1980 and later that year it was replaced by a larger bronze, Large Spindle Piece, cast in 1974.

The bronze pieces erected in the garden of the Tate in 1979 include the Upright Motive Nos. 1/2/7 of 1955–6 and the Two-piece Reclining Figure which was a model of the bronze that went to the Lincoln Centre, Chicago and dates from 1963–5. There is also the Two-piece Reclining Figure No. 5 of 1963–4 as well as his large

Totem Head of 1968. On the Piazza beside Boodles' in St. James's, there is a fine bronze, Goslar Warrior, of 1973–4 loaned by Reid and Lefevre Ltd.

Moore's latest piece, Standing Figure and Knife Edge, was cast in Berlin in 1976 and erected on a high knoll near the reservoir on the west side of Greenwich Park in 1979. It is a very fine example of his later work. It is also admirably sited and it can best be reached by walking through a door into the Park, where there is a largish gap between some houses near the top of Croom's Hill.

The 1978 exhibition of Henry Moore sculpture in Kensington Gardens, coinciding with his eightieth birthday, had a 19 feet high

Knife-Edge Two-piece, by Henry Moore

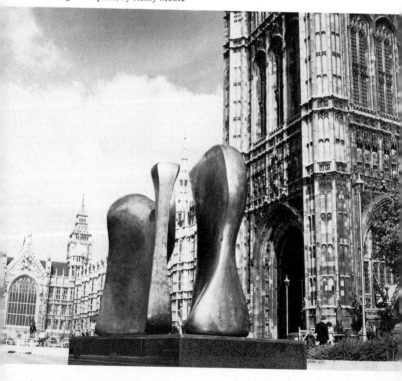

fibreglass sculpture admirably sited on the north side of the Serpentine almost opposite Peter Pan. It was called The Arch and was taken from a bronze of 1971. In 1980 the Henry Moore Foundation replaced this with a gift of a Roman travertine marble version of it sculpted the previous year.

The Lincoln Centre Reclining Figure in the Tate garden was returned in 1980 to Charing Cross Hospital where it first went in 1975. The fine Totem Head went to Barnsley.

Large Totem Head, by Henry Moore (*overleaf*)

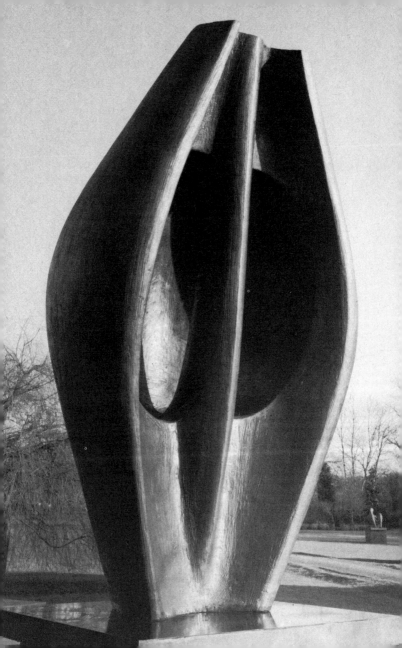

Henry Moore, O.M., C.H.

SUBJECT	LOCATION	MATERIAL	SCULPTED	ERECTED
West Wind	St. James's Underground Station—seventh floor	Stone	1928–9	1929
Three Standing Figures	Battersea Park	Stone	1947–8	1948
Time-Life Screen	157 New Bond Street	Portland Stone	1952–3	1953
Draped Reclining Figure	Terrace of 153 New Bond Street	Bronze	1952–3	1953
Draped Seated Woman	Stifford Estate, Jamaica Street, Stepney	Bronze	1954–8	1958
Two-piece Reclining Figure No. 3	Brandon Estate, off Cook's Road, Kennington	Bronze	1961	1961
Reclining Mother and Child	Birdcage Walk	Bronze	1960–1	1966
Knife-Edge Two-piece	Abingdon Street Gardens, Opposite House of Lords	Bronze	1962–5	1967
Locking Piece	Riverwalk House, Millbank	Bronze	1963–4	1968

SUBJECT	LOCATION	MATERIAL	SCULPTED	ERECTED
Two-piece Reclining Figure No. 1	Chelsea School of Art Mauresa Road	Bronze	1959	1969
Two-piece Reclining Figure Working Model for Lincoln Centre, Chicago	Charing Cross Hospital	Bronze	1963–5	1975
Two-piece Reclining Figure No. 5	Tate Gallery Garden	Bronze	1963–4	1979
Upright Motive Nos. 1/2/7	Tate Gallery Garden	Bronze	1955–6	1979
Goslar Warrior	Boodles' Club Piazza, St. James's lent by Reid and Lefevre Ltd.	Bronze	1973–4	1979
Reclining Mother and Child	Boodles' Club Piazza, St. James's	Bronze	1979	1978
Standing Figure and Knife-Edge	Greenwich Park, Near Reservoir	Bronze	1976	1979
Large Spindle Piece	The Mall, Admiralty Arch	Bronze	1968–74	1980

The Thornycrofts

Sculptors may run in families but few have had the success of the
Thornycrofts, who can boast three generations. John Francis
Thornycroft (1780–1861) was a sculptor, and his son Thomas
(1815–85) is best known for his delightful Boadicea near
Westminster Bridge even though her horses have no reins. It took
him fifteen years to complete and the Prince Consort lent him horses
for his models. He sculpted the Commerce group on the Albert
Memorial. His wife Mary was also a sculptor.

They had two very successful sons who were both knighted.
William Hamo is the best-known sculptor of the family and his
work included the fine statue of Cromwell outside Westminster Hall,
Gladstone in the Strand, Queen Victoria in the Royal Exchange,
General Gordon on the Embankment, Colet at Barnes and a
medallion of Norman Shaw. Coleridge in Poets' Corner is also his
work. He was elected an R.A. in 1888 and knighted in 1917.

His elder brother John (1843–1928) was a very successful naval
architect who specialized in fast motor torpedo boats for the Navy.
His firm, now Vosper Thornycroft, still supplies them. He was made
a F.R.S., and it was Sir John who presented his father's Boadicea to
London in 1902, the year he was knighted.

Sir Richard Westmacott, R.A.

Richard Westmacott, born in 1775, was both the son of a sculptor
and the father of one. He went to Rome in 1793 and stayed there
four years, during which time he won the much-coveted Gold Medal
awarded by the Pope. His studies there ensured that he became a
classical sculptor and this he remained all his life. During his stay he
became a pupil of Canova.

Back in England, he produced a number of busts and a wide
variation of work including fireplaces for the Brighton Pavilion,
Carlton House and Buckingham Palace as well as the pediment of
the British Museum. His best works are probably the effigies of
Admiral Collingwood and Sir Ralph Abercromby in St. Paul's as
well as Pitt, Addison and Fox in Westminster Abbey, although he is
best known for his Achilles (q.v.) erected in Hyde Park in 1822. This
caused a good deal of criticism as he had based it on a Roman
sculpture which was not of Achilles and then altered it by adding a

shield and a few minor details. Westmacott also carved the reliefs on
the north side of the Marble Arch in 1827. Made an A.R.A. in 1805
and R.A. in 1811, he was knighted in 1837 and died nineteen years
later.

Sir Charles Wheeler, K.C.V.O., C.B.E., P.R.A.

Charles Wheeler (1892–1974) soon became known as a noted
portrait sculptor but he also did decorative motifs on buildings such
as the gilt springbok on South Africa House when it was rebuilt in
1934. His most important commission was for the work on the Bank
of England when Sir Herbert Baker did his best to mutilate the
building put up by Sir John Soane. Wheeler did stone statues of
Charles Montagu and Montagu Norman on the first floor of the
central court of the Bank. The gilt figure of Ariel on the dome at the
corner of Lothbury and Princes Street is Wheeler's work, as are the
figures on the front of the Bank. The two caryatids with cornucopias
represent Productiveness and the four atlantes beside them embody
the Warders of the Bank, while above them there is the central
figure of the Old Lady of Threadneedle Street holding a
representation of a building on her knee which is based on the seal
of the Bank of England. Wheeler's work on the Bank dates from
about 1930 to 1937 when Ariel was put in position. His figures on
the façade are certainly not worthy of a man who was to become
P.R.A for ten years from 1956–66, having been elected R.A. in 1940.
He became K.B.E. in 1966.

Wheeler sculpted the bronze bust of Admiral Jellicoe which was
erected on the north wall of Trafalgar Square and in the same year,
1948, he created the bronze figure for the fountain on the west side
of the Square, the east side bronze being by William Macmillan,
R.A.

Four years before, Wheeler sculpted a stone figure of Mary of
Nazareth. The year after he died this was given to St. James's
Church, Piccadilly to go in its churchyard which had been
transformed into a garden of rest and a memorial to Londoners by
Viscount Southwood. His most exciting London work is a fountain
in George Square off Lombard Street, with a central bronze figure
of Poseidon standing up, and on the right side there is a crouching
merman and a mermaid who was modelled from his second and

much younger wife. This was the gift of Barclays Bank, and on both
the corners of their nearby building there are bronze figures,
Hercules and the Lion is on the fountain side and St. George and
the Dragon on the Lombard Street corner. These two date from
1975 and the fountain from 1969. Wheeler also engraved the two
huge bronze doors of the Bank, one of which is in gilt.

Much less satisfactory were his two large cumbersome figures over
the entrance to the Ministry of Defence in Horse Guards Avenue.
They are called Earth and Water and date from 1953.

Sir Charles Wheeler, K.C.V.O., C.B.E., P.R.A. (1892–1974)

SUBJECT	SITE	MATERIAL	DATE
Ariel	Bank of England	Gilt	1932
Charles Montagu	Bank of England	Stone	1932
Sir Montague Norman	Bank of England	Stone	1932
Sculpture of façade	Bank of England	Stone	1932
Springbok	South Africa House	Gilt	1934
Fountain	Trafalgar Square	Bronze	1948
Admiral Earl Jellicoe	Trafalgar Square	Bronze	1948
Earth and Water	West side only Ministry of Defence entrance	Stone	1953
Mary of Nazareth	St. James's Piccadilly	Stone	1975
Hercules and the Lion	George Square, off Lombard Street	Bronze	1975
St. George and the Dragon	Lombard Street	Bronze	1975
Poseidon Group	George Square, off Lombard Street	Bronze	1969

David Wynne, Born 1926

SUBJECT	SITE	MATERIAL	ERECTED
The Archer	Longlow House, Chiswick	Stone	1957
Teamwork	Hanger Lane, Alperton	Granite	1958
Teamwork	Southall	Aluminium	1959
Birth of Life	British Oxygen House, Hammersmith	Marble	1962
Guy the Gorilla	Crystal Palace	Black Marble	1962
Girl with Doves	Cadogan Place, South garden	Bronze	1970
The Dancers	Cadogan Place North Garden	Bronze	1971
Girl with a Dolphin	St. Katharine's Way	Bronze	1973
Boy with a Dolphin	Pier House, Oakley Street	Bronze	1975
Dancer with Bird	Cadogan Square	Bronze	1975
Horse and Rider	Forecourt of I.P.C. Ltd, Sutton	Bronze	1980

David Wynne

A sculptor born in 1926 and who has had a lot of commissions is David Wynne. His Boy with a Dolphin at the bottom of Oakley Street and opposite Albert Bridge is probably his best piece. It has considerable grace and a great deal of movement about it. There is a

somewhat similar one of a Girl with a Dolphin in front of the Tower Hotel in St. Katharine's Way but it lacks the verve and charm of the other.

The Cadogan Estates commissioned three works to go in Cadogan Square and in the north and south parts of Cadogan Gardens. They all have a similarity and again have a good deal of movement but are less good. Some years before these the British Oxygen Company had commissioned his Birth of Life, a marble sixteen-and-a-half-feet high column standing in front of their building between Hammersmith Broadway and Bridge. Nobody would recognize this totem-type pole as being by Wynne any more than they would the well-known teamwork symbol of four men pulling on a rope which is the emblem of Taylor Woodrow and Company and is seen on so many building sites. There is a granite version of it outside their offices at Hanger Lane, Alperton and an aluminium one at Southall. It is named Teamwork. Another example of Wynne's versatility is the delightful Guy the Gorilla at the Crystal Palace, beside the lake, at the bottom of the grounds. *See* Sculpture chapter *under* Animals.

He has done heads of many famous people besides a number of sculptures such as the successful Embracing Lovers in the ambulatory of the Guildhall. Wynne was a recipient of the Queen's Jubilee Medal.

Bibliography

Baker, Margaret, *Discovering London: Statues and Monuments*, Shire
 Publications, 1968.
Banks, F. R., *Penguin Guide to London* (4th ed.), Penguin, 1979.
Borenius, Tancred, *Forty London Statues and Public Monuments*, Methuen,
 1936.
Brown, F. P., *London Sculpture* (English Art Series Vol. III), Pitman, 1934.
Chancellor, E. B., *History of the Squares of London*, Kegan Paul, Trench,
 Trubner, 1907.
Cooper, C. S., *The Outdoor Monuments of London*, Homeland Association
 Ltd., 1910 and 1928.
Farr, Dennis, *English Art 1870–1940*, Clarendon Press, 1979.
Gleichen, Lord Edward, *London's Open Air Statuary*, Longmans, 1928.
Hill, T. W., *Open Air Statues of London*, Home Counties Magazine Vol. XII,
 1910.
Kent, William, *London Worthies*, Heath Cranton, 1898.
– revised by Geoffrey Thompson, *An Encyclopaedia of London*, J. M. Dent,
 1970.
Mannheim, F. J., *Lion Hunting in London*, Caducens Press, 1975.
Needham, Raymond and Alexander Webster, *Somerset House Past and
 Present*, T. Fisher Unwin, 1905.
Pevsner, Nicolas, *London I* (Cities of London and Westminster), Penguin
 (2nd ed.), 1962.
– *London II* (Except London and Westminster), Penguin (3rd ed.), 1973.
Piper, David, *Companion Guide to London* (revised), Fontana, 1970.
Pritchett, V. S., *London Perceived*, Chatto and Windus, 1962.
Royal Society of British Sculptors, *Modern British Sculpture*, Academy
 Architecture, 1923.
– *Modern British Sculpture*, Country Life, 1938.
Sitwell, Osbert, *The People's Album of London Statues*, Duckworth, 1928.
Thompson, Geoffrey, *London Statues*, J. M. Dent & Sons, 1971.
Wadia, Bothna (tr. from the French), *A Dictionary of Modern Sculpture*,
 Methuen, 1962.
Walford, Edward, *Old and New London* 6 Vols, Cassell, Peter and Galpin,
 1878.
White, P. W., *On Public View London's Open Air Sculpture*, Hutchinson,
 1971.
Wittkover, Rudolf, *Giovanni Lorenzo Bernini: Sculptor of Roman Baroque*,
 Phaidon, 1955.
Survey of London – various volumes.

SCULPTORS

Antique Collectors Club, *Dictionary of British Artists 1880–1940*, Woodbridge, 1976.

Thieme-Becker, *Allgemeines Lexikonde Bildenden Kunstler* (37 Vols.), 1907–50.

Benezit, E., *Dictionnaire critique et documentaire des Peintres, Sculpteurs, Dessinateurs et Graveurs* (10 Vols.), 1976.

Chancellor, E. Beresford, *Lives of British Sculptors*, Chapman & Hall, 1911.

Clapp, Jane, *Sculpture Index*, The Scarecrow Press Inc. Metuchen, N.J. 1970. Vols I and II.

Farr, Dennis, *English Art 1870–1940*, Clarendon, 1978.

Fielding, Marlte, *Dictionary of American Painters, Sculptors and Engravers*, U.S.A., 1926.

Grant, Col. M. H., *Dictionary of British Sculptors from XIII to XX Century*, 1953.

Gunnis, Rupert, *Dictionary of British Sculptors 1660–1851*, Odhams, 1953.

Mackey, James, *Dictionary of Western Sculptors in Bronze*, Antique Collector's Club, 1977.

Mallett, D. T., *Mallett's Index of Artists*, International, Kingsmead Reprints, 1970.

– *Mallett's Index of Artists*, Biographical, Kingsmead Reprints, 1977.

– Supplement to *Mallett's Index of Artists*, Kingsmead Reprints, 1977.

Redgrave, Samuel, *A Dictionary of Artists*, Raymond Reprints, 1970.

Sheilman, M. H., *British Sculptors and Sculptors of Today*, Cassell, 1901.

Waters, Grant M., *Dictionary of British Artists working 1900–1950* Vols. I and II, Eastbourne Fine Art, 1975.

Avery obituary index of Architects and Artists, G. K. Hall, Boston, 1963.

Index

This index is a site index only, as the statues, sculptures etc are listed alphabetically in their respective chapters. Map references are given in brackets